THE HORSES
OF SAN MARCO
& THE QUADRIGA
OF THE LORD

THE HORSES OF SAN MARCO & THE QUADRIGA OF THE LORD

Michael Jacoff

PRINCETON UNIVERSITY PRESS

731.832
J17h

Copyright © 1993 by Princeton University Press
Published by Princeton University Press, 41 William Street, Princeton, New Jersey
08540
In the United Kingdom: Princeton University Press, Chichester, West Sussex

Library of Congress Cataloging-in-Publication Data

Jacoff, Michael, 1943
 The horses of San Marco and the quadriga of the lord / Michael
Jacoff.
 p. cm.
 Includes bibliographical references and index.
 ISBN 0-691-03270-X
 1. Cavalli di San Marco (Venice, Italy) 2. Christian art and
symbolism. I. Title.
NK7952.V38J33 1993
731'.832—dc20 93-16276
 CIP

This book has been composed in Janson

Princeton University Press books are printed on acid-free paper and meet the guide-
lines for permanence and durability of the Committee on Production Guidelines for
Book Longevity of the Council on Library Resources

Printed in the United States of America

10 9 8 7 6 5 4 3 2 1

10 9 8 7 6 5 4 3 2 1
(Pbk.)

Designer Heidi Haeuser
Production Coordinator Anju Makhijani
Editor Timothy Wardell

To my parents

Table of Contents

List of Illustrations

1. San Marco, Piazza San Marco, and Piazzetta di San Marco. Aerial View (photo: Borlui, Venice)
2. Plan of San Marco (after O. Demus, *The Church of San Marco in Venice: History, Architecture, Sculpture.* Dumbarton Oaks Studies 6. Washington, D.C., 1960, pl. 1)
3. West Façade, San Marco (photo: Alinari/Art Resource, New York)
4. South Façade, San Marco (photo: Alinari/Art Resource, New York)
5. North Façade, San Marco (photo: Alinari/Art Resource, New York)
6. Horses, San Marco (photo: Alinari/Art Resource, New York)
7. Horses, San Marco (photo: Cameraphoto, Venice)
8. Horses, San Marco (photo: Böhm, Venice)
9. Piers from St. Polyeuktos, San Marco (photo: Böhm, Venice)
10. Porphyry Emperors, San Marco (photo: Alinari/Art Resource, New York)
11. Porphyry Head, San Marco (photo: Alinari/Art Resource, New York)
12. Christ, San Marco (photo: Böhm, Venice)
13. St. Luke, San Marco (photo: Böhm, Venice)
14. St. Mark, San Marco (photo: Centro Tedesco di Studi Veneziani, Venice)
15. St. John, San Marco (photo: Böhm, Venice)
16. St. Matthew, San Marco (photo: Centro Tedesco di Studi Veneziani, Venice)
17. Heracles and the Boar, San Marco (photo: Alinari/Art Resource, New York)
18. Virgin Mary, San Marco (photo: Alinari/Art Resource, New York)
19. St. George, San Marco (photo: Alinari/Art Resource, New York)
20. St. Demetrius, San Marco (photo: Alinari/Art Resource, New York)

(photo: Royal Collection, St. James's Palace. Courtesy Her Majesty Queen Elizabeth II)

40. Sun and Moon, Treatise on Astronomy, Oxford, Bodleian Library, Ms. Bodley 614, fol. 17v (photo: Bodleian Library)

41. Sts. John and Matthew, Wolfenbüttel, Herzog August Bibliothek, Cod. Guelf. 61.2 Augusteus 4°, fol. 89r (photo: Herzog August Bibliothek)

42. Quadriga of Aminadab, Honorius Augustodunensis, Commentary on the Song of Songs, Vienna, Österreichische Nationalbibliothek, Cod. 942, fol. 79v (photo: Bild-Archiv der Österreichischen Nationalbibliothek)

43. Quadriga of Aminadab, Saint-Denis (after A. Martin and C. Cahier, *Monographie de la cathédrale de Bourges*, vol. 1, Paris, 1841–44, pl. 6)

44. Return of the Ark from the Philistines and the Car of the Gospels, *Bible moralisée*, Vienna, Österreichische Nationalbibliothek, Cod. 2554, fol. 36v (photo: Bild-Archiv der Österreichischen Nationalbibliothek)

45. Quadriga of Aminadab and Christ Preaching to the Jews, *Bible moralisée*, Toledo, Catedral, 2, fol. 86 (photo: MAS, Barcelona)

46. Opicinus de Canistris, Duomo of Pavia with the *Regisole*, Rome, Biblioteca Apostolica Vaticana, Cod. Pal. Lat. 1993, fol. 2 (photo: Biblioteca Vaticana)

47. Marten van Heemskerck, North Side of the Lateran with the Statue of Marcus Aurelius, Berlin, Kupferstichkabinett, Staatliche Museen Preussischer Kulturbesitz, 79 D 2, fol. 71v (photo: Kupferstichkabinett)

48. Murder of Buondelmonte de' Buondelmonti near the Statue of Mars, Giovanni Villani, *Cronaca*, Rome, Biblioteca Apostolica Vaticana, Cod. Chigi L. VIII, 296, fol. 70r (photo: Biblioteca Vaticana)

49. Pisa, Duomo, from P. Tronci, *Descrizione del Duomo di Pisa*, Pisa, Archivio Capitolare, Ms. C 152, p. III (photo: G. Pellegrini, Pisa)

50. Giovanni Antonio Dosio, Krater with Bacchic Scenes, Berlin, Kupferstichkabinett, Staatliche Museen Preussischer Kulturbesitz, 79 D 1, fol. 17r (photo: Kupferstichkabinett)

51. Griffin, Pisa, Duomo (photo: Alinari/Art Resource, New York)

52. Triumph of Titus, Rome, Arch of Titus (photo: Alinari/Art Resource, New York)

53. Victory Procession, Rome, Arch of Titus (photo: Alinari/Art Resource, New York)

54. Triumph of Julius Caesar, *Liber ystoriarum romanorum*, Hamburg,

List of Abbreviations

Cavalli di S. Marco
> *I cavalli di S. Marco: Catalogo della mostra. Convento di Santa Apollonia Venezia Giugno/Agosto 1977.* Venice, 1977.

Demus, *Church of San Marco*
> Demus, O. *The Church of San Marco in Venice: History. Architecture. Sculpture.* Dumbarton Oaks Studies 6. Washington, D.C., 1960.

Demus, *Mosaics of San Marco*
> Demus, O. *The Mosaics of San Marco in Venice.* 4 vols. Chicago, 1984.

Demus, "Skulpturale Fassadenschmuck"
> Demus, O. "Der skulpturale Fassadenschmuck des 13. Jahrhunderts." In Wolters, *Skulpturen von San Marco*, 1–15.

Galliazzo
> Galliazzo, V. *I cavalli di San Marco.* Treviso, 1981.

Herzner
> Herzner, V. "Die Baugeschichte von San Marco und der Aufstieg Venedigs zur Grossmacht." *Wiener Jahrbuch für Kunstgeschichte* 38 (1985): 1–58.

JWCI
> *Journal of the Warburg and Courtauld Institutes*

PL
> *Patrologiae cursus completus: Series latina.* Ed. J. P. Migne. 221 vols. Paris, 1844–64.

Wolters, *Skulpturen von San Marco*
> *Die Skulpturen von San Marco in Venedig: Die figürlichen Skulpturen der Aussenfassaden bis zum 14. Jahrhundert.* Ed. W. Wolters with O. Demus, G. Hempel, J. Julier, and L. Lazzarini. Deutsche Studienzentrum in Venedig Studien 3. Munich and Berlin, 1979.

The Vulgate is quoted according to *Biblia Sacra iuxta Vulgatam versionem.* 2nd ed., ed. R. Weber. Stuttgart, 1975. Translations follow the Douay/Rheims version with minor changes.

Preface

They would see the sumptuousness of Venice,
not its shape. . . .
E. M. Forster, *Passage to India*, XXXII

The richness of Venetian art and the directness of its appeal are such that they crowd out, at times, any interest in the ideas that inform some of its most notable creations. The façades of San Marco are a case in point. They owe their place as one of the most familiar icons of Western culture to their sheer splendor, a splendor perfectly suited to the setting. Countless visitors have admired not only the precious materials and magnificent works of art, but also the way marble, bronze, and mosaic are revealed and bound into a larger whole by a unique, endlessly changing play of light. Nobody today, visitor or Venetian, looks for any great rigor of thought or expression here. Insofar as any content is discerned at all, it is little more than banal vainglory.

This conception of the façades of San Marco is seriously flawed. Much of their decoration was shaped by a systematic effort to convey a set of specific ideas. The present study is not a comprehensive account of this program. It is confined to the part played by the most celebrated component of the façades, the team of four gilded bronze horses that make up a quadriga on the west front. It seeks to demonstrate that these horses play a crucial role in a fundamental theme of the decoration. Only a few additional aspects of the program will be briefly considered.

The present enterprise can be characterized in broader terms. The horses of San Marco are, of course, classical works. Hence their presence at the church is a manifestation of a perennially intriguing feature of the artistic culture of the Middle Ages. Ancient, primarily Roman works of art were reused throughout the period, although the frequency of the practice varied considerably. Given their artistic caliber, scale, and siting, the horses at San Marco are surely among the most remarkable examples of the phenomenon.

The relatively small number of such episodes belies their significance. Attitudes towards the physical remains of antiquity reveal much about the ways in which the new Christian civilization of the Middle Ages conceived of its relations to the pagan Roman world from which it had emerged and to which it still felt bound in so many respects. To inquire into the role of the horses in the thirteenth-century façade program of San Marco is to probe the uses of the past in a richer sense than is usually supposed.

The pertinent questions are obvious, but they have never been seriously posed. To what extent were the Greco-Roman associations of such a four-horse team known to the persons responsible for its installation at San Marco? Had the quadriga acquired additional meanings during the Middle Ages? Do any of these associations have special relevance for San Marco? Is there anything to be learned from comparisons with other instances of the reuse of antiquities in medieval Italy? Answering these and related queries brings to light the acumen and boldness with which these ancient horses were harnessed in the service of medieval Venice.

A few words about the extended series of excursuses are necessary. The first discusses the view that the original position of the horses at San Marco differed somewhat from the present one. The second examines a possible clue concerning their role. In both cases the conclusions are negative. Rather than take the reader on lengthy detours in the main body of the text, it seemed preferable to address these issues separately at the end. The final two excursuses deal with later appearances of the theme that will be identified here as essential to the display of the horses at San Marco. The passage from Dante's *Commedia* and the print by Titian have been singled out not only because of their intrinsic importance, but also because of their relevance for the present study. As the only other depiction of this subject in Venice, the latter naturally invites attention here. The former is a critical component of the larger context in which the woodcut must be seen. In the final analysis, this book is almost as much about the history of the expression of an idea in texts and images over a period of more than a thousand years as it is about the thirteenth-century decoration of the façades of San Marco.

In the course of preparing this study, I have received help from many people. I would like to thank, first of all, arch. Ettore Vio, the Proto of San Marco, and the staff of the Procuratoria, particularly geom. Giuseppe Fioretti and dottoressa Maria DaVilla Urbani, for their generous assistance. My thanks go also to Hugo Buchthal, Julian Gardner, Rachel Jacoff, Dale Kinney, Thomas Mathews, Debra Pincus, and Jane Timken.

This book benefited considerably from discussions with each of them and from their comments upon a draft. It was also improved by suggestions from the readers who reviewed the manuscript for Princeton University Press. At the Press, it benefited from the attention of Elizabeth Powers and Timothy Wardell who were a source of good advice in many matters. For that and for their support I am most grateful.

My profound debt to the work of Otto Demus will be evident on every page dealing directly with San Marco. I also owe a considerable debt of gratitude to Adrienne Atwell for taking time from a busy schedule to prepare the reconstruction drawing and for making a variety of helpful suggestions in the process. Her drawing is a most important contribution to the argument. I am also grateful to prof. Renato Polacco and prof. Vittorio Galliazzo for kindly permitting me to reproduce their reconstructions. Ornella Francisci Osti helped greatly in obtaining some of the photographs. I would also like to thank Constance Lowenthal and Margaret Frazer for an invitation long ago to lecture on the horses at the Metropolitan Museum of Art in New York when a major exhibition was devoted to them. Preparation of that talk first led me to think seriously about the problems raised by their presence at San Marco. Finally, I gratefully acknowledge the help of the Gladys Krieble Delmas Foundation at an early stage of my research and again when it came time for publication.

The Thirteenth-Century Façades of San Marco and the Conquest of Constantinople in 1204

In the course of the thirteenth century, the façades of San Marco underwent a transformation. Until then the church, erected in the last third of the eleventh century, had had a sparsely adorned brick exterior. Now it was sheathed in a panoply of sculpture and mosaics, columns and marble revetment (figs. 1–5). A glittering synthesis of reused and newly created works, this embellishment was carried out between the 1220s and the 1270s.[1]

The decoration then introduced does not, unfortunately, survive intact. The appearance of the west façade when work was drawing to a close is known through a remarkable document, the mosaic in the Porta Sant'Alipio dating from the 1260s (fig. 29). Located at the northern end of the west front, it is the final scene of a cycle depicting the story of the Venetian acquisition of the relics of St. Mark and shows his body being borne into the church. Although the translation of the relics took place in 828/29, San Marco is represented with its thirteenth-century façade

1. Demus never undertook a unified account of the thirteenth-century campaign, but his discussions of individual aspects remain fundamental. On the architecture and the sculpture, see his *Church of San Marco*, 76–82 and 100–90, and his "Skulpturale Fassadenschmuck"; on the mosaics, his *Mosaics of San Marco*, 2, 1: 185–206. See also Herzner's major article. For the most recent discussion of the complex history of the façades and the zone immediately behind them, see R. Polacco with G. Rossi Scarpa and J. Scarpa, *San Marco: La Basilica d'oro* (Milan, 1991), 28–39, 107, and 144f., with reconstructions of the west façade in the eleventh and twelfth centuries (19 and 35). For an older reconstruction of the appearance of the west façade before the thirteenth-century changes, see chapter II, note 18.

decoration already in place. Its overall form and many of its individual components are recorded with considerable faithfulness.[2]

The Porta Sant'Alipio mosaic reflects the great pride Venetians took in the new splendor of the church of their patron saint. This sentiment also found expression in contemporary Venetian literature. In Martin da Canal's *Les estoires de Venise*, San Marco is called "the most beautiful church in the world." Although he is not specifically speaking of the façades, da Canal probably counted them among the building's most important features. Their mosaics are the only component of San Marco's decoration mentioned in his work. His book, the most important source to survive from thirteenth-century Venice, was written in the late 1260s and early 1270s just as the façade decoration was nearing completion.[3]

The chief loss revealed by a comparison between the Porta Sant'Alipio mosaic and the west façade as it stands today involves the lunette on the upper level at the center of the façade. The original decoration was replaced by a vast window, the *finestrone*. Another important change is also readily apparent. As its style indicates, the figural and ornamental sculpture that now rises along the crest of the façade like the spume of a wave is an addition. Both modifications took place in the early fifteenth century. Other changes will be noted in due course.[4]

The alterations to which the façades have been subjected have seriously impaired their visual and conceptual coherence. One of the fundamental themes of the program is, nonetheless, immediately discernible. The primary impetus for the refashioning of the façades was undoubtedly Venice's great victory over Byzantium in 1204. Under the astute leadership of Doge Enrico Dandolo, the Venetians had played a key role in the complex series of events that diverted the Fourth Crusade from its original goal in the Holy Land and that culminated in the conquest of

2. The subject, date, and condition of the Porta Sant'Alipio mosaic are discussed by Demus, *Mosaics of San Marco*, 2, 1: 201–4. As he shows (201; see also 193f.), restorations do not appear to have altered it significantly. For the restorations, see also *Patriarchal Basilica in Venice: San Marco*, vol. 2, *The Mosaics. The Inscriptions. The Pala d'Oro*, with contributions by M. Andaloro et al. (Milan, 1991), 209, where a color reproduction is found. On the mosaic's rendering of the façade, see Demus, *Church of San Marco*, 103, and *Mosaics of San Marco*, 2, 1: 204. The question of its reliability in details is considered below, pages 31 and 114–16.

3. Martin da Canal, *Les estoires de Venise: Cronaca veneziana in lingua francese dalle origini al 1275*, ed. and trans. A. Limentani, Civiltà veneziana: Fonti et testi 12, Ser. 3,3 (Florence, 1972), 128 (1, CXXXI, "la plus bele yglise qui soit el monde"). For more qualified expressions of the same opinion, see 20 (1, XII); 154 (2, I); and 362 (2, CLXXXVIII). The façade mosaics are mentioned in a well-known passage, 20 (1, XII).

4. On the introduction of the *finestrone* and the new sculpture, see below, pages 26 and 49f.

Constantinople. Their reward was commensurate. Long an important commercial and military force in the eastern Mediterranean, Venice now emerged as the mistress of a colonial empire encompassing numerous possessions in the Aegean and elsewhere. She acquired, in addition, a leading part in the affairs of the short-lived Latin Empire established in the wake of the conquest. In the words of his new title, the doge of Venice had become "Dominator quarte et dimidie partis totius imperii Romanie." The resplendent adornment of the façades of the church of the city's patron saint was conceived as a triumphant declaration of the Serenissima's new status as a great power in the Mediterranean world.[5]

The link between the new decoration and the conquest of 1204 is direct and concrete, for the façades incorporate numerous spoils carried off from Constantinople. It is widely assumed that this is the manner in which many of the columns, revetment panels, and works of sculpture were acquired. Although this view is almost certainly correct, demonstrating the provenance of these materials is far from easy. None are mentioned in the extensive contemporary accounts of the sack of Constantinople to which the successful assault gave way.[6]

Archaeological discoveries in the 1960s make definite conclusions possible in the cases of two sets of objects that are particularly prominent features of the façades. The first group is the pair of piers that stand before the south façade (figs. 4 and 9). Widely believed since the late fifteenth century to have been brought from Acre, they are generally called the *Pilastri acritani*. It is now known, however, that this provenance is false. Excavations in Istanbul at a site once occupied by the early sixth-

5. On the Venetian role in the events of 1204 and on their consequences for Venice, see R. Cessi, *Storia della Repubblica di Venezia*, rev. ed. (Milan and Messina, 1968 [reprint Florence, 1981]), 178–215, and F. C. Lane, *Venice: A Maritime Republic* (Baltimore, 1973), 36–43. For fuller and more recent discussions, see D. E. Queller, *The Fourth Crusade: The Conquest of Constantinople, 1201–1204* (Philadelphia, 1977), and D. M. Nicol, *Byzantium and Venice: A Study in Diplomatic and Cultural Relations* (Cambridge, 1988), 124–87. The triumphal character of the new façades and its direct relation to the conquest of 1204 are widely recognized. For a particularly strong statement, see Herzner, 56f.

6. A systematic survey of the building materials and sculpture at San Marco obtained in Constantinople in the aftermath of the Latin victory has yet to be undertaken. For some discussion, see Demus, *Church of San Marco*, 26f., 113f., 120f., and 129. On column shafts and capitals acquired in this way, see F. W. Deichmann, ed., with J. Kramer and U. Peschlow, *Corpus der Kapitelle der Kirche von San Marco zu Venedig*, Forschungen zur Kunstgeschichte und christlichen Archäologie 12 (Wiesbaden, 1981), 1–7. For some of the sculpture on the façades of San Marco that probably belonged to the booty of 1204, see, in addition to the immediately following pages, pages 51, 80, and 91f. below.

On the sack, see C. M. Brand, *Byzantium Confronts the West, 1180–1204* (Cambridge, Mass., 1968), 259–69.

century church of St. Polyeuktos have yielded fragments that correspond precisely to the ornament of the piers. There can be no doubt that the piers were once part of this building. Capitals recovered there also prove that a number of those on the west front of San Marco also came from St. Polyeuktos. In addition, the excavations yielded evidence that this church, apparently already abandoned, was systematically stripped of its decoration roughly at the time of the Latin conquest.[7]

A remarkable find leaves no doubt regarding the Constantinopolitan provenance of another work on the south façade not far from the piers. Two porphyry reliefs, each depicting two emperors, are now set into the southwest corner of the Tesoro (figs. 4 and 10). Clearly fragments cut from the same monument, they probably date from about 300. The two figures on each relief clasp one another by placing an arm on the companion's shoulder. In 1958 it was argued that these reliefs should be identified with a sculptural group representing embracing figures that, according to Byzantine sources, was located in the Philadelphion in Constantinople. The boldness of this speculation was vindicated a few years later. The righthand figure of the San Marco group has lost its left foot, and the corresponding section of the base is also lacking. Carved in a lighter red stone, the replacement for the missing section is easily distinguishable. A fragment containing some of what is wanting—the heel and a part of the base on which it rests—was found in Istanbul near the church of the Myrelaion (Bodrum Camii). Although the precise site of the Philadelphion is unknown, it must have been located in the general vicinity of this building. The proposal identifying the Venetian group

7. The fullest review of the problem of the history of the piers and their links to St. Polyeuktos is F. W. Deichmann, "I pilastri acritani," *Rendiconti: Atti della Pontificia Accademia Romana di Archeologia* 3rd ser., 50 (1977–78): 75–89, esp. 77f. See also Deichmann, *Corpus der Kapitelle*, 138–41nos. 639 and 640. For the piers and their counterparts among the finds at St. Polyeuktos, see R. M. Harrison, *Excavations at Saraçhane in Istanbul*, vol. 1 (Princeton, 1986), 131nos. 5 a i–iv; 133nos. 6 a i–iv; 162fig. L; 164f.nos. 22 d i, 22 e i, and 22 f; and xii, 112f., 280, and 409f. on relevant aspects of the building's history. On these matters, see also Harrison's most recent publication, *A Temple for Byzantium: The Discovery and Excavation of Anicia Juliana's Palace-Church in Istanbul* (Austin, 1989), 74f., 80, 100f., 132, and 142f. Attempts to save local tradition by proposing that the piers were first taken from Constantinople to Acre and later from there to Venice are unconvincing.

For the capitals, see Deichmann, *Corpus der Kapitelle*, 76f.no. 304; 92nos. 372–73; 98f.nos. 410 and 413; and 103–5nos. 439–40 and 447–48; but cf. 4 where they are listed in different groups. See also Harrison, *Excavations*, 164f.nos. 22 c i–iii, 22 l i–ii, and 22 m i–iv. The fullest discussion of their connection with St. Polyeuktos is U. Peschlow, "Dekorative Plastik aus Konstantinopel an San Marco in Venedig," *Aphierōma stē mnēmē Stylianou Pelekanidē*, Makedonika: Periodikon Suggramma Hetaireias Makedonikon Spoudōn, Parartēma 5 (Thessalonica, 1983), 407–11. See also Harrison, *Temple*, 94 and 132.

with the one said to have stood in the Philadelphion is now widely accepted.[8]

Of course, the most celebrated of all the prizes brought back from Constantinople is the team of four gilded bronze horses (figs. 6–8) set above the central portal of the west façade. The strong impression they make is due to their life-size scale and realism and also to their glittering surfaces and powerful, yet graceful movements. As already noted, these bronzes were made in antiquity. They are now generally thought to be Roman works, but the view that they are Greek in origin still finds some adherents. Although monumental groups depicting chariots drawn by four horses existed in large numbers in both ancient Greece and Rome, San Marco's team is the only one to survive.[9]

8. The original thesis is that of P. Verzone, "I due gruppi in porfido di S. Marco in Venezia ed il Philadelphion di Costantinopoli," *Palladio* n.s., 8 (1958): 8–14. For the finding of the fragment, which is not a joining one as sometimes said, see R. Naumann, "Der Antike Rundbau beim Myrelaion und der Palast Romanos I. Lekapenos," *Istanbuler Mitteilungen* 16 (1966): 209–11, and pl. 43,2. For acceptance of this view, see, e.g., W. Müller-Wiener with R. and W. Schiele, *Bildlexikon zur Topographie Istanbuls: Byzantion, Konstantinupolis, Istanbul bis zum Beginn des 17. Jahrhunderts* (Tübingen, 1977), 267, and C. Mango, *Le développement urbain de Constantinople (IVe-VIIe siècles)* (Paris, 1985), 28f. For recent editions of the Byzantine sources, see A. Cameron and J. Herrin, *Constantinople in the Early Eighth Century: the Parastaseis syntomoi chronikai* (Leiden, 1984), 150f. (70) and 265f., and A. Berger, *Untersuchungen zu den Patria Konstantinupoleos*, Poikila Byzantina 8 (Bonn, 1988), 330f. and 334f. Cameron and Herrin, unlike Berger, are dubious about this identification. The fullest recent discussion of the group is H. P. L'Orange with R. Unger, *Das spätantike Herrscherbild von Diokletian bis zu den Konstantin-söhnen, 284–361 n. Chr.*, Deutsches Archäologisches Institut, Das römische Herrscherbild, 3 Abteilung, vol. 4 (Berlin, 1984), 6–10 and 103.

On the location of the Philadelphion and its relation to the findspot of the fragment, see Naumann, "Der Antike Rundbau," 209–11, and fig. 3, and Naumann, "Neue Beobachtungen am Theodosiusbogen und Forum Tauri in Istanbul," *Istanbuler Mitteilungen* 26 (1976): 134, and fig. 8. Naumann's view is accepted, e.g., by Müller-Wiener, 21fig.2 and 25fig.3; Mango, 28–30; and Berger, map on 347. Cf. C. L. Striker, *The Myrelaion (Bodrum Camii) in Istanbul* (Princeton, 1981), 14.

For the various provenances given in the sixteenth-century Venetian sources and also for the ways in which the group was interpreted during the Renaissance and after, see M. Perry, "Saint Mark's Trophies: Legend, Superstition and Archaeology in Renaissance Venice," *JWCI* 40 (1977): 39–45.

9. The fullest account of all aspects of the history of the horses is Galliazzo's. For a review of the arguments about their origin, see Galliazzo, 6–57 and 185–253. Despite prevailing opinion, he favors a Greek one. On this point, see most recently J. Bergemann, "Die Pferde von San Marco: Zeitstellung und Funktion," *Mitteilungen des Deutschen Archaeologischen Instituts, Roemische Abteilung* 95 (1988): 115–28, esp. 122: late Republican or early Augustan copies of a Greek mid-fourth-century model.

Because of concerns about their condition, the horses were removed one by one between 1974 and 1981 and reinstalled inside the church in 1983. See Galliazzo, 47–49. I shall speak throughout as if they were still in their original places. Copies are now to be seen where they once stood.

A well-attested Venetian tradition extending back to the fifteenth century asserts that the horses were part of the booty of 1204. Despite the relative lateness of this report, there is no reason to doubt its reliability. Indeed, Byzantine sources that describe the monuments of Constantinople speak of a number of teams of four gilded horses. Which of them was seized by the Venetians has been the subject of some controversy. The most plausible view is that the horses at San Marco are those that had stood on a tower at the north end of the Hippodrome, probably since the time of Theodosius II (408–450) who is said to have brought them from Chios. The other groups are rather shadowy, and the tower's is the only one that can be proved to have existed at roughly the time of the sack.[10]

It is probable that, as is widely assumed, the Venetians lost little time in seizing the horses in the immediate aftermath of the successful assault on Constantinople in April 1204. This must have been the case, if the horses were transferred to Venice within a year or two along with columns and precious marbles, as some sixteenth-century accounts report. Written some three centuries or more after the sack, however, these accounts may telescope events that in fact stretched over a longer period. The Venetian depredations of the monuments of Constantinople should not be associated with the pillage that took place during the infamous three-day sack that followed the fall of the city to the Westerners. Selecting, removing, and transporting large quantities of column shafts, capitals, and reliefs suitable for use at San Marco as well as a number of bronze statues would have required time and organization. At least in the case of the architectural members, this must have been a matter of systematic procurement rather than haphazard looting: the

10. For fourteenth-, fifteenth-, and sixteenth-century accounts of the horses by Venetians and others, see Galliazzo, 6–18; Perry, "Saint Mark's Trophies," 27–38; and L. Borrelli Vlad and A. Guidi Toniato, "Fonti e documentazioni sui cavalli di S. Marco," in *Cavalli di S. Marco*, 138–40. For the four-horse chariot teams among the monuments of Constantinople, for the Byzantine sources dealing with them, and for this argument for indentifying the one at San Marco with that on the Hippodrome tower, see most fully Galliazzo, 67–74, and fig. 32 with a reconstruction of the Hippodrome with the horses in place. For the passages in the Byzantine texts concerning these quadrigas and for recent commentaries on them, see Cameron and Herrin, *Constantinople in the Early Eighth Century*, 60f. (5), 100–3 (38), 160f. (84), 171–73, 215–17, and 273f., and Berger, *Untersuchungen zu den Patria Konstantinupoleos*, 291f., 544f., and 550–55. For other views about which quadriga the Venetians took, see, e.g., Borrelli Vlad and Guidi Toniato, 137f., who prefer to leave the question open, and S. G. Bassett, "The Antiquities in the Hippodrome of Constantinople," *Dumbarton Oaks Papers* 45 (1991): 89n.20, who calls an identification of the horses at San Marco with those on the Hippodrome tower "hasty."

columns, for example, had to be the appropriate size. Large-scale operations of this kind imply that plans to refashion the façades of San Marco had already begun to take shape.[11]

One sixteenth-century report about this moment in the history of the horses can certainly be dismissed. After being brought to Venice, it is said, the horses languished for a time in the Arsenal. There they were nearly melted down to make cannon before their true value was recognized by Florentine connoisseurs. This tale is implausible for several reasons.[12]

The purported Venetian neglect of the horses is scarcely consistent with the effort involved in getting them down from the tower in the Hippodrome and transporting them to Venice. The expenditures for conveying them across the sea only make sense if it was intended to display the horses in Venice. It need not be assumed, of course, that the loggia of San Marco was already settled upon as the site. If the Venetians had only been interested in the value of the horses' metal, they would have melted them down on the spot in Constantinople. This was, indeed, the fate suffered by many of the city's other classical bronzes at the hands of the Western conquerors.[13]

An interval between the horses' arrival and their deployment on the

11. For the relevant sources and the common view that the horses were seized and shipped to Venice soon after the conquest of 1204, see Galliazzo, 3, 14–17, and 77f. He puts the transfer in late 1205 or early 1206. For similar views, see Perry, "St. Mark's Trophies," 27n. 2, and Herzner, 51, who puts it between 1205 and 1207. That at least a rough plan must have guided the selection of architectural spoils for San Marco has not been widely recognized. This important point is made by Deichmann, *Corpus der Kapitelle*, 13f. See also Kramer, 3–6, in the same volume.

12. The fullest version of the story appears in S. Erizzo, *Discorso di M. Sebastiano Erizzo sopra le medaglie de gli antichi*, 4th ed. (Venice, n.d.), 98, in the separately paginated section entitled "Dichiaratione di molte medaglie antiche." This story does not appear in earlier editions of Erizzo's work which was first published in 1559 and was much revised in later editions. The fourth edition was issued in the 1570s or 1580s. The story is told in abbreviated form by F. Sansovino, *Venetia, città nobilissima, et singolare, descritta in XIIII libri*, ed. G. Martinioni (Venice, 1663), 94, a work first published in 1581. Earlier, however, Sansovino had merely said that the horses remained in a concealed place for a time, perhaps meaning no more than that they were not on view. See F. Sansovino, *Delle cose notabili che sono in Venetia, libri II* (Venice, 1561), 27r. Galliazzo, 14, 16, and 77, and Herzner, 54, also reject Erizzo's story, and the explanation of the delay given here is similar to theirs in several respects. For further doubts, see M. Greenhalgh, "*Ipsa ruina docet*: l'uso dell'antico nel Medioevo," in *Memoria dell'antico nell'arte italiana*, vol. 1, *L'uso dei classici*, ed. S. Settis, Biblioteca di storia dell'arte, nuova serie 1 (Turin, 1984), 150. The tale, however, is still sometimes credited. On these sources, see also Perry, "St. Mark's Trophies," 28 and 36.

13. On the melting down of bronze statues by the Westerners, see, e.g., Brand, *Byzantium Confronts the West*, 263f., and Galliazzo, 63–66.

façade is not difficult to explain. The timing of their installation would naturally be determined by the pace at which work on the façade was progressing. The horses would not have been set up on the loggia while they would still run the risk of damage from operations nearby. They may well have been stored at the Arsenal until the façade was ready to receive them. The sixteenth-century tale is best understood as a reflection of the Renaissance view that medieval attitudes towards classical antiquity were benighted. The conception of Florence as the font of the new enlightenment probably also contributed to it.

Opinions regarding the date at which the horses were actually installed range from the dogate of Pietro Ziani (1205–1229) to the 1260s. The years around the middle of the century are often favored. But the 1230s or the early 1240s may be tentatively said to be the most probable time. On the one hand, there is some indication—to be presented later—that the horses were in place by that period. On the other, an installation during the 1220s when the extensive campaign was just being launched seems unlikely since that would have needlessly endangered them. In any case, the horses were certainly on the façade by about 1270 as the Porta Sant'Alipio mosaic attests.[14]

The bulk of the spoils from Constantinople found on the façades— capitals, shafts, and revetment panels—have been absorbed anonymously, so to speak, into the overall decoration. There can be no doubt, however, that the two piers, the four emperors, and the horses were indeed intended to serve as trophies: the manner in which they were acquired is an essential component of their meaning in their new context. The viewer is expected to see them not simply as particularly impressive contributions to the façade's general magnificence, but also as reminders of a victory that marked a momentous turning point in Venetian history. The commemorative function of these trophies is multifaceted. For

14. Although Galliazzo maintains in one place that the horses were installed on the church shortly after their arrival in Venice ("appena fu possibile e perciò nei primi decenni del Duecento" [77f.; see also 14]), he states elsewhere that it took place between 1235 and 1250 (4). Herzner, 51–54, who believes that the loggia was built to display the horses, posits considerable time between arrival and installation for the necessary work. The question of the loggia's date is considered below, pages 95–97, and the evidence for an installation by the 1230s or early 1240s, pages 39–41. An installation under Ziani is the view of O. Demus, *Die Mosaiken von San Marco in Venedig, 1100–1300* (Baden bei Wien, 1935), 49, but later he merely says by c. 1250 (*Church of San Marco*, 27n. 93). Among others, G. Perocco, "I cavalli di S. Marco a Venezia," in *Cavalli di S. Marco*, 75, places it around 1250. The possibility of an installation as late as the 1260s is raised by M. Muraro, *La vita nelle pietre: Sculture marciane e civiltà veneziana del Duecento* (Venice, 1985), 51.

Venetian and visitor alike, these objects provided concrete, incontrovertible evidence of the great triumph. But in other respects the messages intended for the two audiences were different. The citizen was to be inspired with the example of high achievement to which he must be equal, while the foreigner was to be awed with the might of the Venetian state that had toppled an empire.

The selection of the sites for the display of these trophies was clearly influenced by a desire to maximize the effectiveness with which they address the viewer. Because of changes in the south façade (fig. 4), the extent to which this is true of the two piers and the four emperors is no longer readily apparent. The present nondescript character of this portion of the church's exterior is misleading. It originally possessed a strong focus, for one of the principal entrances to the church was located here. This portal, which provided access from the Piazzetta di San Marco on the south, was closed in the early sixteenth century to form the Cappella Zen. The pedimented wall behind the chapel's altar now blocks the lower half of the arched opening that once led to the southern end of the west arm of the narthex. Adjacent to the Palazzo Ducale, the south side of San Marco faces the ceremonial approach to the church that begins at the landing beside the lagoon and proceeds through the Piazzetta (figs. 1 and 36). The south front has, therefore, been aptly termed the church's "official" façade.[15]

Although the two piers from St. Polyeuktos now stand to the right of the site of the south portal, in the original arrangement they flanked it. Echoing the two great monolithic columns on the quay itself, they helped to establish a triumphal way leading down the Piazzetta to the church. The siting of the four emperors is also emphatic, for they are placed at the jutting angle of the Tesoro. Their prominence would have

15. On the installation of the Cappella Zen for the tomb of the cardinal whose name it bears, see Demus, *Church of San Marco*, 79f., and B. Jestaz, *La chapelle Zen à Saint-Marc de Venise: D'Antonio à Tullio Lombardo*, Forschungen zur Kunstgeschichte und christlichen Archäologie 15 (Stuttgart, 1986).

For the official character of the south façade, see Demus, *Church of San Marco*, 113, and "Skulpturale Fassadenschmuck," 8. Muraro has written a number of times of a Via Sacra leading from the two columns on the lagoon side of the Piazzetta to the church. See, e.g., Muraro, *Vita nelle pietre*, 29. On this portal and its importance, see also G. Perocco and A. Salvadori, *Civiltà di Venezia*, vol. 1 (Venice, 1973), 144–48, with reconstructions of the twelfth-century appearance of the Piazzetta and the portal (figs. 157 and 161); Herzner, 32; and Polacco, *San Marco*, 18, 30, and 37 with a reconstruction. On the differences between the south and west façades in character and status and the extent to which they were determined by the topography of the area and by the religious and secular ceremonies that took place before them, see the general discussions of Demus, Herzner, and Perocco and Salvadori just cited.

been enhanced if, as has been argued, the main ceremonial entrance to
the Palazzo Ducale in its twelfth- and thirteenth-century form was lo-
cated where the fifteenth-century Porta della Carta is now, that is, only a
short distance away. Several of the reliefs along the south wall of the
Tesoro between the four emperors and the palace may also be prizes of
1204. The fact that the spoils extend across the breadth of the south
façade rather than cluster around the south portal is perhaps itself an
argument for the existence of an important entrance to the Palazzo
Ducale in this area at this time. If nothing more than a blind corner lay at
the right, this arrangement would make less sense.[16]

The impact of the works at this end of the south façade would have
been more forceful, if another proposal regarding a change in this area is
correct. It has been suggested that in the thirteenth century the west
façade of the Palazzo Ducale lay along a line coinciding with the position
of the Porta della Carta. It would have been, in other words, roughly six
meters back from the present one. If this were the case, the view from the
south towards the Tesoro wall and the adjacent portal would not have
been partially blocked, and this entire expanse would have been more
likely to be perceived as a single whole.[17]

San Marco's most fully elaborated and unified façade is that on the
west. It seems only natural that the horses, as the most imposing of all the
spoils seized by the Venetians, should have been given pride of place at its
very center. Poised high at the edge of the façade, they masterfully survey

16. For the original position of the piers, see G. Saccardo, "I pilastri acritani," *Archivio
veneto* 34 (1887): 305–8, and also Demus, *Church of San Marco*, 29n. 100, and 113. Saccardo
proposes that the one originally on the west was simply swung round, as it were, and
reinstalled on the east and that this took place at the time that the decoration of the
Baptistery, which lies directly behind them, was carried out under Doge Andrea Dandolo
(1343–1354). During the thirteenth century a portico was probably located where the
Baptistery is now. See O. Demus, "Ein Wandgemälde in San Marco, Venedig," *Harvard
Ukrainian Studies* 7 (1983): 125–44. For the spoils of 1204 among the Tesoro wall reliefs,
see Demus, *Church*, 113, and F. Zuliani, *I marmi di San Marco: Uno studio ed un catalogo della
scultura ornamentale marciana fino all'XI secolo*, Alto medioevo 2 (Venice, [1969]), 68no. 39;
95f.no. 71; and 162n. 13, nos. 143–44 (=Wolters, *Skulpturen von San Marco*, 54nos. 197–
98).

On the two Piazzetta columns, see below, pages 91–93.

The question of the earlier doorway is reviewed by D. Pincus, *The Arco Foscari: The
Building of a Triumphal Gateway in Fifteenth-Century Venice* (New York, 1976), 37–42, who
leaves the matter open. Among those who argue for the existence of an important doorway
in this position, see especially F. Zanotto, *Il Palazzo Ducale di Venezia*, vol. 1 (Venice, 1842),
37f.

17. For this suggestion, see Perocco and Salvadori, *Civiltà di Venezia*, vol. 1, 140, and fig.
157, and G. Perocco, "San Marco: History of the Basilica," in *Patriarchal Basilica in Venice:
San Marco*, vol. 1, *The Mosaics. The History. The Lighting*, with contributions by O. Demus et
al. (Milan, 1990), 23.

the Piazza before them. In their commanding position above the main entrance of San Marco, they serve as dramatic and enduring emblems of Venice's triumphant power. This is, indeed, the light in which their presence at the church and the pre-eminent position assigned to them have been almost universally understood.[18] There can be no doubt that the authorities responsible for the installation of the horses indeed viewed them as trophies that deserved the highest honors. The pages that follow seek to show, however, that another important consideration also affected the decision to display them at San Marco.

18. For recent statements, see, e.g., Perry, "St. Mark's Trophies," 28f.; Perocco, "Cavalli di S. Marco," 66; E. Muir, "Images of Power: Art and Pageantry in Renaissance Venice," *American Historical Review* 84 (1979): 21; Demus, "Skulpturale Fassadenschmuck," 5; Galliazzo, 4 and 76–78; Herzner, 52f.; and Polacco, *San Marco*, 106.

The Quadriga of the Lord:
A Christian Metaphor
and Its Transmutations

So self-evident is the reading of the horses at San Marco as emblems of triumph that it has obscured the fact that they play other important parts as well in the façade program. Of these additional roles one stands out in particular. During the Middle Ages the quadriga was the subject of a well-known *interpretatio christiana* which rendered these four ancient bronzes singularly appropriate for a prominent position on the west front of the church. The concept in question is the *Quadriga Domini*.[1]

Likening the four Evangelists—or their Gospels—to a four-horse chariot team was an effective device. It vividly evoked their parallel and coordinated roles in spreading the message of Christ and it also summoned up the vigor and speed with which they carried his word to the world. Moreover, by implicitly or, on occasion, explicitly making Christ the charioteer, it stressed the guidance and control that he exercised over their actions. In addition, because of the four-horse chariot's association with Roman triumph, the ultimate victory of Christianity was implied. The suggestion of ascendant force derives from mythology as well: the chariot of the sun was drawn by just such a four-horse team. In Christian thought the quadriga was also put to use as another of those interlocking

1. In classical Latin the term *quadriga*—like its English equivalent—can denote either a "chariot with its team of four horses," that is, the vehicle as a whole, or simply a "team of (four) chariot-horses." See *Oxford Latin Dictionary*, ed. P. G. W. Glare (Oxford, 1982), 1531. (In medieval Latin, as will be seen, the word took on additional meanings.) In my use of the English term, I have indicated, where necessary, which of its senses is intended. In my translations, however, I have simply rendered the Latin *quadriga* with the English form of the word, except in the passage from St. Jerome where I have retained the more precise language in the quotation from an earlier one.

quaternities, such as the four rivers of Paradise and the four parts of the world, that were seen as explaining why the Gospels, too, should be precisely four in number. Finally, the *Quadriga Domini* possessed Biblical as well as classical resonance, for it echoed the long-established relationship between the Evangelists and the vehicle-like object of two of Ezekiel's visions (Ezekiel 1 and 10). It affirmed, therefore, the continuity of the Old and New Testaments, while its triumphal associations made it clear that the former finds its fulfillment in the latter. The juxtaposition of classical and Biblical references probably constituted a significant part of the appeal of the image.

Widespread though it was in the Middle Ages, the linking of the Evangelists and the four-horse chariot has received scant attention from modern scholars. The *Quadriga Domini* is indeed treated in a variety of lexicons and surveys and in discussions of a number of medieval works of art. These brief accounts, however, offer little more than miscellaneous citations of examples, nearly all of them drawn from eleventh- and twelfth-century sources. In this situation, it is not surprising that the contributions of earlier authors have been either neglected or, as in the cases of St. Jerome and St. Augustine, ignored. The lack of a systematic overview of the development of this idea beginning with patristic times has also meant that a fundamental distinction between its early and late forms has gone unrecognized. An awareness of this distinction is essential to an understanding of the differences in the ways in which the concept of the *Quadriga Domini* was given visual expression during the Middle Ages. The following sketch of the history of this trope makes no pretense at comprehensiveness; it is merely intended to establish the salient points relevant here.[2]

The metaphor of the four Evangelists as the team of the chariot of the

2. The most useful general accounts appear in art historical contexts. See A. Martin and C. Cahier, *Monographie de la cathédrale de Bourges*, vol. 1 (Paris, 1841–44), 125; J. Sauer, *Symbolik des Kirchengebäudes und seiner Ausstattung in der Auffassung des Mittelalters*, 2nd ed. (Freiburg im Breisgau, 1924), 62f.; O. A. Erich, "Aminadab," in *Reallexikon zur deutschen Kunstgeschichte*, vol. 1 (Stuttgart, 1937), cols. 638–41; A. Aurenhammer, "Aminadab," in *Lexikon der christlichen Ikonographie*, vol. 1 (Vienna, 1959), 103–5; L. Grodecki, "Les vitraux allégoriques de Saint-Denis," *Art de France* 1 (1961): 26–29; and G. Schiller, *Ikonographie der christlichen Kunst*, vol. 4, 1 (Gütersloh, 1976), 102–4. It is briefly touched upon by F. J. Dölger, "Das Sonnengleichnis in einer Weihnachtspredigt des Bischofs Zeno von Verona," *Antike und Christentum* 6 (1940): 51–56, and H. de Lubac, *Exégèse médiévale: Les quatre sens de l'écriture*, vol. 2, 2 (Paris, 1964), 36–39. M. L. Gavazzoli, "L'allegoria del carro nelle opere letterarie e figurative del XII secolo," *Aevum* 46 (1972): 116–22, contains little that is relevant. None of these accounts consider any of the appearances of the idea before c. 1000 that are discussed here, except for Martin and Cahier who cite the passage in the commentary now attributed to Haimo of Auxerre. For Dante's use of the image, see excursus III.

Lord was employed by a number of fourth-century Church Fathers. One of its most influential appearances is contained in a letter of Jerome written in 394 to Paulinus of Nola concerning the study of the Bible. After stressing the importance of a knowledge of Holy Scripture and its correct interpretation, he offers a few comments on each of the books and their authors, following the Biblical sequence from Genesis to Apocalypse. His account of the New Testatment will be short, he tells the reader, and proceeds:

> Matthew, Mark, Luke, and John are the Lord's team of four [*quadriga domini*], the true cherubim or store of knowledge. With them the whole body is full of eyes, they glitter as sparks, they run and return like lightning, their feet are straight feet, and lifted up, their backs also are winged, ready to fly in all directions. They hold together each by each and are interwoven one with another: like wheels within wheels they roll along and go withersoever the breath of the Holy Spirit wafts them.[3]

The *Quadriga Domini* figures only briefly here, for the passage is largely given over to the imagery of the throne-chariot of Ezekiel's vision. Nevertheless, Jerome's letter played an important role in the development that followed. It gave the association between the four-horse chariot and the Evangelists the stamp of his authority, and the

3. "Tangam et novum breviter Testamentum: Mattheus, Marcus, Lucas, Iohannes, quadriga domini et verum Cherubin, quod interpretatur 'scientiae multitudo,' per totum corpus oculati sunt, scintillae micant, discurrunt fulgora, pedes habent rectos et in sublime tendentes, terga pennata et ubicumque volitantia. Tenent se mutuo sibique perplexi sunt et quasi rota in rota volvuntur et pergunt, quocumque eos flatus sancti spiritus duxerit." *Sancti Eusebii Hieronymi Epistulae*, vol. 1, ed. I. Hilberg, Corpus scriptorum ecclesiasticorum latinorum 54 (Vienna and Leipzig, 1910), 462 (Epistula LIII, 9). The translation is that of W. H. Fremantle with G. Lewis and W. G. Martley, *St. Jerome: Letters and Selected Works*, A Select Library of Nicene and Post-Nicene Fathers of the Christian Church, ed. P. Schaff and H. Wace, 2nd ser., vol. 6 (New York, 1893), 101. On the letter, see J. N. D. Kelly, *Jerome: His Life, Writings and Controversies* (London, 1975), 192f. On some aspects of the place of this passage in patristic discussions of quaternities, see A. C. Esmeijer, *Divina Quaternitas: A Preliminary Study in the Method and Application of Visual Exegesis* (Amsterdam, 1978), 48.
 Another undoubtedly influential early use of the image occurs in St. Augustine, *De consensu evangelistarum*, ed. F. Weihrich, Corpus scriptorum ecclesiasticorum latinorum 43 (Vienna and Leipzig, 1904), 10 (I, 7.10). For some additional patristic examples, see Dölger "Sonnengleichnis," 2 and 54, and Lubac, *Exégèse médiévale*, 36n. 7.
 For a closely related earlier metaphorical use of the quadriga, see the characterization of Constantine's relationship to his sons in the oration on the thirtieth anniversary of his rule by Eusebius (*Eusebius Werke*, vol. 1, ed. I. A. Heikel, Die Griechischen Christlichen Schriftsteller der ersten drei Jahrhunderte 7 [Leipzig, 1902], 201[111]).

popularity of his writings helped to diffuse the idea widely. The letter's impact was considerably enhanced by the use to which it was subsequently put. In the ninth century it began to be employed as the opening preface (the familiar *Frater Ambrosius*) in Latin Bibles and it became a standard component of a large majority of them especially after the middle of the thirteenth century. In addition, the example of this passage was probably responsible for the many appearances of this idea in similar contexts, such as a set of verses on the Bible by Alcuin and for its presence in another extensively used Bible preface.[4]

Jerome played another and even more important part in the history of the concept of the *Quadriga Domini*. He utilized the Latin word *quadriga* in the Vulgate to translate two closely related Hebrew terms for chariot, *merkavah* and *rekev*, on many of the numerous occasions of their appearance in the Old Testament. He did not, however, do so consistently; at many other points in the text he rendered the same words with *currus*, the general Latin term for chariot that leaves unspecified the number of animals in the team. The latter, indeed, would appear to be a more appropriate choice, since the Hebrew terms are also general ones and do not indicate the number of animals present. The Septuagint translates both by *harma*, again a broad designation for chariot: it makes no use of *tethrippos* or any of the other Greek terms that denote a chariot drawn by four horses.[5]

4. For the use of Jerome's letter as a preface, see S. Berger, "Les préfaces jointes aux livres de la Bible dans les manuscrits de la Vulgate," *Mémoires présentés par divers savants à l'Académie des Inscriptions et Belles-lettres* 11,2 (1904): 21 and 33no. 1, and M. E. Schild, *Abendländische Bibelvorreden bis zur Lutherbibel*, Quellen und Forschungen zur Reformationsgeschichte 39 (Heidelberg, 1970), 42–48. Collections of Jerome's letters also circulated widely during the Middle Ages.

For Alcuin's verses, see *Poetarum latinorum medii aevi*, vol. 1 (=*Poetae latini aevi carolini*, vol. 1), ed. E. Dümmler, Monumenta Germaniae historica (Berlin, 1881), 291 (Carmen LXVIII), and for the preface to Matthew in the *Glossa ordinaria* (Berger, 55no. 200 and Schild, 55f.), see *PL* 114: 63. For the *Quadriga Domini* in a preface to the Gospels by Isidore of Seville (Berger, 23 and Schild, 56f.), see *PL* 83: 175.

5. For *quadriga* and *currus* in the Vulgate, see B. Fischer, ed., *Novae concordantiae bibliorum sacrorum iuxta Vulgatam versionem critice editam*, 5 vols. (Suttgart, 1977), 1: 1112f. and 4: 4105. For *merkavah* and *rekev*, see G. Lissowsky with L. Rost, *Konkordanz zum hebräischen Alten Testament* (Stuttgart, 1958), 865 and 1335f. For *harma*, see E. Hatch and H. A. Redpath, *A Concordance to the Septuagint*, vol. 1 (Oxford, 1897), 158f. For the full range of Greek and Latin terms used to translate these Hebrew words, see E. Beurlier, "Char," *Dictionnaire de la Bible*, vol. 2, ed. F. Vigoroux (Paris, 1899), 565f., who notes that *quadriga* is misleading since the chariots mentioned in the Bible were probably drawn by two or at most three horses. On Jerome's practice of rendering the same Hebrew expression with different Latin counterparts for the sake of variety, see especially A. Condamin, "Les caractères de la traduction de la Bible par saint Jérôme," *Recherches de science religieuse* 2 (1911): 434–40. For his introduction of Greco-Roman motifs into the Old Testament, see F. Stummer, "Griechisch-römische Bildung und christliche Theologie in der Vulgata des Hieronymus," *Zeitschrift für die Alttestamentliche Wissenschaft* 58 (1940–41): 252–56.

Once enshrined in the Biblical text, the quadriga naturally became the subject of exegesis. What had begun as a vivid metaphor was transformed into a commonplace of the Christian interpretation of the Scriptures. The two prevailing views are succintly set forth by Rabanus Maurus in his discussion of the quadriga in the section of his encyclopedia, the *De universo*, dealing with the circus. In a characteristic addition of Christian references to the information he derived from Isidore of Seville's *Etymologiae*, he declares that "Quadrigas, moreover, in sacred Scriptures are understood either as the four Evangelists or the Gospels, or as the four principal virtues, that is, prudence, justice, fortitude, and temperance."[6] Since one is typological and the other moral, these alternative exegeses are not mutually exclusive. Both were widely used. Other interpretations too were advanced from time to time.[7]

The interpretation of Biblical four-horse chariots as allusions to the four Evangelists is well illustrated by discussions of an obscure passage in the Song of Songs. Verse 6:11 in the Vulgate reads: "I did not know: my soul troubled me because of the quadrigas of Aminadab."[8] According to most medieval accounts, the woman who speaks these words is an allegory of the Synagogue and Aminadab stands for Christ. Thus, to quote a particularly popular commentary written by Haimo of Auxerre in the ninth century, "This is the meaning: she says, 'I am disturbed,' because of the sudden preaching of the Gospel which, like the swiftest quadriga, has flown suddenly through the whole world. And she rightly terms this preaching not a chariot but a quadriga, because the preaching of the Gospel rests upon the authority of the four Evangelists and the four

6. "Quadrigae autem in Scripturis sacris aut quatuor Evangelistae sive Evangelia intelliguntur, vel quatuor virtutes principales, hoc est, prudentia, justitia, fortitudo, et temperantia." Rabanus Maurus, *De universo* (PL 111: 551 [XX, 31]; see also 119 [V, 3] and 215 [VII, 8] for the same idea). For Isidore's corresponding passage, see *Etymologiarum sive originum libri xx*, ed. W. M. Lindsay (Oxford, 1911) (XVIII, 36). For the popularity of the metaphor of the cardinal virtues as a quadriga in the Carolingian period, see S. Mähl, *Quadriga virtutum: Die Kardinaltugenden in der Geistesgeschichte der Karolingerzeit*, Beiheft zum Archiv für Kulturgeschichte 9 (Cologne and Vienna, 1969), 12–14.

7. For example, the quadriga was also sometimes associated with the vices as in an influential sermon on the Song of Songs by Bernard of Clairvaux (*Sancti Bernardi Opera*, vol. 2, *Sermones super Cantica Canticorum*, ed. J. Leclercq, C. H. Talbot, and H. M. Rochais [Rome, 1958] 18–24 [Sermo 39]). A sampling of the range of medieval interpretations of Biblical quadrigas can be found in H. Meyer and R. Suntrup, *Lexikon der mittelalterlichen Zahlenbedeutungen*, Münstersche Mittelalter-Schriften 56 (Munich, 1987), 353 (1 Kings 8:11), 356f. (1 Chron. 18:4 and 2 Chron. 9:25), 359f. (Song of Songs 6:11 and Isaiah 66:20), 378–82 (Nahum 3:2, Habakkuk 3:8, and Zechariah 6:1–5), and 842f. (2 Chron. 1:17).

8. "Nescivi anima mea conturbavit me propter quadrigas Aminadab." On the much discussed difficulties in interpreting the original Hebrew (where this is verse 12), see *Song of Songs*, ed. and trans. M. H. Pope, Anchor Bible 7c (New York, 1977), 584–92.

Gospels are like the four of the quadriga of the New Testament, which Christ himself, as charioteer, controls, himself guiding and drawing up the chariot of the Gospels."[9] Many other similar, if somewhat less florid explications of Song of Songs 6:11 can be cited. Indeed, although other Biblical four-horse chariots were also often interpreted in this fashion, this passage emerged as a focal point for the idea, and the name of Aminadab came to be closely associated with this symbolic vehicle.[10]

The conception of this car of the Gospels underwent several significant changes during the Middle Ages. In later centuries, for example, the vehicle of Christ sometimes became that of his Church, its occupant a passenger borne in triumph rather than a divine charioteer guiding its course.[11] In the present context, however, the most important reformulation concerns the way in which the relationship between the vehicle and the four Evangelists was construed. In the original form of the concept, the analogy lay, of course, in the correspondence of the Evangelists in number and function to the horses harnessed to the chariot. For those acquainted with the Greco-Roman four-horse chariot, this is self-evident. It is hardly surprising that Jerome felt no need to explain what he meant by referring to the Evangelists as the *Quadriga Domini*. Other patristic authors who employed related images likewise took the matter for granted.

Not until some centuries later were the facts and relationships so

9. "Et est sensus: Conturbata (inquit) sum propter subitam Evangelii praedicationem, quae veluti velocissima quadriga totum subito mundum pervolavit. Et bene hanc praedicationem non currus, sed quadrigas appellat: quia Evangelii praedicatio quatuor evanglistarum auctoritate consistit, et quatuor Evangelia quasi quatuor quadrigae sunt Novi Testamenti, cui praesidet auriga ipse Christus, temperans et disponens ipse currum Evangeliorum." *Expositio in Cantica Canticorum*, PL 70: 1092f. On the Christian interpretation of the Song of Songs in the Middle Ages, see F. Ohly, *Hohelied-Studien: Grundzüge einer Geschichte der Hoheliedauslegung des Abendlandes bis um 1200* (Wiesbaden, 1958), and E. A. Matter, *The Voice of My Beloved: The Song of Songs in Western Medieval Christianity* (Philadelphia, 1990). On Haimo's commentary, see Ohly, 73–75, and Matter, 37f. It also circulated under the names of Cassiodorus (*PL* 70: 1055–1106), Haimo of Halberstadt (*PL* 117: 295–358), and Thomas Aquinas.

10. For similar interpretations of this passage, see those of Bede, the *Glossa ordinaria*, and Honorius Augustodunensis, all cited below. For additional examples and for different interpretations, see Cornelius a Lapide, *Commentarius in Canticum Canticorum* (Antwerp, 1725), 282–84; R. F. Littledale, *A Commentary on the Song of Songs from Ancient and Mediaeval Sources* (London, 1869), 293–97; and Meyer and Suntrup, *Lexikon der mittelalterlichen Zahlenbedeutungen*, 359. For examples of other Biblical quadrigas interpreted in this or closely related ways, see Meyer and Suntrup, 356f. (1 Chron. 18:4), 360 (Isaiah 66:20), 378f. (Habakkuk 3:8), 380 (Zechariah 6:1–5).

11. See below, pages 55–57.

concisely evoked by Jerome's compact phrase spelled out. It was Bede who first did so, and his explication appears in a discussion of the vehicles of Song of Songs 6:11. For him as for so many medieval exegetes, the four-horse chariots of Aminadab represent the preaching of the Gospel. In words that were closely echoed by the ninth-century commentary just quoted, he declares that this preaching is rightly compared, "not to chariots in general, but to quadrigas, because it was commended by the authority of the account, of course, of four authors, yet both the mind and the hand of these authors were set to writing by the single spirit of God through Jesus Christ; in the same manner, you see, although single quadrigas are well contrived for running by the united speed of four horses, yet they are governed by the command of a single charioteer so that they run on the correct path."[12] The care with which this author, writing in northern England in the early eighth century, lays out the parallel may well reflect his uncertainty whether his readers were sufficiently familiar with the ancient chariot to grasp the point of the image.

Such concern would have been well founded. By the twelfth century, discussions of the *Quadriga Domini* envisage a vehicle that differs radically from the Greco-Roman one. Four horses sometimes still draw it, but the car proper is equipped with four wheels rather than two. These four wheels now usurp the role previously played by the horses in the analogy with the Evangelists. The explication of the chariots of Aminadab offered by Honorius Augustodunensis in his commentary on the Song of Songs provides a characteristic example of the new conception. "The quadriga of Christ," he asserts, "is the Gospel; the four wheels are the four Evangelists." The horses stand, instead, for the Apostles, a role for which they are rather less suited since the numbers no longer correspond. Indeed, the new conception is in general less apt and vivid. The role of the Evangelists is now mechanical. They are identified with the supports on which the vehicle rolls rather than the steeds that provide its motive power. The original vigor of the image has largely dissipated. The fleet chariot has become a ponderous wagon.[13]

12. "[N]on curribus absolute sed quadrigis comparem quia nimirum quattuor scriptorum auctoritate memoriae commendata est sed uno Dei spiritu per Iesum Christum eorundem scriptorum et mens et manus ad scribendum directa quo modo si unas quadrigas concordi quattuor equorum velocitate videas ad cursum paratas sed unius aurigae regimine ut recto tramite currant esse gubernatas." Bede, *In Cantica Canticorum*, in *Bedae Venerabilis Opera*, vol. 2, *Opera Exegetica*, ed. D. Hurst and J. E. Hudson, Corpus Christianorum, series latina 119B (Turnhout, 1983), 313f. On this work, see Ohly, *Hohelied-Studien*, 64–70, and Matter, *Voice of My Beloved*, 97–101.

13. "Quadriga Christi est Evangelium; quatuor rotae, sunt quatuor evangelistae." Honorius Augustodunensis, *Expositio in Cantica Canticorum* (PL 172: 454). For the horses as the Apostles, see a prologue to this work where the quadriga is again identified with the Gospel

Several factors probably contributed to this metamorphosis. Four-wheeled wagons were a familiar part of everyday life in the later Middle Ages, whereas the Greco-Roman two-wheeled chariot can only have been a relatively dim memory in much of Western Europe. Indeed, one of the new meanings that the word *quadriga* took on in medieval Latin is that of wagon, and four-wheeled vehicles are sometimes seen in Western medieval art in subjects that call for the four-horse chariot of antiquity.[14]

Yet, as will be seen presently, the Greco-Roman four-horse two-wheeled chariot was by no means altogether forgotten in the West during these centuries. Other influences, therefore, were probably also at work in the shift to a new conception of the allegorical vehicle. It is certainly significant that the car's new form made it resemble more closely the four-wheeled throne-chariot of Ezekiel's visions. This theophany had already been intertwined with the *Quadriga Domini* by Jerome, and the cherubim with which the wheels appear there were very closely associated with the Evangelists from an early date. It may also be relevant that the Aminadab of Song of Songs 6:11 was sometimes identi-

and the wheels with the Evangelists (*PL* 172: 353). On this work, see Ohly, *Hohelied-Studien*, 254–62, and more recently V. I. J. Flint, "The Commentaries of Honorius Augustodunensis on the Song of Songs," *Revue Bénédictine* 84 (1974): 196–211 (reprinted in V. I. J. Flint, *Ideas in the Medieval West: Texts and Their Contexts* [London, 1988]), and Matter, *Voice of My Beloved*, 58–76. Aurenhammer, "Aminadab," 103, errs in stating that Honorius identifies the four Evangelists with the four horses of the quadriga. Yet Honorius certainly knew that quadrigas were drawn by four horses: he referred to them explicitly in likening the chariot of Christ carried on the wheels of the Evangelists to that used in Roman triumphal ceremonies (*Speculum Ecclesiae* [*PL* 172: 955f.]). (For further discussion of that passage and a quotation from it, see below, pages 75f.) He introduced the "quadriga Christi" on several other occasions: *Sigillum Beatae Mariae* (*PL* 172: 512); *Speculum Ecclesiae* (*PL* 172: 834, 969, and 1016); and *Elucidarium* (*PL* 172: 1176). For additional literature on Honorius and his commentary on the Song of Songs, see chapter IV, note 1.

As in the earlier form of the idea, so in the later one the actual point of comparison was often left unstated. Of the many instances in which the Evangelists were explicitly identified with the four wheels in the twelfth and thirteenth centuries, see, e.g., *Glossa ordinaria* (*PL* 113: 1160, on Song of Songs 6:11—where the presence of the four horses is also noted—and 114: 63, prologue to Matthew); Alain de Lille, *Liber in distinctionibus dictionum theologicalium* (*PL* 210: 917); Innocent III, *Sermo de communi de evangelistis* (*PL* 217: 607); and G. Durandus, *Rationale divinorum officiorum* (Lyons, 1612), 463 (VII, 44 [taken from Innocent's sermon]). The earliest example known to me is a letter from Ermenrich von Ellwagen to Abbot Grimald written in 854. See *Epistolae*, vol. 5 (=*Epistolae Karolini aevi*, vol. 3), ed. E. Dümmler, Monumenta Germaniae historica (Berlin, 1899), 541, and Mähl, *Quadriga virtutum*, 149–56.

A precedent existed for identifying the Gospels with the wheels of a vehicle bearing the word of God. See St. Ambrose, *Expositio psalmi CXVIII*, ed. M. Petschenig, Corpus scriptorum ecclesiasticorum latinorum 62 (Vienna and Leipzig, 1913), 81 (IV, 28). Ambrose, however, was not speaking of a four-horse chariot.

14. For *quadriga* as wagon, see, e.g., R. E. Latham, *Revised Latin Word-List from British and Irish Sources* (London, 1965), 386. On medieval vehicles and their relations to Greco-Roman ones, see E. M. Jope, "Vehicles and Harnesses," *A History of Technology*, vol. 2, *The Mediterranean Civilizations and the Middle Ages, c. 700 B.C. to c. A.D. 1500*, ed. C. Singer et

fied with the Abinadab of 1 Kings 7:1 and 2 Kings 6:3. After its return from the Philistines, the Ark of the Covenant was kept, for a time, in the latter's house and it was conveyed from there to Jerusalem in his wagon or cart (Vulgate: *plaustrum*). Because of the similarities in the two men's names, some medieval commentators regarded their vehicles as the same.[15]

Clarification of this and other aspects of the origin and development of the concept of the *Quadriga Domini* must await further study. Enough has been established here to raise the possibility that this idea is relevant for understanding the four horses on the façade of San Marco. This account also suggests a way to understand their divergence from a number of recognized medieval representations of this idea. The question that must be considered next is whether any evidence can be found to show that the horses were indeed intended to summon up the *Quadriga Domini*.

al. (Oxford, 1956), 537–62, esp. 539–41, on the problems of terminology including the shift in the meaning of *quadriga*. Also useful is A. C. Leighton, *Transport and Communication in Early Medieval Europe, AD 500–1100* (New York, 1972), 70–124.

For a four-wheeled chariot of the sun, see, e.g., the illustration in the commentary on Martianus Capella by Remigius of Auxerre of c. 1100 (Munich, Bayer. Staatsbibl., Clm 14271, fol. 11v; E. Panofsky, *Renaissance and Renascences in Western Art*, 2nd ed. [Stockholm, 1960], 85, and fig. 53). The fact that the horses are sometimes shown in tandem pairs rather than four abreast as in antiquity probably reflects the new importance of this harnessing method in the Middle Ages (Leighton, 112–14).

15. That Ezekiel's vehicle had four wheels emerges more clearly in Ezek. 10:9–19 than in Ezek. 1:15–21. For the early sources linking the creatures in Ezekiel's vision and the Evangelists, see, e.g., U. Nilgen, "Evangelistensymbole," in *Reallexikon zur deutschen Kunstgeschichte*, vol. 6 (Munich, 1973), 517–19. For the identification of Aminadab and Abinadab, see, e.g., Honorius Augustodunensis, *Expositio in Cantica Canticorum* (PL 172: 454f.), and Grodecki, "Vitraux allégoriques de Saint-Denis," 27f.

The Horses of San Marco
as the Lord's Quadriga

KNOWLEDGE OF THE *QUADRIGA DOMINI*
AND OF THE QUADRIGA IN MEDIEVAL VENICE

If linking the horses at San Marco to the concept of the *Quadriga Domini* is to be more than just an attractive theory, concrete evidence must be brought forward to support it. But two questions should be addressed first. One is whether anyone in thirteenth-century Venice would have been likely to be acquainted with this concept. The other is whether any Venetians would have recognized that the four horses constitute the team of a quadriga.

That the idea of the *Quadriga Domini* was probably known in Venice at this period could be safely inferred from its broad currency, but there is specific evidence as well. This is furnished by the first of three sermons concerning St. Mark written by St. Peter Damian (1006–1071). In order to demonstrate Mark's special importance, he quotes the description in Apocalypse 4:7 of the four animals surrounding the throne of God and points out that the symbol of Mark is the first to be named. Echoing Jerome, he then declares that this group of animals "is, of course, that quadriga of the Lord, and true cherubim; wherever it runs, he [the Lord] goes, supported by it in every respect." After further explaining that this is also the quadriga of Aminadab spoken of in Song of Songs 6:11, he continues, "The quadriga of Aminadab is, in fact, the Gospel of Christ composed of the most harmonious diversity of the four Evangelists. Of course, Christ, the charioteer, draws up that quadriga and [in it] traverses the four-part fabric of the world with the nimblest speed of preaching, just as it was said by the Psalmist: 'who sends forth his speech to the earth: his word runs swiftly (Ps. 147:15).'" Whether Damian understood the

concept in its original form is not clear. He does not cite the horses explicitly, although in not doing so he simply follows what was, it will be recalled, a well-established tradition. What is most important in the present context is that neither does he specifically make the wheels the crux of the relationship.[1]

These sermons were certainly addressed to the Venetians and they were probably preached by their author in San Marco itself. They remained known in Venice long after their initial presentation. Some of their more grandiloquent words, especially those concerning the honor conferred upon Venice by the possession of the relics of St. Mark, were quoted in Venetian sources. The earliest quotation that has so far come to light appears in the account of the translation of the body of Mark from Alexandria to Venice in Andrea Dandolo's mid-fourteenth-century chronicle. Damian's sermon, then, provides good reason to believe that the concept of the *Quadriga Domini* was familiar in thirteenth-century Venice.[2]

The other critical question was whether anyone there would also have realized that the four horses seized in Constantinople form a quadriga. As noted earlier, a misapprehension about the form of the Greco-Roman chariot had spread fairly widely in Western Europe by the twelfth century. For many, its defining feature became the four wheels on which it was thought to have run. In contrast, the four horses were apparently now a largely secondary component, one, indeed, that seems to have been often forgotten. Yet an accurate conception of the quadriga certainly survived in some circles throughout the Middle Ages. As already noted, quadrigas are discussed in the accounts of the circus in the *Ety-*

1. "Haec est sane quadriga illa Domini et verum Cherubin, quo innixus omnia circuit ubique discurrit. . . . Quadriga vero Aminadab Christi est evangelium, cum concordissima quatuor evangelistarum diversitate compactum. Quam sane quadrigam Christus auriga disponit, et quadrifidam mundi machinam agillima praedicationis celeritate percurrit, sicut per psalmistam dicitur: Qui emittit eloquium suum terrae velociter currit sermo eius." *Sancti Petri Damiani Sermones*, ed. G. Lucchesi, Corpus Christianorum, continuatio medievalis 57 (Turnhout, 1983), 70f. (Sermo XIV, 11). Grodecki, "Vitraux allégoriques de Saint-Denis," 28, erroneously states that Damian refers to the four wheels as the Evangelists.

2. For the view that Peter Damian's sermons were actually preached in Venice, see Demus, *Church of San Marco*, 96, n. 148, and G. Fasoli, "Nascita di un mito," in *Studi storici in onore di Giacchino Volpe, vol. 1 (Florence, 1958), 460 (reprinted in G. Fasoli, Scritti di storia medievale* [Bologna, 1974], 456). Lucchesi, *Sancti Petri Damiani Sermones*, 62, notes that he may have delivered them himself, but according to J. Leclerq, *Saint Pierre Damien ermite et homme d'église* (Rome, 1960), 161, his sermons were often simply forwarded to be read in the appropriate church.
 For a quotation from the second sermon (*Sancti Petri Damiani Sermones*, 77f. [Sermo XV, 5]), see A. Dandolo, *Chronica per extensum descripta*, ed. E. Pastorello, Rerum italicarum scriptores, 2nd ed., 12,1 (Bologna, 1938), 146 (VIII, 2).

mologiae of Isidore of Seville and the *De universo* of Rabanus Maurus. Both explain that the term for this kind of chariot derives from the number of horses in the team that draws it. Their works were the most widely used compendia of knowledge during the Middle Ages. The four horses that draw the quadriga are also cited explicitly in some later medieval accounts of it.[3]

Images as well as texts demonstrate that the true form of the quadriga was still sometimes remembered. Along with the garbled depictions noted previously, Western medieval art contains many accurate, if somewhat awkward representations of such vehicles. The commonest are images of Sol that descend from well-known Greek and Roman formulae showing the god of the sun in his chariot. A miniature (fig. 40) in a twelfth-century English astronomical treatise (Oxford, Bodleian Library, Ms. Bodley 614, fol. 17v) provides a good example. The car in which Sol rides is, to be sure, a crude, boxlike affair, but it is carried on two wheels and it is pulled by a team of four horses harnessed abreast, just as its ancient predecessors had been. Given Venice's close ties to Byzantium, it should be noted that quadrigas are properly depicted in numerous Byzantine works of art.[4]

3. For the discussions by Isidore and Rabanus, see the references in chapter I, note 6. For a thirteenth-century account that defines the quadriga by the four horses that draw it, see *Summa Britonis sive Guillelmi Britonis expositiones vocabulorum biblie*, vol. 2, ed. L. W. and B. A. Daly (Padua, 1975), 625. For some references to the four horses by those who conceive of the quadriga as a four-wheeled vehicle, see chapter I, note 13.

4. On the English manuscript, see C. M. Kauffmann, *Romanesque Manuscripts, 1066–1190*, A Survey of Manuscripts Illuminated in the British Isles 3 (London, 1975), 77f.no. 38. On this miniature, see G. Kerscher, "*Quadriga temporum*. Studien zur Sol-Ikonographie in mittelalterlichen Handschriften und in der Architekturdekoration," *Mitteilungen des Kunsthistorischen Institutes in Florenz* 32 (1988): 18. Kerscher, 14–22, assembles and classifies numerous examples of depictions of Sol in his chariot ranging from the Carolingian period to the twelfth century and briefly notes their Roman sources. Like the English miniature, most show four horses abreast. Many also show a two-wheeled car, but wheels are sometimes omitted entirely. His list only contains images of the sun and moon and is primarily concerned with their appearance in astronomical works.

Other examples of accurately depicted quadrigas in the West could also be cited. For an Italian late thirteenth- or early fourteenth-century one, see below, page 77 and fig. 54. See also M. N. Boyer, "The Humble Profile of the Regal Chariot in Medieval Miniatures," *Gesta* 29 (1990): 25–30, who reviews the varying accuracy of some medieval depictions of ancient vehicles.

For an example of a correct Byzantine depiction of a quadriga that reached the West during the Middle Ages, see the fragments of an early Byzantine silk decorated with quadrigas, one in the Cathedral Treasury in Aachen (P. E. Schramm and F. Mütherich, *Denkmale der deutschen Könige und Kaiser*, 2nd ed. [Munich, 1981], 42, 115no. 6, 478, and pl. 6) and the other in the Musée de Cluny in Paris (J. Beckwith, *The Art of Constantinople: An Introduction to Byzantine Art, 330–1453*, 2nd ed. [London, 1968], 58f., and fig. 72). They are said to have been found in the tomb of Charlemagne and may have been gifts from a Byzantine emperor.

But Venetians would not have been dependent upon such indirect sources for an acquaintance with the quadriga. Some of them very probably had a firsthand knowledge of it. Four-horse chariot races, which had played such an important role in the public life of Byzantium at an earlier period, were still held in the Hippodrome in Constantinople during the twelfth century, although their frequency was much reduced from former times. Spectacles in the Hippodrome were certainly attended by Westerners. The access of one group of Italians to the entertainments of the Hippodrome is well documented. A clause assuring Pisans of seating there was inserted in the treaty of 1111 that governed Pisan commercial activities in the Byzantine empire and the status of their colony in Constantinople. Given the number of Venetian merchants who visited Constantinople, as well as the sizable Venetian colony resident there, at least some citizens of the Serenissima must have been familiar with these chariots. It seems reasonable to suppose, therefore, that those who seized these bronzes in the Hippodrome after the capture of Constantinople in 1204 and those who were responsible for their placement at San Marco were well aware that these animals constituted the team of a four-horse chariot, that is, of a quadriga.[5]

In the light of these facts it is somewhat surprising that the mosaicists of San Marco failed to depict a true quadriga when called upon to do so. Paired symmetrically on either side of a set of windows on the south wall

5. For quadriga racing in the Hippodrome as late as the twelfth century, see R. Guilland, "Études byzantines: La disparition des courses," *Mélanges offerts à Octave et Melpo Merlier*, vol. 1 (Athens, 1956), 31–47, esp. 31f. (reprinted in his *Études de topographie de Constantinople byzantine*, vol. 1, Berliner byzantinische Arbeiten 37 [Berlin, 1969], 542–55). See also H. Hunger, *Reich der neuen Mitte: Der christliche Geist der byzantinischen Kultur* (Graz, 1965), 187, with an important additional source, and C. Mango, "Daily Life in Byzantium," *XVI. Internationaler Byzantinisten-kongress: Wien, 1981, Akten*, vol. 1,1 (=*Jahrbuch der Österreichischen Byzantinistik* 31,1 [1981]: 344–49 [reprinted in his *Byzantium and Its Image: History and Culture of the Byzantine Empire and Its Heritage* (London, 1984)]), where significant changes in the later period are noted. For the view that the chariots in the races at the Hippodrome consisted exclusively of quadrigas, see Guilland, "Études sur l'Hippodrome de Byzance: A propos du chapitre 69 du Livre I du Livre des Cérémonies. Les courses à Byzance," *Byzantinoslavica* 23 (1962): 223f. (reprinted *Études de topographie*, 1: 570f.).

On the Pisan treaty, see R.-J. Lilie, *Handel und Politik zwischen dem byzantinischen Reich und den italienischen Kommunen Venedig, Pisa und Genua in der Epoche der Kommenen und der Angeloi (1081–1204)* (Amsterdam, 1984), 69–76 and 73 for this clause. For the passage in the treaty itself, see *Documenti sulle relazioni delle città toscane coll'oriente cristiano e coi Turchi*, ed. G. Müller (Florence, 1879), 44 and 53. Others may have had similar privileges. According to R. Guilland, "Études sur l'Hippodrome de Byzance III: Rôle de l'empereur et des divers fonctionnaires avant et pendant les courses.—Les spectateurs de l'Hippodrome," *Byzantinoslavica* 26 (1965): 7, the Hippodrome contained "des loges destinées aux colonies d'étrangers établies dans la capitale," but he does not name specific groups. On the Venetian colony in Constantinople and the number of Venetians there in the twelfth century, see Nicol, *Byzantium and Venice*, 88–90, 97f., and 122f.

of the west arm are two scenes depicting the final episodes of the attempt by the Apostles Simon and Jude to convert the Persians (figs. 24 and 25). Simon exorcizes a demon from an idol of the god of the sun; Jude another from that of the goddess of the moon. The chariot occupied by Sol ought, of course, to be a quadriga, but it has two, not four horses. The mosaics date from about 1200.[6]

The failure to render the proper number of horses may have been the result of a variety of factors. First of all, the chariot of the sun not infrequently appears in Western medieval art in this abbreviated two-horse version as well as in its true four-horse form. The context in which this depiction is found may also be significant. In the Jude episode across the way, Luna stands in a chariot drawn by two oxen, that is, a biga, a vehicle in which she is often shown in medieval art. This is how she appears, for example, in the English twelfth-century miniature (fig. 40). The compositions of the two San Marco mosaics have clearly been shaped by a desire to make them correspond closely, a wish that is quite understandable given their symmetrical positions on the south wall and the parallelism of the actions they depict. The representation of the chariot of the sun with two rather than four horses so that their number matches that of the team of the moon directly opposite may be due in part to the same impulse. Strong relationships of this kind are a characteristic feature of all the scenes of the lives of the Apostles in this part of San Marco.[7]

It should also be kept in mind that it was easier, of course, to depict a two-horse team than a four-horse one. At the distance from which a spectator on the floor of the church views these mosaics, the difference between the two is hardly perceptible. A variety of considerations suggest, then, that the rendering of the vehicle in the martyrdom of Simon should not be seen as weighing heavily against a Venetian familiarity

6. On the iconography, date, and condition of these scenes, see Demus, *Mosaics of San Marco*, 1, 1: 219, 224f., and 230. For an overall view of the south wall of the west arm, see 1, 1: fig. 18, and 2, 1: fig. 3; for details of the two chariots, see 1, 2: black and white pls. 373 and 374.

7. For the two-horse version of the sun's chariot, see, e.g., Kerscher, "*Quadriga Temporum,*" figs. 5 (Parma, Baptistery, south portal tympanum, beginning of the thirteenth century) and 34 (Stockholm, Nationalmuseum, altar frontal, twelfth century). His illustrations also contain numerous examples of Luna's chariot drawn by two oxen. According to Demus, *Mosaics of San Marco*, 1, 1: 225, the San Marco scenes do not correspond to other representations of these episodes. He concludes that they were "expressly created for their emplacement on the basis of the Latin *passio [Simonis et Judae].*" This text explicitly identifies both the sun's and moon's chariots as quadrigas. See J. A. Fabricius, *Codex apocryphus Novi Testamenti*, vol. 2, 2nd ed. (Hamburg, 1719), 633. On the relationships among these scenes, see Demus, 226f.

with the true quadriga. In any event, the car itself is correctly shown in both cases with two, not four wheels. It is clear that this aspect of the Greco-Roman chariot was properly understood in Venice around the time the four horses were brought from Constantinople.

Given the knowledge of the quadriga in Venice, it is a little puzzling that the horses at San Marco were not installed close together and roughly equidistant from one another as they would be in a chariot team. Perhaps this had something to do with a desire to keep them relatively low on the loggia. The arch in the middle would then have necessitated their separation into two distinct pairs. Yet it is unclear why there should have been a reluctance to place the horses somewhat higher.

THE ORIGINAL DECORATION OF THE CENTRAL ARCH
OF THE WEST FAÇADE

That the four horses at San Marco were intended to evoke the concept of the *Quadriga Domini* is strongly suggested by the works with which they were originally juxtaposed in the decoration of the west façade. At present the area directly above and behind them is filled by a vast semicircular window, the *finestrone* (figs. 3 and 6). An unarticulated expanse of glass on this scale is foreign to the character of the original eleventh-century building and to that of its thirteenth-century refashioning. As has been widely recognized, this window was inserted in the fifteenth century. The time at which it took its present form is probably indicated by the reliefs decorating the arch that surrounds it: they date from the 1420s or early 1430s. It was certainly in place by 1496 when Gentile Bellini painted his *Procession in Piazza San Marco* (fig. 30).[8]

In the original thirteenth-century scheme, this zone contained, it has been proposed, the five reliefs representing Christ and the four Evangel-

8. For the insertion of the great window and its date, see Demus, *Church of San Marco,* 207 (between 1419 and 1439); R. Polacco, "I bassorilievi marmorei duecenteschi raffiguranti il Cristo e gli Evangelisti sulla facciata settentrionale della Basilica di S. Marco," *Arte Veneta* 32 (1978): 16 (between 1415 and 1470); Galliazzo, 8 (between 1415 and 1470); and Polacco, *San Marco,* 32 and 205 (first two decades of the fifteenth century). On the reliefs in the arch and their date, see G. Goldner, "The Decoration of the Main Façade Window of San Marco in Venice," *Mitteilungen des Kunsthistorischen Institutes in Florenz* 21 (1977): 31 (between 1430 and 1435); W. Wolters, *La scultura veneziana gotica (1300–1460),* vol. 1 (Venice, 1976), 87f. and 245nos. I.4 and I.5 (c. 1420); and A. Markham Schulz, "Revising the History of Venetian Renaissance Sculpture: Niccolò and Pietro Lamberti," *Saggi e memorie di storia dell'arte* 15 (1986): 11 and 17–21 (1420s or early 1430s). On Bellini's view, see P. F. Brown, *Venetian Narrative Painting in the Age of Carpaccio* (New Haven, 1988), 144–50 and 286no. 7 and colorplates XII and XVIII.

ists that are now found at the Porta dei Fiori on the north side of the church (figs. 5, 12–16, and 33). There are several considerations that support this view. It is quite apparent, to begin with, that these reliefs, although certainly dating from the thirteenth century, were not originally intended for their present setting. The arrangement there is awkward and asymmetrical. Christ is placed between John and Matthew who are paired on the west wall of the north transept. Forming a second pair at right angles to the first, Luke and Mark are found in the spandrels above the Porta dei Fiori which is set into the north wall of the north arm of the narthex.[9]

The now fairly widespread recognition that these five reliefs were not meant for this location has been fostered by the existence of an apparently straightfoward explanation of how they came to be found here. They were originally carved, it is said, for a thirteenth-century iconostasis at San Marco and were transferred to the north façade when that choir screen was replaced by the present one in the late fourteenth century. There are, however, serious difficulties with the proposed reconstruction of the thirteenth-century iconostasis. Questions have been raised about the inclusion of a number of works now found elsewhere at San Marco and also about its measurements.[10]

9. This proposal was first advanced by Polacco, "Bassorilievi," and reiterated in his "San Marco e le sue sculture nel Duecento," in *Interpretazioni veneziane: Studi di storia dell'arte in onore di Michelangelo Muraro*, ed. D. Rosand (Venice, 1984), 59, 72, and fig. 11, with a slightly different reconstruction. In his most recent publication (*San Marco*, 119), however, Polacco retracts most of his original proposal, suggesting that only the relief of Christ was in the lunette and that the reliefs depicting the Evangelists were in the four spandrels flanking the *finestrone*. For rejection of Polacco's views, see below, notes 15 and 17. Demus declared that the *finestrone* probably never contained "ikonographisch wesentliche plastiche Elemente" ("Skulpturale Fassadenschmuck," 4), but he was not specifically speaking of Polacco's thesis.

For a survey of the literature dealing with these reliefs, see Polacco, "Bassorilievi," 10–14; Wolters, *Skulpturen von San Marco*, 22–24nos. 18–22; and Polacco, *San Marco*, 114f. The reliefs depicting Christ and St. John were placed in the Convento di Sant'Apollonia in 1973.

10. The theory that the reliefs came from the iconostasis was proposed by F. Kieslinger, "Le transenne della basilica di San Marco del secolo XIII," *Ateneo Veneto* 132 (1944–45): 57–61. For a review of opinions regarding Kieslinger's thesis, see Polacco, "Bassorilievi," 12–14, where his objections—including the problem of the dimensions of the iconostasis—are also presented. Demus has accepted the view that this was the source of the reliefs depicting Christ and the Evangelists, while questioning the inclusion of others. See "Die Reliefikonen der Westfassade von San Marco: Bemerkungen zur venezianischen Plastik und Ikonographie des 13. Jahrhunderts," *Jahrbuch der Österreichischen Byzantinischen Gesellschaft* 3 (1954): 88; *Church of San Marco*, 126n. 32, and 137f.; and "Skulpturale Fassadenschmuck," 3. See also Wolters, *Skulpturen von San Marco*, 22. R. Polacco, "I mosaici di San Marco," *Venezia Arti* 3 (1989): 194, and *San Marco*, 118, argues that the choir was enclosed by a low parapet, not an iconostasis until the late fourteenth century. As he

It is far more probable that these reliefs were originally located on the west façade. The most telling argument in support of this view is that they fill what would otherwise be a major gap in the thirteenth-century program. There are now two sets of representations of the Evangelists on the west front, one in the intrados of the arch framing the window behind the horses and the other in the aediculae at the top of the façade. Both date from the 1420s or 1430s and belong to the same general phase of activity that saw the glazing of the great central window.[11]

The only reference to the authors of the Gospels in the surviving portions of the thirteenth-century west façade decoration is the set of small circular reliefs with their symbols in the Porta Sant'Alipio at its north end (fig. 23). It is, however, quite unlikely that the Evangelists themselves would have been entirely omitted from the original program of the west façade. Given the dedication of San Marco, it is natural to expect that the role of the Evangelists in Christian revelation would be given considerable prominence in its exterior decoration. Limited in size and in a distinctly secondary position, the reliefs in the Porta Sant'Alipio, which show only their symbols, fall far short in this respect. Nor, assuming for the moment that the reliefs of Christ and the Evangelists are still in their original position, would a placement on the north front have adequately served such a purpose. This is the least important of the three façades. In addition, the absence of any representation of the Evangelists on the west façade in its thirteenth-century form would contrast starkly with the frequency with which they appear inside the church. The inclusion of the Evangelists in the sculpture added to the west front in the fifteenth century may also be significant in this context. These figures may well have been introduced to ensure the Evangelists' continued presence, since, if this view is correct, the earlier representations of them had just been eliminated through the insertion of the great window.

had pointed out earlier ("Bassorilievi," 14), there is no evidence whatever that the choir closure which had been introduced in the eleventh century was replaced or modified before the late fourteenth. For the view that the reliefs were in fact intended for the north façade, see L. Cochetti Pratesi, "Contributi alla scultura veneziana del Duecento: III. La corrente bizantineggiante," *Commentari* 12 (1961): 27f.n. 52. The earliest evidence of the presence of the five reliefs on the north façade is in the views by A. Visentini in A. Zatta, *L'augusta ducale Basilica dell'Evangelista San Marco* (Venice, 1761), pls. II and III.

11. The argument presented here regarding the gap filled by the reliefs now on the north façade differs slightly from that of Polacco, "Bassorilievi," 16, who first noted this crucial omission. He speaks generally of their supplying a missing "iconografia della 'rivelazione.'" Their specific role in introducing the theme of revelation will be addressed in chapter III.

On the later Evangelists in the intrados, see the discussions cited in note 8. Although only one of them bears the name of an Evangelist, the four figures with books almost certainly represent the full set. For those at the top of the façade, see Wolters, *Scultura veneziana gotica*, 1: 86 and 244no. I.1.

That they were repeated twice in the later campaign and that the second set crowns the façade, along with yet a third depiction of Mark, indicates the importance attached to this theme.[12]

The style of the five reliefs fits naturally on the west façade. According to the most convincing analysis, all but one are the work of the Heracles Master, one of the two leading sculptors active at San Marco during the thirteenth-century campaign. In this account, Mark, the weakest, is by an assistant. The work from which this sculptor derives his name is a relief depicting Heracles with the Keryneian hind and the Lernean hydra (fig. 22). That panel is part of a set of six, each placed in one of the spandrels of the arches of the lower section of the west façade (figs. 17–22). Two other members of this important series have also been attributed to him, and the rest are reused works. He and members of his workshop were also responsible for some of the sculpture in the portals of the west façade and for contributions on the north and south flanks of the building as well.[13]

12. On the Evangelist symbols in the Porta Sant'Alipio, see Wolters, *Skulpturen von San Marco*, 36nos. 81–84. A minor group also appears in a panel on the south wall of the Tesoro on the south façade (Wolters, 54f.no. 199).

The mosaics before 1300 include the following representations of the Evangelists (all references to Demus, *Mosaics of San Marco*): a) main porch mosaics of the later eleventh century (1, 1: 21–30, and 1, 2: colorplates 11–12 and black and white pls. 14–15); b) late twelfth-century pendentive mosaics of the central dome (1, 1: 192–94, and 1, 2: colorplates 5 and 64 and black and white pls. 234 and 322–24); c) thirteenth-century pendentive mosaics of the second bay of the north arm of the narthex (2, 1: 89, and 2, 2: colorplate 67 and black and white pl. 290). Two thirteenth-century sets probably once existed within the two western piers supporting the dome of the church's western arm (2, 1: 44). For the sculptures on top of the ciborium, see Demus, *Church of San Marco*, 167f., 183f., and fig. 64. For the Pala d'oro set, see W. F. Volbach et al., *La Pala d'oro*, vol. 1 of *Il Tesoro di San Marco*, ed. H. R. Hahnloser (Florence, 1965), 14–17nos. 12–15 and pl. after p. XV. This list does not include instances in which depictions of the twelve Apostles incorporate the four Evangelists.

The symbols of the Evangelists, now much restored, are depicted in the twelfth-century mosaics of the pendentives of the east dome (Demus, *Mosaics of San Marco*, 1, 1: 43, 169f., 253, and 255, and 1, 2: colorplate 1 and black and white pl. 27). Those in the north dome are not original (1, 1: 84f.)

As Demus has noted, the reiteration of themes regarded as significant is a fundamental feature of the decoration of San Marco. See, e.g., "Skulpturale Fassadenschmuck," 5 and 8, and *Mosaics of San Marco*, 1, 1: 22.

13. For the attribution of the reliefs of Christ and the Evangelists and for the work of the Heracles Master as a whole, see Demus, *Church of San Marco*, 127–45 and 164f., esp. 137–39, and "Skulpturale Fassadenschmuck," 13f. For a review of other attributions of the five north façade reliefs, see Polacco, "Bassorilievi," 10–12, and Wolters, *Skulpturen von San Marco*, 22f. They are generally viewed, in varying combinations, as the work of this sculptor or as products of his workshop. For the six west façade reliefs, see Wolters, 30–34nos. 69–74, and below, pages 51f. They are all by a single Greek artist working in Venice, according to W. Dorigo, "Sul problema di copie veneziane da originali bizantini," in *Venezia e l'archeologia: Un importante capitolo nella storia del gusto dell'antico nella cultura artistica veneziana: Congresso internazionale Venezia 25–29 Maggio 1988*, Rivista di Archeologia Supplementi 7 (Rome, 1990), 154f.

If these reliefs were in fact originally placed on the west façade, the area directly above and behind the horses seems to be the most likely position for them. There is no other space available that is sufficiently prominent for such an important theme and that also allows them to be displayed as a unified group. One other possibility, however, is raised by the mosaic in the Porta Sant'Alipio (fig. 29) whose general accuracy in representing the west façade has already been noted. In the mosaic six green vertical rectangles containing ornament are to be seen in the spandrels beside the arches of the lower part of the façade. It is clear that these forms stand for the six similarly shaped reliefs that are found in just these positions on the façade itself. The mosaic also shows four very similar rectangles between the lunettes of the upper part of the façade, and these forms, like those below, may well also serve as a notation that sculpture was located at these points. The idea that they mark the original position of the four Evangelist reliefs has, however, been rightly rejected. In such an arrangement, the Evangelists would be too dispersed to form a cohesive unit. In addition, since it provides no appropriate place for Christ, this arrangement would be inconsistent with the fact that the five works clearly form a group.[14]

The great arch behind the horses would have comfortably accommodated the five reliefs. In its present form, this arch is approximately 9.5 m wide at its base. The span of the original one, judging from the Porta Sant'Alipio mosaic, must have been roughly the same. The average size of the Evangelist panels is 184 x 98 cm and the one with Christ measures 163 x 80 cm.[15]

Using the Porta Sant'Alipio mosaic as a basis, it is not difficult to imagine what the thirteenth-century configuration of this area might have been (figs. 29 and 33–35). The mosaic cannot be followed in all respects, however. First of all, in order to accommodate the Evangelist

14. For a color reproduction of the Porta Sant'Alipio mosaic, see the citation in the introduction, note 2. For the rejection of this hypothesis, see Polacco, "Bassorilievi," 14 and 17. Cf. his *San Marco*, 119, where he takes the view that the Evangelist reliefs were indeed located in these positions.

15. The figure for the width of the present arch is based upon a drawing incorporating the results of the recent photogrammetric survey. On this campaign, see E. Vio, "Le levate fotogrammetriche della Basilica di S. Marco," *Venezia Arti* 2 (1988): 157–62. I would like to thank Sig. Vio for kindly making the drawing available to me. For the dimensions of the five reliefs I have relied upon Wolters, *Skulpturen von San Marco*, 22–24. The measurements of the individual Evangelist panels, as given there, are John: 168 x 93 cm; Matthew: 187 x 99 cm; Luke: 191.5 x 100.5 cm; and Mark: 191 x 100 cm. Although Polacco's reconstruction contains minor discrepancies, Galliazzo is not justified in pronouncing it "non accettabile per le proporzioni e le misure" (51n. 1).

reliefs in the middle register, that band must be assumed to have been higher in proportion to the other two than the mosaic indicates. Secondly, it seems rather more likely that the center of the uppermost register was occupied by the relief of Christ rather than a window as the mosaic shows. The other possible location for this panel is at the center of the Evangelist series. But the disparity between its size and that of the others would have been more jarring in that case. In addition, placing Christ at the top helps to set him off from the Evangelists without, at the same time, sacrificing the unity of the group.[16]

In assessing the justifiability of putting aside the direct evidence of the mosaic in these instances, it should be kept in mind that, despite its general accuracy, this depiction shows considerable license in portraying some aspects of the façade. For example, the mosaic shows the doorways filling the entire height of the portals, although in fact they only extend approximately half that distance. Many other similar adjustments and simplifications could be cited. It is clear that the Porta Sant'Alipio representation of the church cannot always be taken at face value with regard to secondary features. Given the scale of the mosaic, it would have been difficult to render precisely the decoration that originally lay within the great arch. The character of the rest of the image indicates that no compulsion would have been felt to do so.[17]

The lunette (figs. 4 and 32) in the upper bay at the west end of the south façade also provides some useful indications regarding the original form of this area. A strong resemblance exists between this bay and the one behind the horses on the west. In both, four columns carrying five small arches are found in the lower portion. As already noted, the Porta Sant'Alipio mosaic proves that the upper section in the one on the west, like that on the south, also contained a lunette pierced with openings. The mosaic also provides a small additional piece of evidence regarding the relationship. The crosshatching in the small arches carried by the columns and in the windows above in its depiction of the western lunette

16. Although Polacco's first reconstruction ("Bassorilievi," fig. 8) places Christ in the top register, his second ("San Marco e le sue sculture," fig. 11) puts this relief in the middle one, leaving the upper one with three windows as in the mosaic. For some precedents for Christ as an isolated figure above a row of Evangelists, see Nilgen, "Evangelistensymbole," 535.

Polacco, "Bassorilievi," 14 and 16, points out that the mosaic shows a series of green tablike shapes in the middle register and suggests that, like those previously noted, they denote the presence of sculpture. They are, however, different in form and there are eight of them. Their significance, therefore, is not so clearcut.

17. For further discussion of the unreliability of the mosaic in details, see excursus I. Cf. P. Diemer, review of Wolters, *Skulpturen von San Marco*, *Kunstchronik* 35 (1982): 107, who rejects Polacco's theory because it is at variance with the mosaic.

suggests that these openings were also occupied by lattice panels just as
those on the south still are.

These similarities provide some support for the view that the internal
arrangement of the lost western lunette would also have resembled that
of the surviving southern one. There is no reason to think that the south
lunette ever contained sculpture. Yet its sequence of registers and its
configuration of solids and voids—including a blank rather than an
opening at the center of the uppermost band—seem unusually well
suited for the display of these five reliefs. The western lunette probably
once possessed much the same organization. That these two bays should
have been very similar in so many aspects of their design is understand-
able. They surmount what were the two principal entrances to the
church, one facing Piazza San Marco to the west and the other, now
closed by the Cappella Zen, opening upon the Piazzetta to the south.
The close visual relationship between these bays helped to mark out the
special status of the portals below.[18]

Suspicions about the reliability of the evidence of the south lunette are
inevitable. As is immediately apparent, the ornamental carving within
the south lunette and the four capitals that support it are all modern
replacements. So are the rest of the marbles and mosaics. The originals
were presumably among the victims of the highly unfortunate restora-
tion of the north and south façades of the church during the 1860s and
1870s. (After strenuous protests were raised in Venice and abroad in
1877, the west front, upon which work had just begun, was spared.) Since
some of the original sixth-century capitals survive, it can be determined
that the present ones are accurate if lifeless copies. The same may be true
of the lattice screens. In any case, the organization of the lunette is what
is important here. Views of this area that predate the restoration prove
that the configuration of the lunette was not altered in the nineteenth-
century campaign.[19]

18. The relationship between the south and west lunettes is briefly noted by Polacco,
"Bassorilievi," 16. As he points out, the southern one was the basis of the rendering of this
area in A. Pellanda's often reproduced reconstruction drawing showing the west façade as it
appeared before the thirteenth-century additions (e.g., *Cavalli di S. Marco*, fig. 76). (For a
second version of the Pellanda reconstruction that differs slightly from the first in the
rendering of this area, see, e.g., F. Forlati, *La Basilica di San Marco attraverso i suoi restauri*
[Trieste, 1975], 106fig. 3.)

On the original south portal, its replacement by the Cappella Zen at the beginning of
the sixteenth century, and the importance of the south façade, see above, page 9.

19. On the restoration of the 1860s and 1870s and the reaction to it, see F. Forlati, "The
Work of Restoration in San Marco," in Demus, *Church of San Marco*, 196f.; M. Dalla Costa,
La Basilica di San Marco e i restauri dell'Ottocento: Le idee di E. Violet-le-Duc, J. Ruskin, e le

Without attempting to follow the south façade lunette in every detail, the reconstruction offered here (fig. 35) is largely based upon it. This reconstruction differs in a number of respects, most of them quite minor, from the original one (fig. 33).[20] The most important difference concerns the sequence of the Evangelists. The fact that the reliefs show Matthew and Mark facing to the left and Luke and John to the right, precludes the conventional order of Matthew, Mark, Luke, and John. In the earlier reconstruction, all face inward, and the sequence, reading from the viewer's left, is John, Luke, Matthew, and Mark. It seems rather more probable, however, that they were originally paired with John and Matthew facing each other and Luke and Mark similarly arranged. Indeed, this is the manner in which they are now displayed at the Porta dei Fiori. If they were so coupled initially, then it is likely that Luke and Mark formed the left-hand pair and John and Matthew the right-hand one. Only this ordering of the reliefs puts Mark immediately at Christ's right, that is, from Christ's point of view, and thus singles him out for special honor. This corresponds to the privileged position he often occupies in depictions of such groups at San Marco.[21]

The proposed sequence of Evangelists is, to be sure, an unusual one, but it finds an exact parallel elsewhere on the west front of the church. The four roundels with the symbols of the Evangelists in the Porta

"Osservazioni" di A. P. Zorzi (Venice, 1983); and J. Unrau, *Ruskin and St. Mark's* (London, 1984), 191–205. For change in the color of the stone in this lunette during the restorations, see Unrau, 127 and 218n. 13. On the capitals, see Deichmann, *Corpus der Kapitelle*, 130nos. 592–95 and 137nos. 635 and 638. For an eighteenth-century view of this area, see Zatta, *Augusta ducale Basilica*, pl. IV. For photographs of the south façade that were taken before restoration began there in 1865, see, e.g., Unrau, 126f.figs. 100 and 101.

20. The new reconstruction has been based, wherever possible, upon the drawings incorporating the results of the recent photogrammetric survey. Unfortunately, the horses were not included in those drawings. Their placements in the reconstruction—including the slight irregularities in their positions with respect to the columns behind them and to the sides of the great arch—have been determined by measurements of the positions of the supporting columns taken by myself and Adrienne Atwell and their scale by the figures given by Galliazzo, 106–8. While the curve of the main arch follows the survey drawing, the articulation of its face, like that of much of the area within it, is based upon the present form of the corresponding arch on the south. Galliazzo's theory that the present positions of the horses differ somewhat from the original ones is reflected in his reconstruction (fig. 34). Arguments against that view will be presented in excursus I.

21. For example, the Evangelists in the pendentives of the central dome and those in the lower section of the Pala d'oro are arranged in such a way that Mark is at the upper right (from Christ's point of view) and Christ's blessing hand points to him. (On these works, see the references in note 12.) Polacco's assertion ("Bassorilievi," 16) that Mark has the position of honor on the right in his reconstruction is puzzling. In his scheme Mark is on the viewer's right, not Christ's, and it is the latter's that should be the determining standpoint in this regard.

Sant'Alipio are, it will be remembered, the only reference on the façade as it now stands to the authors of the Gospels that dates from the thirteenth century. They are arranged in just this order, namely, Luke, Mark, John, and Matthew. Why this sequence of the Evangelists was adopted on the west façade is unclear. It cannot be explained by a desire to put Mark at Christ's right, for the normal order would also have done so.

The proposed arrangement of the reliefs in the lunette exhibits another unusual feature. Both Mark and John face away from Christ. The rudeness of their turned backs is, however, more apparent than real, since the Evangelists are on a lower register than he is. A precedent, albeit a distant and partial one, exists for this arrangement.[22]

THE *QUADRIGA DOMINI* COMPOSITION AT SAN MARCO

It appears, then, that the immediate background against which the horses were originally seen contained reliefs representing Christ and the four Evangelists. Together, the components of the decoration of the central portion of San Marco's west façade would have vividly evoked the concept of the *Quadriga Domini*. This was accomplished with remarkable economy. It was simply the juxtaposition of the four horses with the reliefs of Christ and the four Evangelists that summoned up the idea. For this reason, it was imperative that the viewer perceive this disparate set of works as interrelated parts of a single ensemble. The site chosen for the group ensured this. Framed by the great arch and its lateral supports, these works were set off as a distinct unit within the overall decoration of the façade. An internal relationship was also established. The horses and the Evangelists were arranged in two parallel rows, each symmetrically divided into pairs. Within each of the four pairs, the members turn towards one another. The result was a simple but effective composition. The visual ties between its two components would have been all the stronger, if, as is probable, the reliefs, like the horses, were originally gilded. It is also possible that the viewer was told that the works together

22. A Carolingian miniature also shows the Evangelists paired with two of them facing away from Christ who is on a higher level, although there the separation of the two registers is much greater (Brussels, Bibl. Royale, Ms. 18723, fol. 16v; see P. Bloch with U. Nilgen and E. Förster, "Evangelisten," in *Reallexikon zur deutschen Kunstgeschichte*, vol. 6 [Munich, 1973], 479f., and fig. 15).

bore a larger meaning. An inscription explaining or alluding to the *Quadriga Domini* could easily have been placed on the framing arch or in the lunette itself. Most of the façade mosaics were accompanied by elaborate inscriptions.[23]

But an explanatory inscription would not have been necessary for the composition made up of the horses and the five reliefs to succeed in conveying its meaning to a broad audience. The association of the Evangelists with the quadriga of the Lord was a commonplace, as already noted, during the Middle Ages. The San Marco group would certainly have summoned up the *Quadriga Domini* for any viewer familiar with the idea in its original form, the form, that is, in which the Evangelists were identified with the team of four that drew the vehicle. Even those who only knew the idea in the later variant linking the Evangelists and the vehicle's wheels are unlikely to have missed the point.

THE *QUADRIGA DOMINI* COMPOSITION
AND THE WOLFENBÜTTEL *MUSTERBUCH*

The original grouping of the horses and the reliefs at San Marco appears to be a reflected—if only in a partial and distorted manner—in a contemporary manuscript. The Wolfenbüttel *Musterbuch* (Wolfenbüttel, Herzog August Bibliothek, Cod. Guelf. 61.2 Augusteus 4°) dates from the second quarter of the thirteenth century and is usually thought to be a Saxon work. The drawings of which it consists are based on a variety of works of art. Many were probably contemporary Byzantine frescoes and mosaics seen in the course of an artist's travels in the Balkans or elsewhere in the eastern Mediterranean. Venice too must have been visited, for several of the drawings are closely connected with the mosaics of San

23. That the organization of this zone of the façade helps focus attention on the horses has often been noted. See, e.g., Demus, *Church of San Marco*, 113f.; Galliazzo, 78; and Herzner, 57.

All of the west façade sculpture appears gilded or painted in the view of the church in Gentile Bellini's *Procession in Piazza San Marco* of 1496 (fig. 30). As Demus, *Church of San Marco*, 164f., and "Skulpturale Fassadenschmuck," 5, maintains, this gilding probably corresponds to what existed in the thirteenth century, although it may have been renewed in the intervening years. The role of the gilding in harmonizing the sculpture and the mosaics with their gold grounds is noted by Demus and also by Galliazzo, 8 and 12. See also Wolters, *Skulpturen von San Marco*, 38 and 58–63 (L. Lazzarini), for a technical analysis of what remains of the sculpture's gilding and polychromy. For possible traces of the presence of gilding on the reliefs of Luke and Mark, see Wolters, 23f.nos. 21–22.

Marco. So strong are these ties, indeed, that it has been argued that this modelbook was actually the work of a Venetian hand rather than, as usually supposed, a German one.[24]

The *Musterbuch* is linked to the sculpture of San Marco as well as to its mosaics. The two principal figures on fol. 89r (fig. 41) are closely related to the reliefs depicting the Evangelists John and Matthew now on the north façade of the church (figs. 15 and 16). Despite the stylistic differences, the similarities of pose, gesture, and drapery pattern are quite evident. In addition, the Wolfenbüttel figures form a facing pair, just as the Evangelists still do in their present position. According to the reconstruction presented here, this was also the way they were displayed in their original placement on the west front (fig. 35).[25]

The discussion in which the relationship between the Wolfenbüttel figures and those at San Marco was first recognized did not take into account the proposal that the Evangelist reliefs were originally in the central arch of the west façade. Nor did the proponent of the reconstruction placing the reliefs in that position consider the implications of the Wolfenbüttel leaf. These omissions are simply the result of the fact that the two studies were published in the same year: each author was unaware of the other's work. If the Wolfenbüttel leaf is looked at again with the reconstruction in mind, another feature of the drawing takes on considerable interest. A horse appears at the upper left corner. Since the reconstruction places the Venetian Evangelists in close proximity to the quadriga, the possibility naturally suggests itself that this animal is based upon one of the four bronzes at San Marco. That the *Musterbuch* should

24. The most recent general study is H. Buchthal, *The "Musterbuch" of Wolfenbüttel and Its Position in the Art of the Thirteenth Century*, Byzantina Vindobonensia 12 (Vienna, 1979). See also R. Kroos, "Sächsische Buchmalerei, 1200–1250," *Zeitschrift für Kunstgeschichte* 41 (1978): 289f. For the view that the *Musterbuch* is actually a Venetian work, see Buchthal, 28, 56–59, and 64. On its connections with Venice, see also Demus, *Mosaics of San Marco*, 2, 1: 15f. and 226, and H. Belting, "Zwischen Gotik und Byzanz. Gedanken zur Geschichte der sächsischen Buchmalerei im 13.Jahrhundert," *Zeitschrift für Kunstgeschichte* 41 (1978): 245 and 254–57. Cf. M. Gosebruch, "Die Zeichnungen des Wolfenbütteler 'Musterbuches': Ihre westlichen Beziehungen-ihre byzantinische Vorlage," *Niederdeutsche Beiträge zur Kunstgeschichte* 20 (1981): 25, 41, and 50, whose rejection of the *Musterbuch*'s Venetian connections is unconvincing.

I would like to thank Dr. Wolfgang Milde, who is in charge of the manuscript division of the Herzog August Bibliothek, for his kind assistance during my visit to Wolfenbüttel to study the *Musterbuch* and for sharing his knowledge of it with me.

25. The relationship between the drawing and the reliefs was first noted by Belting, "Zwischen Gotik und Byzanz," 254f. For a fuller discussion, see Buchthal, *"Musterbuch" of Wolfenbüttel*, 37f., 56, and 62.

include a drawing after an ancient work of art is unexpected, but certainly not unprecedented. It is increasingly apparent that depictions of antiquities are not as rare among similar medieval compilations as might be supposed.[26]

What is crucial here is the *Musterbuch*'s juxtaposition of the two Evangelists with the horse. As will be argued shortly, the bringing together of the Evangelists with the four horses at San Marco is best understood as the outcome of a unique set of circumstances rather than the repetition of an established iconographic scheme. Indeed, no visual precedent for this composition appears to exist. The simplest explanation for the appearance together of the Evangelists and the horse in the *Musterbuch* is that the drawing is based, directly or indirectly, on the group that once occupied the central arch of the upper part of the west façade of San Marco.[27]

There are a number of difficulties with the view that the Wolfenbüttel leaf reflects the original decoration of this zone. In the drawing the horse is smaller than the two Evangelists and it is located above them, whereas the bronzes at San Marco are larger than the reliefs and would have been below them. These disparities, as well as the fact that only one of the horses appears here rather than all four, should be seen in the context of the widespread pattern of dislocation and fragmentation in the drawings. A large proportion of the figures and groups found there are isolated quotations that have been removed from their original settings. Most of these forms appear to be haphazardly scattered across the sheets. The Evangelists certainly have nothing to do with the six half-figures at the bottom of the page. The latter derive from a depiction of the Transfiguration that was also the source of figures elsewhere in the *Musterbuch*.[28] It is conceivable, therefore, that the origin of the horse is unre-

26. Gosebruch, "Zeichnungen des Wolfenbütteler 'Musterbuches,'" 44, rejects the usual identification of this animal as a horse (e.g., Buchthal, *"Musterbuch" of Wolfenbüttel*, 66n. 91) and calls it a cross between a horse and a ram. That the creature was based, at least primarily, on a horse is strongly suggested by the tall, narrow ears, long neck, large chest, fetlocks, and indication of hooves and mane.

For other examples of antiquities represented in related medieval collections, see A. Nesselrath, "I libri di disegni di antichità. Tentativo di una tipologia," in *Memoria dell'antico nell'arte italiana*, ed. S. Settis, vol. 3, *Dalla tradizione all'archeologia*, Biblioteca di storia dell'arte, Nuova serie 3 (Turin, 1986), 94–98 and 117–19.

27. Neither Belting nor Buchthal consider the horses in their accounts of the relationship between the Evangelists. The latter (*"Musterbuch" of Wolfenbüttel*, 38 and 56) takes the view that the two sets of Evangelists derive from a common source.

28. On the figures below the Evangelists, see Buchthal, *"Musterbuch" of Wolfenbüttel*, 24.

lated to that of the Evangelists and that chance alone had placed it next to them. In the light of what now seems to have been the likely arrangement at San Marco, however, this would be a remarkable coincidence indeed.

There is also a question whether the horse is an original part of the drawings. It has been asserted that it is an addition to this leaf by another hand using a different ink. Several of the other components of this drawing are also said to have been inserted later. They are the head in the middle on the right, the trefoil arch in the stand between the two Evangelists, and the inscription in the scroll. Yet it has also been maintained that, on the contrary, all these motifs, except for the inscription, formed part of the drawings from the beginning.[29]

The horse does indeed lack some of the firmness and assurance of the other figures on the leaf. All of the drawings in the *Musterbuch*, with the exception of the possible additions on fol. 89r, are usually said to be the work of one hand. It has also been recognized, however, that the *Musterbuch* exhibits a range of style and technique. The tentativeness of the horse finds echoes elsewhere. It is also true that the black ink with which it is drawn is slightly darker than that of the rest of the figures on this leaf. It is, however, different from the brown ink in which the trefoil arch and the inscription on the scroll were executed. In an infrared photograph, the horse appears virtually as clearly as the indisputably original elements, although the trefoil arch and the inscription are distinctly weaker.[30]

The fact that the horse has been inserted into the limited space that remained in the upper left corner of this leaf is suggestive. Even if the

29. For the view that these motifs are later additions, see H. R. Hahnloser and F. Rücker, *Das Musterbuch von Wolfenbüttel* (Vienna, 1929), 6, and W. Milde, *Mittelalterliche Handschriften der Herzog August Bibliothek* (Frankfurt am Main, 1972), 116. For the opposing view, see M. Gosebruch, "Die Anfänge der Frühgotik in Niedersachsen," *Niederdeutsche Beiträge zur Kunstgeschichte* 14 (1975): 36 and 56f.n. 52, and Gosebruch, "Zeichnungen des Wolfenbütteler 'Musterbuches,'" 44.

30. For the view that the drawings are the work of a single artist and for the stylistic and technical range, see especially Hahnloser and Rücker, *Musterbuch von Wolfenbüttel*, 11–13, 17f., and 25, and Buchthal, *"Musterbuch" of Wolfenbüttel*, 26f., 55, and 64. For similar tentativeness, see, e.g., most of the figures on fol. 91v (Buchthal, fig. 16). The leaf is reproduced in color in *Wolfenbütteler Cimelien*, ed. P. Ganz et al., exh. cat. (Wolfenbüttel, 1989), fig. 73. The differential fading in the infrared photograph, which is published by Milde, *Mittelalterliche Handschriften der Herzog August Bibliothek*, fig. 57, is pointed out by Buchthal, 66n. 91, who nevertheless regards the horse as an addition. Dr. Milde has kindly shared with me his view that the inscription on the scroll should be dated in the fifteenth century on paleographical grounds. The marks in the book of the other Evangelist are also later additions, as Gosebruch, "Anfänge der Frühgotik," 56f.n.52, notes. They are in the same brown ink as the inscription and they appear equally faded in the infrared photograph. Both were presumably added at the same time.

horse is by the hand responsible for the rest of the drawings on fol. 89r, it must have been an afterthought. The compression necessitated by this positioning has no real parallel among these leaves despite the prevailing crowding and the freedom with which figures have been incorporated wherever space was available. More room for the horse could have been readily found elsewhere, at least before a text was written over almost all the other drawings by about 1250 at the latest. The careful insertion of the horse at this point suggests that it possessed some link with the Evangelists in the mind of the person who introduced it.[31]

It is possible that the Wolfenbüttel drawing is not based directly upon the horses and the reliefs at San Marco. It has been argued that the sources of the present drawings were not actual works of art, but, instead, images in an earlier modelbook in which such works were more coherently recorded. Only the preceding modelbook, then, not the *Musterbuch* would have been the outcome of firsthand knowledge. It is also conceivable, though far more unlikely, that the source of the *Musterbuch* group was a preliminary drawing for the decoration of this zone of the west façade of San Marco rather than the sculptures themselves in situ. Another of the relationships between the *Musterbuch* and San Marco has been explained in this way.[32]

The problem, then, is complex and it resists neat resolution. On balance, the most credible view is that the Wolfenbüttel leaf contains a reflection, partial and distorted though it may be, of the group of horses and Evangelists at the center of the west façade of San Marco. This conclusion has several implications for the general relationship between the *Musterbuch* and Venice. Only one is important here. If this hypothesis is correct, the drawings provide a *terminus ante quem* for the installation of the horses and the five reliefs.

The *Musterbuch* is usually dated in the 1230s or, at the latest, around

Analysis of the chemistry of the inks might yield further evidence regarding the relationships of the various components of fol. 89r. According to Dr. Milde, the examination of the inks to which Gosebruch refers ("Anfänge der Frühgotik," 56n. 52, and "Zeichnungen des Wolfenbütteler 'Musterbuches,'" 44) was carried out by visual inspection and did not involve laboratory procedures.

31. For the identification of the text and for the date it was written here, see W. Milde, "Zum 'Wolfenbütteler Musterbuch,'" in R. Haussherr, ed., *Die Zeit der Staufer*, vol. 5 (Stuttgart, 1977), 331. Paleographical evidence indicates that the writing must belong to the first half of the thirteenth century.

32. The view that the *Musterbuch* derives from an earlier modelbook is that of Buchthal, *"Musterbuch" of Wolfenbüttel*, 21f., 27f., and 55f. He also argues (22f.) that a figure in the *Musterbuch* was based upon a preliminary drawing rather than the corresponding mosaic at San Marco, and Demus, *Mosaics of San Marco*, 2, 1: 15f. follows him in this.

1240. The dates on the Venetian side are not firmly established. All that can be definitely said regarding the horses, as noted earlier, is that they were installed by about 1270. The Porta Sant'Alipio mosaic dates from the 1260s and it shows them and the rest of the new decoration of the west façade in place. Work on the new façades appears to have begun in the 1220s, and it is hardly likely that the horses were the first works to be installed given the risk of damaging them as operations continued.[33]

The principal accounts of the reliefs of Christ and the four Evangelists assign them to the 1240s. Some recent discussions, however, place them in the 1250s or 1260s. The latter view is, of course, incompatible with the hypothesis that the *Musterbuch* drawing derives from the San Marco group.[34]

This hypothesis is also incompatible with the recent contention that the thirteenth-century façade decoration was the outcome of two altogether distinct stages. In this account, the lunette behind the horses is part of the second phase of construction which was carried out during the 1250s and 1260s. In contrast, the thirteenth-century façade campaign has usually been seen as a single but protracted undertaking during which a number of interruptions and changes in plan occurred. Other than requiring a slightly earlier dating of the five reliefs, the hypothesis that the *Musterbuch* drawing derives from the San Marco group fits comfortably with this traditional view.[35]

33. For the usual dating of the *Musterbuch* in the 1230s, see, e.g., Buchthal, *"Musterbuch" of Wolfenbüttel*, 32. For a date c. 1240, see Haussherr, *Zeit der Staufer*, 1: 596no. 765 (R. Kroos). Cf. Gosebruch, "Zeichnungen des Wolfenbütteler 'Musterbuches,'" 56: shortly after 1225. For the date of the installation of the horses, see above, page 8.

34. Demus, *Church of San Marco*, 136–38, dates the reliefs in the second quarter of the thirteenth century. He implies, however, that they cannot be much earlier than the 1240s, since he puts the Heracles Master's earliest work about 1230 and regards these panels as the work of a later phase of the sculptor's career. Cochetti Pratesi, "Contributi alla scultura veneziana del Duecento III," 22, explicitly places them in the 1240s. Cf. Diemer, review of Wolters, *Skulpturen von San Marco*, 109, who questions whether the pace of this sculptor's work was as slow as usually supposed. In his most recent discussion ("Skulpturale Fassadenschmuck," 14) Demus speaks of the date of the Heracles Master's work as an open question.

 Polacco, *San Marco*, 107 and 117, dates the reliefs of Christ and the Evangelists in the 1260s. While Herzner does not discuss the reliefs, he argues (50) that the works most closely associated with them do not predate the late 1250s.

35. The two-stage theory is Herzner's (40–57). For his views on the date of the lunette behind the horses, see 37f. and 45f. The view that work on the sculpture and mosaics of the west façade was a slow but largely continuous process is most clearly reflected in Demus' dates for its various components and in his views about the interrelationships among them. See *Church of San Marco*, 118–90 passim, "Skulpturale Fassadenschmuck," 14, and *Mosaics of San Marco*, 2, 1: 205f.

Arguing the case for an early dating of these reliefs and setting out the broader one against the recently proposed chronology of San Marco's façades would lead far from the present theme. Only one general observation can be made here. Nothing that has been securely determined precludes the view that the five reliefs and the horses were indeed installed at a sufficiently early date, that is, in the 1230s or early 1240s, to have been reflected in the *Musterbuch*. Final conclusions, however, must await fuller study of the chronology of the thirteenth-century façade campaign.

The Lord's Quadriga
and Venice's Patron Saint

The *Quadriga Domini* composition at San Marco is the equivalent, in some respects, of a familiar feature of medieval church façade decoration in the twelfth and early thirteenth centuries. It is closely related to the representations of the *Maiestas Domini* that so frequently occupy the tympana of French and Italian churches erected during those years. There is only one difference between the group of reliefs in the lunette that form the core of the San Marco composition and the standard imagery of Christ in Majesty: here he is accompanied by the Evangelists themselves rather than their symbols. The *Maiestas* is a complex theme with a variety of ramifications. One of its meanings has much in common with that of the *Quadriga Domini*. Like the *Quadriga Domini*, the *Maiestas* is a statement about the role of the Evangelists in the revelation of God's word and about the harmony of their conjoint efforts.[1]

Yet the *Quadriga Domini* composition at San Marco cannot be adequately understood as simply another instance of a general pattern. It appears, after all, on a church dedicated to one of the authors of the Gospels, and this Evangelist was also the patron saint of the city. The relationship with St. Mark played a major role in the ideology of the Venetian state. The *Quadriga Domini* composition, therefore, should

1. On the *Maiestas Domini*, see F. van der Meer, *Maiestas Domini* (Rome, 1938). On its popularity in the tympana of French twelfth-century church portals, see van der Meer, 366–78, and W. Sauerländer, *Gothic Sculpture in France, 1140–1270*, trans. J. Sondheimer (New York, 1973), 28. For Italian examples, see van der Meer, 379, and R. Jullian, *L'éveil de la sculpture italienne*, vol. 1, *La sculpture romane dans l'Italie du nord* (Paris, 1945), 189, 213, 225, and 279f. For two early thirteenth-century French tympana in which Christ is accompanied by the Evangelists rather than their symbols, see Sauerländer, 28 and 421f., and pls. 66 and 67. He notes the rarity of the type in French portal sculpture.

For depictions of Christ and the four Evangelists or their symbols as expressions of the idea of the harmony of the Gospels, see Nilgen, "Evangelistensymbole," 529–45.

not be read as an abstract doctrinal statement about the Evangelists. For Venetians, it had a strong immediacy and it would have been seen as a specific and emphatic reminder of Mark's importance as a member of this select group. That it was indeed conceived in this spirit is suggested by a small, but revealing feature of its design. The concept of the *Quadriga Domini* is, by its very nature, impartial. It presents the four Evangelists as co-equals and it could be used with the same effectiveness as a means of underscoring the significance of any one of them. A way was nonetheless found to single out Mark for special honor without compromising the essential character of the image. As noted earlier, the sequence of the Evangelists was so arranged that Mark is at Christ's immediate right in the reliefs in the lunette.[2]

The role of the *Quadriga Domini* composition in this regard, however, only emerges fully when it is seen in a larger context. The single most important component of the thirteenth-century exterior decoration of San Marco is a series of mosaics depicting the life of Mark and the fate of his relics. The *Quadriga Domini* composition complements these scenes. The mosaics set forth the special tie between Venice and Mark, while the *Quadriga Domini* proclaims his exalted place in the history of salvation. Whether the imagery of the *Quadriga Domini* was similarly exploited in connection with any other Evangelist elsewhere in medieval art will be considered later. First the relationship of this theme to the cycle of mosaics with the story of Mark—and also its links with other features of San Marco's thirteenth-century façade decoration—must be traced in detail.

The original prominence of the Mark scenes has been partially obscured by later changes in the façades. The first part of the narrative, the story of his mission and martyrdom, is located on the vault of the Cappella Zen (fig. 26). Until the early sixteenth century, this space was, it will be recalled, the church's south portal. Because of its closure, these scenes are no longer visible from the exterior. The second half of the story unfolds in the four side portals of the west front where the Venetian acquisition of his relics is recounted. This segment begins with Mark's body being spirited from Alexandria by two Venetian merchants, continues with the miraculous voyage bringing it to Venice, and ends with its triumphant arrival at San Marco. Unfortunately, only the final scene, the

2. For a general account of Mark's place in the religious and political life of medieval Venice, especially as it relates to the church of San Marco, see Demus, *Church of San Marco*, 3–60.

one in the Porta Sant'Alipio, survives: all the rest were replaced during
the seventeenth and eighteenth centuries. The subjects and the general
iconography of the lost mosaics, however, can be established with rea-
sonable certainty. The principal evidence is Gentile Bellini's *Procession in
Piazza San Marco* of 1496 which records them in considerable detail (figs.
30 and 31).[3]

The scenes in the south portal and those of the west front together
form a continuous cycle that was meant to be read as a single statement.
Although the narrative continuity has been recognized, the care taken in
its design has not been adequately appreciated. This attention is demon-
strated by the neatness with which the two segments of the narrative join
at the southwest corner. The south portal sequence ends with Mark's
burial in Alexandria; the west façade scenes begin at the southernmost
portal with the removal of his body from the tomb, the first step in the
journey whose final moment is depicted in the Porta Sant'Alipio at its
northern end. For the visitor arriving from the lagoon, this is the logical
narrative direction. The narrative continuity must have been the out-
come of careful planning, for the first part of the cycle in the south portal
was executed after the second section on the west front. The former
probably dates from the 1270s, but the latter appears to belong to the
1250s and 1260s. Since the two segments dovetail perfectly, the plan to
put the first part of the cycle in the south portal must have been con-
ceived by the time the west front scenes were begun.[4]

The viewer was also invited to read the scenes on the south together
with those on the west because of the correspondence in their positions.
All occupied the upper section of a portal, although only the former fill a
deep barrel vault. The latter decorate either the rear walls of the niches
and the lower portions of the adjacent shallow barrel vaults or, in the case
of the Porta Sant'Alipio, a semidome.

The two parts of the Mark story are linked in a deeper way. The scenes
on the south set forth the grounds for Venice's claim to a unique relation
with its patron saint, the relation that justifies the purloining of the relics

3. On the Mark scenes in the south portal and on the west façade, see Demus, *Mosaics of San
Marco*, 2, 1: 185–94 and 199–206; and 2, 2: colorplate 78 and black and white pls. 336–40
and 347–50 with details from Bellini's painting.

4. The continuity is noted, e.g., by Demus, *Mosaics of San Marco*, 2, 1: 187, but he explains
the distribution of the scenes differently. "[T]he *translatio* was part of the state legend: the
claim of the church to be the shrine of the evangelist's relics, his resting place, had to be
demonstrated first, on the 'title page'; the story of his life was an amplification, a commen-
tary."
I have followed Demus' dating of the mosaics. See *Mosaics*, 2, 1: 191 and 204–6.

depicted on the west. They do so, moreover, with unprecedented force-
fulness, for the south portal contains the earliest depiction of the episode
that forms the capstone of the Venetian argument. According to the
legend, Mark had crossed the Venetian lagoon on his way back to Rome
after founding the church of Aquileia. During the passage, he fell asleep
and in a dream he was informed by an angel that his body would someday
be honored in a church at the place where San Marco was eventually
built. The *praedestinatio* or *vaticinatio*, as the episode was known, is seen in
the northeast corner of the vault of the Cappella Zen (fig. 26). Directly
opposite and balancing it visually and thematically, is the depiction of his
burial in Alexandria which will prove to have been only temporary. The
fulfillment of the prophecy is represented in the final scene on the west
façade, the Porta Sant'Alipio mosaic showing the arrival of his body at
San Marco, its final resting place. The *praedestinatio* does not appear in
either of the two earlier Mark cycles at the church, the early twelfth-
century one among the enamels of the Pala d'oro or in the mosaics of the
Cappella di San Pietro and the Cappella di San Clemente in the choir
which belong to the first half of the twelfth century. The episode was
introduced into the Mark legend sometime between 1200 and 1260. The
impact of its depiction in the south portal vault is all the greater since the
viewer sees it on the very spot where it took place and the building that
the vision foretold appears before him as proof of the prophecy's truth.[5]

The effectiveness of the argument advanced in these mosaics is in-
creased by its specificity. The concrete details incorporated at a number
of key points in the cycle help to confirm the truth of the story. Partic-
ularly suggestive is the way in which architectural imagery is used to fix
the narrative topographically. The first example is the Pharos of Alex-
andria, the lighthouse that was one of the city's most familiar landmarks,
at least to seafarers, and also one of the seven wonders of the world. It
appears in the scene showing Mark's arrival there by ship and again when
the Venetian merchants prepare to depart from the city's harbor with his
relics (figs. 28 and 31). The first scene is in the vault of the old south
portal and the second in the second portal of the west façade. The
representation, which is almost identical in the two scenes, may reflect
an actual lighthouse in Alexandria. Such a building would have been well

5. On the introduction of the *praedestinatio* into the Mark legend, its significance for
Venetian claims, and its importance in the south portal mosaics, see Demus, *Mosaics of San
Marco*, 2, 1: 187f. On the Pala d'oro Mark scenes, see Volbach, *Pala d'oro*, 33–38nos. 69–78,
and pls. 37–41, and for the choir chapel cycle, Demus, *Mosaics of San Marco*, 1, 1: 57–83,
and figs. 11 and 63–69; and 1, 2: colorplate 28 and black and white pls. 38–43 and 63–69.

known to Venetians because of their commercial activities there. The faithfulness of the depiction of the west façade of San Marco in the Porta Sant'Alipio mosaic serves, in a similar way, to identify unmistakably the building into which Mark's body is being carried.[6]

The final stage of the argument is to be found in the depiction of the rediscovery of Mark's relics after their temporary loss during the late eleventh century. The prayer for their recovery and its miraculous answer are seen in mosaics, dating from the 1250s, on the west wall of the south transept inside the church. While the south portal mosaics show the promise of Venetian possession of Mark's relics and the west façade ones recount its fulfillment, those in the south transept confirm that they are still at San Marco. The fact that San Marco already displays its new thirteenth-century façade decoration as the relics arrive in the Porta Sant'Alipio mosaic underscores this point. The faithfulness of the rendering of the exterior of San Marco in the Porta Sant'Alipio scene finds a counterpart in the accurate view of the inside of the building in the south transept mosaics. The interest in full and precise reporting manifested by this group of mosaics extends beyond architecture to include other matters such as, for example, details of the doge's costume. The care with which all these facts are recorded should be attributed not only to local pride, but also to the desire to make Venetian claims regarding Mark as convincing as possible.[7]

6. On the two depictions of the Pharos, see Demus, *Mosaics of San Marco*, 2, 1: 200, where the fact that it is a new motif in the cycle and the existence of the close relationship are noted. The structure with its series of levels that diminish in size corresponds closely to the representations of lighthouses in Roman art. See, e.g., F. Castagnoli, "Faro," in *Enciclopedia dell'arte antica classica e orientale*, vol. 3 (Rome, 1960), 596f. That in Alexandria is known to have had three stories like the one in the mosaics.

Although the pharos does not appear, as Demus notes, in the earlier mosaics of the life of Mark at the church, it may not be a new motif in connection with him. According to A. Niero, "I cicli iconografici marciani," in B. Bertoli, A. Niero and W. Dorigo, *I mosaici di San Marco: Iconografia dell'Antico e del Nuovo Testamento* (Milan, 1986), 28, the pharos is represented by the tower to the right of Mark in the northwest pendentive of the central dome of the late twelfth century (Niero, fig. 99e, and Demus, *Mosaics of San Marco*, 1, 2: colorplate 64 and black and white pl. 322). The structure there bears a general resemblance to the later ones.

The accurate representation of the Egyptian pyramids in the third Joseph cupola of the narthex is another indication of the concern with specificity at this time. See Demus, *Mosaics of San Marco*, 2, 1: 166, and 2, 2: colorplate 67 and black and white pls. 290f. and 295.

7. On the south transept mosaics, see Demus, *Mosaics of San Marco*, 2, 1: 27–44; 2, 2: colorplates 7–15 and black and white pls. 33–58; and also 1, 1: 260, for their role in confirming the claims of the west façade mosaics. As Brown, *Venetian Narrative Painting*, 220f., has noted, some of the documentary features of the Mark scenes foreshadow elements of what she has termed the "eyewitness style" in late fifteenth- and early sixteenth-century Venetian painting.

The introduction of the *praedestinatio* is not the only important difference between the south portal Mark cycle and the earlier depictions at San Marco of his life. There has been a change in emphasis, and it is in this regard that the significance of the *Quadriga Domini* composition emerges most clearly. The south portal cycle omits a number of scenes whose inclusion in the earlier versions was largely motivated by local political and ecclesiastical conflicts that had been resolved by the time these mosaics were conceived. The ambitions of the later cycle are broader and its claims more incisively articulated. Just as it seeks to place the Venetian assertion of a special bond with Mark on a more secure footing, so too it sets forth Mark's importance in the Christian dispensation more directly and forcefully. This it achieves by bringing to the fore Mark's role as author of a Gospel. Neither the Pala d'oro narrative scenes nor those in the choir chapels include a depiction of Mark writing his Gospel. In the south portal vault, however, the two opening scenes of the cycle are devoted to this theme. In the first he writes his Gospel and in the second he presents it to St. Peter who, according to the inscription, approves it and transmits it to the church (fig. 27).[8]

But a narrative cycle depicting the life of Mark was not the place to show his inclusion in the group of four men, each of whom had been divinely chosen and inspired to spread the message of Christ to the world by writing a Gospel. Nor could it readily record the belief that each of those four Gospels made a distinct and necessary contribution to the knowledge of Christ's life and teachings that was concordant with all the others.

Those tasks were assigned, instead, to the *Quadriga Domini* composition at the center of the west façade. Of course, these ideas could have been conveyed without the horses. The group of reliefs showing Christ and the Evangelists in the lunette is, by itself, sufficient to introduce them. But the evocation of the *Quadriga Domini* that results from the addition of the horses does so far more vividly. The wish to give these ideas greater force may help to explain what, as will be seen presently, was the boldness of the Venetian authorities responsible for composing this image. It is clear, at any rate, that the façade Mark cycle and the

8. This account of the relationship between the various cycles is based on Demus, *Mosaics of San Marco*, 2, 1: 188. He explains the omission of a depiction of Mark writing his Gospel from the choir chapel scenes by noting that Mark's authorship is implied in the nearby main apse mosaic (*Mosaics*, 1, 1: 58). Although not included among the narrative scenes, it is found elsewhere on the Pala d'oro: Mark, like the other Evangelists, is seen writing his Gospel in one of the four medallions surrounding the central enthroned Christ. See Volbach, *Pala d'oro*, 14f.no. 12, and pl. 9.

Quadriga Domini group should be read together. The former sets forth Venice's unique bond to Mark, while the latter proclaims his importance as one of the four authors who carried the word of God to the world.

The *Quadriga Domini* composition should also be read in conjunction with one of the major features of the interior of San Marco. It is now generally recognized that the vast array of mosaics inside San Marco follow, for the most part, a coherent plan in the selection of subjects and their distribution on the vaults and walls. Thus, the mosaics in the eastern section of the church center on the Incarnation and Advent of Christ, while those of the central space, along with its extensions to the north and south, are devoted to his actions on earth. The unifying idea for the scenes in the western arm is the dissemination of Christ's message throughout the world by means of his disciples. The theme is first stated in the depiction of Pentecost in the dome that covers most of this zone. This aspect of the meaning of the scene is especially developed in the San Marco version because of the treatment of the foreigners who recognize their languages when the Apostles, inspired by the Holy Ghost, speak in tongues (Acts 2:1–15). No other medieval representation of the scene includes so many of them, and the variety and particularity of their characterizations are also unique. The theme is further developed in the mosaics on the adjacent spaces below the dome to the north and south. They represent the Apostles' campaigns to convert the peoples of the earth and the Apostles' martyrdoms. All these mosaics date from the end of the twelfth century or the beginning of the thirteenth and they belong to the final phase of the original cycle.[9]

It is physically impossible, of course, to see the *Quadriga Domini* group together with the mosaics behind it inside the church's west arm. Yet the connection between them is strong. The central theme in both cases is the role of Christ's closest followers in carrying the word of God to humanity. The only difference is that the west arm scenes concern the actions of the Apostles, the *Quadriga Domini* composition those of the Evangelists.

If the *Quadriga Domini* composition was indeed an essential component of the overall façade program, some explanation must be found for

9. On the program of the interior mosaics and on the iconography and dates of the scenes of the west arm, see Demus, *Mosaics of San Marco*, 1, 1: 150–54, 219–29, and 231–73, esp. 256. See also Niero "Cicli iconografici marciani," 16–34, esp. 30; Niero's various contributions to *Patriarchal Basilica*, 1, esp. 69–78; and Polacco, *San Marco*, 233–36.

its seemingly cavalier dismemberment in the early fifteenth century when the reliefs with Christ and the four Evangelists were removed. Although approximately two hundred years had elapsed since the group as a whole had been put in place, its message was presumably still understood and its importance recognized. Related images appear in a number of fifteenth-century Italian works of art. One possibility is that the change was connected with the fire of 1419 that caused extensive damage to the roof of the church. This arch is close to the roof, and the account of the fire in a fifteenth-century chronicle speaks of damage near the "vault of the great door," a phrase that might refer to a part of the west façade near the central doorway. Direct evidence regarding the involvement of the lunette behind the horses is lacking. Although the relief of Christ is in poor condition, there is no obvious reason to attribute this to fire. In any case, the fire is at best only a partial answer: other things being equal, the reliefs would presumably have been reinstalled in their former positions after repairs had been effected.[10]

The best explanation for the dismantling of the thirteenth-century decoration within the arch may lie in the weight now attached to another consideration. Whether or not it was occasioned by the fire, the insertion of the vast window must have resulted from a desire to increase the light reaching the church's interior. The strength of this concern may be gauged from the fact that the introduction of this window was by no means the only substantial alteration of this kind. A rose window was inserted in the corresponding position at the end of the church's south transept where it fills the entire space available. A large window was also opened in the south wall of the Cappella di San Clemente. In the opinion of one authority, the window on the west and the two on the south all belong to the years between 1419 and 1439. More recent opinion, however, places the south transept rose window in the fourteenth century. This concern with light should be seen, of course, in the context of the

10. On the fire of 1419 and another in 1439 in which the roof was again seriously damaged, see Forlati in Demus, *Church of San Marco*, 194. While Galliazzo, 8, asserts that the fire of 1419 was a factor in the change, Polacco, "Bassorilievi," 16, contends that it was not. If the new sculpture on the arch framing the lunette indeed dates from the 1420s or early 1430s (see chapter II, note 8), then the change must have already taken place before the fire of 1439. For the report on the fire in the chronicle of Pietro Dolfin, see Galliazzo, 8, and Demus, *Mosaics of San Marco*, 1, 1: 5, along with a second similar report by Marin Sanudo. For the text, see *La Basilica di San Marco in Venezia illustrata nei riguardi dell'arte e della storia da scrittori veneziani: Documenti per la storia dell'augusta ducale Basilica di San Marco in Venezia* (Venice, 1881), 213no. 847. On the condition of the reliefs, see Wolters, *Skulpturen von San Marco*, 22f.nos. 18–22. For fifteenth-century images related to the *Quadriga Domini*, see excursus IV.

dominance of Gothic forms and values in Venetian architecture during the fourteenth century and for much of the fifteenth as well.[11]

The glazing of the arch at the end of the west arm may have been related to another effort to improve San Marco's lighting. It is possible that one of the church's most unusual features was introduced to capitalize upon the increased luminosity provided by the *finestrone*. The *pozzo*, the light well that enables illumination from the new west window to reach the narthex, may have been opened at this period for precisely this purpose.[12]

The number of new windows introduced is not the only measure of the desire for greater light inside San Marco. Its strength is also indicated by the fact that the illumination provided by two of these windows was obtained only at the price of the destruction or the transfer of the decoration that had previously occupied the site. Although the creation of the one in the Cappella di San Clemente may not have brought about the loss of any scenes, the insertion of the south transept rose window eliminated a number of mosaics depicting Christ's miracles. Breaking through the *pozzo* in the narthex also appears to have entailed the destruction of mosaics. In the case of the great window on the west, it can only be supposed that increasing the illumination inside San Marco had come to be deemed of such overriding importance as to justify the sacrifice of a major constituent of the façade program. As noted earlier, the inclusion of the Evangelists in the new sculpture decorating the intrados of the arch and the crest of the façade may have been an attempt to compensate for the removal of the reliefs. Because no close visual relationship was established between the new figures and the horses, however, the integrity of the *Quadriga Domini* composition was not restored.[13]

11. Demus, *Church of San Marco*, 207, dates all three windows between 1419 and 1439, but elsewhere (86n.114) puts the south transept one after 1450. E. Arslan, *Venezia gotica: l'architettura civile gotica veneziana* (Venice, 1970), 85 and 98n.76, places the south transept window in the fourteenth century, and H. Dellwing, *Die Kirchenbaukunst des späten Mittelalters in Venetien* (Worms, 1990), 89f. and 173, puts it c. 1300 or a little later. Demus, *Mosaics of San Marco*, 1, 1: 6, 65, and 124, adheres to his fifteenth-century dating of the two south windows. On these changes, see also W. Dorigo, "The Medieval Mosaics of San Marco in the History of the Basilica," in *Patriarchal Basilica*, 1: 48. The role of Gothic taste in the insertion of the west window is noted by Demus, *Church of San Marco*, 87n. 115; Polacco, "Bassorilievi," 16; and Galliazzo, 8.

12. This explanation is Polacco's (*San Marco*, 32 and 205). Demus' dating of the *pozzo* has changed from the eleventh century (*Church of San Marco*, 82) to the sixteenth century (*Mosaics of San Marco*, 1, 1: 9 and 315n. 6). Herzner, 46f.: thirteenth century.

13. For the effects on the mosaics of the opening of the two south windows and the *pozzo*, see Demus, *Mosaics of San Marco*, 1, 1: 6, 22, 65, and 115–17. The concern with improving light conditions in the church was not new. On the removal of the flooring of the original

The most important reused works of art on the west façade after the horses are several of the reliefs that occupy, as already noted, the spandrels of the arches of its lower section. It can now be recognized that the manner in which the horses were employed corresponds closely to the treatment that was accorded this other group of spoils. Three of the reliefs in the series are certainly or quite probably Byzantine in origin. The first depicts Heracles with the Erymanthian boar, the second St. Demetrius, and the third the Archangel Gabriel (figs. 17, 20, and 21). The most plausible datings place them in the fifth, the eleventh or twelfth, and the twelfth or early thirteenth centuries respectively. It may well be that the Venetians obtained one or more of them, like the horses, in Constantinople after the conquest of 1204, as has often been suggested. No firm evidence has yet come to light, however, regarding their provenance.[14]

For each of these reliefs, a companion piece with an appropriate theme was carved. Demetrius was coupled with St. George (fig. 19) who was, like his partner here, a much venerated military saint. In a grouping that evokes the Annunciation without actually representing it, Gabriel was matched with the Virgin Mary (fig. 18). Finally, Heracles with the Erymanthian boar was complemented with another relief showing him with the fruits of similar struggles against the Keryneian hind and the Lernean hydra (fig. 22). The resulting set of six works, half of them spoils and half of them contemporary, was then arranged as a sequence of three concentric pairs.

The importance of the six panels in the façade decoration derives not only from their size and the prominence of their placement but also from their role in the program. This group of figures has been rightly characterized as a series of guardians for the state and its rulers. A variety of parallels, some Western and others Byzantine, can be cited for their

galleries in the late twelfth and early thirteenth centuries for this purpose, see Demus, *Church of San Marco*, 83–88.

14. On these reliefs, see Wolters, *Skulpturen von San Marco*, 31–33nos. 69, 71, and 73. The account that follows recapitulates the extended analysis by Demus, but I have stressed his arguments regarding the work's Venetian references at the expense of those concerning their general meanings. For his fullest discussion, see *Church of San Marco*, 125–35, where, however, in contrast to the opinion he expresses in all his other discussions of it, he calls Gabriel a Venetian rather than a Byzantine work. See also his earlier discussion in "Reliefikonen der Westfassade," 91–104, and his most recent one in "Skulpturale Fassadenschmuck," 5f. Cochetti Pratesi, "Contributi alla scultura veneziana del Duecento III," 19n. 25, is quite skeptical about Demus' argument that a program governed the use of these reliefs. His views, however, have been accepted by others. See, e.g., Muir, "Images of Power," 21f., and Herzner, 50. See also Polacco, *San Marco*, 112f.

functioning in this capacity. These traditional roles were, no doubt, important factors in the decision to install these particular spoils so prominently on the west façade and in the selection of the subjects for the new reliefs with which they were paired. But many of these figures also possessed a special relevance for Venice. The churches of Venice contained important relics of St. George, and he had long been especially venerated there. Heracles recalled nearby Heracliana (Eraclea) where the first doge had taken office. The Annunciation that is summoned up by the pairing of Gabriel and the Virgin also had a particular local meaning. According to legend, Venice had been founded in 421 on 25 March, the feast of the Annunciation. It must be noted, however, that the identification of this day with the foundation of the city may not yet have emerged by the thirteenth century.[15]

The prizes that form the core of this group are, to be sure, hardly of the artistic stature of the horses, and the far-reaching reinterpretation to which the latter have been subjected finds no true counterpart here. Yet the same concern with reusing older works in a manner that significantly enriches the program is apparent in both cases. And in both, the themes introduced in this way have a strongly Venetian cast. These ends have also been achieved in precisely the same way. It is simply the juxtaposition of the older works with newly created ones that directs the viewer to the new and larger meaning.[16] It appears, moreover, that the execution of these plans was entrusted to the same hand in both cases: the new spandrel panels, as already noted, were probably by the same sculptor who carved most of the reliefs with Christ and the Evangelists.

Given the composite nature of these groupings, their ability to convey their meanings was especially vulnerable to the loss of one of the constituent parts. Once the reliefs of Christ and the four Evangelists were

15. Demus first referred to the foundation of Venice in his account of the program of these reliefs in "Skulpturale Fassadenschmuck," 5. It has been said that the tradition that Venice was founded on the feast of the Annunciation may go back to the eleventh or twelfth century. For this view, see A. Niero, "I santi patroni," in S. Tramontin et al., *Culto dei santi a Venezia* (Venice, 1965), 78–80. The evidence has recently been surveyed by C. Hope in his reply to a letter to the editor in *The New York Review of Books* 37, no. 18 (11/22/1990), 52. He concludes that the earliest statement that the foundation of Venice took place on 25 March belongs to the 1330s and that the association of the foundation with the Annunciation was first made explicit in the late fifteenth century. On the legend, see also E. Muir, *Civic Ritual in Renaissance Venice* (Princeton, 1981), 70f.

16. Demus, "Skulpturale Fassadenschmuck," 6, is acute on this point. Speaking of the spandrel reliefs, he notes "die Ingenuität und das Geschick der Autoren des Fassadenprogramms . . . ihre Fähigkeit, aus zufällig vorhandenen Spolien durch Umdeutung und ergänzende Zutaten ikonographisch sinnvolle Komplexe zu gestalten, und zwar durch blosse Aneinanderreihung von Einzelfiguren."

removed to make way for the new glazing in the fifteenth century, the horses alone could only vaguely hint at what had formerly been clearly enunciated. It is not surprising, then, that their role in evoking the *Quadriga Domini* has been almost entirely ignored in the vast literature concerning them.[17]

17. The only recognition of this role that I have encountered is L. Charbonneau-Lessay, *La mystérieuse emblématique de Jésus Christ: Le Bestiaire du Christ* (Bruges, 1940), 219. His remarks, in their entirety, are as follows. "A la fin du premier millénaire chrétien et durant le Moyen-âge, le cheval fu assez souvent pris pour l'emblème des quatre Evangélistes, et l'on s'est demandé si les quatre chevaux de bronze qui figurent sur le portail occidental de la cathédrale de Saint-Marc, à Venise, n'étaient point les hiéroglyphes des Saints Matthieu, Marc, Luc et Jean qui furent les principaux 'coursiers' porteurs de la Loi Nouvelle."

Envisioning the Lord's Quadriga: The San Marco Group and the Other Medieval Formulations

The composition on the west façade of San Marco is by no means the only visual statement of the relationship between the Evangelists and the quadriga produced during the Middle Ages. Indeed, this theme figures in a number of well-known works of art. Yet the San Marco group stands apart from all the other images in the way in which it is formulated and in the use to which it was put. The first of these divergences is of particular interest here. Like the fifteenth-century removal of the reliefs of Christ and the Evangelists noted earlier, the difference in formulation helps to explain why this aspect of the role of the horses has gone unrecognized for so long.

Endowing the *Quadriga Domini* with concrete form in a visual image was not an easy matter. No guidance was provided by the spare two-word phrase through which the idea was primarily known. It left unspecified the precise nature of the relationship between the Evangelists and the vehicle, a relationship that would have to be spelled out in any depiction worthy of the name. The course matters took depended entirely on the knowledge and imagination applied to the task.

An important group of representations of the theme appears in a series of illustrated copies of the commentary by Honorius Augustodunensis on the Song of Songs. Five date from the second half of the twelfth century and two from the early fourteenth. Except for the latest, which was made in Switzerland, all were produced in southern Bavaria and nearby parts of Austria. Honorius had spent most of his life in Bavaria, and it was there that he wrote this work during his later years. It is

possible that it had already been illustrated, perhaps under his direction, before he died in the 1150s.[1]

In the illustrated copies of Honorius' commentary on the Song of Songs, the opening of the third section of the work is decorated with a miniature based upon the immediately following text. There he explains the significance of the quadrigas of Aminadab of verse 6:11 and that of the Sunamite woman first named in verse 6:12. A manuscript made in Salzburg in the third quarter of the twelfth century (Vienna, Öster-reichische Nationalbibliothek, Cod. 942) provides a characteristic example (fig. 42). The central figure is the woman whom Honorius calls the Sunamite, a variant of the more common term Shulamite or Sulamite. He interprets her as the converted Synagogue, and the miniature shows her holding the banner usually associated with *Ecclesia*. Led by Am-inadab, she rides triumphantly in the car of the Gospels towards the west while a group of Jews appears at the left. Like the rest of the miniature, the particular form of the allegorical vehicle—labeled *Quadriga Aminadab*—reflects the accompanying text. There, as noted earlier, Honorius explicated the parallel between the quadriga and the Gospels in the new mode that had come to prevail by the twelfth century, that is, by identifying the Gospels with the quadriga's four wheels rather than its four horses. Accordingly, in the miniature the Evangelist symbols are placed within the wheels of the vehicle. The team that draws it consists of only two horses, and the inscriptions state that they represent the Apos-tles and the Prophets. No trace of the classical four-horse chariot or of the original form of the concept of the *Quadriga Domini* remains.[2]

1. On Honorius' links with Germany and Austria and on the date of his commentary, see the studies by V. I. J. Flint: "Commentaries," 199f. and 209; "The Career of Honorius Augustodunensis: Some Fresh Evidence," *Revue Bénédictine* 82 (1972): 62–86; "Heinricus of Augsburg and Honorius Augustodunensis: Are They the Same Person?" *Revue Bénédic-tine* 92 (1982): 148–58; and "The Chronology of the Work of Honorius Augustodunensis," *Revue Bénédictine* 82 (1972): 234 (all reprinted in Flint, *Ideas in the Medieval West*). That Honorius himself shaped the cycle is suggested by G. Schmidt, *Die Malerschule von St. Florian* (Graz, 1962), 195. This is also the view of M. Curschmann, "Imagined Exegesis: Text and Picture in the Exegetical Works of Rupert of Deutz, Honorius Augustodunensis, and Gerhoch of Reichersberg," *Traditio* 44 (1988): 153, 156, and 159, who cites textual evidence for it. He also rightly notes (156) the difficulty of giving visual form to Honorius' conception.

2. On the Vienna miniature and those in the other Honorius manuscripts, see G. Swarzen-ski, *Die Salzburger Malerei von den ersten Anfängen bis zur Blütezeit des romanischen Stils*, vol. 1 (Leipzig, 1913), 94f.; Schmidt, *Malerschule von St. Florian*, 195f., who provides a useful review of the relationship among the manuscripts; Curschmann, "Imagined Exegesis," 152–60, who analyzes this particular illustration and reproduces many of the examples; and Matter, *Voice of My Beloved*, 65. The other examples are Augsburg, Universitätsbibl., Cod. I

The car of the Gospels also appears in French art of the twelfth and thirteenth centuries. There is, first of all, the representation of this theme in one of the roundels of Suger's recondite "Anagogical" window at Saint-Denis of the early 1140s (fig. 43). Again labeled *Quadrige Aminadab*, the vehicle reflects a common conflation in medieval exegesis. As noted earlier, the new wagon or cart (Vulgate: *plaustrum*) of Abinadab in 2 Kings 6:3 that carried the Ark of the Covenant to Jerusalem after its return from the Philistines was sometimes identified with the quadrigas of Aminadab in Song of Songs 6:11. They are united here. Since it contains the Tablets of the Law, the box is, in fact, the Ark itself. Yet it is, at the same time, the body of the car of the Gospels. As the principal inscription makes clear, the main theme of this juxtaposition of the Ark and Christ on the cross is the relationship between the Old and New Covenants. The disposition of the wheels and Evangelist symbols leaves no doubt that the image again reflects the later form of the concept of the *Quadriga Domini*.[3]

The immense pictorial cycles of the *Bible moralisée*, which were created in the first half of the thirteenth century, also contain a number of relevant miniatures. The car of the Gospels makes its appearance at several points in the story of the Ark of the Covenant. Its depiction in a copy in Vienna (Österreichische Nationalbibliothek, Cod. 2554) made in Paris between about 1215 and 1225 is particularly revealing. The miniature (fig. 44) illustrates the interpretation of a stage of the return of the Ark from the Philistines (1 Kings 6:10–16) that preceded the one to which Suger's window refers. During this journey too it was carried upon a *plaustrum*, drawn this time, however, by two cows. According to the

2 2° 13, fol. 48v: 1150–75 (rediscovered by Curschmann, 154n. 21, 157, and fig. 10); Munich, Bayer. Staatsbibl., Clm 5118, fol. 77v: 1150–1200 (Curschmann, fig. 8); Munich, Bayer. Staatsbibl., Clm 77r: 1175–1200 (Haussherr, *Zeit der Staufer*, 1: 565f.no. 740, and 2: fig. 532); Baltimore, Walters Art Gallery, W. 29 (olim Lambach, Cod. XCIV), fol. 89v: 1190–1200 (K. Hoffmann, *The Year 1200*, exh. cat. [New York, 1970], 1: 286f.no. 280, and illustration on 287); St. Florian, Stiftsbibl., Cod. XI, 80, fol. 26v: 1301 (Schmidt, 64no. 19, and 195f., and pl. 3b); and St. Paul in Lavanttal, Stiftsbibl., 44/1, fol. 53r: 1300–1325 (R. Eisler, *Die illuminierten Handschriften in Kärnten*, vol. 3, Beschreibendes Verzeichnis der illuminierten Handschriften in Österreich [Leipzig, 1907], 94f.no. 49, and fig. 49). There is no corresponding miniature in another twelfth-century copy of the commentary of Honorius in Munich (Bayer. Staatsbibl., Clm 18125). All the twelfth-century miniatures closely resemble one another except in minor details, and the scheme is repeated in the St. Florian version and more loosely in that in St. Paul in Lavanttal. On the Honorius miniatures and the other works discussed in this chapter, see also the surveys cited in chapter I, note 2.

3. For a full discussion of the panel's meaning, see Grodecki, "Vitraux allégoriques de Saint-Denis," 26–30. See also S. M. Crosby et al., *The Royal Abbey of Saint-Denis in the Time of Abbot Suger (1122–1151)*, exh. cat. (New York, 1981), 86no. 16.

commentary text just to the left, the vehicle (French *Bible moralisée* text: *chars*) bearing the Ark signifies the four Evangelists bearing the Holy Church and the cows stand for good churchmen. The miniature shows *Ecclesia* riding in a four-wheeled conveyance preceded by two bishops and accompanied by two other clerics. The lefthand bishop appears to be hauling the vehicle by means of a rope. The four Evangelist symbols appear in conjunction with the wheels, just as in the miniature in the Salzburg Honorius manuscript which the scene in the *Bible moralisée* resembles in a number of other respects as well. The corresponding miniatures in the three other thirteenth-century copies of the *Bible moralisée*, all of which were also made in Paris before 1250, are generally similar except in one regard: the vehicle has no wheels and the symbols of the Evangelists are arrayed alongside it, sometimes in positions analogous to those of the absent wheels. Despite the variations among them, it is clear that all these images again derive from the later form of the concept of the *Quadriga Domini*.[4]

Song of Songs 6:11, the key text for much of the medieval conception of the chariot of the Gospels, receives only a curiously prosaic illustration in the thirteenth-century copies of the *Bible moralisée*. In the manuscript in the cathedral of Toledo, the text miniature shows a woman riding in a

4. On the appearance of the theme in the *Bible moralisée*, see Grodecki, "Vitraux allégoriques de Saint-Denis," 29. On the Vienna manuscript, see *Bible moralisée: Faksimile-Ausgabe im Originalformat des Codex Vindobonensis 2554 der Österreichischen Nationalbibliothek*, with commentary by R. Haussherr, Codices selecti 40 and 40* (Graz, 1973). For the other miniature in the Ark cycle in Vienna 2554 that depicts this theme, see *Faksimile*, pl. 104 (fol. 44r: commentary illustration for the Death of Oza [2 Kings 6:6–7] whose accompanying explanation makes explicit the identification of the Evangelists with the four wheels, although the miniature shows a two-wheeled vehicle). For the texts, see H. W. Stork, *Bible moralisée: Codex Vindobonensis 2554 der Österreichischen Nationalbibliothek: Transkription und Übersetzung* (St. Ingebert, 1988), 105 (89a) and 129 (104a). For the corresponding miniatures and for others depicting this theme in the longer cycle in the copy that is now divided between Oxford, Paris, and London (c. 1235–1245), see A. de Laborde, *La Bible moralisée illustrée conservée à Oxford, Paris et Londres*, vol. 1 (Paris, 1911), pls. 132 and 150 (Oxford, Bodl. Lib., Ms. Bodley 270b, fols. 132r and 150r).

As Grodecki, 44n. 107, notes, the theme also appears in the *Bible moralisée* in the commentary miniature for Genesis 45:16–28. There, however, it takes a different form: the four-wheeled wagon (Vulgate: *plaustrum*) bearing Joseph's gifts is equated with the four Evangelist symbols bearing a large open book on a litter (Vienna 2554, fol. 13r [*Faksimile*, pl. 24] and Oxford 270b, fol. 32r [de Laborde, 1: pl. 32]).

The illustrations of all these scenes in the two unpublished copies (Vienna, Öster. Nationalbibl., Cod. 1179, fols. 23r, 88r, and 102r [c. 1215–1225] and Toledo, Catedral, vol. 1, fols. 26r, 102r and 118r [c. 1220s–1235]) do not differ from those considered here in any way that is material for the present study. On the relationships among the four manuscripts, see especially Haussherr's discussion in his commentary (16–32) published with the facsimile of Vienna 2554, and also R. Branner, *Manuscript Painting in Paris during the Reign of Saint Louis* (Berkeley, 1977), 22–65, whose slightly earlier datings I have followed.

four-wheeled wagon beside which Christ stands pointing upward (fig. 45). The commentary text identifies the quadriga as the four Gospels, but the corresponding miniature (fig. 45), just below the one illustrating the Bible verses, shows no vehicle. Instead, Christ preaches to a group of Jews one of whom kneels in acceptance of his message. He is accompanied by the Evangelists depicted as four nimbed figures holding books.[5]

There is, then, a fundamental distinction between the San Marco composition and the northern versions. The Honorius miniatures, the window at Saint-Denis, and the scenes in the *Bible moralisée* all agree in identifying the Evangelists with the wheels on which the vehicle rolls rather than with the horses that draw it. In the Venetian group, however, the original link with the latter was preserved.

The San Marco composition differs from the other medieval images in its scope as well as in its form. All the northern works depict the quadriga of Aminadab from the Song of Songs or the wagons bearing the Ark of the Covenant from 1 and 2 Kings or, in the case of Saint-Denis, a combination of the two. Moreover, they present the vehicle and its burden as prefigurations not only of the Gospels, but also of *Ecclesia* or, at Saint-Denis, of the new Christian dispensation as a whole. It is possible that these Old Testament vehicles were mentioned in an inscription that, as noted earlier, might have accompanied the San Marco composition. The group itself contained, however, no overt reference to any of them. It lacked, therefore, any explicit typological meaning. The relationship between the Evangelists and the team of a quadriga was, apparently, the sole concern.

Because of its narrower scope, the Venetian formulation is much closer in spirit to the use of the *Quadriga Domini* as a metaphor—the form in which the idea was probably initially expressed—than to its exegetical applications. By simply juxtaposing the Evangelists and the horses, it retains something of the openness and suggestiveness of the original trope. That metaphor had merely been an effort to provide a

5. The Toledo commentary scene (2: fol. 86r) is copied in garbled form in the Oxford-Paris-London manuscript. The corresponding miniature (Paris, Bibl. Nat., Ms. Latin 11560, fol. 86r [de Laborde, 2: pl. 310]) is identical to the Toledo one in most respects, but shows Christ accompanied by five unnimbed figures, three of whom hold books. This reflects a general pattern: the Oxford-Paris-London manuscript is, at least for the most part, a sometimes careless copy of the one in Toledo. The Song of Songs is omitted from the two copies of the *Bible moralisée* in Vienna. I know of no other direct illustration of this verse in medieval art that incorporates this idea.

vivid characterization of the role of the authors of the Gospels by liken-
ing them to the team of a quadriga. The northern versions instead make
visually manifest a hidden Christian meaning believed to be fixed in the
text of the Old Testament. The contrast between the simplicity and
directness of the San Marco group and the complexity and schematism
of the northern allegories is indeed striking.

That the Venetian Quadriga of the Lord differs so radically from the
familiar formulations of the idea elsewhere has had serious conse-
quences. This divergence, as already noted, is one of the two main rea-
sons why this aspect of the role of the horses at San Marco has gone
unrecognized for so long. The other, as will be recalled, is the fifteenth-
century removal of the reliefs of Christ and the Evangelists that were
originally seen directly behind and above the horses.

Yet another difference between the *Quadriga Domini* group at San
Marco and the northern examples concerns function. The latter are all
general statements; not one is used to honor a particular Evangelist.
Only in Venice was this image put in the service of local needs. There, as
argued earlier, it helped trumpet the importance of Mark, the city's
patron saint. The best parallel for the exploitation of the *Quadriga
Domini* at San Marco does not come from the visual arts. It is found,
instead, in Peter Damian's first sermon on Mark. There too, as will be
remembered, the *Quadriga Domini* was used as a vivid reminder of
Mark's membership in the team of the Evangelists and appeared in a
context in which Venice's special relationship with him was also cele-
brated. On the façade, as in the sermon, the *Quadriga Domini* serves the
larger glorification of Venice.[6]

Despite these differences, the possibility that the appearance of this
theme at San Marco may be connected in some way with the northern
works should not be entirely ruled out. It may not be a coincidence that
the subject was introduced in Venice during the same general period in
which the car of the Gospels enjoyed a modest vogue in the art of France,
Germany, and Austria. These are, in fact, the only other medieval at-
tempts to give direct visual expression to the relationship between the
Evangelists and the quadriga before about 1300 that have so far come to
light.[7]

6. For the sermon, see above, pages 21f.

7. Some medieval works may implicitly refer to this idea rather than directly illustrate it.
This may be the case, for example, with the third-century mosaic depicting Christ in what
appears to have been a quadriga—only two horses survive—in the tomb of the Julii below

There is certainly nothing implausible in supposing that the San Marco composition is linked to one or another of the northern works. Influences from northern Europe have been noted in several other parts of the decoration of San Marco that belong to the first half of the thirteenth century and elsewhere in Venetian art of this period as well. To be sure, most of these connections are stylistic, but a few involve matters of iconography and program. It may be relevant that all four illustrated copies of the Song of Songs commentary by Honorius Augustodunensis that date from the twelfth century issued from Salzburg and nearby areas during the second half of the twelfth century. Close artistic contact existed between this region and Venice at that period. It must also be noted, however, that the direction of the influences recognized so far is from Venice to Salzburg, that is, the reverse of what is required here.[8]

Word of one of these northern images—or perhaps an example— could easily have reached Venice. One or the other might have been carried, for instance, by an itinerant artist from the north. The fruits of

St. Peter's. On that image's meaning, see O. Perler, *Die Mosaiken der Juliergruft im Vatikan* (Freiburg, 1953), 13–32. For representations of the *Maiestas Domini* in which the chariot imagery of Ezekiel 1 plays an important role, see van der Meer, *Maiestas Domini*, 255–81, and H. P. L'Orange, *Studies in the Iconography of Cosmic Kingship in the Ancient World* (Oslo, 1953), 124–33.

From the context, it appears likely that the term *quadriga* in a number of inscriptions accompanying medieval works of art alludes to this concept. The corresponding images cannot be said, however, to represent it. This is the case with a mid-twelfth-century enamel plaque depicting the Agnus Dei and the four rivers of Paradise (Paris, Musée de Cluny: Esmeijer, *Divina Quaternitas*, 51, and fig. 41). Whether this was also true, it seems likely, in the late eighth-century Canterbury Gospels (London, Brit. Lib., Royal Ms. 1.E.VI, fol. 1v) is unknown, since the miniature associated with the inscription is lost. See Esmeijer, 51, and J. J. G. Alexander, *Insular Manuscripts 6th to 9th Century*, A Survey of Manuscripts Illuminated in the British Isles 1 (London, 1978), 58f.no. 32. The *quadriga* in the inscription accompanying a mid-twelfth-century miniature in the *Speculum virginum* (London, Brit. Lib., Arundel Ms. 44, fol. 46r) showing the Virgin and Child with St. John the Baptist and St. John the Evangelist—each of the four figures accompanied by a wheel—does not appear to be that of the Evangelists. See Gavazzoli, "Allegoria del carro," 120, and pl. 4, and E. S. Greenhill, *Die geistigen Voraussetzungen der Bilderreihe des Speculum Virginum: Versuch einer Deutung*, Beiträge zur Geschichte der Philosophie und Theologie des Mittelalters 39,2 (Münster, 1962), 101–5, and fig. 6.

Esmeijer, 51, 66f., and fig. 38, unconvincingly suggests that this concept may be evoked in ninth-century miniatures (Trier, Stadtbibl., Cod. 23) showing the Evangelist symbols in circles.

8. Demus has discussed northern influences in the decoration of San Marco on several occasions. See *Church of San Marco*, 136f., 149, 152f., 161, and 163; "Skulpturale Fassadenschmuck," 6f. and 10–13; and *Mosaics of San Marco*, 2, 1: 55, and 218f. See also Buchthal, *"Musterbuch" of Wolfenbüttel*, 59–62, and L. Cochetti Pratesi, "Contributi alla scultura veneziana del Duecento: II. Le altre realizzazioni della corrente antelamica," *Commentari* 11 (1960): 206f. and 209–14. For the Salzburg connection, see Demus, *Mosaics of San Marco*, 1, 1: 293, and idem, *Romanesque Mural Painting*, trans. M. Whittall (New York, 1970), 138–40 and 629f.

one such journey are to be seen, as noted earlier, among the drawings of the *Wolfenbüttel Musterbuch*. Austria is again relevant here, for it has been suggested that a visit to the city by a painter from Salzburg would be the best explanation for Venetian influence in that region.[9] Nor is it difficult to imagine numerous other avenues by which a knowledge of the northern car of the Gospels might have reached Venice around this time. The early thirteenth century was a period of particularly close contact with northern Europe because of Venice's role in the Fourth Crusade and in the affairs of the Latin Empire in Constantinople. The interest that such an image would arouse in a city whose patron saint was an Evangelist is equally easy to understand. In the absence of concrete evidence, however, the possible role of the northern sources must remain in the realm of conjecture.

Although the San Marco group may have been inspired by one of the northern images, it nevertheless differs from them, to repeat, in one essential respect. Alone among medieval versions of the theme, it preserves the original form of the concept of the *Quadriga Domini* in which the Evangelists were identified with the team drawing the vehicle rather than its wheels. This allegiance need not be attributed to some unique Venetian concern with authenticity in this matter. It was simply the result of the availability of the horses seized in Constantinople in 1204 and the recognition that they constituted the team of a quadriga. These are, it should be stressed, the crucial facts. Indeed, it is quite conceivable that this availability and this awareness themselves suggested the idea of incorporating this theme into the program. Even if the idea arose from an acquaintance, direct or indirect, with northern depictions of the car of the Gospels, it was the horses, nevertheless, that shaped the form it took at San Marco. In either case, the opportunity presented by the horses was exploited with boldness and imagination. Their deployment at San Marco betrays, *mutatis mutandis*, much the same interplay of chance and resourcefulness that has been discerned at work in the genesis of the program of the six reliefs in the spandrels of the west façade. The same mentality, if not indeed the same mind, can be sensed behind both.[10]

9. Demus, *Mosaics of San Marco*, 1, 1: 293.

10. Demus, *Church of San Marco*, 132, raises the possibility that the program of the spandrel reliefs "was suggested and, in part, conditioned by the fortuitous existence of suitable spoils." His later, fuller characterization of the process that led to the spandrel relief program ("Skulpturale Fassadenschmuck," 6) makes especially evident its similarity to that which lies behind the *Quadriga Domini* composition. The pertinent passage is quoted in chapter III, note 16.

The Horses of San Marco
and the Rhetoric of Reused Roman
Statuary in Medieval Italy

It will never be known whether the possibility of using the horses in a composition evoking the *Quadriga Domini* entered into the discussion when the Venetians made the decision to appropriate the horses in Constantinople. There is certainly no need to have recourse to this idea in order to explain why the Venetians might have coveted them. When it comes to the installation of the horses at San Marco, however, the situation is somewhat different. At first sight, it is true, there seems to be no difficulty in understanding why they were placed at the center of the west façade. The desire to commemorate a momentous victory by prominently displaying a particularly splendid trophy at the church of the city's patron saint appears to provide an entirely adequate motive. Yet a consideration of this episode in the larger context of the reuse of classical works of art in medieval Italy raises serious questions about this seemingly self-evident proposition.

The horses at San Marco conform in several respects to a well-established pattern, for the public display of antique statuary conveying political messages was a familiar phenomenon in Italian cities during the Middle Ages. The equestrian statues that were once to be found in a number of them are particularly instructive in this regard. In addition to sharing the equine theme, they are similar to the Venetian works in scale and, in some cases, material.[1]

1. On the general phenomenon, see A. Esch, "Spolien: Zur Wiederverwendung antiker Baustücke und Skulpturen im mittelalterlichen Italien," *Archiv für Kulturgeschichte* 51 (1969): 1–64, and S. Settis, ed., *Memoria dell'antico nell'arte italiana*, 3 vols., Biblioteca di

The *Regisole* in Pavia (fig. 46), a lost gilded bronze equestrian statue seen here in a drawing of 1335 or shortly thereafter (Rome, Biblioteca Apostolica Vaticana, Cod. Pal. Lat. 1993, fol. 2r), is a good example of an ancient statue that became a public monument in a medieval Italian city. The earliest sources dealing with the statue belong to the fourteenth century. According to them, it was brought to Pavia when the city served as the capital of the Lombard kingdom. It had been seized in Ravenna after a successful assault or, in another version, was captured in a raid while being transported from Ravenna to Milan. Other accounts appear to confuse the *Regisole* with the equestrian statue of Theodoric in Ravenna that Charlemagne took to Aachen. They report that he had carried off the *Regisole* from Ravenna with the intention of taking it to France, but abandoned it in Pavia. In any event, it was probably acquired in the eighth century and was first set up in the courtyard of the palace. By the early twelfth century it had been transferred to a position in front of the Duomo. Except for brief intervals, it remained there until it was destroyed by French soldiers in 1796. The copy that is now seen in the Piazza del Duomo was erected in 1937.[2]

As a reminder of Pavia's greatness in former times, the *Regisole* became a major civic symbol, serving as a focal point of the sense of communal identity and independence. Its political meaning emerges especially clearly from its treatment by the Milanese after they captured the city in

storia dell'arte, nuova serie 1–3 (Turin, 1984–86). The relevant contributions to the latter are C. Frugoni, "L'antichità: dai *Mirabilia* alla propaganda politica," and Greenhalgh, "*Ipsa ruina docet*," in vol. 1, *L'uso dei classici* (Turin, 1984), 5–72 and 115–67; and S. Settis, "Continuità, distanza, conoscenza. Tre usi dell'antico," in vol. 3, *Dalla tradizione all'archeologia* (Turin, 1986), 375–486. See also M. Greenhalgh, *The Survival of Roman Antiquities in the Middle Ages* (London, 1989). The political aspects are extensively discussed in these accounts. See also N. Gramaccini, "Zur Ikonologie der Bronze im Mittelalter," *Städel-Jahrbuch* n.f., 11 (1987): 147–70. Roman equestrian figures displayed during the Middle Ages are most fully treated by Frugoni. See also A. Reinle, "Der Reiter am Zürcher Grossmünster," *Zeitschrift für Schweizerische Archäologie und Kunstgeschichte* 26 (1969): 21–47.

2. On the *Regisole* and the early sources dealing with it, see W. Haftmann, *Das italienische Säulenmonument*, Beiträge zur Kulturgeschichte des Mittelalters und der Renaissance 55 (Leipzig and Berlin, 1939), 120–24; L. H. Heydenreich, "Marc Aurel und Regisole," in *Festschrift für E. Meyer* (Hamburg, 1959), 146–59; G. Bovini, "Le vicende del 'Regisole' statua equestre ravennate," *Felix Ravenna* 3rd ser., 36 (1963): 138–54 (=G. Bovini, "Il 'Regisole': Un monumento equestre ravennate trasportato a Pavia nell'Alto Medio Evo," *Corsi di cultura sull'arte ravennate e bizantina* 10 [1963]: 51–66); Frugoni, "L'antichità," 46–49; and J. Bergemann, *Römische Reiterstatuen: Ehrendenkmäler im öffentlichen Bereich*, Beiträge zur Erschliessung hellenistischer und kaiserzeitlicher Skulptur und Architektur 11 (Mainz am Rhein, 1990), 100f.no. P46. On the drawing, see R. Salomon, *Opicinus de Canistris: Weltbild und Bekenntnisse eines Avignonesischen Klerikers des 14. Jahrhunderts*, Studies of the Warburg Institute 1a (London, 1936), 128f. and 152–54. For the statue taken to Aachen, see below, page 67.

1315. They pulled it down, dragged it through the streets, broke it in pieces, and took the fragments to Milan. The citizens of Pavia, however, managed to reacquire the *disjecta membra*. They repaired and regilded them and reinstalled the statue in 1335. It is, presumably, this renewed display of the statue that is depicted in the drawing which must have been made very shortly after the necessary work was completed. Its presence on the city's seals beginning in the fourteenth century, its peregrinations during the sixteenth century, and the circumstances under which it was destroyed all attest to its enduring life as a political symbol.

The *Regisole* was either a Roman work or a descendant of the well-known Roman equestrian type. Dates proposed for it range from the second to the sixth centuries. It was sometimes said during the fourteenth century to have been commissioned by Theodoric, and its historical meaning for the citizens of Pavia may well have extended back beyond the eighth century to antiquity. The city, like so many others during the Middle Ages, called itself a second Rome. It seems natural to suppose that the *Regisole* was regarded as support for this claim, but concrete evidence is lacking.[3]

The roles of two other equestrian figures as symbols of a bond to ancient Rome are well documented. The best known example is the celebrated Marcus Aurelius in Rome. Well over life-size, this statue is again a gilded bronze, like the horses at San Marco and the *Regisole*. A drawing (fig. 47) by Marten van Heemskerck of about 1535 shows it still in place at the Lateran before it was moved to the Capitoline Hill a few years later. This is where it was to be seen, along with a variety of other antiquities, during the Middle Ages. Although the drawing shows the statue as it had been reinstalled by Pope Sixtus IV in 1474, it appears to have been shifted only a very small distance from its medieval site. Then, too, it probably stood at the northwest corner of the papal palace not far from the north transept of the Lateran church that also bordered this open area. And it seems likely that then, as later, the statue faced towards the main approach from the center of Rome to this complex of buildings. It was certainly in this location by the tenth century and was probably brought to this site in the second half of the eighth century.[4]

3. For the dates of the *Regisole*, see Bovini, "Vicende del 'Regisole,'" 149f., and most recently Bergemann, *Römische Reiterstatuen*, 101, who argues for a second-century one. For a general discussion of the claims advanced by medieval cities to be a second Rome and for the case of Pavia in particular, see Settis, "Continuità, distanza, conoscenza," 422–35, esp. 431f.

4. On the medieval phase of the history of the Marcus Aurelius, see R. Krautheimer, *Rome: Profile of a City, 312–1308* (Princeton, 1980), 192f. and 199; Frugoni, "L'antichità," 32–70;

During the Middle Ages the Marcus Aurelius was chiefly identified in two sharply divergent ways. Until the twelfth century the statue was regularly said to portray the Roman emperor Constantine. In this guise it functioned as a symbol of the temporal power of the papacy. Encountered by a medieval visitor at the palace and church of the popes, a statue of the first Christian emperor would call to mind the Donation of Constantine, the alleged gift to Pope Sylvester on which papal claims to have inherited the authority of Imperial Rome were based. The statue was probably first brought to the Lateran to convey precisely this message. In the middle of the twelfth century, however, a new identification appeared. The statue represented not Constantine but a local hero who saved Rome from an enemy besieging the city before the advent of Christianity. Interpreted in this way, the statue is a triumphal monument and commemorates the signal contribution of one of the city's inhabitants to the common good. The new conception has been convincingly linked to the movement that saw the refounding of the Roman Senate in 1143. Rome's secular, communal authorities sought to rule the city free from papal and imperial interference and based their claims to do so on the precedent of Republican Rome. Redefining the statue as an exemplar of ancient civic virtue seems to reflect very much the same spirit.[5]

An equestrian statue was also to be seen in Florence for much of the Middle Ages. Fragmentary and made of stone, this lost work stood beside the Ponte Vecchio. Although rather neglected, this episode is of considerable interest. Indeed, it takes on a special significance because this statue can be seen through the eyes of the greatest poet of the Middle Ages and also through those of one of the period's most remarkable

I. Herklotz, "Der Campus Lateranensis im Mittelalter," *Römisches Jahrbuch für Kunstgeschichte* 22 (1985): 24–29; N. Gramaccini, "Die Umwertung der Antike—Zur Rezeption des Marc Aurel in Mittelalter und Renaissance," in *Natur und Antike in der Renaissance*, ed. H. Beck and P. C. Bol, exh. cat. (Frankfurt, 1985), 51–69; and L. de Lachenal, "Il monumento nel Medioevo fino al suo trasferimento in Campidoglio," in *Marco Aurelio: Storia di un monumento e del suo restauro*, ed. A. Melucco Vaccaro and A. Mura Sommella (Milan, 1989), 129–55. See also P. P. Bober and R. Rubinstein, *Renaissance Artists and Antique Sculpture: A Handbook of Sources* (London, 1986), 206–8no. 176, and Bergemann, *Römische Reiterstatuen*, 105–8no. P51. For the date of its installation at the Lateran, see Herklotz, 34 and 41f. For its precise location and manner of display, see P. Fehl, "The Placement of the Equestrian Statue of Marcus Aurelius in the Middle Ages," *JWCI* 37 (1974): 362–67. For the approach from the rest of the city and the statue's relation to it, see Krautheimer, 248, 256f., and 326, and Fehl, 365.

5. For this account, see Krautheimer, *Rome*, 192f. and 198f. The fullest discussion is Herklotz, "Campus Lateranensis," 24–29. See also Gramaccini, "Umwertung der Antike," 53–61. Frugoni, "L'antichità," 50–64, and Lachenal, "Monumento," 131, draw different conclusions regarding the meaning of the tale identifying the statue as a local hero.

historians. Its meaning in late medieval Florence emerges with a clarity and richness that are unparalleled in any of the other cases.

The history of the statue is discussed in detail by Giovanni Villani in his *Cronaca*, written during the first half of the fourteenth century. It is also depicted in a miniature (fig. 48) in an illustrated copy of his work (Rome, Biblioteca Apostolica Vaticana, Cod. Chigi L. VIII, 296, fol. 70r) dating from the second half of the century. To pick up the story with the more plausible portions of Villani's account, the statue was installed beside the Ponte Vecchio in 801. There is some reason to think that it was erected on the south side and that it was subsequently transferred to the opposite end, where it was to be found in later times. This may have occurred when the statue was reinstalled after having been brought down by a flood in 1178. From either end of the bridge, it would have greeted the traveler arriving at the main gate to the city from the south, the Porta Santa Maria. This was a prominent site, for the Ponte Vecchio was the only bridge crossing the Arno here until the thirteenth century. After the twelfth century, when the walls were extended to include the Oltrarno as well as other areas, the statue was well within the city. It was reinstalled in 1299 after nearby work necessitated its temporary removal and was washed away in the great flood of 1333.[6]

The miniature in the Villani chronicle was produced while memories of the Mars were still fresh and presumably shows the final form of the statue's installation. To judge from Villani's account, the only major change in the form of display since 801 is that the direction in which it faced was reversed in 1299. But the miniature is certainly unreliable in showing a complete figure. Although Villani is silent on the point, Dante makes it clear (*Inferno* XIII, 147, and *Paradiso* XVI, 145) that by his time the statue was fragmentary. Boccaccio, who discusses it in his commentary on the *Commedia*, emphasizes the work's ruined condition. According to him, nothing above the waist survived. Like Villani, both Dante and Boccaccio had known the work before its destruction in 1333. Mars,

6. For Villani's account of the Florentine Mars, see *Chroniche di Giovanni, Matteo e Filippo Villani*, vol. 1 (Trieste, 1857), 42 (III, 1); 184 (VIII, 39); and 374 (XI, 1). On the illuminated manuscript, see L. Magnani, *La cronaca figurata di Giovanni Villani*, Codices e Vaticanis selecti 24 (Città del Vaticano, 1936). The fullest modern discussion of the statue remains that of R. Davidsohn, *Geschichte von Florenz*, 4 vols. (Berlin, 1896–1922), 1: 559f. and 748–52; 2, 1: 44–46; and 3: 102, who takes the view that it stood for a time on the south side. Most of the important sources are quoted by P. Toynbee, *A Dictionary of Proper Names and Notable Matters in the Works of Dante*, rev. C. S. Singleton (Oxford, 1968), 430–32. (Its fall in 1178 is not reported by Villani, but it is recorded in *L'ottimo commento della Divina Commedia*, vol. 3 [Pisa, 1829], 383.) See also Haftmann, *Italienische Säulenmonument*, 124f., and M. Lopes Pegna, *Firenze dalle origini al Medioevo*, 2nd ed. (Florence, 1974), 100–2.

with whom Florentines identified the statue by at least the fourteenth century, was not, as has been noted, represented in antiquity as an equestrian figure. The true subject of the statue and its date are unknown.[7]

It is suggestive that Villani places the installation of the statue at the Ponte Vecchio around 800. This was approximately the time at which, it would appear, the equestrian figures in Pavia and Rome were also first put on display in their new medieval settings. This was also the time at which the most famous episode of this kind occurred. As noted earlier, Charlemagne removed an equestrian statue said to represent Theodoric from Ravenna and had it re-erected at his palace in Aachen. The resonant symbolism of this translation and its place in Charlemagne's attempt to gain recognition as the emperor of the Romans are well known. How this apparent cluster should be interpreted remains to be seen. This problem cannot be pursued here.[8]

The meaning of the statue for Villani is clear, since it appears at critical points in his chronicle like a leitmotiv. It represented Mars who was the patron of Florence in pagan times and had been the cult image in his temple. The temple was built and its statue consecrated under favorable astrological signs. When the city converted to Christianity around 300, John the Baptist supplanted Mars as its patron, and the pagan god's sanctuary was turned into a church dedicated to this saint. This is the first explicit statement of the belief that the Baptistery of Florence, which was actually built between about 1060 and 1150, was originally a temple of Mars. Because the Florentines believed that misfortune would befall the city if the statue was treated disrespectfully, they placed it on a tower near the Arno after removing it from the building. When the city was destroyed by Totila in 450, the statue fell into the river. It was recovered and, as already noted, set up anew at the time of the rebuilding of Florence under Charlemagne around 800, in the belief that reconstruc-

7. Davidsohn, *Geschichte von Florenz*, 1: 750f., points out the work's incompatibility with the ancient iconography of Mars. He suggests that it depicted Theodoric or some other Germanic king, but this is rejected by Lopes Pegna, *Firenze*, 102. Davidsohn also notes an eleventh-century document that appears to refer to the statue as a "pyramid" and takes this to mean that it was not yet identified with Mars. On its condition, see most fully Giovanni Boccaccio, *Esposizioni sopra la Comedia di Dante*, ed. G. Padoan, vol. 6 of *Tutte le opere di Giovanni Boccaccio*, ed. V. Branca (Verona, 1965), 627.

8. On the Theodoric in Aachen, see H. Hoffmann, "Die Aachener Theoderichstatue," in *Das erste Jahrtausend: Kultur und Kunst im werdenden Abendland an Rhein und Ruhr*, ed. V. H. Elbern, vol. 1 (Düsseldorf, 1962), 318–35; F. Thürlemann, "Die Bedeutung der Aachener Theoderich-Statue für Karl den Grossen (801) und bei Walahfrid Strabo (829): Materialien zu einer Semiotik visueller Objekte im frühen Mittelalter," *Archiv für Kulturgeschichte* 59 (1977): 25–65; and Frugoni, "L'antichità," 34f. and 42–47.

tion of the city would not be possible without it. Thus, if treated with due consideration, the statue was a magical guarantee of Florence's well-being. But it had another meaning as well. Like the Baptistery, the Mars was visible proof of the city's Roman origins so strongly stressed by its medieval historians and a witness to the continuity of its ancient traditions.[9]

For Villani the statue is by no means merely the object of naive pride. He refers to it as an idol several times and felt the need to explain why the city's first Christians kept by them an object that would be expected to inspire nothing but abhorrence. His answer is that many pagan customs still continued and the state of the recent converts' faith was imperfect. Thus, they retained a superstitious belief in the statue's magical powers. Much the same thing is said about its reinstallation when Florence was rebuilt in 801. He severely condemns the notion that the city could not have been reconstructed if the Mars had not been recovered from the Arno and set up again, calling this the "opinion of pagans" and against reason. He also dismisses the superstition that any change affecting the statue would lead to a change in the city's fortunes. And he rejects the view that the role of the god of war in the astrological configuration at the refounding of Florence was in any way connected with the city's fortunes or the civic discord that plagued it. Yet he also reports the statue's link to the most fateful episode in Florence's long history of internal strife. The murder of Buondelmonte de' Buondelmonti in 1215 that began the bitter enmity between the Guelfs and Ghibellines took place at its feet. This is the event depicted in the miniature showing the statue in the illustrated copy of his chronicle.[10]

Dante's treatment of the statue of Mars contrasts strongly with that of Villani, his junior by some fifteen years. In the *Commedia* the Mars is an

9. Villani, *Chroniche*, 22 (I, 42); 28 (I, 60); 30 (II, 1); 42 (III, 1). For illustrations showing the statue at the temple of Mars, see Magnani, *Cronaca*, pls. IX and XIV (fols. 29v and 44r). On the belief regarding the origin of the Baptistery, see W. and E. Paatz, *Die Kirchen von Florenz*, vol. 2 (Frankfurt am Main, 1955), 173 and 211f.n. 2. For the importance of Florentine ideas concerning the city's Roman origins, see particularly N. Rubinstein, "The Beginnings of Political Thought in Florence," *JWCI* 5 (1942): 198–227, esp. 207f. and 212–18.

10. On the statue's retention after the conversion to Christianity and on the reinstallation of the work at the refounding of Florence, see Villani, *Croniche*, 28 (I, 60) and 42 (III, 1). Of the necessity of the latter he says: "Questo non affermiamo, nè crediamo, perocchè ci pare oppinione di pagani e d'águri, e non di ragione, ma grande semplicità, ch'una si fatta pietra potesse ciò adoperare." Boccaccio, *Esposizione sopra la Comedia di Dante*, 627f., expresses a similar sentiment. For the death of Buondelmonte and its link to Mars, see Villani, 74 (V, 38). He also refers to the superstition that a change in the statue's position would bring harm to Florence in his account of the split of the Guelfs into Black and White factions in 1300: he notes that it had been removed in the previous year and that when it was replaced it faced west rather than east as before (184 [VIII, 39]).

entirely baleful presence. The statue—or that which it represents—figures as the source of Florence's worst travails, and its malevolence is explained. In Hell Dante encounters a soul who declares that Florence will always suffer because of the wrath of its first patron at having been displaced (*Inferno* XIII, 143–50). The setting for this meeting is itself telling: Dante is among the suicides, those who were fatally divided against themselves. Its aptness derives from the belief recorded by Villani that linked Mars to discord within the city. Although the explanation of Mars' anger offered by Dante may be implied in Villani's discussion of the statue, its explicit statement here gives this conception a new emotional force. The soul also reiterates the belief, again familiar from Villani, regarding the need to resurrect the statue in 801. But now the tale takes on a darker tone for it seems to prove that the power of Mars over Florence survives even in the Christian era.

The statue makes a second appearance in the *Commedia* in *Paradiso* XVI. There tragic proof is given for the claim that Mars' revenge has cost Florence dearly. Here again Dante locates the consequences of this anger in the city's internal strife. The statue is introduced by Dante's ancestor Cacciaguida in his survey of the rise and fall of the fortunes of Florence and the history of its leading families. At an early point in his discourse he refers in passing to the successive patrons of Florence by speaking of its populace "between Mars and the Baptist," that is, between the statue by the Ponte Vecchio and the Baptistery (v. 47). Cacciaguida concludes his recital with the murder of Buondelmonte whom he calls the statue's victim in Florence's last peaceful days (vv. 140–47). There he does not name it but merely refers to it as "that mutilated stone which guards the bridge."[11] Dante had already alluded to its fragmentary state in *Inferno* XIII, 147, where the damage it has suffered is yet another example of the imagery of dismemberment that pervades the canto's account of the suicides. His stress on the statue's mutilated condition does more than simply render the figure more ominous. It makes the object itself a symbol of the ravages Mars has caused and thus a further reminder that many of Florence's wounds, like those of the suicides, were self-inflicted.[12]

11. "Ma conveniesi, a quella pietra scema/ che guarda 'l ponte, che Fiorenza fesse/ vittima ne la sua pace postrema" (*Paradiso* XVI, 145–147). Text and translation from Dante Alighieri, *The Divine Comedy: Paradiso*, vol. 1, *Italian Text and Translation*, trans. C. S. Singleton (Princeton, 1975), 184f.

12. Dante's negative concept of Mars and his statue are discussed by J. T. Schnapp, *The Transfiguration of History at the Center of Dante's Paradise* (Princeton, 1986), 16–69, esp. 36f.,

The problematic and troubling features of the Mars seen in Villani's and Dante's accounts are paralleled by a variety of superstitious beliefs and practices that are reported to have centered around the statue. By the fourteenth century at least, the attitude of Florentines towards their equestrian statue appears to have been rather different from the view held by citizens of medieval Pavia and Rome regarding comparable works. The malignant aspect of the Mars in local eyes is obviously connected with the fact that the statue was believed to represent a pagan god. This is a reminder of an important strand in medieval attitudes towards antiquities. Many ancient works of art were seen as menacing things associated with idolatry and possessed of sinister powers. The consequences that this conception sometimes had for the treatment of antique statuary during the Middle Ages will be considered later.

Equestrian statues were by no means the only reused antiquities in medieval Italy to serve as focal points of a sense of common identity, well-being, and ties to ancient Rome. One additional example deserves to be considered here because it was accompanied by an inscription that leaves no doubt regarding its meaning. Pisa, long one of Venice's principal maritime rivals, boasted an extensive array of Roman sculpture, mostly in the form of sarcophagi. They are mainly found at the Duomo, with the most important works gathered near the Porta San Ranieri on the east side of the south transept. It is seen on the right in an early seventeenth-century view of the building (fig. 49). This concentration is readily explained by the fact that this part of the church's exterior faces towards the city. In this regard, the situation corresponds closely to the siting of the Marcus Aurelius at the Lateran.[13]

46f., and 53f. Schnapp also places the *Commedia*'s association between Mars and Florentine civil strife in a larger literary context. On the imagery of dismemberment in *Inferno* XIII and its relation to the statue of Mars, see C. S. Singleton's remarks in Dante Alighieri, *The Divine Comedy: Inferno*, vol. 2, *Commentary* (Princeton, 1970), 224f., and more fully L. Spitzer, "Speech and Language in *Inferno* XIII," *Italica* 19 (1942): 81–104, esp. 92–98 (reprinted in *Dante: A Collection of Critical Essays*, ed. J. Freccero [Englewood Cliffs, 1965]), where it is also argued (101) that the anonymous Florentine suicide represents "Florence herself who is steadily committing suicide by giving herself up to intestine wars."

For some comments on the relationship between Dante's and Villani's accounts, see Schnapp, 47n. 8. On their connection with other early Florentine sources, see C. T. Davis, *Dante's Italy and Other Essays* (Philadelphia, 1984), 75–78, 80, 102, and 292f. He notes (76n. 11) that "there is no testimony to superstitious fear of a vengeful presence in the statue in any surviving Florentine writer earlier than Dante, the Ottimo [ca. 1335], and Villani."

13. On the use of spoils in Pisa, see Esch, "Spolien," 12, 53f., and 59; M. Seidel, "Studien zur Antikenrezeption Nicola Pisanos," *Mitteilungen des Kunsthistorischen Institutes in Florenz* 19 (1975): 307–92; F. Donati and M. Cecilia Parra, "Pisa e il reimpiego 'laico': La nobilità

The most prominent of the antiquities assembled there was a Roman neo-attic krater. It is seen on a column before the south transept in the seventeenth-century view. Slighlty less than a meter in height and carved with Bacchic scenes, it dates from the early second century A.D. The manner in which the krater was displayed during the later Middle Ages is well documented. The monument is recorded, first of all, in a drawing (fig. 50) by Giovanni Antonio Dosio made between 1560 and 1569. The krater, capped by a medieval cover with a figure at its apex, rested on a short column that was in turn carried on the back of a lion. The latter was supported by a base that surmounted another column. In the drawing the upper section containing the krater is shown beside rather than above the lower one in order to fit them both on the sheet in larger scale. The monument is also briefly described and its inscription quoted by Vasari at the end of his lives of Nicola and Giovanni Pisano; his account agrees with the drawing except for a few details. The inscription, which is located on the block below the lion, recorded the date of the erection of the monument. Dosio transcribed the year as 1320, but Vasari gives it as 1313.[14]

The complex base was replaced by a single column in 1604 probably because of damage suffered in a fire at the Duomo in 1595. The original lower column, which was porphyry, was transferred to the Camposanto where it is still to be found, and in 1810 the krater was moved there as well. The seventeenth-century view shows the monument in the form it assumed after the fire of 1595 and puts it a short distance from the south transept. There does not appear to be any reason to think that the

di sangue e d'ingegno, e la potenza economica," in *Colloquio sul reimpiego dei sarcofagi romani nel Medioevo*, ed. B. Andreae and S. Settis, Marburger Winckelmann-Programm 1983 (Marburg/Lahn, 1984), 103–19; Greenhalgh, *"Ipsa ruina docet,"* 134–38; Greenhalgh, *Survival of Roman Antiquities*, 74–77; and Settis, "Continuità, distanza, conoscenza," 389, 395–98, and 432, with a helpful plan of their distribution at the Duomo. For the seventeenth-century account (Pisa, Archivio Capitolare, Ms. C 152) in which the drawing of the cathedral appears, see P. Tronci, *Il Duomo di Pisa descritto dal Can. Paolo Tronci*, ed. P. Bacci (Pisa, 1922).

14. On the krater, see P. E. Arias, E. Cristiani, and E. Gabba, *Camposanto monumentale di Pisa: Le antichità*, vol. 1 (Pisa, 1977), 155f.no. C 24 est. On the medieval installation, see Seidel, "Studien zur Antikenrezeption Nicola Pisanos," 321, and the entry on the surviving lower column in *Camposanto monumentale di Pisa: Le antichità*, vol. 2, ed. S. Settis, (Modena, 1984), 119f.no. 59 (G. Tedeschi Grisanti). Seidel argues for the correctness of Dosio's date. For the later changes in the form of the monument, see Tedeschi Grisanti and Seidel, 324f.n. 76. On these matters, see also the discussion of the drawing in C. Hülsen, *Das Skizzenbuch des Giovannantonio Dosio im Staatlichen Kupferstichkabinett zu Berlin* (Berlin, 1933), 12. For Vasari's account, see *Le vite de' più eccellenti pittori scultori e architettori*, vol. 2, ed. R. Bettarini and P. Barocchi, *Testo* (Florence, 1967), 71. See also Bober and Rubinstein, *Renaissance Artists and Antique Sculpture*, 124no. 91.

original fourteenth-century siting was different. Vasari, who saw it before the changes, describes it as being on the stairs across from the Ospedale Nuovo which corresponds to what the view shows and the position of the modern copy that has replaced it.

The significance of the krater in early fourteenth-century Pisa is plain from the first sentence of the inscription. As recorded by Vasari, it reads: "This is the talent that the Emperor Caesar gave to Pisa with which they weighed the wealth that was given to him."[15] This assertion connects the krater with a widely diffused tradition which is reported by Villani and other thirteenth- and fourteenth-century sources. Pisa, it was said, had been the port through which all tribute for the Roman Empire had flowed. The present name of the city was explained by the fact that the weight (Italian: *peso*) of these offerings was measured there before being sent on to Rome. Thus, the *Talento di Cesare*, as the krater was called, served as a tangible confirmation of the grandiose legends of the city's importance in Roman times.

The new installation of the krater in 1313 or 1320 may have been related to the close ties between Pisa and Emperor Henry VII. Long identified with the imperial party, Pisa was among his staunchest supporters during his expedition to reclaim Italy for the empire. It was there that he spent the winter of 1312/13 after the failure of his siege of Guelf Florence. And it was there, in the Duomo, that he was buried after he died during the following summer in the midst of this campaign. During just these years Giovanni Pisano carved a tympanum, now only partially preserved, for the Porta San Ranieri that contained a Madonna and Child, a personification of Pisa, and a depiction of Henry himself. Only a few fragments of this composition survive, but it is known from a description by Vasari. It must have formed a prominent part of the setting against which the krater was seen. The use of the krater as a reminder of the special role of Pisa in the Roman Empire may well have been related to the aspirations of its citizens for an equally prominent place in the revived imperial order that Henry hoped to establish.[16]

The krater was almost certainly to be seen in Pisa before the fourteenth century, for it was the source of a famous quotation by Nicola

15. "Questo è 'l talento che Cesare Imperadore diede a Pisa con lo quale si misurava lo censo che a lui era dato." Vasari, *Vite*, 2, *Testo*: 71. My account is based on the persuasive analysis of the significance of the krater by Seidel, "Studien zur Antikenrezeption Nicola Pisanos," 321–24.

16. For the idea of a tie to Henry VII, see Seidel, "Studien zur Antikenrezeption Nicola Pisanos," 323, and Grisanti in *Camposanto: Antichità*, 2: 119. For the tympanum, see H. Keller, *Giovanni Pisano* (Vienna, 1942), 57–59 and 70, and G. L. Mellini, *Giovanni Pisano* (Venice, [1970]), 176f. and 253.

Pisano. The representation of Simeon supported by a boy in the Presentation in the Temple in Nicola's pulpit in the Baptistery of Pisa of 1260 is modeled upon Dionysus helped by a similar figure on the krater. This suggests that the krater already had an important place in Pisa's civic consciousness: Nicola's borrowing would take on an additional meaning if it was an allusion to a significant public monument. The krater may well already have been associated with the legend about the weighing of Roman tribute.[17]

It is possible that Nicola saw the krater close to the site of its later, fourteenth-century installation. The source of another of the borrowings from antiquity in his Baptistery pulpit was also a work with significant associations for Pisan history that was to be seen in this area. The Virgin in the Adoration of the Magi is based upon the figure of Phaedra in the Hippolytus sarcophagus now in the Camposanto. An inscription records that the sarcophagus had been reused in 1076 for the burial of Countess Beatrice by her daughter Matilda, a great benefactress of the city and its Duomo. As befitted Matilda's importance, her mother's sarcophagus was probably placed in the area near the Porta San Ranieri. In 1303, as another inscription records, it was installed in a raised position on the south wall just to the right of that entrance. This is where it is seen in the seventeenth-century view. This inscription connects the reinstallation of the sarcophagus with the construction of the stepped platform around the church. Perhaps this change also necessitated the dismantling of an earlier display of the krater in this area and thus led to the new arrangement. When and under what circumtances the krater was first set up at the Duomo are unknown. It is increasingly clear that a significant portion of the spoils at the Duomo, which was begun in 1063, were acquired in Rome; whether this is also true of the krater is again uncertain.[18]

The horses of San Marco fit well into this broad group. Their kinship with the *Regisole* is particularly close. Both were trophies of war. It is

17. For Nicola's borrowings, their implications, and the probability that the krater was already linked to the tribute legend, see Seidel, "Studien zur Antikenrezeption Nicola Pisanos," 313–24.

18. For Nicola's borrowings from the sarcophagus and the latter's civic significance, see Seidel, "Studien zur Antikenrezeption Nicola Pisanos," 325–37. For the view that it was in this area since its reuse, see Donati and Cecilia Parra, "Pisa e il reimpiego 'laico,'" 107f. S. Settis, "Iconografia dell'arte italiana, 1100–1500: Una linea," *Storia dell'arte italiana*, vol. 1, 3, *L'esperienza dell'antico, dell'Europa, della religiosità* (Turin, 1979), 231, maintains that the krater was already set up in this area in Nicola's time, but Seidel, 324, leaves the question open. On the Roman origins of spoils at the Duomo, see especially Settis, "Continuità, distanza, conoscenza," 389, 394f., and 397.

clear, moreover, that the horses became closely identified with the inde-
pendence and well-being of the state just as the *Regisole* was. The most
vivid evidence that the horses indeed served as major civic symbols is an
episode that occurred in 1379 during the Fourth Genoese War. It is first
recorded in fifteenth-century Paduan chronicles. After the enemy had
captured nearby Chioggia, the Venetians urgently sued for peace.
Francesco da Carrara, a Paduan ally of the Genoese, is reported to have
replied to the Venetian messenger bearing these overtures: "Return to
your Signoria and tell them that we will never listen to their embassies
until we have first put bridles on the horses that are on the royal palace of
Saint Mark."[19] This striking image raises the possibility that the Vene-
tians themselves, as they were later wont to do, had already begun to
point to the absence of bridles as a symbol of the city's liberty.[20] In any
case, the episode is strongly reminiscent of the Milanese seizure of the
Regisole in Pavia in 1315 and dramatically illustrates the role of the horses
as emblems of the power of the Venetian state.

The Roman references seen in so many of the other major antiquities
in medieval Italy were also a significant factor here. They have, neverthe-

19. "Ritorna ala tua Signoria e digli, che mai non aldiremo suo ambasarie, se prima non
faciemo inbrenare i cavagli, ch'è sovra la regia di San Marcho." Galeazzo and Bartolomeo
Gatari, *Cronaca Carrarese confrontata con la redazione di Andrea Gatari*, ed. A. Medin and
G. Tolomei, Rerum italicarum scriptores, 2nd ed., 17, 1, 1 (Città di Castello and Bologna,
1909–31), 179. The version of this episode that is usually cited is that of Andrea Gatari,
Chronicon Patavinum, ed. L. A. Muratori, Rerum italicarum scriptores 17 (Milan, 1730),
308. He puts these words in the mouth of Pietro Doria, the Genoese commander, and gives
them a more elaborate form. Since Andrea's chronicle is a later reworking of the versions by
Galeazzo and Bartolomeo (*Cronaca Carrarese*, xix-xxiii and xxxiin. 1), it seems preferable to
rely upon the latter rather than the former. Although later versions of the *Cronica de la
guerra da Veniciani a Zenovesi*, written by Daniele di Chinazzo shortly after the war, also
attribute these words to Pietro Doria, the original text omits them entirely, as noted by
V. Lazzarini, "La presa di Chioggia (16 Agosto 1379)," *Archivio veneto* 5th ser., 48/49
(1951): 64n. 1. For that text, see Daniele di Chinazzo, *Cronica de la guerra da Veniciani a
Zenovesi*, ed. V. Lazzarini, Monumenti storici pubblicati dalla Deputazione di Storia Patria
per leVenezie n.s. 11 (Venice, 1958).
On this episode, see Perry, "Saint Mark's Trophies," 29f.; Borrelli Vlad and Guidi
Toniato, "Fonti e documentazioni," 139; and Galliazzo, 6.

20. It should be noted, however, that this motif does not reappear for some time. G.
Stringa, *La chiesa di S. Marco* (Venice, 1610), 9v, provides a particularly florid example. After
identifying the horses as spoils of 1204, he asserts that the Venetian Senate ordered them
placed on the church without the bridles that they had had to show "à chiunque li mira, che
mai à loro [i.e., the Senators], per gratia speciale di Dio, et di S. Marco lor Protettori, è stato
posto (da che questa lor Città è nata che pur fin'hora passati sono 1188. anni) il freno, ma
sempre sono vissuti liberi con somma gloria et giubilo di tutta la città, & di tutte le altre, ad
essi suddite, & fedele." By the time Stringa was writing, of course, the Paduan or Genoese
vow was probably widely known.
For some spurious and apparently postmedieval tales in which the horses are associated
with major Venetian achievements, see Perry, "St. Mark's Trophies," 30–33.

less, received little attention. This is largely due to the extent to which the circumstances of the horses' acquisition have influenced perceptions of their political meaning. The supplanting of Byzantine power seems to be the obvious message. There are good reasons, however, to think that the horses at San Marco assert a Venetian claim to the legacy of Imperial Rome as well as that of Byzantium.

In Venice ancient Rome was not invoked by misidentified statues mistakenly linked to some aspect of the distant past as in Rome and Florence. Nor was the Venetian claim based upon a fanciful tale as in Pisa. Here the statement was objectively grounded in the nature of the works themselves. In the case of the horses, the link with the Roman past resided in the memory of the role of quadrigas in Roman triumphal processions. The persons responsible for the decisions to carry off the horses and to display them at San Marco were probably familiar with this practice. The memory of Roman triumphal ceremonies lived on throughout the Middle Ages: indeed it has been said to have been central to the medieval conception of ancient Rome. Although some of its specific customs were, no doubt, only dimly remembered, others remained well known. The latter certainly included the role of the four-horse chariot. That the person celebrating a triumph was carried in a quadriga is noted by both Isidore of Seville in the *Etymologiae* and by Rabanus Maurus in the *De universo* in their accounts of these ceremonies. The horses drawing the chariot also appear in the description of Roman triumphs by Sicard of Cremona (1160–1215) in his *Mitrale*, to mention an approximately contemporary source. He does not specify, however, that there were four of them.[21]

One account is of particular interest here. The four-horse team appears in an extended description of the customs of Roman triumph in a sermon on the Ascension by Honorius Augustodunensis. He interprets the ceremony as a prefiguration of Christ's triumph, giving each of its practices a Christian meaning. Among them, he includes the quadriga

21. For the place of triumph in the medieval conception of ancient Rome, see A. Pinelli, "Feste e trionfi: continuità e metamorfosi di una tema," in *Memoria dell'antico nell'arte italiana*, vol. 2, *I generi e i temi ritrovati*, ed. S. Settis (Turin, 1985), 282f. For the quadriga in Roman triumphs, see Isidore, *Etymologiarum*, XVIII, 2; Rabanus, *De universo* (PL 111: 535 [XX, 2]); and Sicard, *Mitrale* (PL 213: 82 [II, 6]). Sicard's account is discussed by P. E. Schramm, "Die römische Literatur zur Topographie und Geschichte des alten Rom im XI. und XII. Jahrhundert," in his *Kaiser, Könige und Päpste: Gesammelte Aufsätze zur Geschichte des Mittelalters*, vol. 4, 1 (Stuttgart, 1970), 37f. The ancient sources on the use of the quadriga in Roman triumphal ceremonies are cited by W. Ehlers, "Triumphus," in *Paulys Realencyclopädie der classischen Altertumswissenschaft*, Reihe 2, vol. 7a (Stuttgart, 1939), 503f.

whose four horses he specifically mentions. The quadriga, naturally, stands for the Gospel, the analogy lying, as will be remembered, in the number of its wheels, not that of the horses drawing it. In bringing together the four-horse chariot of Roman triumph and the *Quadriga Domini*, this passage provides a precedent for the display of the horses at San Marco in which the same two references are simultaneously introduced.[22]

There is concrete evidence that this knowledge of Roman triumphs could be intelligently applied to an actual work of art at the period the horses were installed on San Marco. An Englishman named Master Gregory visited Rome during the thirteenth century, possibly sometime between 1226 and 1236, and wrote an account of its ancient monuments. Near the Pantheon he saw a triumphal arch that had been erected, he says, by Augustus. It was probably the lost *Arcus Pietatis*. Gregory identified the subjects of the reliefs decorating it as the Battle of Actium and related episodes. This prompted him to display his erudition in a description of the triumph celebrated by Augustus after the victory. Among the facts that he records is the use of four horses to draw the emperor's chariot. Such scenes were common upon triumphal arches, and it has been said that Gregory's account is actually based on a relief depicting the triumph that decorated the one he saw. This may well be the case, although his language leaves some room for doubt on the point. Even if he had this image before him, it is doubtful that all his statements are based on direct observation. He reports that the chariot team was made up of white horses. This was indeed the color of the horses employed by the Romans on such occasions. Any paint in the relief, however, that might have recorded their color had probably disappeared by then. If none remained, Gregory was simply supplementing what he observed with information derived from his reading. The whiteness of the horses is cited in the accounts of Roman triumph by both Honorius and Sicard. That Gregory was so well informed regarding Roman triumphs con-

22. Honorius' parallel (*Speculum Ecclesiae*, PL 172: 955f.) is lengthy. Only the portion that deals with the chariot can be quoted here. "Per currum auro et gemmis conspicuum, in quo victor triumphat, innuitur Evangelium, sapientia et signis fulgidum, per quod cognito Christi triumpho mundus exultat. Rotae quibus currus volvitur sunt evangelistae per quos triumphus Christi depromitur. Hic currus quatuor niveis equis trahitur, quia Christus in curru Evangelii a doctoribus in virtutibus candidis per quatuor partes mundi vehitur." For a discussion of this passage, see H. Meyer, "*Mos Romanorum*. Zum typologischen Grund der Triumphmetapher im 'Speculum Ecclesiae' des Honorius Augustodunensis," in *Verbum et signum: Beiträge zur mediävistischen Bedeutungsforschung F. Ohly überreicht*, ed. H. Fromm, W. Harms, and U. Ramberg, vol. 1 (Munich, 1975), 50f.

trasts sharply with the ignorance he reveals in his descriptions of numerous other works of art that he encountered in Rome.[23]

One relief that decorated a triumphal arch in Rome and that depicted an emperor riding in a four-horse chariot during a triumphal procession was certainly visible during the Middle Ages. It is found on the Arch of Titus (fig. 52), one of the ancient monuments of Rome that especially attracted the attention of medieval visitors. This relief—or something very much like it—caught the eye of a local artist. A miniature (fig. 54) in a manuscript from Rome, the *Liber ystoriarum Romanorum* (Hamburg, Staats- und Universitätsbibliothek, Cod. 151, fol. 90v), represents the triumph of Julius Caesar. Preceded by prisoners and a soldier carrying armor captured from the enemy, Caesar rides in a quadriga along with a Victory who crowns him with a wreath. As a comparison with the relief on the Arch of Titus shows, this depiction of a Roman triumph is accurate in many features. The figures in the chariot and the team that draws it closely resemble, as has been recognized, the corresponding group in the triumph of Titus. The city gate towards which Caesar advances recalls the triumphal arch under which the procession in the second part of the representation of the triumph of Titus is passing (fig. 53).[24]

23. *Magister Gregorius Narracio de mirabilibus urbis Rome*, ed. R. B. C. Huygens, Textus minores 42 (Leiden, 1970), 24f. (22), and *Master Gregorius The Marvels of Rome*, trans. with a commentary by J. Osborne (Toronto, 1987), 30f. (22). On Master Gregory, see most recently D. Kinney, "'Mirabilia urbis Romae,'" in *The Classics in the Middle Ages*, ed. A. S. Bernardo and S. Levin (Binghamton, 1990), 214–18. On the identity of the arch, see Osborne, 79–82. It is generally recognized that the decoration of the *Arcus Pietatis* included narrative reliefs, but very little is known about them. That a depiction of the triumph of Augustus was, in fact, among them is the view of G. McN. Rushforth, "*Magister Gregorius de Mirabilibus Urbis Romae*: A New Description of Rome in the Twelfth Century," *Journal of Roman Studies* 9 (1919): 40. He also notes the likelihood that Gregory had consulted texts in preparing his account. For the white horses used in Roman triumphs, see Ehlers, "Triumphus," 504. On Gregory's discussion and other examples of medieval accounts of triumphal arches in Rome, see Frugoni, "L'antichità," 19–23, and I. Herklotz, "*Sepulcra" e "Monumenta" del Medioevo: Studi sull'arte sepolcrale in Italia* (Rome, 1985), 216f.

24. For the knowledge of the Arch of Titus and the visiblity of its reliefs during the Middle Ages, see M. Pfanner, *Der Titusbogen* (Mainz am Rhein, 1983), 4. A facsimile of the Hamburg manuscript, along with a commentary, has been published (T. Brandis and O. Pächt, *Historiae Romanorum: Codex 151 in scrin. der Staats- und Universitätsbibliothek Hamburg*, 2 vols. [Frankfurt am Main, 1974]). Although Brandis states (*Kommentar-band*, 130) that only three horses are shown, the full complement appears to be present: the fourth is the innermost one which has raised its head, perhaps neighing, in a manner similar to that seen in the English twelfth-century miniature (fig. 40). For the view that the miniature is based on the relief on the Arch of Titus, see E. Monaci, ed., *Storie de Troja et de Roma altrimenti dette Liber ystoriarum Romanorum*, Miscellanea della Reale Società di Storia Patria 5 (Rome, 1920), xlvii–xlix, and Schramm, "Römische Literatur zur Topographie und Geschichte des alten Rom," 24. See also Pinelli, "Feste e trionfi," 292n.3, who suggests that the

Awareness of Roman triumph at this period was probably not confined to a few learned men or adventurous artists exploring the remains of the past. The climax of the efforts of Frederick II to reassert imperial control in Northern Italy was his great victory over the Second Lombard League at Cortenuova in November 1237. Like so many aspects of the ideology of his regime and the means by which it was set forth, his celebration of this success was clearly based upon Roman sources. Although Frederick did not use a quadriga, some of the other practices of Roman victory ceremonies were revived for the occasion. To the acclaim of the populace, he entered Cremona a few days later in a triumphal procession containing the prisoners and the booty seized at the battle. The greatest trophy was the Milanese *carroccio*. An example of the war wagon that was a characteristic feature of warfare in medieval Italy, it would carry, among other things, the standards of Milan and it symbolized the city's liberty. In the victory parade it was drawn by an elephant—a familiar animal in Roman triumphal contexts—draped with banners bearing imperial eagles, and trumpeters proclaimed the victory from its back. Chained to its flagstaff, which had been lowered as a sign of defeat, was the captured podestà of Milan, Pietro Tiepolo, with his arms bound behind him like the captives in the Roman miniature. Shortly thereafter, Frederick sent the *carroccio* to Rome along with a letter heavily stressing the parallels with the triumphal celebrations of the Roman caesars. By order of the Senate, it was finally set on columns at the Capitol to commemorate his victory.[25]

Frederick's message, with its unmistakable references, must have reverberated throughout Italy. Close attention was certainly paid to these events in Venice. Frederick's ambitions in Northern Italy directly threatened the many commercial advantages Venetians enjoyed there and the political ties that helped to sustain them. But there was also a more

miniature's source was the relief depicting the triumph of Marcus Aurelius now in the Palazzo dei Conservatori in Rome or a similar work. Cf. Pächt, *Kommentar-band*, 191–217, esp. 193f. He rejects the view that the miniature was based on the triumph of Titus or on any other Roman relief and argues that the scene and features of others in the Hamburg volume derive from a late antique manuscript. For the late thirteenth-century dating, see *Kommentar-band*, 27. For a later one, see J. Gardner, "An Introduction to the Iconography of the Medieval Italian City Gate," *Dumbarton Oaks Papers* 41 (1987): 210n.77.

25. For the Cremona procession, its aftermath, and the sources on these events, see E. Kantorowicz, *Kaiser Friedrich der Zweite*, 2 vols. (Berlin, 1931), 1: 401 and 408–10, and 2: 180f.; T. C. van Cleve, *The Emperor Frederick II of Hohenstaufen: Immutator Mundi* (Oxford, 1972), 407–9; and Pinelli, "Feste e trionfi," 322f. All emphasize the strong evocation of Roman triumphs. For the incorporation of the *carroccio* into a monument on the capitol, see Herklotz, *"Sepulcra" e "Monumenta"*, 212. The Latin sources refer to the *carroccio* as a *currus*.

personal motive. The figure so ignominiously exhibited with the *carroccio* at Cremona was a son of Jacopo Tiepolo, the doge of Venice at the time.

The temptation to regard the installation of the horses at San Marco as a reply to the Cremona triumph and the subsequent display of the Milanese *carroccio* at the Capitol in Rome should probably be resisted. The events through which the Venetians had gained possession of the horses had nothing to do with the struggle against Frederick, and the horses had almost certainly reached Venice long before his arrival on the scene. It is true that the actual installation of the horses at San Marco probably took place, as argued earlier, during the 1230s or the early 1240s, at a time, that is, when the conflict with Frederick was reaching its height. It was also argued, however, that the timing of the horses' installation was determined by the pace of work on the façades. In that case, it would merely be a coincidence that they were put in place at approximately the same time as Frederick's Cremona triumph. If the horses were set up shortly after his victory celebration, the satisfaction of the Venetians in demonstrating that they too could forcefully express themselves in this language would no doubt have been all the greater. In the present context, however, the significance of the Cremona display and its aftermath is simply that it demonstrates the potency of the imagery of Roman triumph as a political symbol in thirteenth-century Italy.[26]

This possible dialogue should be seen in a larger context. The actions and ambitions of Frederick II were among the major issues that confronted Venice during much of the first half of the thirteenth century. A variety of other works of art in Venice or associated with Frederick take on additional meaning when seen in the light of the relationship between the two. The full significance of the horses in this regard will only emerge when the broader pattern has been systematically explored. Such an exploration, however, is beyond the scope of this study.

There is another context in which the Roman resonance of the horses must be understood that can only be adumbrated here. The horses are by no means the only prominent references to Rome in the thirteenth-century façade decoration of San Marco. Of the others, the best known is the late antique group of porphyry portraits of Roman emperors set in the projecting corner of the Tesoro on the south side of the church (fig. 10). The four figures are generally believed to represent the members of the first Tetrarchy (293–305): Diocletian, Maximianus, Constantius

26. On the date of the acquisition of the horses and the timing of their installation, see above, pages 6–8 and 39–41.

Chlorus, and Galerius. As noted earlier, the figures were acquired by the
Venetians in Constantinople after the conquest of 1204.[27]

The same area contains another imperial portrait in porphyry, this
time representing one of the early Byzantine heirs of the rulers of Rome
(fig. 11). It is prominently located on the railing at the prowlike south-
west corner of the loggia. A late and obviously spurious local tradition
identifies the portrait as the condottiere Carmagnola who was beheaded
in the Piazzetta in 1432 for treason, but it is clearly a late antique or early
Byzantine work. It is now generally thought to represent the Emperor
Justinian. It was probably also among the spoils of 1204.[28]

An even more extensive gallery of imperial portraits may have been
planned. The provenance of the Colossus in Barletta (fig. 55) is reported
in a poem that was written by a local author around the time that the
statue was set up beside the church of San Sepolcro in 1491. According to
this source, it had been seized by the Venetians in Constantinople, pre-
sumably during the sack of 1204, but then abandoned near Barletta when
the vessel carrying it homeward was wrecked along these shores in a
storm. The date of the Colossus and the identity of the figure have long
been the subject of controversy. The fifth century is now generally
favored, and an identification with Emperor Marcian (450–457) has
often been proposed. It is certainly quite plausible that the bronze statue
reached Barletta in this way.[29]

Another feature of the façades points in the same direction. Their use
of porphyry is not confined to these portraits. It is a particularly forceful

27. See above, pages 4f.

28. J. D. Breckenridge, "Again the 'Carmagnola,'" *Gesta* 20 (1981): 1–7. Cf. Mango,
Développement urbain de Constantinople, 29, who raises the possibility that the head may date
from the first half of the fourth century.

29. For the poem and the other early sources, see H. Koch, "Bronzestatue in Barletta," in
Antike Denkmäler, Deutsches Archäologisches Institut, vol. 3 (Berlin, 1912–13), 20–27.
The Venetian role is accepted, e.g., by Koch; R. Delbrueck, *Spätantike Kaiserporträts* (Ber-
lin and Leipzig, 1933), 225; and, most recently, U. Peschlow, "Eine wiedergewonnene
byzantinische Ehrensäule in Istanbul," in *Studien zur spätantike und byzantinischen Kunst
Friedrich Wilhelm Deichmann gewidmet*, vol. 1, ed. O. Feld and U. Peschlow (Bonn, 1986),
30f. Cf. Greenhalgh, "*Ipsa ruina docet*," 150, and *Survival of Roman Antiquities*, 240, who is
somewhat skeptical, apparently because the Venetians seem to have made no further effort
to recover the statue and complete the final leg of its journey.
 A. Corboz, *Canaletto: Una Venezia immaginaria*, vol. 2 (Milan, 1985), 481f., suggests that
the statue would have been placed on the façade of San Marco between the horses, if it had
reached Venice. This is entirely implausible. Such an arrangement would have been quite
awkward due to the size of the figure: now only partly preserved, it must originally have
been roughly 5 m high. Moreover, there is no precedent for the display of an antique statue
in such a manner during the Middle Ages, and the statue's placement there would be
incompatible with the role of the horses as the *Quadriga Domini*.

presence in the central portal of the west façade where eight of the column shafts are made of this material. The stump of a porphyry column, known as the *Pietra del bando*, occupies an especially prominent position at the southwest corner of the church. It is usually said to have been brought from Acre after a Venetian victory over the Genoese there in 1258. The shafts of the forward columns supporting the two outer horses are also porphyry. Porphyry's imperial associations, which were established in antiquity, remained well known throughout the Middle Ages.[30]

Imperial connotations have also been ascribed to the horses in some recent accounts. They would have gained such an association in Venetian eyes, it is said, because of the site in which they had been found. The Hippodrome, where they had been displayed for so long, was closely linked by its ceremonial life and its location to the ruler of the Byzantine state. Although it is possible that the horses had acquired an imperial meaning in this way, direct evidence in contemporary sources is lacking.[31]

If the Venetians associated the horses with imperial rule, it may have been due as much to ancient Rome as to medieval Constantinople. After the end of the Republic, the celebration of a triumph had been reserved for the emperor and members of his family. Triumphs continued to be viewed in this light by some well-informed persons during the Middle Ages. Two medieval descriptions of Roman triumphs that have already been cited are also of interest in this context. Sicard treated the subject in a chapter on royal insignia and referred to the person celebrating the triumph as *imperator*. Honorius too regarded triumph as royal and used the same term. But he also noted that a consul could be so honored. Both

30. For a survey of the types of stone used at San Marco, see G. Boni, "I marmi," in *La Basilica di San Marco in Venezia illustrata nella storia e nell'arte da scrittori veneziani*, ed. C. Boito (Venice, 1888), 389–402. For general accounts of the significance of porphyry in the Middle Ages and for discussion of some of the more prominent objects at San Marco, see R. Delbrueck, *Antike Porphyrwerke* (Berlin and Leipzig, 1932), 29–32 and 84–91, and J. Deér, *The Dynastic Porphyry Tombs of the Norman Period in Sicily* (Cambridge, Mass., 1959), 126–65, esp. 155. For the porphyry columns on the façades, see Deichmann, *Corpus der Kapitelle*, plans 6–8, and for the two under the horses, Galliazzo, 8. On the *Pietra del bando*, see Demus, *Church of San Marco*, 29 and 113, and Delbrueck, 86 and 91.

31. For the meaning that the horses may have taken on from their display at the Hippodrome, see Galliazzo, 74f., and Herzner, 52f. For further consideration of this question, see below, pages 99 and 101f. Demus only imputes a general imperial association to the horses. See "Bisanzio e la scultura del Duecento a Venezia," in *Venezia e l'oriente fra tardo Medioevo e Rinascimento*, ed. A. Pertusi (Florence, 1966), 143, and "Skulpturale Fassadenschmuck," 5. See also Bassett, "Antiquities in the Hippodrome of Constantinople," 89 and 95.

authors, as will be remembered, include the quadriga in their accounts. Whether anyone in Venice at this time had such precise knowledge of Roman triumph is, of course, another question. Yet the triumphal function of the quadriga was so well known that Venetians may well have seen the horses as a symbol of the supreme power of ancient Rome.[32]

The cumulative weight of these references to the emperors of Rome and Byzantium has not been adequately recognized. This is not altogether surprising. It is largely due to the habit of seeing several of these works as miscellaneous booty, haphazardly gathered and installed, rather than as objects carefully selected and mounted to convey a specific set of ideas. It is, however, surely no accident that a significant portion of the spoils from the sack of 1204 prominently displayed on the exterior of San Marco have strong links with the rulers of ancient Rome or their Byzantine heirs. The horses, the porphyry portraits, and the extensive use of porphyry should be seen as components of a carefully marshalled argument setting forth a Venetian claim, based on the conquest of Byzantium, to the legacy of Imperial Rome. Some of Venice's widely traveled, well-informed, and observant citizens were undoubtedly familiar with the major medieval assemblages of ancient works of art in Italy and elsewhere. The political messages of what was to be seen at the Lateran in Rome, at the Duomo in Pisa, and at the palace of Charlemagne in Aachen could hardly have been lost on them. The gathering of the horses, the imperial portraits, and a variety of other works at San Marco should be interpreted as a concerted effort to create a Venetian counterpart of such collections. Together they give Venetian claims a voice whose power of expression and persuasiveness rivaled or surpassed those with which similar assertions were set forth elsewhere.[33]

It is possible that the antiquities at San Marco were meant to help conjure up an even more specific phase of the past. One of the characteristic features of the work carried out at San Marco during the thirteenth century is the widespread influence of Early Christian and early Byzantine art. The best known example is the dependence of the narthex

32. For triumph as an imperial prerogative, see Ehlers, "Triumphus," 499. The texts of Sicard and Honorius are cited in notes 21 and 22 above.

33. For a broad characterization of the role of the spoils in conveying this message, see Muir, "Images of Power," 20f. Some of its individual aspects have also been noted. See, on the horses, the references in note 31 above; on the four emperors, Greenhalgh, "*Ipsa ruina docet*," 149; and on the spoils along the south façade in general, Polacco, *San Marco*, 106. The conception of the horses as symbols of imperial succession emerges clearly in a number of sixteenth-century Venetian sources. See Herzner, 56, for Sanudo's use of the idea.

mosaics upon the miniatures of the fifth-century Cotton Genesis or a sister manuscript. A variety of reliefs on the façades and others inside the builidng are Early Christian works, some perhaps retouched in the thirteenth century. Others are thirteenth-century imitations of works from that period. It has been maintained that the use of such artistic materials and models was dictated by ideological concerns. The Imperial Rome whose legacy is claimed was not the pagan one of Augustus but the Christian one established by Constantine and later ruled by Justinian. This view has been widely accepted, although some serious questions have also been raised about it.[34]

Definite conclusions, however, are premature. The originator of this ideological explanation of the role of Early Christian and early Byzantine art in thirteenth-century Venice was careful to present it with some qualifications. While citing evidence in its support, he recognized that further study would be needed to confirm it. As so often happens in cases of particularly attractive theories, his cautions were largely forgotten and the requisite additional investigation never undertaken. Basic questions, in fact, remain regarding the nature and extent of Venetian thinking about a *Renovatio imperii romani* during the thirteenth century. How focused and refined it was is far from clear. A more systematic canvassing of contemporary texts and a fuller assessment of the artistic evidence might clarify some aspects of the problem. Further consideration of the relationships between the Roman antiquities at San Marco and similar collections elsewhere might also yield important insights regarding Venetian intentions. These matters cannot be pursued here. What is important for the purposes of this study is that a close relationship can now be recognized between the horses of San Marco and other major works of Roman art displayed in medieval Italy. This relationship sheds some revealing light on the way in which the horses were installed at San Marco. It is to the nature of their placement there that attention must now turn.

34. Demus advanced this thesis in several publications. See mainly "A Renascence of Early Christian Art in Thirteenth-Century Venice," in *Late Classical and Mediaeval Studies in Honor of Albert Mathias Friend, Jr.*, ed. K. Weitzmann (Princeton, 1955), 348–61, and *Church of San Marco*, 165–83. Demus' views are accepted, e.g., by H. Buchthal, *Historia Troiana: Studies in the History of Medieval Secular Illustration*, Studies of the Warburg Institute 32 (London, 1971), 54–58; Greenhalgh, "*Ipsa ruina docet*," 118 and 150; and Muraro, *Vita nelle pietre*, 23–25. Reservations have been expressed, e.g., by Esch, "Spolien," 53n. 196, and, most fully, H.-M. Herzog, *Untersuchungen zur Plastik der venezianischen "Protorenaissance"* (Munich, 1986), 143f. On the relationship between the narthex mosaics and the Cotton Genesis, see K. Weitzmann and H. L. Kessler, *The Cotton Genesis: British Library, Codex Cotton Otho B. VI* (Princeton, 1986), 18–20.

The Problem of the Placement
of the Horses at San Marco

It can now be seen that important features of the installation of the horses at San Marco correspond to a clearcut pattern. The parallels in the functions of the works in Pavia, Rome, Florence, Pisa, and Venice are mirrored in the similarities in the manner in which they were displayed. All of them except the Mars were to be found at churches closely identified with the political authorities—or, in the case of the Lateran, the ecclesiastical one—on whose behalf they have been mobilized. Even the Mars was associated with the church of Florence's patron saint, if only as its previous occupant. The churches in Pavia, Rome, and Pisa are the cities' cathedrals, but the horses were placed at San Marco rather than at San Pietro in Castello, the bishop's seat in medieval Venice. This is simply another indication of the extent to which the former had eclipsed the latter as the church at the center of the city's civic consciousness.[1]

The similarities between the display of the horses and that of the other works extend to the precise mode of presentation. All were raised on columns or an analogous support. Each of the four bronzes at San Marco rests on two short columns (fig. 8), and this was, almost certainly, the arrangement from the very beginning. The evidence regarding the *Regisole* and the *Talento di Cesare* is unequivocal: at least from the fourteenth century they were to be seen on single columns. The installation of the Florentine Mars was similar, although in this case, if the miniature can be relied upon, the support was a pier rather than a column. This was probably true from a fairly early period. According to Villani, it was placed on a tower by the Arno after its removal from the temple of Mars around 300, but he explicitly states that it was put on a "piliere" or a

1. On the roles of the two churches, see Demus, *Church of San Marco*, 10.

"pilastro" when it was reinstalled around 800 and again in 1299. He also believed that the statue had stood on a column in its original role as an idol in the sanctuary of Mars. The Marcus Aurelius was only placed upon the large rectangular base seen in the Heemskerck view by Pope Sixtus IV in 1474. During the Middle Ages it probably stood on the four columns that appear just to the left of it in the drawing. Medieval beliefs about the original display are again suggestive here: Master Gregory asserted that in antiquity the statue had been set on four columns before the altar of Jupiter on the Capitol. The use of columns as supports for so many of these statues is readily understandable: civic symbols were often displayed in this manner in medieval Italy.[2]

There is, however, a significant difference between the emplacement of the horses and that of all the other works. The former were installed upon the church itself, whereas the latter were found before or beside the buildings with which they were associated. Considered in a slightly different perspective, the anomaly of the position of the horses emerges more sharply. The inclusion of ancient sculpture in the exterior decoration of a church is, of course, far from uncommon in medieval Italy. But such works are, almost invariably, reliefs rather than large freestanding objects.

One instance of a sizable work standing on its own on the exterior of a medieval Italian church might be thought to constitute a precedent for the placement of the horses at San Marco. An eleventh-century bronze griffin (fig. 51) was displayed on a column on the gable at the east end of

2. On the horses' supports, see Galliazzo, 86. His argument that their original installation differed somewhat from the present one is considered in excursus I. He thinks it probable that they were already set on columns when they were displayed on the Hippodrome tower (74 and 86), although his reconstruction (fig. 32) does not show them. Two early fifteenth-century visitors to Constantinople report seeing columns on which the horses were said to have been displayed. See Galliazzo, 6–8 and 86.

For Villani's statements concerning the installation of the Florentine Mars, see the references in chapter V, notes 6 and 9. The suggestion that the Marcus Aurelius was once placed on the four nearby columns is that of Fehl, "Placement of the Equestrian Statue of Marcus Aurelius." For their previous display, see Gregory, *Narracio de mirabilibus urbis Rome*, 13 (4), and Gregory, *Marvels of Rome*, 19 (4) and 48.

On the pattern of placing civic symbols on columns in medieval Italy and its antique precedents, see Haftmann, *Italienische Säulenmonument*, esp. 111–36. See also Seidel, "Studien zur Antikenrezeption Nicola Pisanos," 323f., and Frugoni, "L'antichità," 14, and 34f. For examples in Padua and Siena, see below, page 97.

The broad medieval association of columns and statues also had a negative side: it was believed that pagan idols had been set on columns in antiquity. This belief was widely reflected in the visual arts. For examples at San Marco, see figs. 24 and 25; Demus, *Mosaics of San Marco*, 1, 2: colorplate 8 and black and white pls. 358 and 365; and Volbach, *Pala d'oro*, pl. 38 right. For numerous examples elsewhere, see the illustrations in M. Camille, *The Gothic Idol: Ideology and Image-making in Medieval Art* (Cambridge, 1989).

the Duomo in Pisa until 1828 when it was transferred to the Camposanto where it is now found. It is visible at the upper right in the seventeenth-century view (fig. 49), although there it appears as a bird rather than a quadruped. A copy still occupies its original place. New evidence has recently been introduced regarding the question of when the griffin was installed. Attention has been drawn to a twelfth-century Pisan chronicle that records that bronzes were carried back to Pisa as part of the booty from the city of Mahdiyya in Tunisia after it had been captured by a largely Pisan force in 1087. If the griffin was one of them, then, it too, like the horses, was a trophy of war. The Duomo was begun in 1063, and the sculpture was presumably put in place as soon as the eastern part of the building was ready to receive it, perhaps not long after it had arrived. Even before the proposal to connect the griffin with the Tunisian booty was advanced, it was generally assumed to have been installed in the eleventh or twelfth centuries.[3]

The relevance of the Pisan griffin, however, is more limited than appears at first sight. First of all, it is distinctly smaller than the horses: at about a meter in height, it is less than half their size. The proportions in the seventeenth-century view are quite misleading in this regard, for the drawing considerably exaggerates the griffin's dimensions. Despite its prominent placement, the griffin remains a distinctly peripheral feature of the exterior decoration. As an acroterion-like ornament along the building's skyline, the griffin plays a very different role at the Duomo of Pisa than the horses do at San Marco where they are found at the very center of the west façade. Another important difference concerns its origin: the griffin is an Islamic work. For this reason it does not belong to the group of monuments among which the horses at San Marco find their most natural places, that is, the series of large freestanding Roman works seen in a variety of Italian cities during the Middle Ages. It is true that, like them, it rested on a column. If the griffin's Muslim origins remained known, however, it could never have served to convey the claim of a tie to ancient Rome that is certainly one of the chief messages of the nearby *Talento di Cesare*, the horses at San Marco, and their counterparts in Florence, Pavia, and Rome.

3. For the Tunisian provenance, see M. Jenkins, "New Evidence for the History and Provenance of the So-called Pisa Griffin," *Islamic Archaeological Studies* 1 (1978): 79–81. The text in question is B. Maragone, *Annales Pisani*, ed. M. Lupo Gentile, Rerum italicarum scriptores, 2nd ed. 6,2 (Bologna, 1930–36), 6f. On the sculpture, see most recently J. D. Dodds, ed., *Al-Andalus: The Art of Islamic Spain*, exh. cat. (New York, 1992), 216–18no. 15. Herzner, 54n. 178, cites the griffin as a precedent for the display of the horses as a trophy on a church façade.

The parallel offered by a church in southern Italy is also limited. The decoration of the portal (fig. 56) on the west side of the north transept of the Chiesa Nuova della Santissima Trinità in Venosa is entirely composed of reused works. Two Roman lions rest on brackets in the spandrels and flank a Roman funerary relief with five busts. These and the many other spoils incorporated into the building were obtained locally, and their presence is presumably an attempt to establish a connection with the area's Roman past. According to the most recent account, this section of the Chiesa Nuova dates from the early thirteenth century. The church, however, was never completed, and the ensemble is curiously ghostly.

The two animals in Venosa are indeed Roman, but the similarity with the situation at San Marco goes no further. The lions are smaller than the horses, are made of stone rather than bronze, and are placed above what appears to have been a secondary entrance to the church. A more significant distinction is that the lions are not displayed as freestanding works: only their front halves project from the wall. The fact that the Venosa lions are not placed on columns is also suggestive. This support is one of the hallmarks of the group of freestanding antiquities to which the horses belong.[4]

If the works in Pisa and Venosa fail to supply a precedent, they nevertheless suggest a possible explanation for the special treatment ac-

4. On the Venosa portal, see Settis, "Continuità, distanza, conoscenza," 393, and C. Bozzoni, *Saggi di architettura medievale: La Trinità di Venosa. Il Duomo di Atri*, Rome, 1979, 45f., 54f., and 65, who dates this portal c. 1210, rejecting the older view that the church was built in the later eleventh century or the first half of the twelfth. That the lions are half imbedded in the wall is clearly seen in Bozzoni, figs. 22, 80, and 81. For two Roman lions incorporated in the twelfth-century tower of the Duomo at nearby Melfi, in this case with only heads and necks protruding, and a possibly related, but as yet unstudied episode at Benevento, see L. Todisco, "L'antico nel campanile normanno di Melfi," *Mélanges de l'École Française de Rome: Moyen âge-Temps modernes* 99 (1987): 123–158, esp. 155.

A few other works require brief mention. The Roman lion above the Porta Regia of the Duomo of Modena was placed there only in 1818. See *Lanfranco e Wiligelmo: Il Duomo di Modena* (Modena, 1984), 344R.13. The placement of two fragmentary antique torsos on top of the pilasters at the sides of the central portion of the façade of San Matteo in Genoa is probably also postmedieval. (For a view of the façade, see C. Ceschi, *Chiese di Genova* [Genoa, 1966], pl. 32.) F. Alizeri, *Guida illustrativa del cittadino e del forastiero per la città di Genova e sue adiacenze* (Genoa, 1875), 98, suggests that they were placed here in 1323 along with a four-seasons sarcophagus. There is, however, no reason to associate them with the sarcophagus which was, in any case, probably only immured there after 1378 as shown by C. Dufour Bozzo, *Sarcofagi romani a Genova* (Genoa, 1967), 45–47no. 24. Unlike the sarcophagus, they are not mentioned in the façade's extensive inscriptions and their display would be unique in the Middle Ages. According to the most recent study, a bust that was displayed at the apex of the façade of the Duomo of Acerenza is a sixteenth-century work rather than a Roman or medieval one as previously thought. See L. Todisco, "Il busto della cattedrale di Acerenza," *Xenia* 12 (1986): 41–64.

corded the horses at San Marco. Like the griffin and the lions, the
bronzes in Venice do not include a human figure. In this regard, the
Venetian works are quite different from the equestrian statues in Pavia,
Rome, and Florence which were displayed as independent monuments.
The horses could be more readily assimilated among the carved animals,
real and mythical, that are such a ubiquitous feature of medieval church
exteriors, especially those of the Romanesque period.

Such animal decoration is certainly a natural context in which to
consider the horses at San Marco. Indeed, one way in which animals
appear on Italian church façades from the twelfth to the fourteenth
centuries may be relevant here. The scheme has several variants. In its
simplest form, a pair of sculpted lions or other animals is placed perpen-
dicularly to the wall on brackets or columns beside an arch surmounting
the main entrance. The Venosa portal is an example. Closer to San
Marco is the extended version of this scheme in which four to eight
animals appear in the corresponding positions in relation to all the por-
tals on a façade or the sections of a façade's blind arcade. The façade of
the Duomo at Siena (fig. 57), for instance, contains six of them in these
positions. This portion dates from the end of the thirteenth century and
it provides a good example of an arrangement seen on several thirteenth-
and fourteenth-century Tuscan church façades. A related scheme was
sometimes used in twelfth-century Umbria. Four animals appear in a
band across the façade just above the level of the portals and thus slightly
higher than their Tuscan counterparts. In this regard, San Marco is more
like the Umbrian examples than the Tuscan ones.[5]

There is, then, a precedent for prominent sculptures of animals at or
near the same height on the façade as the horses at San Marco. But its

5. For examples of the scheme with only two lions and for some related forms, see C. Ricci,
L'architettura romanica in Italia (Stuttgart, 1925), pls. 93, 97, 117, 135, 137, 190f., 210f., and
213f. For the façade of the Duomo in Siena, see A. Middeldorf Kosegarten, *Sienesische
Bildhauer am Duomo Vecchio: Studien zur Skulptur in Siena, 1250–1330* (Munich, 1984), and
J. White, *Art and Architecture in Italy, 1250–1400*, 2nd ed. (Harmondsworth, 1987), 114–
22. An interpretation of the meaning of the animals there is offered by H. Keller, "Die
Bauplastik des Sieneser Doms. Studien zu Giovanni Pisano und seiner künstlerischen
Nachfolge," *Kunstgeschichtliches Jahrbuch der Bibliotheca Hertziana* 1 (1937): 157 and 160.
The possibility of finding one is rejected by White, 117. For further discussion of the
animals on the Siena façade, particularly the horses which may be based upon an antique
source, see excursus II. For other Tuscan examples of the extended type, see Ricci, pls. 95f.
(Lucca, Duomo), and D. Negri, *Chiese romaniche in Toscana* (Pistoia, 1978), figs. on pp. 37–
39, 194–98, and 406–9 (Grosseto, Duomo; Pistoia, San Pier Maggiore; and Massa Marit-
tima, Duomo). For the twelfth-century Umbrian examples, see J. Esch, *La Chiesa di San
Pietro di Spoleto: La facciata e le sue sculture* (Florence, 1981), figs. 6, 7, and 10 (cathedrals of
Foligno, Assisi, and Spoleto). At Grosseto and the Duomo in Orvieto (White, figs. 278f.)
the figures are Evangelist symbols.

relevance for the problem at hand is again limited. Most of the other animals only emerge half-length. Only at the cathedrals of Grosseto and Orvieto are these freestanding works. Both postdate San Marco. The sculpture at Grosseto belongs to the late thirteenth century and Orvieto was begun in 1310. The horses again differ from all the other animals in that they rest upon the wide shelflike support of the loggia rather than project forward from the plane of the wall. Yet another significant difference is that the horses are grouped together at the center of the façade rather than being evenly distributed across its entire width. The animals at Siena illustrate the arrangement in all the cases with more than two animals: uniformly spaced, the row extends all the way from one side of the façade to the other. It is only because the horses are displayed close to one another that they appear as a team of four, that is, as a quadriga.

There is one final respect in which the horses stand apart from the animals at Siena and elsewhere. The bronzes at San Marco are antique works. But, except for the Venosa lions, all the other animals are contemporary creations. This remains the crucial perspective in which the horses must be viewed. That those responsible for the horses' display saw them in this context is demonstrated by the fact that the installation corresponds to that of other freestanding antiquities set up in Italy during the Middle Ages. Like them, the horses are placed on columns.

The Umbrian churches are the only examples of the placement of four or more animals in this general position that are known to be early enough to have influenced the arrangement at San Marco. There is no obvious reason why they should have been selected as models for the reworking of San Marco's façades. Nor are there any other aspects of the exterior of the Venetian church that reveal significant connections with them. The profusion of animals in medieval church façade decoration may have been seen as providing some sanction for displaying the horses in this manner. But the decision is unlikely to have been inspired by this general practice or any particular version of it.

There is one pattern in the use of antiquities in medieval Italy that has been said to shed some light, if only indirectly, on the assemblage at San Marco. City gates, it has been maintained, were one of the common sites for the display of ancient sculpture during the Middle Ages. Antiquities could not be installed in this way in Venice, since the city lacks walls. Hence, the argument goes, their display at San Marco. But the strength of such a pattern, at least in the case of large freestanding sculpture, is far from clear. The most frequently cited example of the display of antique statuary at an Italian city gate is that of the three life-size standing figures

found at the Porta Consolare of Spello near Assisi. In the present arrangement they are supported on corbels with their backs against the wall. Whether they were installed during the Middle Ages, however, is under dispute.[6]

In any event, it is difficult to see how these observations advance an understanding of what occurred at San Marco. Surely the horses and the other spoils were not placed on San Marco *faute de mieux*. Moreover, the works that are most analogous to the horses are not the relatively minor antiquities sometimes found on medieval gates, but, as has been shown, major monuments displayed at significant sites within the city.

Umbria also provides an example of large freestanding bronze sculptures representing animals affixed to the façade of a medieval building. A lion and a griffin, measuring about 1.8 m in length, stand above the impressive main portal on the north side of the Palazzo dei Priori in Perugia. They have long been regarded as medieval works, but the possibility has been raised that they are Etruscan or Roman. Like the horses at San Marco, the Perugia bronzes functioned as civic symbols. Nevertheless, they have rather less relevance for the Venetian display than might be supposed. The building that they decorate is secular, not ecclesiastical, and they were installed later than the horses at San Marco; the part of the structure on which they are found was only built between 1293 and 1297. It has been said that they were placed on the Fontana Maggiore which stands in the piazza before the north façade of the Palazzo dei Priori in 1281 and that they were transferred to their present positions in 1301. If they are indeed ancient works, the choice of the first setting would not be surprising. There are other instances of fountains as the site of display for antique statuary during the Middle Ages.[7]

6. The views regarding the link between antique spoils and city gates are Greenhalgh's: "*Ipsa ruina docet*," 141f. and esp. 151, where the pattern is said to be relevant for Venice, and *Survival of Roman Antiquities*, 79–83, 244, and esp. 247, for the same point. On the decoration of medieval Italian city gates, see Gardner, "Iconography of the Medieval Italian City Gate." Although Greenhalgh, "*Ipsa ruina docet*," 119, and *Survival of Roman Antiquities*, 45, appears to take it for granted that the Spello statues were placed there in the Middle Ages, it has also been said (e.g., Frugoni, "L'antichità," 27n. 31) that this took place in the sixteenth or seventeenth century. Gardner, 209, cites additional opinions for and against a medieval installation and concludes that it is quite possible that they were put in place during the Middle Ages.

7. The possibility of a Roman origin of the Perugia bronzes is most fully explored by F. Magi, "Osservazioni sul grifo e il leone di Perugia," *Rendiconti: Atti della Pontificia Accademia Romana di Archeologia* 3rd ser., 44 (1971–72): 275–303. See also Greenhalgh, "*Ipsa ruina docet*," 151–53, and *Survival of Roman Antiquities*, 214 and 245f. He suggests that there was "a late mediaeval fashion for setting antique statues atop modern fountains" and cites fourteenth-century examples in Siena (on which see below note 14) and Verona.

Nor can a precedent for the placement of the horses on San Marco be found outside Italy during the Middle Ages. The best known instance of the medieval reuse of such sculpture in northern Europe is the now lost equestrian statue of Theodoric that Charlemagne took to Aachen. Supported by one or more columns, it stood in the complex of structures that made up his palace. Its exact site is unknown.[8] Precise information is also lacking in the case of the only other four-horse team known to have been reused during the Middle Ages. Like the Theodoric, it no longer survives. A twelfth-century Russian chronicle reports that Vladimir I (c. 956–1015) brought a set of four bronze horses that he had seized in Cherson in the Crimea in 989 to his capital Kiev. Like the horses at San Marco, it was also a trophy gained in war against Byzantium. Again like the Venetian team, this was, presumably, a Greek or Roman sculptural group. At the time the chronicle was written, the horses were to be seen behind the Church of the Virgin (the Desyatinnaya) which Vladimir had begun to construct about 990. It is interesting to note that in Kiev, as in Venice and Constantinople, the quadriga team was to be seen close to a palace as well as a church.[9]

The installation of the horses is also at variance with the manner in which antiquities were usually displayed in medieval Venice. None of the other reused works that were physically incorporated into the exterior decoration of San Marco are large freestanding objects like the horses. Two other examples of such sculpture were set up in Venice during the thirteenth and fourteenth centuries, but their installation differs entirely from that of the horses. The first is the famous bronze lion on the easternmost of the two columns at the mouth of the Piazzetta (figs. 36 and 37). It is particularly instructive in this context. Almost three meters

8. On the display, see Hoffmann, "Aachener Theoderich statue," 323. He places it between the Palatine Chapel and the principal hall of the palace complex. Thürlemann, "Bedeutung der Aachener Theoderich-Statue," 36, suggests a position in front of the latter. Cf. L. Falkenstein, *Der 'Lateran' der Karolingischen Pfalz zu Aachen*, Kölner historische Abhandlungen 13 (Cologne and Graz, 1966), 59f., who argues that the available evidence is insufficient to determine the statue's exact site.

9. For the text, see *The Russian Primary Chronicle: Laurentian Text*, ed. and trans. S. H. Cross and O. P. Sherbowitz-Wetzor (Cambridge, Mass., 1953), 116. Cf. L. Reau, *L'art russe des origines à Pierre le Grand* (Paris, 1921), 96n. 1, for a query about the correctness of this reading of the passage. On the Desyatinnaya, see G. H. Hamilton, *The Art and Architecture of Russia*, 3rd ed. (Harmondsworth, 1983), 21–23. On the use of the horses there, see also D. Ainalov, *Geschichte der russischen Monumentalkunst der vormoskovitischen Zeit* (Berlin and Leipzig, 1932), 9. The existence of this Russian parallel for the Venetian horses has been noted on a number of occasions. See, e.g., Demus, *Church of San Marco*, 114n. 9, citing a suggestion by André Grabar.

long and two meters tall, not counting the tail or wings, the lion is roughly similar to the horses in scale and material. Like them, it may well have been part of the booty of 1204, although a recent study of the work maintains that it was instead acquired further east in Asia Minor, in Cilicia, during the twelfth century. According to the latest account, the lion is an orientalizing Greek work of about 300 B.C. and was extensively modified and restored in antiquity, the Middle Ages, and the nineteenth century.[10]

Although the origin of the lion and the circumstances in which it reached Venice are difficult to establish, the facts regarding its use there are reasonably clear. It was placed in its present position sometime between the late twelfth century and the end of the thirteenth, most probably before 1250. The *terminus post quem* is provided by the erection of the column, along with its companion to the west, which took place in the 1170s, according to Venetian tradition. The *terminus ante* is established by a document of 1293 which authorizes funds for repairing a lion that is described as "supra columpnam." As has often been noted, its need of restoration suggests that it had already been there for some time. It was installed, then, at approximately the same time as the horses. Although a place for the lion could readily have been found at San Marco, it was instead set up as an independent monument in what can now be recognized as the usual manner for such works.[11]

10. B. M. Scarfi, "La statua del leone della Piazzetta," in *Il leone di Venezia: Studi e richerche sulla statua di bronzo della Piazzetta*, ed. B. M. Scarfi (Venice, 1990), 31–123, esp. 33, 39, 98, and 110f., for the matters discussed here. For the likelihood that the lion was part of the booty of 1204, see, e.g., J. B. Ward Perkins, "The Bronze Lion of St. Mark at Venice," *Antiquity* 21 (1947): 29, and Esch, "Spolien," 36n. 131. The reason offered by Scarfi, 33, for rejecting this provenance is its absence from the chronicle tradition. This is not a strong argument. Contemporary sources dealing with the sack of Constantinople are completely silent regarding statuary carried off by the Venetians. Although Venetian sources beginning in the fifteenth century give this provenance for the horses, from the same date they erroneously report that the piers before the south façade came from Acre after a Venetian victory against the Genoese in 1258. The latter are now known to have been, instead, among the spoils from Constantinople after the conquest in 1204. See above, pages 3f. It is clear, then, that the sources cannot always be relied upon in this regard.

The only general survey of the display of antiquities in medieval Venice is M. Perry Caldwell, "The Public Display of Antique Sculpture in Venice, 1200–1600" (Ph.D. diss., University of London, 1975), 7–34 and 78–100. Unfortunately, it remains unpublished. See also G. Traina, "Fruizione utilitaristica e fruizione culturale: i reimpieghi nelle Venezie," in *Colloquio sul reimpiego dei sarcofagi*, 63–70; Herzog, *Untersuchungen zur Plastik der venezianischen "Protorenaissance"*; M. Greenhalgh, "The Discovery of Roman Sculpture in the Middle Ages: Venice and Northern Italy," in *Venezia e l'archeologia*, 157–64; and I. Favaretto, *Arte antica e cultura antiquaria nelle collezioni venete al tempo della Serenissima* (Rome, 1990).

11. For the date of the erection of the lion and the document of 1293, see Scarfi, "Statua del leone," 33.

According to local sources, the second Piazzetta column only received its statue in 1329 (fig. 38). It represents St. Theodore, the first patron of Venice who was displaced by Mark when the latter's relics were acquired in the ninth century. The figure is a composite. The torso came from a Roman statue and the head from a Hellenistic one. The figure was completed with arms and legs, fitted out with halo, shield, and weapons, and placed upon a crocodile. Here again, this large freestanding work whose core, at least, is antique was not displayed at San Marco, but set upon a column in the standard manner. The contrast between the handling of the horses, on the one hand, and the treatment of the lion and the fragments composing Theodore, on the other, is all the more striking given their common function. These works are among the most prominent of the many symbols of the power of the Venetian state that are gathered at San Marco and in the open spaces adjacent to it.[12]

Although the lion and the saint are displayed quite differently from the spoils incorporated into the façades of San Marco, they follow a pattern seen in the use of some of the latter in one significant respect. The ancient fragments of which Theodore is largely composed have been adapted to endow them with a local meaning. The lion has undergone a similar transformation. According to the most recent study, the wings that transformed it into a symbol of Mark were added in the Middle Ages. Whether this addition took place before or after the bronze reached Venice is unknown. What is clear is that the Venetians subjected the constituents of the Theodore, and perhaps the lion as well, to the same process that was observed earlier in the display of the horses and of the three reused works among the spandrel reliefs on the west façade of San Marco. The only difference is that here the specifically Venetian meanings have been introduced by adding attributes to the objects themselves rather than simply juxtaposing them with other works that point to the new interpretations.[13]

Antique statuary is, then, exceedingly rare on medieval church façades. Yet antique reliefs are relatively frequent in such settings, at least in medieval Italy. There are various factors that help to explain this disparity. During the Middle Ages, heathen idolatry was largely thought

12. On the statue of Theodore, recently replaced by a copy, see Wolters, *Scultura veneziana gotica*, 1: 20, who rejects the view that the head was made in the fifteenth century. On the role of Theodore in Venice, see Demus, *Church of San Marco*, 20–22.

13. Scarfi, "Statua del leone," 57 and 110, leaves open the question of the date of the addition of the wings. Perry, *Public Display of Antique Sculpture*, 32f., has also noted the Christian adaptations of both works.

to consist of the worship of freestanding sculpture. The fact that the cult images of the ancient Greeks and Romans had been statues remained well known. The idols of Sol and Luna in the mosaics depicting the martyrdom of Simon and Jude (figs. 24 and 25) are examples of a formula that was repeated in numerous medieval works of art. It has been maintained, indeed, that ancient statuary was regarded as a quintessentially pagan form of art during the Middle Ages and that this attitude towards it, along with its uselessness for practical purposes, was responsible for the destruction meted out to so much of it during the period. Given the association of ancient statues with cult images, the widespread medieval belief that they harbored demons is readily understandable. One of the equestrian figures considered here is a case in point. Magical powers and malevolence were attributed, as noted earlier, to the fragmentary figure in Florence that was thought to have been the cult image in the temple of Mars.[14]

There is no reason to think that the horses would have been exempt from the superstitions so frequently attached to ancient works of art in the Middle Ages. The wide-eyed accounts of ancient sculpture that was to be seen in Constantinople written by Western particpants in the conquest of 1204 contain several examples of such beliefs. Robert de Clari, author of the most extensive description, says that the numerous bronze statues of men and beasts that stood on the *spina* of the Hippodrome used to "play by enchantment," but do so no longer. Even if the horses reached Venice free from such accretions, the authorities in charge of the decoration of San Marco had reason to be wary about them in this regard. A similar chariot team had been depicted by the church's

14. Greenhalgh, *Survival of Roman Antiquitites*, 202–18, surveys the medieval treatment of ancient statuary. For the medieval view of ancient statuary as "heathen par excellence" and the factors that might nevertheless permit some to be displayed, see Esch, "Spolien," 33–36 and 45f. See also Camille, *Gothic Idol*, 73–128, with numerous illustrations, and Frugoni, "L'antichità," 7–11. For reactions to antique statuary in Rome in the twelfth and thirteenth centuries, see Kinney, "'Mirabilia urbis Romae.'" On the supposed role of Pope Gregory in the destruction of ancient works of art, see T. Buddensieg, "Gregory the Great, the Destroyer of Pagan Idols: The History of a Medieval Legend concerning the Decline of Ancient Art and Literature," *JWCI* 28 (1965): 44–65.

The medieval propensity to link antique statuary and pagan idols emerges clearly in a contemporary account of the purchase of ancient sculpture by Henry of Blois in Rome around 1150 to take back to England. See John of Salisbury, *Memoirs of the Papal Court*, ed. and trans. M. Chibnall, rev. ed. (Oxford, 1986), 79f. (XL). On this well-known episode, see Frugoni, 29 and 33 f.n. 7, and Krautheimer, *Rome*, 189. Even the Marcus Aurelius was once tarred with this brush. The opponents of Pope Alexander II (1061–1073) said his supporters might worship the statue (Herklotz, "Campus Lateranensis," 24). The tendency to associate such works with magical powers is vividly illustrated by the Sienese treatment of a statue of Venus in the 1350s. On that episode, see Esch, 45f., and Panofsky, *Renaissance and Renascences*, 112 and 151.

mosaicists only a short time earlier; it appears in the closest possible association with pagan idolatry in the scenes of the martyrdoms of Simon and Jude.[15]

As the *Regisole*, the Marcus Aurelius, and other works demonstrate, all ancient statues were not regarded as irretrievably tainted by associations with idolatry. Their chances of survival were significantly enhanced if they had acquired an important local historical meaning or could be interpreted as bearing a Christian message. But even then, apparently, to display such a work in a public place was one thing, to install it on a church quite another.

A broad feature of medieval art is also relevant here. The making of freestanding monumental sculpture had largely come to an end after the collapse of Rome and it only slowly began to reappear in the twelfth and thirteenth centuries. That large-scale stone sculpture during the Middle Ages mainly took the form of reliefs rather than freestanding works had, of course, a direct impact on church façade decoration. The dominant role that reliefs played there, a dominance that is only beginning to weaken in the thirteenth century, also helps to explain the paucity of ancient statuary reused in such contexts.

This question also has a practical side. Accommodating large freestanding sculpture like the horses would have been physically difficult on many medieval church façades. If properly displayed, such works would have to project forcefully from the plane of the wall. A narthex or porch might provide a suitable support, but an undertaking of this kind would otherwise have required special provisions. What made it possible to install the horses quite easily on the façade of San Marco is, of course, the loggia that runs at mid-height along the building's north, west, and south sides.

The loggia at San Marco owes its existence to the fact that the lower

15. On the statues of the Hippodrome, see Robert de Clari, *La conquête de Constantinople*, ed. P. Lauer (Paris, 1924), 88 (XC). He does not mention the horses on the Hippodrome's north tower, almost certainly the ones now at San Marco. For his belief that two statues contained prophecies of the fall of Constantinople and that the same was true of reliefs on the columns of Arcadius and Theodosius, see 88f. (XCI and XCII). On his account and that of Villehardouin and on the former's discussion of the Hippodrome, see J. P. A. van der Vin, *Travellers to Greece and Constantinople: Ancient Monuments and Old Traditions in Medieval Travellers' Tales*, 2 vols. (Leiden, 1980), 1: 73–80, esp. 78, 266–71, and 305f., and 2: 540–52 with the texts. Indigenous tales of this sort are discussed by C. Mango, "Antique Statuary and the Byzantine Beholder," *Dumbarton Oaks Papers* 17 (1963): 53–75 (reprinted in his *Byzantium and Its Image*), and van der Vin, 1: 315–19.

Greenhalgh, *Survival of Roman Antiquities*, 244, notes the possibility that the horses were viewed as pagan "and therefore unsuitable for a Christian building." The likelihood that Giotto later cast the horses themselves in the role of idols will be considered in excursus II.

story of the façade is set farther forward than the upper one. On the west façade, this projection consists entirely of the deep embrasures that frame the doorways (fig. 36).[16] Comparing the present loggia with what is shown in the Porta Sant'Alipio mosaic indicates that there have been no major changes in its western section since the thirteenth century.

The existing loggia had a predecessor. Nineteenth-century soundings on the west façade uncovered the cornice of an earlier terrace some 43 cm behind and 35 cm lower than that of the present loggia. It has been argued that this earlier loggia was introduced during the twelfth century and widened and raised during the thirteenth-century reshaping of the façades. One of the reasons for the widening may well have been to allow the horses to be installed without unduly obstructing egress to the loggia from the doorway behind the horses. The greater width would also keep them from blocking passage between the northern and southern halves of the western section. It has recently been maintained, however, that the narrower loggia was only added during a first phase of the thirteenth-century refashioning and then expanded in a second one. In this view the loggia was created precisely in order to make it possible to display the horses on the façade. This objective, however, can hardly have been the sole motivation for the construction of a loggia encompassing three sides of the building and for the deepening of the portals that went with it: there were far simpler means of affixing the horses to the façades.[17]

If a loggia was already in place when the horses arrived in Venice, it

16. The relationship between the western section of the loggia and the deep embrasures is seen most clearly in the often reproduced sections of the church published in Zatta, *Augusta ducale Basilica*, pls. VI–VIII and XI.

17. For the view that the loggia was first introduced in the twelfth century and then expanded in the thirteenth, see R. Cattaneo, "Storia architettonica della Basilica," in *Basilica di San Marco*, ed. C. Boito, 168, where the report concerning the earlier cornice is found. Polacco, *San Marco*, 101 and 104, is of the same opinion and connects the expansion with the problem that the horses would have created for egress on a narrower loggia. His reconstruction (35) of the appearance of the west façade before the thirteenth-century campaign shows a terrace, as does that of Pellanda for which see chapter II, note 18.

For the opposing view and the link between the horses and the erection of the loggia, see Herzner, 44f., 51f., and 54, and Perocco, "Cavalli di S. Marco," 69. Dorigo, "Medieval Mosaics of San Marco," in *Patriarchal Basilica*, 1: 45, and Grabar (in M. Muraro and A. Grabar, *Treasures of Venice* [Geneva, 1963], 32) also date the terrace in the thirteenth century.

The pavement of the loggia behind the horses was lowered somewhat during the present century. Compare fig. 7 showing the present state and fig. 8 with the earlier one. The change facilitated access from the interior of the church by decreasing the difference in levels and also eased passage between the north and south sections of the loggia through the narrow area behind the horses. It seems natural to suppose that in the thirteenth century the pavement level corresponded to the bases of the columns and the intermediary panels that fill the lower part of the arch behind the horses just as it does now.

would have provided a ready-made platform for their display. As the question of where to exhibit the horses was being weighed, such a terrace might even have suggested the possibility of the façades as a site. A pre-existing loggia cannot, however, explain the decision to install them there in any larger sense.

This survey of possible counterparts for the placement of the horses on the loggia of San Marco makes it clear that their presence there is without true precedent. A proposal to display them in this manner might well have met with hesitation, if not actual resistance. The decision to install them on the church, therefore, can no longer be taken simply for granted as has so often been the case. In fact, a number of specific explanations have, from time to time, been offered for it. None of them, however, were framed with an awareness of its unexpectedness, and their adequacy must be scrutinized anew in this light.

The commonest view of the matter, as already noted, centers on the fact that the horses were the most splendid spoils of the great victory of 1204. It seems only natural that they should be displayed so prominently on the church's principal façade. But the triumphal message of the horses could have been proclaimed with at least approximately equal effectiveness from a position next to San Marco in the piazzas to the west or south. Although they would not have loomed high above the viewer, they would have been even more conspicuous standing proudly on their own.

To be sure, such an arrangement would have run counter to the prevailing disinclination to display works of art as isolated monuments during the Middle Ages. Indeed, it has been said that the possibility of such an independent installation of the horses would never have been considered at this period. But the horses, as has been seen, belong to a group of works that were handled in just this unusual manner. The pattern established by the *Regisole* in Pavia, the Marcus Aurelius in Rome, and the *Talento di Cesare* in Pisa leads to the expectation that the horses would also be found in a position before or beside San Marco.

This period, in fact, saw the tentative beginnings of a revival of the freestanding monument, and the earliest instances often consisted of an animal on a column or pier. A lost example was erected in nearby Padua in 1209: a sculpted lion that had been captured in war was placed on a column before Sant'Andrea as a victory memorial. In Siena, around 1300, a carving by Giovanni Pisano of the city's emblem, a wolf suckling Romulus and Remus, was set on a column beside the west façade of the Duomo. Important and well-known examples from Germany are the

lion monument in Braunschweig of 1166 and the equestrian figure in
Magdeburg of the mid-thirteenth century. In all these cases, of course,
the sculpture is contemporary not antique. The most apposite compari-
sons for the horses remain the *Regisole* and related works. But all these
works, ancient and medieval, demonstrate that installing the horses as a
freestanding monument was a real option at this time. What an indepen-
dent display of the horses might have looked like is suggested by Cana-
letto's well-known *Capriccio* (fig. 39) of 1743, if the high bases that he
imagined are replaced by columnar supports.[18]

In order to serve as symbols of Venetian power, the horses had to be
associated, of course, with a building that stood for the city's greatness.
But actual physical incorporation into the structure as opposed to display
in its immediate vicinity was obviously not felt to be necessary to estab-
lish this link in Pavia, Pisa, and Rome. In Venice the same view seems to
have sometimes prevailed, for all the spoils from the conquest of Con-
stantinople were not incorporated into the fabric of San Marco. The two
richly ornamented piers from St. Polyeuktos were placed some five me-
ters in front of the south façade of the church. Another trophy, the *Pietra
del bando*, is also relevant here. According to Venetian tradition, as al-
ready noted, a prize of a victory over the Genoese in 1258, it too was set
up on its own a short distance away beside San Marco's southwest corner.
Indeed, the usual explanation for the isolation of these objects is that it
enhances the impact of their triumphal message.[19]

There have been a number of more sharply focused attempts to ac-
count for the selection of this particular site for the horses. One sugges-
tion is that the horses were placed here to replicate as closely as possible
their original position in Constantinople. Just as they had once stood

18. For the dismissal of the possibility of an independent display of the horses, see Herzner,
53: "Ein eigenes, freistehendes Triumphmonument für sie [i.e., the horses] zu errichten,
war im Mittelalter unmöglich und konnte schon deshalb gar nicht in Erwägung gezogen
werden." He regards the present arrangement as inevitable (see below note 27). For recog-
nition that the installations of the *Regisole* and related works depart from the general
pattern, see Frugoni, "L'antichità," 34.

For the monument in Padua, see Haftmann, *Italienische Säulenmonument*, 127–31, and
O. Ronchi, *Guida storico-artistica di Padova e dintorni* (Padua, 1922), 68f., with an illustration
of a copy of the original destroyed in 1797. For the one in Siena, see Middeldorf
Kosegarten, *Sienesische Bildhauer am Duomo Vecchio*, 99, 117f., and 350. On the Braunsch-
weig lion, see *Der Braunschweiger Burglöwe: Bericht über ein wissenschaftliches Symposion in
Braunschweig vom 12.10. bis 15.10.1983* (Göttingen, 1985), and on the Magdeburg rider,
E. Badstübner, "Justinianssäule und Magdeburger Reiter," in *Skulptur des Mittelalters:
Funktion und Gestalt*, ed. F. Möbius and E. Schubert (Weimar, 1987), 184–210.

On the *Capriccio*, see Corboz, *Canaletto*, 2: 470–92 and 602.

19. See, e.g., Greenhalgh, "*Ipsa ruina docet*," 149.

high on a tower above one end of the long Hippodrome, so they were now raised on the west front of San Marco with the Piazza San Marco stretching out before them. The parallel is further reinforced by the broader congruity between the grouping of the Hippodrome, the Imperial Palace, and Hagia Sophia, on the one hand, and that of the Piazza San Marco, the Palazzo Ducale, and San Marco itself, on the other. Replicating the old position of the horses as closely as possible was intended, according to this explanation, to drive home the brute fact of their appropriation and all that it entailed.[20]

It has also been argued that there were other specific reasons why the placement of the horses on the loggia would have been regarded as an especially apt way of commemorating the Venetian triumph. The explanation again starts from the display of the four bronzes at the Hippodrome. According to this view, the horses had become symbols of Byzantine hegemony, because of the Hippodrome's strong associations with the emperors. The Venetian claims to the legacy of imperial Byzantine power were thus asserted by the transfer to San Marco of one of its preeminent symbols. The loggia of San Marco was likewise associated, it is said, with the head of the Venetian state, for the doge is known to have appeared there on some occasions. The position selected for the horses made the claims they conveyed more concrete by centering them, if only indirectly, on the doge. It has even been suggested that when the doge took his position there, he would have appeared to have been drawn in a chariot by the horses in a manner analogous to that seen in images of Roman and Byzantine emperors.[21]

20. This idea is most fully developed by Galliazzo, 76f. Herzner, 55, fully subscribes to this analysis. See also Demus, *Church of San Marco*, 114n. 9. The similarity in the present and former positions of the horses has been widely pointed out. See, e.g., Perry, "St. Mark's Trophies," 28.

The replication would have been much closer if there were any truth to a curious nineteenth-century notion that the horses at San Marco had once been displayed on the four buttresses of the west façade of Hagia Sophia. See G. and G. Fossati, *Rilievi storico-artistici sulla architettura bizantina dal IV al XV e fino al XIX secolo* (Milan, 1890), 28. For rejection of this idea, see W. R. Lethaby and H. Swainson, *The Church of Sancta Sophia Constantinople: A Study of Byzantine Building* (London, 1894), 192. The reconstruction of the west façade of Hagia Sophia by W. Salzenberg, *Alt-christliche Baudenkmale von Constantinopel von V. bis XII. Jahrhundert* (Berlin, 1854), 16, and pl. XII shows four equestrian statues in this position. This proposal has rightly dropped from the literature.

21. For the horses as symbols of Byzantine power and the ducal associations of the loggia, see Galliazzo, 74–77, and Herzner, 52–56. The strongest statement on the doge's use of the loggia is Herzner, 56. For the parallel with earlier imperial images, see Polacco, "San Marco e le sue sculture," 59, and *San Marco*, 114. For the imperial associations of quadrigas in ancient Rome and those that the San Marco group may have taken on from its display at the Hippodrome, see above, pages 81f.

Earlier precedents have also been invoked. Sculptural groups repre-
senting chariots with their teams, many of them quadrigas, were fre-
quently set atop Roman triumphal arches. In a general way, the position
of the horses above the central portal of the west façade of San Marco
resembles this scheme, as has often been noted. It has been claimed that
the Venetian arrangement was in fact modeled on such prototypes and
also that it would have called to mind Roman monuments of this kind for
medieval viewers. It has even been maintained that the placement of the
horses is only one aspect of the larger replication of the façade of a
specific Roman building. The proposed model is Trajan's Basilica Ulpia
as it appears in a Roman medallion. That representation shows a col-
umnar lower story surmounted by one with four horses at its center.[22]

The installation of the horses on the façade has also been portrayed as
the outcome of practical considerations. Writing in his first guidebook
to Venice, published in 1561, Francesco Sansovino admitted that the
elevated position of the horses made it difficult to appreciate them fully.
He declared, however, that an installation in the piazza itself had been
wisely avoided because it would have obstructed movement there.
Erizzo, who reported, as noted earlier, that the horses had nearly been
melted down in the Arsenal, explained that the loggia was selected be-
cause it offered safety from further risks. In his later guidebook, San-
sovino took the same view.[23]

Serious questions arise regarding all these accounts. The topographi-
cal parallel is, in fact, somewhat loose. Hagia Sophia is near the Hippo-
drome but not, of course, adjacent to it, and the tower at the latter's north
end has nothing in common with San Marco other than its position at the
end of an oblong space. Such looseness is not in itself grounds for reject-
ing this view, since conceptions of architectural copies, as is well known,

22. For the scheme as a reflection of Roman triumphal monuments, see Grabar in Muraro
and Grabar, *Treasures of Venice*, 32, and for the medieval recognition of the reference,
Demus, *Church of San Marco*, 114. Demus' statement is quoted, presumably in agreement,
by Herzner, 55n. 181. The general resemblance has also been noted, e.g., by Perocco
("Cavalli di S. Marco," 69, and "San Marco," *Patriarchal Basilica*, 1: 24). Perocco does not
assert, however, that the relationship was deliberate or that it would have been recognized
during the Middle Ages. For the Basilica Ulpia as the source, see Corboz, *Canaletto*, 2: 479.

23. Sansovino's first account (1561) appears in his *Delle cose notabili che sono in Venetia*, 27r:
"Ben è vero che per l'altezza non si posson godere, ma colà sù non impediscono la piazza e
son fuori de pie delle genti." According to Erizzo, *Discorso sopra le medaglie de gli antichi*, 98
in the separately paginated section entitled "Dichiaratione di molte medaglie antiche,"
after being retrieved from the Arsenal, the horses were placed "sopra la Chiesa, come in
luogo sicuro, accioche non fossero guastati." (On the Arsenal story, see above, page 7.) For
Sansovino's second account (1581), see his *Venetia, città nobilissima*, 94: "per più commodo,
& sicurezza sopra alla Chiesa."

were quite flexible for much of the medieval period. For just that reason, however, the concern with exact reproduction assumed by this explanation of the decision regarding the horses' display is alien to the prevailing spirit in such episodes during the Middle Ages. To be sure, San Marco is an architectural copy, indeed a fairly close one, of a major building in Constantinople. The model that was used in the rebuilding of the last third of the eleventh century, however, was the church of the Holy Apostles, not Hagia Sophia. Holy Apostles was nowhere near the Hippodrome. Even if Hagia Sophia had supplanted Holy Apostles as the major Byzantine reference point for San Marco in the minds of some Venetians, this explanation of the installation of the horses is still weak.[24]

It may well be that the horses on the tower were seen as symbols of Byzantine power when the Venetians seized them. But the supposition that this was the case has been based largely on general meanings attached to quadrigas and to the Hippodrome. Traditions regarding two other sculptural groups of quadrigas said to have once existed in Constantinople may be relevant here. Byzantine sources report, in a rather confused fashion, that these quadrigas, one of them at another site in the Hippodrome, were used in the fourth century in the annual celebration of the founding of the city. The ceremony took place in the Hippodrome. Perhaps the four-horse team on the tower had become associated with memories of these celebrations. As noted earlier, this team is the only one that is known to have survived until the conquest of the city by the Westerners in 1204. There is, however, no concrete evidence that this particular sculptural group was ever viewed as a political symbol by the inhabitants of Constantinople or by visitors to the city.[25]

It should also be kept in mind that the physical arrangements of the Hippodrome did not directly link the horses and the Byzantine emperor. The tower on which they stood was at the stadium's north end and rose over the starting gates. It had nothing to do with the box from which the

24. The fundamental discussion of medieval architectural copies remains R. Krautheimer, "Introduction to an 'Iconography of Medieval Architecture,'" *JWCI* 5 (1942): 1–33 (reprinted in his *Studies in Early Christian, Medieval, and Renaissance Art* [New York, 1969] with a postscript, and in his *Ausgewählte Aufsätze zur europäischen Kunstgeschichte* [Cologne, 1988] with an updated postscript). His discussion is primarily concerned with monuments and texts from before 1200 and he notes (20) a change towards greater interest in accuracy beginning in the thirteenth century. On the relationship between San Marco and the church of the Holy Apostles, see Demus, *Church of San Marco*, 88–100, esp. 94, on the possible relationship between the Piazza San Marco and the latter's atrium. See also Herzner, 19–28, who calls it the most exact architectural copy of the Middle Ages (27).

25. For the sources regarding the other quadrigas and the cermonies employing them, see the references in the introduction, note 10.

emperor viewed the races. That was located approximately midway on its long east side.

The second part of this explanation of the placement of the horses is that the loggia was closely associated with the head of the Venetian state. This link, however, is not so strong as to make an installation there the one logical place for the horses' display. The notion that the loggia was closely associated with the doge derives primarily from an often cited passage in a letter by Petrarch of 1364 describing a tournament held in Piazza San Marco to celebrate the suppression of a dangerous revolt in Crete. He reports that he viewed the proceedings along with the doge and other noblemen from the loggia on which the horses are located. A broad conclusion should probably not be drawn from Petrarch's account. In his *Estoires de Venise* written in the late 1260s and early 1270s, Martin da Canal describes many splendid gatherings in the city's public spaces. Among them is a tournament held in 1253 in the Piazza San Marco in honor of the election of Ranieri Zeno as doge, and da Canal records that Zeno watched it from the "*poies*" of San Marco. The most recent editor of the text has argued that this term refers to the loggia, citing Petrarch's account and also linguistic evidence. It may well be that the doge was to be found there on that occasion. Yet when da Canal notes the presence of the doge at other entertainments and ceremonies that took place in this area, the doge always views them from the "windows of his palace." This is the position from which Doge Lorenzo Tiepolo watched another tournament in 1272. This is also the place from which the doge listened to the *Laudes* sung by priests accompanying the children's procession during the annual ceremony commemorating the arrival of Mark's relics in Venice. Finally, it is there that he stood during the main public ceremony of the Carnival when pigs were loosed in the Piazza, then hunted and slaughtered on the last Thursday before Lent. Thus, although there is some evidence of the use of the loggia by the doge, this does not appear to have been a regular practice, at least during the thirteenth century.[26]

26. For the tournament of 1364, see Francesco Petrarca, *Prose*, ed. and trans. G. Martellotti et al., La letteratura italiana: Storia e testi 7 (Milan, 1955), 1084 (*Senilium rerum libri*, IV, 3). On this passage, see Perry, "St. Mark's Trophies," 29; Galliazzo, 6; and Herzner, 56. For another account placing a doge on the loggia, see a letter of Beatrice d'Este written during a visit to Venice in 1493 (P. Molmenti, *La storia di Venezia nella vita privata*, 7th ed., vol 2 [Bergamo, 1928], 439 and 497).

For the tournament of 1253, see da Canal, *Estoires de Venise*, 128 (1, CXXXII). On the interpretation of *poies*, see A. Limentani, "Martino da Canal, la basilica di San Marco e le arti figurative," in *Mélanges offerts à René Crozet*, vol. 2 (Poitiers, 1966), 1182–84. For the other occasions, see da Canal, 328 and 332 (2, CLVII and CLX); 254 (2, XCIII); and 260 (2, C). See also the introduction by Limentani, CCLXXXVII-CCXC (227–29).

In any case, if the decisive concern had been to link the symbolic burden of the horses with the doge, an installation at the Palazzo Ducale would have been a more logical choice. But this option, it has been argued, would have been rejected as introducing an unacceptable imperial element into the image of the doge when his power was being increasingly circumscribed. That there would have been reluctance to employ explicitly imperial symbolism in such a manner at this period is questionable. Even if the premise is accepted, however, the helpfulness of this line of thought is diminished by the fact that the placement of the horses on the loggia was certainly not the only way of achieving a less direct linkage. The horses could have been set up, for example, before the south façade of the church. There they would have been shared, as it were, by San Marco and the adjacent Palazzo Ducale, just as the four porphyry emperors are now.[27]

The possibility that anyone in thirteenth-century Venice was aware of the Roman custom of placing chariots on triumphal arches is certainly remote, but it cannot be ruled out entirely. Numerous Roman triumphal arches were still visible during the Middle Ages, especially in Rome where, as noted earlier, they attracted considerable interest. At least one of them may still have retained its crowning sculpture as late as the thirteenth century. A statement made by Master Gregory about the arch he associated with Augustus has been interpreted to mean that he saw some sculpture, presumably freestanding, on its attic. He speaks only of human figures, however, and does not mention a quadriga. That a set of four gilded bronze horses once decorated a celebrated Roman monument is reported by the mid-twelfth-century *Mirabilia urbis Romae*. The structure in question, however, was the Mausoleum of Hadrian, not a trimphal arch. The passage probably refers to a quadriga that originally surmounted the building.[28]

A knowledge of the Roman practice of placing chariots on triumphal arches might have survived in other ways. Their presence is recorded in

I know of no evidence to support the statement by Muraro, *Vita nelle pietre*, 29, that a throne for the doge was located on the loggia between the four horses.

27. For the view that an installation at the Palazzo Ducale would have been rejected as an excessively imperial glorification of the doge, see Herzner, 53. He argues (54) that the horses had, instead, to be used to honor Mark and concludes that "Die Venezianer hatten, wenn man es recht bedenkt, wohl gar keine andere Wahl, als an der Fassade von San Marco einen Platz für die Pferde zu schaffen."

28. On the survival of Roman triumphal arches in the Middle Ages, see Greenhalgh, *Survival of Roman Antiquities*, 116f. On the interest in them and on Master Gregory's report on the arch associated with Augustus, see the references in chapter V, notes 23 and 24.

depictions of such structures in a variety of Roman works. One that, as previously noted, was certainly known in the Middle Ages is the relief on the Arch of Titus showing the spoils from Jerusalem (fig. 53). This relief is mentioned in a number of medieval sources, and its companion was probably the model, as was also pointed out earlier, of a late thirteenth- or early fourteenth-century miniature. Two four-horse teams are depicted on top of the arch on the right of the relief. But they are only details in a large, complex scene, and it is difficult to say whether any medieval spectators would have observed their presence. A knowledge of this practice might also have been transmitted to the Middle Ages by Roman coins or medallions with depictions of triumphal arches bearing chariots. It seems unlikely, however, that this custom was a consideration in the decision regarding the installation of the horses. There is no evidence of such highly developed antiquarian interests or of such literal-minded imitation of Roman sources—as opposed to Early Christian or Byzantine ones—elsewhere in Venetian culture of the thirteenth century.[29]

The relevance of the Roman medallion depicting the Basilica Ulpia is even more dubious. The relationship between this image and the west

According to Rushforth, "*Magister Gregorius*," 40, Gregory was probably referring to statues on top of the arch.

The Roman practice of placing statues on arches is referred to indirectly by Pliny, *Natural History*, ed. and trans. H. Rackham, Loeb Classical Library, 10 vols. (London and Cambridge, Mass., 1938–52), 9: 148f. (XXXIV, 27), but he does not specify that these included quadrigas. In a nearby passage (140–42 [XXXIV, 19]), however, he does record the Roman custom of erecting chariot groups in honor of those who had celebrated a triumph. Pliny's work was read during the Middle Ages. For the placement of statues in general and quadrigas in particular on Roman triumphal arches, see H. Kähler, "Triumphbogen (Ehrenbogen)," in *Paulys Realencyclopädie der classischen Altertumswissenschaft*, Reihe 2, vol. 7a (Stuttgart, 1939), 474–76.

For the report in the *Mirabilia* about the horses at the Mausoleum of Hadrian, see R. Valentini and G. Zucchetti, eds., *Codice topografico della città di Roma*, Fonti per la storia d'Italia 90, vol. 3 (Rome, 1946), 47 (21). It is curious that the text appears to indicate that the four of them were displayed separately in different parts of the building rather than as an ensemble: "In quattuor partes templi [i.e., the Mausoleum] fuere quattuor caballi aerei deaurati." On the *Mirabilia*, see most recently Kinney, "'Mirabilia urbis Romae,'" where the horses are mentioned, 220n. 29. Horses there are also mentioned by earlier Byzantine sources, as noted by Valentini and Zucchetti, 46n. 1. C. D'Onofrio, *Castel S. Angelo e Borgo tra Roma e Papato* (Rome, 1978), 71–75, reviews the matter. Following an earlier suggestion, he maintains unconvincingly that the horses at San Marco are those that originally stood on the Mausoleum of Hadrian.

29. For the visibility of the relief on the Arch of Titus, the medieval sources mentioning it, and the horses on top of the arch, see Pfanner, *Titusbogen*, 4, 50f., and 71f., and pl. 56, 4. For coins showing this arrangement, see P. V. Hill, *The Monuments of Ancient Rome as Coin Types* (London, 1989), 49–55, and figs. 82–84 and 86. On the interest in Roman coins during the Middle Ages, see Greenhalgh, *Survival of Roman Antiquities*, 223–29.

front of San Marco will have to be considered when the sources of the design of the thirteenth-century façades are studied more fully than they have been hitherto. But the parallels are certainly not precise enough to identify Trajan's building as the model for the west front of San Marco. Nor does the medallion clearly show a quadriga, for an additional pair of horses appears on either side of the central four. Since all are the same size and aligned at equal intervals, the ones in the middle do not stand out as an isolated group but simply take their places as members of a continuous row of eight animals. In any case, this suggestion about the medallion cannot be taken very seriously: it is unaccompanied by any attempt to explain why this particular image would have been chosen as the model for the west façade of San Marco.

Although it may seem at first oddly lame, Sansovino's contention that placing the horses before rather than on San Marco would have unduly encumbered the piazza deserves some consideration. The open spaces west and south of San Marco were of the greatest importance for the political and religious life of Venice. It was there that many of the most significant public ceremonies took place, and these often involved elaborate processions. Anything that seriously impeded freedom of movement would certainly have been rejected. Yet it is difficult to see that an installation of the horses in the piazza would have done so to an unacceptable degree. The two piers from St. Polyeuktos were placed before the south façade during the same thirteenth-century campaign and the *Pietra del bando* was also put at the southwest corner of the church at this time. Flagstaffs stood in front of San Marco by the late fifteenth century, as Bellini's view attests. But it is true that these objects are less obstructive than the horses would have been. Sansovino and Erizzo also asserted that the horses were placed on the loggia to protect them from further risk of damage. This is equally unconvincing. High columnar supports of the standard kind would have effectively kept them out of harm's way.[30]

One other matter may be relevant. In their position at the center of the loggia, the horses make a major contribution to the visual cohesion of the façade design. By means of their intrinsic visual interest and their bulk, they help to give it a strong central focus. Their gilding is particularly important in this regard since they stand at the center of a network of golden surfaces. This web includes not only the mosaics with their gold grounds but also the sculpture, much of which, as already noted, was

30. On the ceremonial use of the piazzas, see, e.g., E. R. Trincanato, "Rappresentatività e funzionalità di Piazza San Marco," in G. Samonà et al., *Piazza San Marco: L'architettura. la storia. le funzioni* (Venice, 1970), 79–91.

originally gilded as well. Since the gilding of the figural and ornamental stonework has almost entirely disappeared, the general effect is much diminished today. The original extent of these glittering surfaces and the contribution they make towards unifying the disparate components of the decoration are, however, apparent in Bellini's view of 1496 (fig. 30). Strengthening the façade's center visually was particularly desirable because of the breadth of the west front and the resulting diffuseness of its decoration. Although it is difficult to imagine that the ability of the horses to meet this need was the sole reason for their presence, their helpfulness in this regard may well have reinforced other considerations.[31]

Whether aesthetic considerations entered into the Venetians' treatment of the horses in any other respect is difficult to say. The possibility that the horses were valued for their beauty and realism as well as for their political and religious symbolism should not be dismissed out of hand. That such features of ancient works of art could still inspire admiration is well attested in the writings of thirteenth-century travellers. Intertwined with the garbled history and the tales of magic in the descriptions of the monuments of Constantinople by Robert de Clari and of those of Rome by Master Gregory, are expressions of genuine, if naive praise. Among the objects that elicit their admiration are bronze sculptures of animals. The extent of an appreciation of this kind in thirteenth-century Venice remains, however, among the imponderables of the situation.[32]

But the germane question here is different. It is whether a positive attitude in this respect might have been a determinant in choosing among the possible sites for the installation of the horses. Most accounts of the reuse of antiquities during the Middle Ages stress ideological considerations. This judgment is no doubt largely correct, although the possibility of exceptions must be kept open. In the case of the display of the horses in Venice, as noted earlier, political issues have been strongly emphasized in explanations of the decision to place them on the loggia.[33]

31. On the role of the gilding in harmonizing the sculpture and the mosaics, see the references in chapter II, note 23. Galliazzo, 12, aptly speaks of the horses as a "cerniera ideale" between the golden portions of the upper and lower sections of the west façade.

32. Robert de Clari, *Conquête de Constantinople*, 88 (XC and XCI). Gregory, *Narracio de mirabilibus urbis Rome*, 12–19 (3–8) and 30f. (32), and Gregory, *Marvels of Rome*, 19–24 (3–8) and 36 (32). On the latter, see the remarks of Osborne in Gregory, *Marvels of Rome*, viii and 6–10, and Kinney, "'Mirabilia urbis Romae,'" 218. On some of the parallels between the two authors, see Vin, *Travellers to Greece and Constantinople*, 305f.

33. On the role of aesthetic appreciation in the medieval reuse of antiquities, see Esch, "Spolien," 55–62. For the priority of political over aesthetic concerns in Venetian attitudes

If any Venetians at the time were also concerned with setting off the horses' aesthetic achievements to best advantage, they cannot be said to have been altogether successful in influencing the outcome. To be sure, the horses' central and elevated display makes them a prominent feature of the west façade and a commanding presence for the entire piazza. But in this position it is difficult to inspect them closely and to appreciate their artistic qualities fully. Complaints on this score begin to be heard in the sixteenth century. These criticisms are clearly a sign of the new attitudes towards antiquities and the new expectations about their presentation that arrived with the Renaissance. The new era demanded that antique works of art be displayed with the requisite dignity and in a manner that affords the viewer the best opportunity to admire them.

Sansovino's acknowledgment of the drawbacks in the display of the horses has already been noted. His remark and the accompanying explanation of the horses' installation on the façade were probably prompted by the far more pointed criticism by Enea Vico published a few years earlier in 1555. The latter maintained that the placement of these noble works failed to do them justice because they cannot be seen properly. Vico even proposed an alternative: installation of the horses on high plinths located either in front of San Marco or at the other end of the piazza. The display of the horses in Canaletto's *Capriccio* (fig. 39) corresponds closely to this proposal. Whether or not Canaletto's placement was inspired by the earlier suggestion, one of the purposes of his work may have been to demonstrate what an enlightened display of the horses might look like.[34]

Perceptions of the medieval placement of the horses as an unfortunate error did not cease with the eighteenth century. The closest that a proposal for rectifying it came to being realized was at the last turning point in the horses' history, one tied, like those earlier, to a great shift in world

towards the horses in general and in the decision regarding the installation in particular, see Perry, "St. Mark's Trophies," 28; Galliazzo, 77; and Herzner, 54.

34. For Sansovino's statement, see note 23 above. E. Vico, *Discorsi di M. Enea Vico Parmigiano sopra le medaglie de gli antichi* (Venice, 1555), 40: "La nobil Quadriga di quattro bellissimi, et integrissimi cavalli, collocati sopra la porta maggiore del Tempio di San Marco in Vinegia, opra rarissima, e si di arte, come d'ogn'altra cosa stupenda, e maravigliosa; e forse la piu bella di tutta Europa: a i quali, per esservi drieto alcune fenestrone di vetro oscure, manca talmente la veduta loro, che vengono come a non essere in quella consideratione, che una tanta arte, e si fatta bellezza meriterebbe d'essere havuta." He then proposes the alternative display. On Vico's discussion of the horses, see Perry, "St. Mark's Trophies," 37, who notes the link between Sansovino's and Vico's views, and Galliazzo, 15. For negative judgments of the placement of the horses in the eighteenth century, see Corboz, *Canaletto*, 2: 483–85. He notes (470) the relationship between Canaletto's *Capriccio* and Vico's proposal but regards direct inspiration as unlikely. His interpretation of the painting (485–92) is political.

power. After bringing Venetian independence to an end in 1797, Napoleon had the horses taken to Paris where they were displayed for a time on a triumphal arch at the Carrousel. Upon his defeat, the horses were returned in 1815 under the patronage of Francis I of Austria to whom Venice had fallen as one of the prizes of victory. Requested by the Hapsburg emperor to propose an alternative placement, the sculptor Canova suggested that they be displayed before the Palazzo Ducale facing the lagoon. Fortunately, the idea came to nothing, and the horses were returned to their original positions.[35]

The tenor of the post medieval disparagement is clear: these masterpieces of ancient sculpture ought to be seen standing on their own, as independent works, rather than integrated into the complex decoration of the west façade of San Marco. There, in that broad expanse, they are merely parts of a larger whole. It is hardly surprising that the thirteenth-century arrangement displeased those educated to appreciate the achievements of antiquity for their own sake. For them, the jumbling of the horses with other works of vastly less aesthetic significance—almost all of them medieval—must have sadly diminished the sculptures' impact. This integration, however, is precisely what those responsible for the decision to place the horses there had sought. They imposed it, moreover, despite the fact that this assimilation violated a well-established medieval precedent, a precedent that must have been partially known to some Venetians. There is an irony here. If the standard medieval practice in the display of such works had been followed, the later complaints would never have arisen. The question why this integration was so strongly desired remains to be answered satisfactorily. It has been argued here that there are serious shortcomings in all of the explanations of the installation of the horses on the loggia of the west façade of San Marco that have been proposed so far. One final possibility must now be considered.

35. On Napoleon's seizure of the horses, their display in Paris, their return to Venice, and Canova's proposal, see Galliazzo, 24–26 and 29–32, esp. 30.

Seeing the horses of San Marco in the larger context of the reuse of Roman statuary during the Middle Ages has yielded some important observations. The horses fit well into a group of large-scale freestanding antiquities that conveyed similar political messages. In varying measure, the others too served to commemorate a military victory, to reinforce a sense of common identity, and to proclaim a tie with ancient Rome. But these works were invariably displayed before or beside the church with which they were associated. None were mounted on the building itself. The installation of the horses on the loggia on the west façade of San Marco is, then, anomalous. The challenge presented by this fact has not been met by the explanations for their placement offered so far.

The full import of the role of the horses as the *Quadriga Domini* now comes into focus. Their embodiment of the trope that likened the Evangelists to a team of four horses drawing Christ's chariot is more than a fundamental aspect of their meaning here. It provides the most compelling explanation of the decision to install the horses on the west façade of San Marco rather than in an equally worthy position in the immediate vicinity of the church. Only in this position could they be seen juxtaposed with nearby reliefs of Christ and the Evangelists as crucial parts of a closely integrated composition that played an essential role in the program of the building's exterior decoration. The resulting group presented a compressed and forceful declaration of the importance of Venice's patron saint. It evoked with singular vividness Mark's place as one of the four co-equal Evangelists who conveyed the word of Christ to the world under his guidance. This statement of Mark's indispensable contribution to the triumph of Christianity was the ideal complement for the principal façade mosaics that so insistently set forth Venice's special relationship to him. Seeing the horses in this light is the best way to understand why their installation departs from the standard medieval

practice regarding the display of comparable Roman statuary. A further conclusion can be drawn. It is most unlikely that these ancient bronzes would have gained their unique places on the west façade of San Marco were it not for the new significance that the Greco-Roman four-horse chariot had acquired in the Christian Middle Ages.

It would be simplistic to argue that the decision regarding the display of the horses was based on a single factor. Just as they play more than one role, so more than one motive must have been involved. It is conceivable, moreover, that the decision was made in such a way that even those responsible for it could not say which of a variety of considerations was uppermost in their minds. These other motivations must have included the natural wish to give special prominence to the most impressive of the spoils from the victory over Byzantium. Knowledge of how convincingly the horses could assimilate the Venetian success of 1204 to the triumphs of the ancient caesars was certainly another strong impetus. The additional support they would lend to a claim to the legacy of Imperial Rome may also have appealed to rising ambitions in some Venetian circles. These ideological concerns must have greatly contributed to the desire to highlight the horses by placing them in a particularly conspicuous position. Perhaps the effectiveness of these life-size gilded bronzes in strengthening the visual organization of the church's main façade was yet another consideration. But the horses' role in loose topographical parallels with Constantinople, their placement in an area sometimes used by the doge, and the distant echo of Roman triumphal arches they introduce, belong in another category. They were, in all probability, simply the concomitants—no doubt welcomed, if noted—of a decision reached upon quite different grounds.

Important as the triumphalism of the horses' display undoubtedly was, the application of an *interpretatio christiana* to these ancient bronzes was not a mere pretext. It would be wrong to view it as a gloss introduced to provide the necessary justification for a step that was in fact inspired by other concerns. The idea was too systematically developed and too well coordinated with other aspects of the façade decoration for that. On the contrary, the horses demonstrate how thoroughly the religious and the political aspects of the façade program are fused. Indeed, they can now be seen to epitomize the inextricable blending of the sacred and the secular that pervades so much of the adornment of San Marco.

Decisions imply decision makers. Who first saw the possibility of using the horses as part of a *Quadriga Domini* composition and how the proposal to do so at the center of the west façade of San Marco was

weighed and approved will never be known. It would be futile to search for an equivalent of the famous document produced in the course of resolving a similar question some three hundred years later. As Michelangelo was completing his statue of David in early 1504, a meeting was held at the Opera del Duomo in Florence to discuss where it should be displayed. Minutes were kept and they record the names of the participants—among them some of the leading artists of the day—and also the opinions regarding the best site for the work. No such *verbale* is to be expected from the thirteenth century. Nor is it clear that the question of the disposition of the horses would have been addressed in quite this formal manner or that expert advice would have been so carefully solicited. Among those who might have had some say are the primicerius of San Marco, the church's highest ecclesiastical official, and also the procurators, laymen who helped look after its affairs. Since San Marco was the doge's chapel, it is likely that he or his representatives would have been involved. Perhaps the consultations included the *capomaestro* who oversaw the campaign, if one person had indeed been put in charge of the work on the façades. Given the wide diffusion of the idea of the *Quadriga Domini*, there is no need to assume advice or guidance from a person of unusual learning. Whether any of these individuals had encountered a twelfth- or early thirteenth-century depiction of the *Quadriga Domini* produced in northern Europe can only be conjectured. Although it is impossible to reconstruct the exact process by which the decision was reached, it can no longer be doubted that the matter was soberly deliberated.[1]

Seeing the horses as part of a *Quadriga Domini* composition does more than recover an important component of the meaning of the façade decoration of San Marco. Since it demonstrates that a hitherto unsuspected kind of meaning is present here, it opens a new perspective on the program as a whole. In the current view, the program is altogether straightforward. The façades celebrate the power and wealth of Venice and the relationship with St. Mark that legitimized them. Emblazoning the exterior with numerous trophies and with the story of Mark—told with an emphatic Venetian bias—ensured that even the least sophisti-

1. For the meeting concerning the *David*, see S. Levine, "The Location of Michelangelo's *David*: The Meeting of January 25, 1504," *Art Bulletin* 56 (1974): 31–49. On San Marco's primicerius, its procurators, and the power of the doge at the church, see Demus, *Church of San Marco*, 44–54, and *Mosaics of San Marco*, 2, 1: 30. See also R. C. Mueller, "The Procurators of San Marco in the Thirteenth and Fourteenth Centuries: A Study of the Office as a Financial and Trust Institution," *Studi Veneziani* 13 (1971): 108–14.

cated viewer would take the point. As it is usually read today, this ideo-
logical statement is notable primarily for its bluntness and bombast.

What has been established here regarding the role of the horses dem-
onstrates that the program is a richer and more complex affair. Nothing
has emerged to dislodge the self-glorification of Venice from its core.
But it is now clear that at least one aspect of this celebration is couched
in a rhetoric that is artful indeed. In the final analysis, it is the cogency
of the use of the horses that is most striking. Nothing in the prevailing
conception of the genesis of the façades anticipates the keenness of mind
to which these bronzes owe their presence here. Especially noteworthy is
the perspicacity of the initial recognition that the horses could be used to
evoke the *Quadriga Domini*. The economy of expression and the daring
with which this was carried out are also impressive and they resulted in a
unique visual metaphor. Because of its authenticity and restraint, the San
Marco version is a more telling image of the relationship between the
Evangelists and the quadriga of the Lord than any of the other medieval
visualizations. That the horses would, at the same time, liken the events
of 1204 to the conquests of ancient Rome must have appealed strongly to
the same mentality. This exploitation of the horses' capacity to bear
multiple meanings is itself one of the more remarkable aspects of the
program. It remains to be seen whether other features of the thirteenth-
century façade decoration of San Marco were also the outcome of a
thought process that was rather less rudimentary than previously sup-
posed.

The Galliazzo Thesis on the Original
Positions of the Horses at San Marco

According to Vittorio Galliazzo, the original arrangement of the horses at San Marco has been altered in some respects. His reconstruction (fig. 34) incorporates his views. The principal change that he believes took place affected their position on the loggia. His argument is largely based on discrepancies between the display of the horses depicted in the Porta Sant'Alipio mosaic and their present installation (figs. 7 and 29). In the mosaic the horses are centered against the intercolumniations of the arcade behind them, but today they are not aligned with these openings. Galliazzo interprets the mosaic to mean that in the original installation the hind legs of each horse rested on one of the four panels of the parapet between the columns in the arcade. Only their forelegs were supported on columns. They were, in other words, at the back of the loggia. At present, the horses are set at its front and each is supported by two columns, one under the single lowered foreleg and the other under the two hind legs. Demus also appears to believe that the horses were once seen isolated within the intercolumniations. He asserts that the mosaic shows the "original state" of the horses and the intended visual effect, but does not say explicitly that they have been moved.[1]

This change took place, in Galliazzo's view, around the middle of the fifteenth century in conjunction with other modifications in this area. This is when, as will be recalled, the original decoration in the lunette behind the horses was replaced with the *finestrone*. He argues that the description of the horses by Ciriaco d'Ancona who saw them in 1436 implies that they were still in their original position. The change must have taken place before 1496, the date of Bellini's view (fig. 30) which shows the new arrangement. As Galliazzo points out, the capitals under the forelegs of two of the horses belong to the fourteenth or fifteenth

1. Galliazzo, 4, and Demus, *Church of San Marco*, 113f. For a close-up view of the horses in the mosaic, see *Cavalli di S. Marco*, fig. 107.

century and the other two in this position appear to be modern copies of them. Those under the rear legs are considerably older: two date from the sixth century, while a third is from the thirteenth and the fourth is a copy made in 1843 of the third. The older capitals in the rear, then, would be the ones that originally supported the forelegs, and the newer ones were produced at the time of the change to provide a new forward support. According to Galliazzo, the horses were moved forward to make their display more "secure and scenographic."[2]

Because of the large number of changes that have taken place in the façades, it would certainly be foolhardy to take it for granted that the horses' positions have remained undisturbed since the second quarter of the thirteenth century. The presence of the fourteenth- or fifteenth-century capitals under the forelegs proves that the original display of the horses must have undergone some renovation. But the date of these capitals is not itself strong evidence for a major change in the display of the horses. The replacement of earlier ones would not be surprising at a time when so much other work was being carried out in this area. Nor should the disparities between the depiction of the horses in the Porta Sant'Alipio mosaic and the present installation be taken as sure indications of the extent and nature of possible modifications. As noted earlier, the mosaic is accurate in its general depiction of the west façade, but it cannot be trusted in many details.[3]

The idea that the horses were once set at the back of the loggia should be rejected for a number of reasons. The evidence of the mosaic in this regard is highly suspect. Rendering the horses as glistening shapes against the dark intercolumniations of the arcade behind them is probably simply one of the numerous small liberties that the mosaicist took with the actual appearance of the façade for both aesthetic and practical reasons. The contrast between the horses and their background in the mosaic serves to isolate and emphasize them. Moreover, positioning them within the openings also enabled the artist to avoid some difficulties: it would have been harder to depict the horses with parts of their bodies substantially overlapping the columns or the sides of the arch.

Galliazzo's reconstruction is also open to practical objections. Even in their present positions, the horses leave only a narrow passage for access to the north and south sections of the western loggia from the interior

2. On the date of the change and on the capitals, see Galliazzo, 8–10 and 86. On the capitals, see also Deichmann, *Corpus der Kapitelle*, 132f.nos.605–12. For the introduction of the *finestrone*, see above, pages 26 and 49f..

3. On the mosaic's minor liberties, see also above, page 31.

of the church through the door at the center of the arcade behind them (figs. 7 and 8). If the horses were set further back, this access—as well as movement between the two sections—would have been even more constricted. Indeed, it might have been impossible. With the horses in the position proposed by Galliazzo, the doorway would only have given on to the limited space between the two central ones. This placement of the horses would hardly have been conducive to the kind of public appearance by the doge and his entourage on the loggia that has been envisaged on the basis of Petrarch's description. Of course, there might have been room for passage in front of the horses, if the stepped backing to the apex of the arch over the central portal were less massive. There is, however, no obvious reason to think that this structure has changed since the thirteenth century.

Galliazzo's reconstruction is unconvincing on aesthetic grounds as well. The horses would have been so far back that the view of them from the Piazza would have been significantly impaired. Indeed, they would have been invisible to a spectator standing close to the façade. It is hard to understand why the obvious advantages of placing them at the forward edge would not have been recognized initially. Whatever the justice of the observation, repeated many times since the Renaissance, that the horses seem poised to leap to the Piazza below or take flight, this is clearly the most effective staging.[4]

Finally, the present arrangement corresponds, as demonstrated earlier, to a well-known form of installation for large freestanding antique sculpture during the Middle Ages. No medieval display in which such a work rests partly on a column and partly on some other support has so far come to light.

The difference in the position of the horses with respect to the intercolumniations behind them is not the only discrepancy between the present arrangement of the horses and that seen in the Porta Sant'Alipio mosaic. In the mosaic, the inner legs of the inner two horses are raised, but today it is their outer ones that are in the air. The present configuration is already seen in Bellini's view. As his reconstruction indicates, Galliazzo believes that the mosaic accurately records the original one.

One explanation of the discrepancy in the position of the legs is that the bodies of the inner two horses were interchanged during the

4. According to Galliazzo, 8, 36, and 86, the suggestion of imminent movement was once more pronounced. He argues that the abaci of the rear capitals were added in the nineteenth and twentieth centuries and that in the fifteenth-century installation the horses would have been tilted slightly with the hind parts lower.

fifteenth-century renovations. Such an interchange is conceivable, for the heads and bodies can be detached. But it would probably be a mistake to infer from the evidence of the Porta Sant'Alipio mosaic that this had occurred. The mosaic's rendering of the positions of the forelegs is best understood as simply another understandable liberty. Depicting them in this manner strengthens the visual relationship within each of the lateral pairs: this way the positions of the legs as well as those of the heads are symmetrical. There are several other inaccuracies in the representation of the movements of the horses. These include the splaying of the bent forelegs to the side, the heightening of the level to which the forelegs are raised, and the transformation of the slight turn of the heads to the side into a right angle. Most of these modifications help reduce the horses to two-dimensional forms and thus make them easier to represent. They also endow the animals with a rhythmic, almost dancelike movement. Indeed, as Galliazzo himself notes, they now resemble a heraldic emblem. Given these considerations, it seems best to assume that the bodies of the inner two horses are still in the same position that they occupied in the thirteenth century.[5]

Galliazzo raises the possibility of another interchange among the horses. In his reconstruction of the original configuration of the horses in antiquity, the heads of the outer two horses turned outward rather than inward as today. He argues that the present arrangement resulted from an interchange of the heads of these two horses. At one point he states that this exchange occurred when the horses were installed at the Hippodrome, but elsewhere he suggests that it may have taken place during the fifteenth-century renovation.[6] His reconstruction of the thirteenth-century scheme, however, shows the present arrangement. The heads of the outer two horses already turn inward in the Porta Sant'Alipio mosaic. There appears to be no reason to reject the evidence of the mosaic in this case.

5. For the defense of the accuracy of the mosaic in the depiction of the legs and for the horses as a heraldic emblem, see Galliazzo, 4. On the "relative ease" with which the heads and bodies can be detached and on the fastenings that connect them, see Galliazzo, 85 and 142f. For the view that the mosaic's depiction of the position of the legs is one of its liberties, see also F. Valcanover, "I cavalli di S. Marco nella pittura veneziana," *Cavalli di S. Marco*, 95, and L. Vlad Borrelli, "Interrogativi sui cavalli di S. Marco," *Storia dell'Arte* 38/40 (1980): 43f. and 47f.

6. Galliazzo, 8, 143, 155, 234–36, and 248, and figs. 32, 161, and 163.

Giotto's Representation of the Horses
of San Marco at the Arena Chapel

As has long been recognized, two of the horses of San Marco appear in the *Expulsion of the Merchants from the Temple* (fig. 58) in Giotto's cycle of frescoes at the Arena Chapel in Padua. The horses are the inner pair among the four animals that flank the gables above the building's portico. (The outer two are lions.) The horse on the left in the fresco with its left foreleg raised and its head turned to its right corresponds precisely to the horse at the right end of the team on the loggia in the present arrangement. The other horse in the fresco is more loosely related to those in Venice since its head is not turned. The correspondence between the two groups even extends to their positions on the buildings. Both are set on an intermediate level above arched entryways projecting from the main volume of the structure that continues up behind them. Giotto's frescoes in the Arena Chapel were completed in 1305 or shortly thereafter. He presumably became familiar with the ancient bronzes at San Marco by visiting nearby Venice during his stay in Padua.[1]

Since the horses are merely details in Giotto's complex scene, it is understandable that their relationship to those at San Marco has only

1. For recent accounts in which this relationship is noted, see L. Tintori and M. Meiss, *The Painting of the Life of Saint Francis at Assisi* (New York, 1962), 172; D. Gioseffi, *Giotto architetto* (Milan, 1963), 47; L. M. Bongiorno, "The Theme of the Old and the New Law in the Arena Chapel," *Art Bulletin* 50 (1968): 19; and A. Smart, *The Assisi Problem and the Art of Giotto* (Oxford, 1971), 97 and also 177, where it is suggested that the horses in the *Vision of the Fiery Chariot* in the St. Francis cycle at Assisi may also have been based on the Venetian ones. A. Prosdocimi, "Classicismo di Giotto: Un ricordo dei cavalli di S. Marco e una citazione dalla Colonna Traiana," *Bollettino del Museo Civico di Padova* 68 (1979): 9–11, shows no awareness of the earlier discussions and adds nothing to them. V. Mariani, *Giotto e l'architettura* (Milan, 1967), provides a good reproduction of this part of the fresco (pl. XII). This relationship does not appear to have been considered in the literature on the horses of San Marco.

Bongiorno, 19, and Prosdocimi, 11, assert that the lions flanking the horses in the *Expulsion* are based on the one on the Piazzetta column in Venice. Given the ubiquity of

been noted in passing. In the present context, however, the matter is, potentially, of considerable importance. It is only natural to suppose that the context in which Giotto has reproduced the horses reveals something about their original meaning at San Marco. At a minimum, the *Expulsion* seems to show how that meaning was perceived by a great Italian painter some seventy-five years after the horses were installed. Giotto's use of them, therefore, calls for careful consideration here.

The horses in Padua are the horses of San Marco, but the Temple in the fresco is not based upon the Venetian church. As has been recognized, Giotto's building is modeled on the lower part of the façade of the Duomo in Siena (fig. 57). The most significant parallels are the triple openings, the gables with central medallions over the round arches, and the sculpture depicting animals that stands just above or below the lower corners of the triangular forms. None of these features are found at San Marco. The fact that the gables in both contain medallions is particularly telling, despite the difference in the circles' contents. These medallions distinguish the Siena façade from a number of similar ones.[2]

The horses in Giotto's *Expulsion* have a definite logic in this regard. The outer two animals on the façade of the Duomo in Siena are also horses, the inner group consists of two lions, and the intermediate pair are a griffin and an ox. What Giotto has done, in effect, is to reproduce four of the Siena animals, namely, the two horses and the two lions. At the same time, he substituted two of the horses at San Marco for the Sienese ones. It has been plausibly suggested that the latter were based upon an antique source, the Horsetamers in Rome. Replacing them with

lions in medieval art, some concrete evidence is needed to support this claim. Bongiorno's statement that the positions are similar is not strictly accurate: the Venetian lion extends its forelegs sharply forward, but the lions at the Arena Chapel do not.

The belief that a fourteenth-century source reports that a work by Giotto existed in Venice rests upon an unreliable variant reading. See P. Murray, "Notes on Some Early Giotto Sources," *JWCI* 16 (1953): 75.

2. The relationship of Giotto's building to the façade of the Duomo in Siena is pointed out by P. Cellini, "La 'facciata semplice' del Duomo di Siena," *Proporzioni* 2 (1948): 56–59. On Giotto's representation of architecture in the Arena Chapel, see W. Euler, *Die Architekturdarstellung in der Arena-Kapelle: Ihre Bedeutung für das Bild Giottos* (Berlin, 1967), and J. White, "Giotto's Use of Architecture in 'The Expulsion of Joachim' and 'The Entry into Jerusalem' at Padua," *Burlington Magazine* 115 (1973): 439–47. They neither explicitly endorse nor reject Cellini's view (Euler, 61, and White, 439).

Cf. Tintori and Meiss, *Painting of the Life of St. Francis*, 172; Mariani, *Giotto*, caption to pl. XII; and Gioseffi, *Giotto architetto*, 47. Without considering Cellini's observations, they believe that Giotto's Temple is based on San Marco. G. Vigorelli and F. Baccheschi, *L'opera completa di Giotto* (Milan, 1966), 103no.77, leave open the question whether the source was the Sienese building or the Venetian one.

two ancient bronzes in Venice was, then, quite apt. Finally, Giotto inverted the relationship between the horses and the lions at Siena by placing the former rather than the latter in the center. His horses, like those in Venice, are in the middle section of the façade. He has even preserved something of the pairing of the latter through the turn of the heads of the second and fourth animals from the left.[3]

The design of this portion of the façade of the Duomo in Siena and the execution of much of its sculpture, including the horses, are the work of Giovanni Pisano. His involvement with the project extended from the mid-1280s to the late 1290s. Giovanni, like Giotto, was engaged by Enrico Scrovegni to decorate the Arena Chapel and he contributed the signed Madonna and Child that now stands on the altar. It is usually said to date from about 1305. The angels that accompany the statue are generally attributed to his workshop. It should not, of course, be assumed that the painter and the sculptor actually worked side by side in Padua, since Giovanni may have carved the Madonna and Child elsewhere. Yet it is possible that their endeavors for Scrovegni brought the two artists into contact. Giovanni's work at the Duomo in Siena was certainly one of the major artistic enterprises of the day. If Giotto was not already familiar with what was taking place there, this might have been how he gained his knowledge of it.[4]

There is another way to understand the presence of the horses on the façade of the Temple in the Paduan *Expulsion*. Giotto's dependence upon antique sources for a number of figures and motifs in the frescoes of the Arena Chapel and elsewhere is well known.[5] Although a comprehensive

3. On the source of the Sienese horses, see M. Seidel, "Die Rankensäulen der Sieneser Domfassade," *Jahrbuch der Berliner Museen* 11 (1969): 141–45. For the possible meaning of the Siena animals, see the citations in chapter VI, note 5.

4. On Giovanni's role at the Duomo of Siena, see Middeldorf Kosegarten, *Sienesische Bildhauer am Duomo Vecchio*, 28–32 and 69–128, and White, *Art and Architecture*, 114–22. For differing views on the influence the artists exerted on one another through their work in Padua, see White, 330, and Mellini, *Giovanni Pisano*, 175. According to Keller, *Giovanni Pisano*, 70, the three sculptures were made in Pisa and sent to Padua. As E. Borsook, *The Mural Painters of Tuscany from Cimabue to Andrea del Sarto*, 2nd ed. (Oxford, 1980), 8, points out, the precise date of Giovanni's Madonna and Child and its intended place of display at the chapel are unknown.

5. For discussion of Giotto's use of antique sources, see, e.g., Panofsky, *Renaissance and Renascences*, 68, 137, 148, and 152–54; A. Markham Telpaz, "Some Antique Motifs in Trecento Art," *Art Bulletin* 46 (1964): 372–76; Smart, *Assisi Problem*, 94–106; and H.-W. Kruft, "Giotto e l'antico," in *Giotto e il suo tempo: Atti del congresso internazionale per la celebrazione del VII centenario della nascita di Giotto: 24 settembre–1 ottobre 1967* (Rome, 1971), 169–76.

account of this aspect of his art is lacking, one fundamental point is clear. Such borrowings are not random. These quotations, as might be expected, often play a meaningful role in the scenes into which they have been inserted. This may well be the case with the reflection of the horses in the Paduan fresco. It is possible that the horses in the painting were intended to call to mind an Old Testament episode that resembles Christ's expulsion of the merchants from the Temple. An earlier cleansing of the Temple of Solomon had been carried out by King Josiah (4 Kings 23:11). Among the objects that he removed were sculptures of horses decorating the entrance to the house of the Lord. They had been introduced by apostate kings of Judah and apparently were idols. The presence of horses on Giotto's Temple is, therefore, appropriate. So too is his use of those at San Marco as a model. The horses taken down by Josiah are said to be those of the sun, and the latter's *currus* is mentioned in the same verse.

There are a number of possible objections to reading the horses in Giotto's *Expulsion* as a reference to those removed by Josiah. Josiah's cleansing does not appear among the standard Old Testament prefigurations in medieval exegeses of Christ's expulsion of the merchants from the Temple. In addition, the presence of horses that had been taken away by Josiah would be an anachronism in the time of Christ. Finally, the position of the horses on Giotto's Temple can be explained by that of the horses on the façade of the Duomo in Siena.[6]

Yet the placement of the horses in Giotto's Temple corresponds precisely to the position in which the horses removed by Josiah are said to have been found. Giotto need not have followed the Siena façade to the extent of reproducing its horses on the front of his Temple. Indeed, he omitted all the rest of its extensive sculptural decoration except for the two lions. That he retained the horses may signify a recognition that their presence was fully justified because of 4 Kings 23:11. Statuary clearly suggesting idolatry is a feature of some medieval depictions of the Temple of Solomon. A partial precedent for this juxtaposition of an Old Testament cleansing of the Temple with one from the New is found in the decoration of another Italian church. In the typological cycle in the stained glass windows in the choir of the church of San Francesco at Assisi the scene of Christ expelling the merchants from the Temple is

6. For Old Testament episodes linked typologically with Christ's expulsion of the merchants from the Temple in medieval art, see W. Molsdorf, *Christliche Symbolik der mittelalterlichen Kunst*, 2nd ed. (Leipzig, 1926), 49f.nos. 260–69.

paired with an Old Testament scene of a purification of the Temple through the destruction of idols. It is unclear, however, which of a number of possible episodes the latter was intended to represent. These windows date from the middle of the thirteenth century.[7]

Interpreting the presence of the horses as a reference to those removed by Josiah gains some plausibility from the fact that this allusion would help to support an unusual conception of the Expulsion that is presented here. Christ's actions in the Temple were directed at two groups. The first consisted of the moneychangers who exchanged Jewish coins for Gentile ones which were not permissible for offerings, and the second was made up of the merchants selling animals to be used in sacrifices. Both groups are mentioned by Matthew 21:12–16, Mark 11:15–18, and John 2:13–22, but their accounts of the dealers in animals differ in one respect. Matthew and Mark only mention pigeons, while John, whose account contains a number of additional details, refers to oxen and sheep as well. The sheep and oxen became standard features of the iconography of the scene and they appear prominently at the left and right in Giotto's version.[8]

Christ's treatment of the other group of traders, however, is only hinted in the Arena Chapel fresco. Matthew, Mark, and John all say that Christ overturned the moneychanger's tables. The upsetting of the table with its coins or scales forms an important, sometimes dominant element in many representations. Yet in Giotto's version the only reference to this dramatic action is the table already upside down before Christ, a detail of this crowded scene that nearly escapes attention. In Padua, the

7. The presence of idols in medieval depictions of the Temple is noted by C. H. Krinsky, "Representations of the Temple of Jerusalem before 1500," *JWCI* 33 (1970): 8f. and 12. One of the examples she cites is a mid-eleventh-century Ottonian miniature depicting the Presentation of the Virgin in the Temple (Munich, Bayer. Staatsbibl., Clm 15713, fol. 1v). Two figures based on the ancient *Spinario* appear on top of columns in the standard medieval formula for idols (Krinsky, fig. 1b). On the same motif in a closely related miniature (New York, Pierpont Morgan Lib., Glazier Ms. 44, fol. 2r), see Frugoni, "L'antichità," 14, and fig. 2. The negative associations of the *Spinario* during the Middle Ages are well known. See, e.g., W. S. Heckscher, "Dornauszieher," in *Reallexikon zur deutschen Kunstgeschichte*, vol. 4 (Stuttgart, 1958), 290–94. Krinsky's other example is the scene of the young Christ teaching in the Temple in Duccio's *Maestà* of 1308–11. See J. White, *Duccio: Tuscan Art and the Medieval Workshop* (London, 1979), 121, and fig. 89, and portfolio 16.

On the Assisi window, see R. Haussherr, "Der typologische Zyklus der Chorfenster der Oberkirche von S. Francesco zu Assisi," in *Kunst als Bedeutungsträger: Gedenkschrift für Günter Bandmann*, ed. W. Busch, R. Haussherr, and E. Trier (Berlin, 1978), 105f.

8. Giotto's dependence on John in this scene is noted by M. von Nagy, *Die Wandbilder der Scrovegni-Kapelle zu Padua: Giottos Verhältnis zu seinen Quellen* (Bern, 1962), 24.

cleansing of the Temple is achieved almost exclusively, it seems, by means of the expulsion of the animals and those who sold them. This downplaying of the role of the moneychangers was probably due to the sensitivity of the chapel's donor, Enrico Scrovegni, about his father's infamy as a usurer. The horses on the Temple's façade take on an additional relevance in this context: by stressing the importance of the removal of animals in the earlier cleansing of the Temple as well, they help justify the neglect of the moneychangers in the later one.[9]

The possibility that Giotto's use of the horses might shed light on their original function in Venice was the starting point of this discussion. It is hardly conceivable, however, that the horses at San Marco, like those in Giotto's fresco, were meant to recall the sculpture removed by Josiah. The latter were pagan intrusions at Solomon's Temple and they carried strongly negative connotations. It is clear that the statuary that sometimes appears in medieval depictions of the Temple is meant to compromise the old faith. It was one thing for Giotto to include in the *Expulsion* the idols that sinful Jewish kings had permitted to defile Solomon's Temple: that had been the sanctuary of a religion that was about to be superseded. It was quite another to refer to them on the façade of the church of Venice's patron saint. The idea that Giotto mistakenly believed that the bronzes at San Marco were intended to refer to those removed by Josiah should also be rejected. Given the multiplicity of factors that shaped his representation of the Expulsion, this implausible supposition is unnecessary. It is possible, of course, that the decoration of San Marco does contain some allusions to the Temple of Solomon. But

9. The observations regarding the downplaying of the moneychangers in Giotto's *Expulsion* and the proposed explanation are those of Tintori and Meiss, *Painting of the Life of St. Francis*, 172f. On this point, see also R. H. Rough, "Enrico Scrovegni, the *Cavalieri Gaudenti*, and the Arena Chapel in Padua," *Art Bulletin* 62 (1980): 27f. The fullest discussion of the importance of the theme of usury in the paintings of the Arena Chapel is U. Schlegel, "Zum Bildprogramm der Arena Kapelle," *Zeitschrift für Kunstgeschichte* 20 (1957): 125–46. Her argument is based upon the *Betrayal of Judas* and motifs in other scenes. She does not discuss the *Expulsion* which is adjacent to the *Betrayal* and whose visual and narrative ties to it have been widely noted. On the latter point, see, e.g., Tintori and Meiss, 178, and M. A. Lavin, *The Place of Narrative: Mural Decoration in Italian Churches, 431–1600* (Chicago, 1990), 48f.

The emphasis on the animals in the *Expulsion* may form part of yet another of the well-known relationships among the Arena Chapel scenes. The bolting oxen and sheep contrast with the tranquil creatures in the Nativity directly opposite. The latter include sheep whose shepherds have come to adore the child and also, as tradition dictated, the ox and ass of Isaiah 1:3.

the few suggestions of this kind that have been made so far do not, for the most part, carry conviction.[10]

Although several aspects of the role of the horses in Giotto's fresco have been clarified, intriguing questions remain. Did Enrico Scrovegni have specific motives for these references to Venice and Siena and for their introduction in this particular scene? These problems, however, raise a different set of issues and they lead too far from present concerns to be pursued here.

10. For recent examples of such suggestions, see Harrison, *Temple for Byzantium*, 143, and M. Vickers, "Wandering Stones: Venice, Constantinople, and Athens," in *The Verbal and the Visual: Essays in Honor of William Sebastian Heckscher*, ed. K.-L. Selig and E. Sears (New York, 1990), 231f.

The Lord's Quadriga and Dante's "Procession of Holy Scripture"

(*Purgatorio* XXIX)

Sotto così bel ciel com'io diviso
 ventiquattro seniori, a due a due,
 coronati venien di fiordaliso. 84
Tutti cantavan: "*Benedicta* tue
 ne le figlie d'Adamo, e benedette
 sieno in etterno le bellezze tue!" 87
Poscia che i fiori e l'altre fresche erbette
 a rimpetto di me da l'altra spondo
 libere fuor da quelle genti elette, 90
sì come luce luce in ciel seconda,
 vennero appresso lor quattro animali,
 coronati ciascun di verde fronda. 93
Ognuno era pennuto di sei ali;
 le penne piene d'occhi; e li occhi d'Argo,
 se fosser vivi, sarebber cotali. 96
A descriver lor forme più non spargo
 rime, lettor; ch'altra spesa mi strigne,
 tanto ch'a questa non posso esser largo; 99
ma leggi Ezechïel, che li dipigne
 come li vide da la fredda parte
 venir con vento e con nube e con igne; 102
e quali i troverai ne le sue carte,
 tali eran quivi, salvo ch'a le penne
 Giovanni è meco e da lui si diparte. 105
Lo spazio dentro a lor quattro contenne
 un carro, in su due rote, trïunfale,
 ch'al collo d'un grifon tirato venne. 108

Esso tendeva in sù l'una e l'altra ale
 tra la mezzana e le tre e tre liste,
 sì ch'a nulla, fendendo, facea male. 111
Tanto salivan che non eran viste;
 le membra d'oro avea quant'era ucello,
 e bianche l'altre, di vermiglio miste. 114
Non che Roma di carro così bello
 rallegrasse Affricano, o vero Augusto,
 ma quel del Sol saria pover con ello; 117
quel del Sol che, svïando, fu combusto
 per l'orazion de la Terra devota,
 quando fu Giove arcanamente giusto. 120
Tre donne in giro de la destra rota
 venian danzando; l'una tanto rossa
 ch'a pena fora dentro al foco nota; 123
l'altr' era come se le carni e l'ossa
 fossero state di smeraldo fatte;
 la terza parea neve testé mossa; 126
e or parëan de la bianca tratte,
 or de la rossa; e dal canto di questa
 l'altre toglien l'andare e tarde e ratte. 129
Da la sinistra quattro facean festa,
 in porpore vestite, dietro al modo
 d'una di lor ch'avea tre occhi in testa. 132
Appresso tutto il pertrattato nodo
 vidi due vecchi in abito dispari,
 ma pari in atto e onesto e sodo. 135
L'un si mostrava alcun de'famigliari
 di quel sommo Ippocràte che natura
 a li animali fé ch'ell' ha più cari; 138
mostrava l'altro la contraria cura
 con una spada lucida e aguta,
 tal che di qua dal rio mi fè paura. 141
Poi vidi quattro in umile paruta;
 e di retro da tutti un vecchio solo
 venir, dormendo, con la faccia arguta. 144
E questi sette col primaio stuolo
 erano abitüati, ma di gigli
 dintorno al capo non facëan brolo, 147
anzi di rose e d'altri fior vermigli;

giurato avria poco lontana aspetto
 che tutti ardesser di sopra da' cigli. 150
E quando il carro a me fu a rimpetto,
 un tuon s'udì, e quelle genti degne
 parvero aver l'andar più interdetto,
fermandosi ivi con le prime insegne. 154

Beneath so fair a sky as I describe came four and twenty
elders, two by two, crowned with lilies; all were singing,
"Blessed art thou among the daughters of Adam, and blessed
forever be thy beauties." (vv. 82–87)

When the flowers and the other fresh herbage opposite me
on the other bank were left clear of those chosen people, even
as star follows star in the heavens, four living creatures came
after them, each crowned with green leaves; and each of them
was plumed with six wings, the plumes full of eyes, and the
eyes of Argus, were they alive, would be such. To describe
their forms, reader, I do not lay out more rhymes, for other
spending constrains me so that I cannot be lavish in this; but
read Ezekiel who depicts them as he saw them come from the
cold parts, with wind and cloud and fire; and such as you shall
find them on his pages, such were they here, except that, as to
the wings, John is with me, and differs from him. (vv. 88–105)

The space within the four of them contained a triumphal
chariot on two wheels, which came drawn at the neck of a
griffin; and he stretched upwards one wing and the other
between the middle and the three and three bands so that he
did harm to none by cleaving. So high they rose that they
were lost to sight; he had his members of gold so far as he was
bird, and the rest was white mixed with red. Not only did
Rome never gladden an Africanus or an Augustus with a
chariot so splendid, but even that of the Sun would be poor to
it—that of the Sun which, going astray, was consumed at
devout Earth's prayer, when Jove in his secrecy was just. (vv.
106–20)

Three ladies came dancing in a round at the right wheel,
one of them so ruddy that she would hardly have been noted
in the fire; another was as if her flesh and bones had been of
emerald; the third seemed new-fallen snow; and they seemed
to be led, now by the white, now by the red, and from this

one's song the others took their movement fast and slow. By the left wheel four other ladies made festival, clothed in purple, following the measure of one of them that had three eyes in her head. (vv. 121–32)

Behind the whole group I have described I saw two old men, unlike in dress but alike in bearing, venerable and grave: the one showed himself of the household of that great Hippocrates whom nature made for the creatures she holds dearest; the other showed the contrary care, with a sharp and shining sword, such that on this side of the stream it made me afraid. Then I saw four of lowly aspect; and behind them all an old man coming alone, asleep, with keen visage. And these seven were clad like the first band, but they had no garland of lilies around their heads, rather of roses and of other red flowers: one who viewed them from short distance would have sworn that all were aflame above their eyebrows. And when the chariot was opposite to me, a thunderclap was heard: and those worthy folk seemed to have their further march forbidden, stopping there along with the banners in front. (vv. 133–54)[1]

This passage from Dante's *Commedia* is of considerable interest here. It contains, first of all, one of the most imaginative uses of the *Quadriga Domini* during the Middle Ages. It is also one of the sources of another Venetian image that, like the San Marco composition, incorporates this theme. The work in question is Titian's *Triumph of Faith*. The relationship between Titian's print and Dante's verses was discussed by Erwin Panofsky in *Problems in Titian: Mostly Iconographic*, published in 1969, a year after his death. Panofsky recognized the general relevance of the medieval tradition under consideration here, and Dante's use of it is one of the two examples he cites. Because this medieval tradition has now come into sharper focus, it is possible to amplify his analysis of the iconography of the print. But these lines from the *Commedia* must first be considered more fully.

The climax of *Purgatorio* begins with the great pageant pictured in the tercets of the second half of Canto XXIX. Most of the symbolism of the procession is transparent. As has long been recognized, its principal

1. Text and translation from Dante Alighieri, *The Divine Comedy: Purgatorio*, 1, *Italian Text and Translation*, trans. C. S. Singleton (Princeton, 1973), 320–25.

members are allegorical figures representing the individual books that
make up the Bible as a whole. The twenty-four elders who come first
stand for the constituent parts of the Old Testament. The second group,
which opens with four animals who are obviously the symbols of the
Evangelists, consists of the components of the New Testament.[2]

The centerpiece of the procession is a triumphal chariot (v. 107:
"carro . . . triünfale") drawn by a griffin and flanked by seven dancing
ladies. Both chariot and griffin will play important roles in the events
described in the final section of the *Purgatorio*. Although the car has long
been identified as the Church and the creature who draws it as Christ,
difficulties with these views have recently been noted. The idea that the
chariot stands for the Church has been questioned because of the vehi-
cle's "many pagan associations" in this passage, because of its final de-
struction, and because of the difficulty in applying this interpretation
consistently. It has also been shown that there is no precedent for the
griffin as a symbol of Christ.[3]

2. For an extensive bibliography to 1971 on the procession and for a general discussion, see
A. Ciotti, "Processione mistica," in *Enciclopedia Dantesca*, 2nd ed., vol. 4 (Rome, 1984), 685–
89. Recent discussions include P. Dronke, "The Procession in Dante's *Purgatorio*,"
Deutsches Dante-Jahrbuch 53/54 (1978–79): 18–45 (reprinted in his *Latin and Vernacular
Poets of the Middle Ages* [London, 1991], and in abridged form in *Cambridge Readings in
Dante's Comedy*, ed. K. Foster and P. Boyde [Cambridge, 1981]); P. S. Hawkins, "Scripts for
the Pageant: Dante and the Bible," *Stanford Literature Review* 5 (1988): 75–92; and
P. Armour, *Dante's Griffin and the History of the World: A Study of the Earthly Paradise
(Purgatorio, Cantos XXIX-XXXIII)* (Oxford, 1989). My term for this pageant is taken from
C. S. Singleton, "The Pattern at the Center," in his *Dante Studies*, vol. 1, *Commedia:
Elements of Structure* (Cambridge, Mass., 1954), 47. His discussion (46–49) of the Biblical
nature of the procession is particularly acute.

As has been frequently noted, Dante's idea that there are twenty-four books in the Old
Testament and their identification with the twenty-four elders of Apocalypse 4 stem from
the prologue of Jerome to Kings, often known as the Prologus Galeatus (*PL* 28, 600) and
widely used as a preface for these books in medieval Bibles (Berger, "Préfaces jointes aux
livres de la Bible," 17f. and 36no. 30). This text should not be confused with Jerome's letter
to Paulinus that came to be used as a prologue for the whole Bible. On Dante's use of the
Prologus Galeatus, see I. Opelt, "Hieronymus bei Dante," *Deutsches Dante-Jahrbuch* 51/52
(1976–77): 78–80, and most recently Armour, 5f., who also reviews the question of the
identification of the final group of seven figures with the books of the New Testament that
follow the Gospels.

3. For the questions about interpreting the chariot as the Church, see Dronke, "Proces-
sion," 24f. and 39f. Armour, *Dante's Griffin*, 7–10, argues that this interpretation is "anach-
ronistic" in Dante's frame of reference and surveys some other views. On the lack of
precedent for the griffin as Christ, see C. Hardie, "The Symbol of the Gryphon in *Pur-
gatorio XXIX*. 108 and Following Cantos," in *Centenary Essays on Dante* (Oxford, 1965),
103–31; Dronke, 25f. and 39f.; and Armour, 15–45, who cites additional arguments
against this interpretation. The most extensively developed alternative one is that of
Armour who sees the griffin as a symbol of an ideal Rome and the chariot as "that which will
become the universal church—the whole of human society" (113).

Some of the mystery of this chariot dissipates if it is considered in the context of the *Quadriga Domini*. Whatever else it may represent, this vehicle is a descendant of a long line of chariots of the Gospel. Yet the relevance of this tradition for understanding the chariot's inclusion in the procession has only been recognized in limited ways. Now that the history of the idea is better known, its bearing on this passage can be clarified.

Dante's most important source in this regard was the text with which this study began. The setting in which he has introduced his chariot corresponds precisely to that in which Jerome used the original metaphor of the *Quadriga Domini* in his letter to Paulinus. There it was found in a list of the books of the Bible with brief remarks about each of them; here it appears in a procession made up of figures standing for them. The symbolic chariot also appears, of course, at exactly the same point in both sequences. In both, finally, the vehicle is closely linked with the cherubim of Ezekiel's vision. The relevance of Jerome's letter for understanding Dante's procession in general and the chariot in particular was pointed out at the beginning of this century. It is puzzling that this insight was apparently never followed up.[4]

Dante does not, however, simply replicate Jerome's survey. He has personified the books of the Bible and set them in motion. The catalogue of the books in their textual sequence has been transformed into a procession that embodies the triumphal progress of Biblical revelation. The procession passing before Dante mirrors, as has been very aptly said, "Holy Scripture coming in time." There are, in fact, two distinct time frames here. The first is external, the ineluctable march of Holy Scripture, as a completed whole, through history. The second is internal. Dante does not apprehend the procession in a single view, but instead

4. L. Rocca, *Il Canto XXIX del Purgatorio* (Florence 1904), 37–40, observes that Dante "trovò già bell'e delineata tutta la sua simbolica processione" in Jerome's letter to Paulinus and calls Jerome's phrase "Quadriga Domini," "quasi suggestiva per Dante (37)." Although Rocca's recognition of the importance of this text has been occasionally noted (e.g., U. Bosco, *Il Canto XXIX del 'Purgatorio'* [Rome 1951], 15, and Ciotti, "Processione mistica," 688), the implications of this connection appear never to have been explored. The references to the books of the New Testament in Jerome's letter are cited to support the now standard identification of the final group of figures in the processions by Armour, *Dante's Griffin*, 6n. 9. As he notes, they immediately follow the "Quadriga Domini."

That Dante's procession, with the exception of the dancing ladies, consists of figures standing for the books themselves, not their authors, has often been noted. See most recently Armour, 5f.

As already pointed out, other features of this passage can be traced to Jerome's preface to Kings. The preface to Kings cannot have been the source for the procession as a whole, since it does not mention either the vehicle or the books of the New Testament.

progressively, part by part, until the whole assemblage stops with the chariot, it should be noted, directly across from him. That the procession only comes into Dante's ken piecemeal is an analogue of the incremental making of the sacred text through the successive contributions of different authors writing in separate eras.[5]

Jerome's letter to Paulinus, it will be recalled, came to be used as a standard preface to the Vulgate. For this reason it can be safely assumed that Dante was acquainted with this text, but there is also concrete evidence of his knowledge. When, in the *Convivio*, he comes to the name of Cato in a discussion of great and virtuous Romans, he gives no particulars as he had about the others. Dante justifies this omission by citing the example of "Jerome when in his preface to the Bible, where he reaches Paul, he says that it is better to remain silent than to say little." Jerome's words conclude his brief statement about Paul's contribution to the Bible in his letter to Paulinus. This passage immediately follows his remarks about the Gospels in which the metaphor of the *Quadriga Domini* appears.[6]

Another link between Dante's chariot and the *Quadriga Domini* tradition has also been recognized, but it involves a different phase of the history of the idea. It is an art historian who has treated this relationship most fully. In brief comments on this passage, Panofsky drew attention to the explication of the quadriga of Aminadab by Honorius Augustodunensis in his commentary on the Song of Songs. There, it will be remembered, Honorius interprets the Sunamite woman as the converted Synagogue and the chariot in which she rides, the *Quadriga Christi*, as the Gospel. That Dante may have had the Song of Songs in mind when he composed this section of the *Purgatorio* is suggested by what takes place at the beginning of the next canto. After the procession has halted, the participants turn to the chariot and sing "Come from Lebanon, my spouse" (XXX, 11: "*Veni, sponsa, de Libano*"). As Panofsky and others have

5. This account of Dante's procession is based upon Singleton, "Pattern at the Center," 47–50, and Hawkins, "Scripts for the Pageant," 79f. For the idea that it shows "Holy Scripture coming in time," see Singleton, 49. For the two time frames, see especially Hawkins. He describes the procession as "a diachronic unfolding that ends with a synchronic vision of the 'corpus' of scripture" (80).

6. "[E] seguire Ieronimo quando, nel proemio de la Bibbia, là dove di Paolo tocca, dice che meglio è tacere che poco dire" (Dante Alighieri, *Il Convivio*, ed. M. Simonelli, Testi e saggi di letterature moderne, Testi 2 [Bologna, 1966], 143 [IV, v, 16]). Jerome's words are "tacere melius puto quam pauca dicere" (Epistula LIII, 9). This quotation is discussed by R. Grégoire, "Girolamo," in *Enciclopedia Dantesca*, 3: 209f., and Opelt, "Hieronymus bei Dante," 74f. As the former notes, Dante follows the medieval text tradition of Jerome's letter that gives the last word as "dicere" rather than "scribere."

noted, these words are taken from Song of Songs 4:8. It has also been pointed out that the figure who leads the others in this invocation is the personification of the Song of Songs. Honorius' interpretation of the quadriga of Aminadab may be distantly echoed in the identification of Dante's chariot as the converted Synagogue by some early commentators.[7]

Is Dante's chariot another *Quadriga Domini*? Whatever other meanings the vehicle may possess here or in the arcane allegories of the following cantos, its primary role in the procession of Holy Scripture seems to have much in common with the traditional function of this image. Like so many of its predecessors, it helps to give the four Gospels a collective identity and to set them apart as a group from the rest of the sacred text. Here too it mobilizes associations that help convey their unique place in the overall revelation of God to man through the Bible. Two familiar features are particularly developed here. As before, the chariot serves as a reminder of the unity of the Old and New Testaments since it echoes the throne-chariot of Ezekiel. The triumphal progress of Dante's procession now makes it especially clear that the former finds its fulfillment in the latter. The link Dante establishes between his chariot and that of the triumphs of ancient Rome (vv. 107 and 116f.) is also well grounded in the *Quadriga Domini* tradition: as already noted, the same

7. E. Panofsky, *Problems in Titian, Mostly Iconographic* (New York, 1969), 61f. Pinelli, "Feste e trionfi," 293f., follows his analysis. The possibility that the quadriga of Aminadab may have been one of the "lines of association" of Dante's chariot was noted in passing by J. S. P. Tatlock, "The Last Cantos of the *Purgatorio*," *Modern Philology* 32 (1934): 118, and he cites Honorius' commentary on the Song of Songs in this connection. His primary argument, however, is that Dante's procession was influenced by a passage in another work by Honorius where the bishop is said to be "quasi in curru vectus" in the procession at the beginning of the Mass, just as Christ had entered the world "curru Scripturae vectus" (*Gemma Animae*, PL 172, 545 [I, vi]). This view is revived by J. I. Friedman, "La processione mistica di Dante: Allegoria e iconografia nel canto XXIX del *Purgatorio*," in *Dante e le forme dell'allegoresi*, ed. M. Picone (Ravenna, 1987), 126. The passage from the *Gemma Animae* had already been cited in this connection by F. X. Kraus, *Dante: Sein Leben und Sein Werk: Sein Verhältnis zur Kunst und zum Politik* (Berlin, 1897), 730.
Before Panofsky, the link between Dante's vehicle and this medieval tradition had been briefly touched upon by a number of art historians: Sauer, *Symbolik des Kirchengebäudes*, 63n. 3; Aurenhammer, "Aminadab," 104; and E. Guldan, *Eva und Maria: Eine Antithese als Bildmotiv* (Graz and Cologne, 1966), 118. See also Schiller, *Ikonographie der christlichen Kunst*, 4, 1: 104. The alertness of art historians to this reference may stem from their familiarity with illustrations of the quadriga of Aminadab and related images.
That the leader of the chant in Canto XXX is the personification of the Song of Songs is noted by Singleton, "Pattern at the Center," 50. In the commentary accompanying his translation (Dante Alighieri, *The Divine Comedy: Purgatorio*, vol. 2, *Commentary*, [Princeton, 1973], 719) Singleton notes two echoes of the Song of Songs in Dante's description of the griffin. For the early commentaries identifying the chariot with the converted synagogue, see Armour, *Dante's Griffin*, 8f.

parallel was drawn by Honorius Augustodunensis in one of his most elaborate treatments of the idea. This association was also introduced, as will be remembered, at San Marco.[8]

Seeing Dante's chariot in the context of the *Quadriga Domini* makes it possible to recognize the full unity of his procession. In the usual conception of the chariot as the Church it is something of an intrusion in this sequence of the books of the Bible, although far from an illogical one since the Church rests upon Scripture. It can now be recognized that the chariot itself represents that portion of the holy text that is of supreme importance for Christians.[9]

If Dante draws upon a long-standing image, he nevertheless profoundly transforms it. His symbolic vehicle corresponds to neither of the two standard versions. Since it is drawn by a single griffin, it is not a quadriga in the classical sense. Thus, the image does not conform to the original scheme in which the Evangelists were identified with the chariot's four horses. Nor, since he specifies that his vehicle has two wheels, does it correspond to the later conception of the relationship in which the Evangelists were associated with the four wheels on which the vehicle rolled. Thus, both features of the chariot that had been seen as expressing the harmonious coordination of the four Gospels have been dropped.[10]

There are, nonetheless, strong echoes of both earlier versions here. Without describing it, Dante vividly summons up the Greco-Roman four-horse chariot. In the two tercets that immediately follow the introduction of the vehicle (vv. 115–20), he compares it to those used in Roman triumphs and to that of the sun. The importance that Dante attaches to seeing his allegorical car in the context of classical ones may be gauged by the fact that he cites three examples of the latter. As shown earlier, the true nature of the solar and triumphal chariot was still remembered in the Middle Ages. By the early fourteenth century, it must

8. For the account by Honorius, see above, pages 75f.

9. If this view is correct, the frequent interpretation of the two wheels of the chariot (v. 107) as the Old and New Testaments, an idea that goes back to the early commentators, has to be rejected. In any case, this intepretation is redundant, for the two segments of the Christian Bible are already represented by the two parts of the procession. Armour, *Dante's Griffin*, 9, calls it "tautological." For other doubts about the traditional interpretation of the wheels, see Dronke, "Procession," 25.

10. Hardie, "Symbol of the Gryphon," 113, suggests that the particular kinds of locomotion Dante envisaged influenced the replacement of the four horses by the single griffin. The creature had to be able to "bring . . . on" the chariot and also had to be capable of flight. This explanation seems forced.

have been widely known. Dante was certainly familiar with it and would have expected his readers to share his knowledge.

Yet Dante also recalls, if only indirectly, the later conception of the quadriga and its relationship to the Evangelists. His vehicle stands in the midst of their symbols (v. 106: "dentro a lor quattro"). The most natural reading is to imagine that the Evangelists are walking in two pairs, one behind the other, like their predecessors in the procession (v. 83: "a due a due") and that the chariot occupies the square or rectangular area between the one in front and the one in back. Although this scheme does not link the Evangelist symbols with the wheels, its spatial organization is strongly reminiscent of that seen in some depictions of the later medieval form of the idea. There, of course, the Evangelist symbols were placed at the corners of the square or rectangular body of the vehicle. Perhaps Dante was acquainted with images such as those in the manuscripts containing the commentary on the Song of Songs by Honorius, in Suger's stained glass at Saint-Denis, or in the *Bible moralisée* (figs. 42–44). Dante might just as easily have placed the four symbols in front of the chariot rather than at the corners of the space within which it is found. Indeed, the former configuration is seen in some miniatures illustrating this passage in fourteenth-century manuscripts of the *Commedia*, although others attempt to remain faithful to Dante's precise description.[11]

The women in the entourage of Dante's chariot (vv. 121–32) suggest that the *Quadriga Domini* was not the only well-known symbolic vehicle that Dante had in mind. Since the earliest commentators, the identification of the dancing ladies beside the wheels has been unanimous: on the favored right are the theological virtues (faith, hope, and charity) and on the left the cardinal ones (prudence, temperance, justice, and fortitude). As noted earlier, quadrigas in the Bible were widely interpreted by medi-

11. Early illustrations of Canto XXIX vary widely in their rendering of the relationship between the animals and the car. For the miniatures, see P. Brieger, M. Meiss, and C. S. Singleton, *Illuminated Manuscripts of the Divine Comedy*, 2 vols. (Princeton, 1969), 1: 177f. and 2: pls. 409–13, and Friedman, "Processione mistica." For Botticelli's illustrations, see R. Lightbown, *Sandro Botticelli*, 2 vols. (Berkeley and Los Angeles, 1978), 1:147–51 and 2: 194–96 with reproductions. (Although his illustration for Canto XXIX appears to omit Luke's symbol and only partially indicates Matthew's, all four are clearly visible in those for the subsequent ones.) The possible relationship between the early illustrations of Canto XXIX and the medieval depictions of the *Quadriga Domini* cannot be explored here.

A number of possible visual sources or analogies for the procession as a whole have been suggested. See, e.g., Bosco, *Canto XXIX*, 20–23 and 31, who compares it to that of the saints in the mosaics of Sant'Apollinare Nuovo in Ravenna. On this comparison, cf. Dronke, "Procession," 22.

eval exegetes as standing for the latter group of virtues as well as for the Gospels. Indeed the *Quadriga virtutum* became a well-known motif in its own right.[12] The ladies flanking the chariot are the only participants in the procession who do not stand for books of the Bible. Their inclusion here may well have been suggested by the medieval tradition associating quadrigas with the cardinal virtues.

It is clear then that the *Quadriga Domini* does not appear in *Purgatorio* XXIX in any of its customary guises. Yet memories of it pervade this entire passage and even extend to the beginning of the next canto. Dante's idiosyncratic approach to the *Quadriga Domini* is probably responsible for the failure of the early commentators to recognize this aspect of his chariot. Their preference for simple one-to-one symbolic relationships was doubtless also a factor. Just such a reading was available in the interpretation of the chariot as the Church. The same factors, along with the absence of any coherent account of the medieval use of this imagery, help to explain why the pertinence of this tradition has been largely ignored in the modern Dante literature.

Recognition of Dante's dependence upon the *Quadriga Domini* tradition raises a variety of further questions. One important group concerns the relevance of the *Quadriga Domini* for an understanding of the fate of the chariot in the final cantos of the *Purgatorio*. Another line of inquiry deserves particular attention. As has been recognized, Dante's own act of writing insistently obtrudes itself in this pageant of God's Sacred Writ. Thus, for example, he reminds the reader of his own role as author in setting the scene when the Biblical personifications begin to appear (v. 82). His words about the description of the sky follow immediately upon those regarding the flames of the candlesticks that lead the procession: they are said to "paint" bands of color in the heavens like brushes (vv. 73–78). Earlier, as he was about to start upon his account of the procession, he had already interrupted the flow of the narrative to appeal to holy powers for help in carrying out his task (vv. 37–42). The most remarkable of these intrusions takes place at the climax. Explaining that he cannot afford to expend more effort on his description of the four winged creatures, he breaks off and refers his readers to the texts of Ezekiel and John for fuller reports about them (vv. 97–105).

The passages invoking divine aid and the citations of Biblical testimony are not mere literary flourishes. They serve, among other things,

12. On the association of quadrigas and the cardinal virtues, see above, page 16.

to authenticate the exalted status Dante claims for his own text and for what he reveals there. Perhaps the most telling measure of his ambition here is that he makes himself the arbiter, on the basis of his own eyewitness evidence, of the differences between Ezekiel's and John's accounts of the four creatures.[13]

In the context of these repeated juxtapositions of the making of the *Commedia* and the coming into being of the Bible, the implicit reference to the *Quadriga Domini* takes on an added significance. The image is as much concerned with the authenticity of the Gospels as divinely inspired writings as it is with the concordance of the four distinct accounts. Dante's lack of interest in the latter aspect is demonstrated, as already noted, by his omission of the features of the car that exemplified it. Perhaps what concerned him here was the former. He might well have seen it as relevant for his own endeavors. That Dante's chariot has a strongly personal meaning is clear from its most startling feature when seen in the context of the *Quadriga Domini* tradition: it proves to bear, in the next canto, not Christ or the Church but Beatrice. Recognizing the extent to which the nature of Dante's own enterprise is at issue here may help to counter the often expressed opinion that the procession is stiff and wooden. One of its themes is the divine guidance of authors, that of Dante as well as that of the writers of the Bible.

When the chariot is seen in this light, some unusual interpretations of the griffin take on a special interest. The animal, in one of these views, stands for aspects of Dante's nature and, in another, it is Dante's *daimon*. As has also been noted, Dante's family name, Alighieri, can be playfully read to mean that its members bear wings. It is possible that the emphasis on those of the griffin is significant in this regard. Held in a vertical position, his "ali" extend to a great height and, without harming it, pierce the layer made up of the seven bands of color that stream back from the candlesticks at the beginning of the procession (vv. 43–54, 73–81, 109–11). The Evangelist symbols too are, of course, winged (v. 94).[14]

13. This account of the significance of these intrusions and of Dante's larger ambitions is largely based on Hawkins, "Scripts for the Pageant," 81–86. On the implications of Dante's "Giovanni è meco" (v. 105), see Hawkins, 86, and R. Hollander, "Dante 'Theologus-Poeta,'" *Dante Studies* 94 (1976): 112 (reprinted in his *Studies in Dante* [Ravenna, 1980]). On that statement, cf. Dronke, "Procession," 28.

14. For the view that the griffin stands for aspects of Dante's nature, see Hardie, "Symbol of the Gryphon," 123 and 128, and Dronke, "Procession," 42f., for it as his *daimon*. Cf. Armour, *Dante's Griffin*, 69. See P. Dronke, *Dante and Medieval Latin Traditions* (Cambridge, 1986), 65, for the interpretation of Dante's family name and for the imagery in this part of the *Purgatorio* that metaphorically gives Dante wings. For questions about the traditional identification of the griffin with Christ, see above, page 128.

The griffin is one of the most enigmatic participants in the events at the end of the *Purgatorio*. Although once widely interpreted as Christ, there is little consensus about its significance today. The imagery of the *Quadriga Domini*, the centrality of the theme of sacred writing in this canto, and Dante's possible identification with the griffin suggest yet another way of understanding the creature in its initial appearance. One of the griffin's functions at this stage may be to convey, albeit obliquely and summarily, Dante's vision of himself drawing the chariot of Beatrice just as the Evangelists had pulled that of Christ. It would certainly be a remarkable image. What actual relevance the *Quadriga Domini* tradition may have in this regard is for *Dantisti* to determine.

The Lord's Quadriga in Titian's Triumph of Faith

The San Marco composition is not the only telling evocation of the *Quadriga Domini* produced in Venice. The same concept stands at the center of the *Triumph of Faith* (figs. 59–63), a woodcut designed by Titian. The print occupies a special position in the history of depictions of the idea. Titian has placed this theme in the larger context that had been its framework in key patristic and medieval texts. The ambitious scope of the work is indicated by its scale. The image extends across five sheets, and the example reproduced here measures approximately 38.7 cm × 266.7 cm. This copy belongs to the edition of 1517, which was, according to a recent argument, the first to appear.[1]

The core of this complex image is a representation of Christ's triumphal progress on a heavy carriage drawn by the four Evangelist symbols (fig. 61). As Panofsky and others have shown, this central group derives from illustrations of Petrarch's *Trionfi*. Cycles representing the six triumphs that make up his poem, composed between 1356 and 1374, were a popular subject in fifteenth-century Italian prints, illuminated manuscripts, and *cassone* panels. A Florentine print of the 1460s (fig. 64) provides an example of one of the ways that the final triumph—usually known as the Triumph of Divinity, although actually entitled *Triumphus aeternitatis*—was occasionally illustrated in Italy at this period. It shows the four Evangelist symbols drawing a vehicle bearing God the Father

1. The principal discussions of the iconography of Titian's print are Panofsky, *Problems in Titian*, 58–63, and S. Sinding-Larsen, "Titian's Triumph of Faith and the Medieval Tradition of the Glory of Christ," *Acta ad archaeoligiam et artium historiam pertinentia* 6 (1975): 315–51. The most recent discussions of the work are M. Bury, "The 'Triumph of Christ' after Titian," *Burlington Magazine* 131 (1989): 188–97, who argues that the 1517 edition was the first, and the entry in *Tiziano*, exh. cat. (Venice, 1990), 156–59no. 7.

For other works of art from the Renaissance and later periods that incorporate related themes, see Aurenhammer, "Aminadab," 104, and Schiller, *Ikonographie der christlichen Kunst*, 4, 1: 109f.

and flanked by the twelve Apostles. In a variant of this type, the Evangelists themselves pull the vehicle which sometimes carries the Trinity.[2]

The text of Petrarch's Triumph of Divinity contains no reference either to a vehicle or to the Evangelists. Some aspects of the process by which it came to be illustrated in this manner are well understood. Petrarch explicitly cites a triumphal car only in the first of the triumphs, that of Love, but artists endowed the victorious personifications of all the others with a similar vehicle. Each was drawn by a different team whose members were appropriate for the particular theme. Thus elephants, for example, known for their memory, draw the car of Fame. Since the Triumph of Eternity was equated with the Triumph of Divinity, a corresponding representation of the Evangelists or their symbols drawing a vehicle bearing God must have seemed a suitable illustration for it. The aptness of this image, however, was not immediately recognized. Although the other triumphs already received their distinctive equipages in the earliest cycles, the first illustrations of the Triumph of Divinity simply showed God enthroned in Heaven. The Florentine print is one of the earliest appearances of a vehicle drawn by the Evangelists or their symbols. This type became the norm.[3]

As Panofsky recognized, the new illustrations of Petrarch's Triumph of Divinity should be seen in the context of the medieval tradition of the *Quadriga Domini*. The team and the vehicle's passenger seem to be literal illustrations of the idea in its original form. Tracing the precise connection, however, is a complex task and cannot be undertaken here.

2. The connection between Titian's print and the illustrations of Petrarch's Triumph of Divinity is most fully discussed by Panofsky, *Problems in Titian*, 60–63. On the fifteenth-century depictions of Petrarch's *Trionfi* in general, on those for the Triumph of Divinity in particular, and on the relation of Titian's print to the latter, see V. d'Essling and E. Müntz, *Pétrarque: ses études d'art, son influence sur les artistes . . .* (Paris, 1902), 120–82, esp. 120f. and 199. See also G. Carandente, *I trionfi nel primo Rinascimento* (n. p., 1963), 33–71 and 94–96, and Pinelli, "Feste e trionfi," 300–3. On this print, see J. G. Phillips, *Early Florentine Designers and Engravers* (Cambridge, Mass., 1955), 58, 60f., and 86. For other fifteenth-century Italian examples in which the Evangelists or their symbols draw a vehicle bearing God, see d'Essling and Müntz, 149f., 171f., 178, and 270f., and pls. opposite 152, 170, and 172. For sixteenth-century examples, many of them from northern Europe, see d'Essling and Müntz, 183–267 passim.

3. For the general development of the illustrations to Petrarch's *Trionfi*, see the citations in the preceding note, especially Panofsky, *Problems in Titian*, 60. For this motif as the standard form of illustration for the Triumph of Divinity, see d'Essling and Müntz, *Pétrarque*, 121, and Panofsky, 60. See also C. Ripa, *Iconologia* (Padua, 1611; repr. New York, 1976), 71: "Carro della Divinità del Petrarca: Il Padre, Figliuolo, & sopra d'essi lo Spirito Santo in un carro tirato da i quattro Evangelisti." For an example of the earlier formula, see Pesellino's *cassone* panel of the 1440s in the Gardner Museum in Boston (d'Essling and Müntz, 148, and pl. opposite 148).

The central portion of Titian's *Triumph of Faith* derives, as has long been recognized, from what became the standard illustration of Petrarch's Triumph of Divinity. The team corresponds to the common variant in which the symbols rather than the Evangelists themselves draw the vehicle. But the vehicle to which the symbols are yoked has changed. It is a sturdy wagon rather than the floatlike affair that is usually seen in the Petrarch illustrations. Its large wheels are emphasized and there are four of them, although only two are visible. Its predecessors often ran on just two wheels despite their size and weight, and sometimes none at all are to be seen. The Petrarchan vehicles suggest those of a pageant. Titian's conveyance, however, is better suited for the long journey that is, as will be seen shortly, an important aspect of his conception.

Titian has also added a new feature to the central group. Now the four Doctors of the Church aid the car's triumphal progress by helping to turn its wheels. They appear to be unknown among the fifteenth-century Petrarch illustrations, although they are found in later ones. Botticelli had incorporated them in his illustrations to Cantos XXX, XXXI, and XXXII of Dante's *Purgatorio*, although they are not part of the imagery of the text. There, however, the four simply walk behind the vehicle rather than actively further its advance. Perhaps Botticelli also included them in a more active role in a lost representation of the Triumph of Faith that he is said to have made. The presence of the Doctors of the Church is certainly an appropriate addition in both contexts. Honorius Augustodunensis had already associated the Doctors of the Church with the *Quadriga Domini* in his Ascension sermon.[4]

As with the changes in the vehicle, the introduction of the four Doctors helps ensure that Christ's car will indeed be able to travel the distance it must go. In the Petrarch illustrations in which the team is made up of the Evangelist symbols, the assortment of creatures seems ill-suited for the strenuous task to which they have been set. Nor is the effect more convincing when the Evangelists themselves do the pulling. Titian may have found this inadequacy troubling. It is somewhat mitigated in his *Triumph of Faith* because the Evangelist symbols are now aided by the four Doctors whose exertions in pushing the vehicle are vividly ren-

4. Lightbown, *Botticelli*, 2: 194–96, for the Dante illustrations, and 1: 152 and 2: 218, on the lost Triumph of Faith. Panofsky, *Problems in Titian*, 63, argues that the four Doctors of the Church in Titian's woodcut derive from illustrations of the Triumph of Divinity and cites a sixteenth-century French one that, he implies, reflects the sort of model that Titian used. These later ones may, of course, reflect Titian's influence. For Honorius' sermon, see chapter V, note 22.

dered. The emphasis on the four wheels and the association of four figures with them is a curious throwback to the later medieval form of the concept of the *Quadriga Domini*. Influence from the latter, however, seems most unlikely.

Titian's print is distinguished in a variety of other, far more important ways from its predecessors among the illustrations of Petrarch's Triumph of Divinity. The vehicle forms part of a long procession made up of two groups of figures. Led by Adam and Eve, the first consists primarily of persons from the Old Testament and precedes the vehicle; the second follows it and consists of persons from the New Testament and a crowd of saints. Nothing comparable is to be found among the modest illustrations of Petrarch's Triumph of Divinity of the type showing the Evangelist symbols or the Evangelists drawing the car. There the vehicle is usually shown frontally with the result that the sense of processional movement is limited. In addition, it is usually accompanied by a much smaller group of figures consisting of Apostles or other saints who flank or surround rather than precede and follow it.

The origins of Titian's grand procession have been traced by Panofsky and others. One of the frequently cited sources is Savonarola's vision of a triumphant Christ in his *Triumphus crucis* of 1497. The vehicle upon which Christ rides there is not the *Quadriga Domini*, and the Evangelists are not explicitly mentioned. The throng that accompanies it, however, resembles that in Titian's print, for it too contains figures from the Old Testament as well as the New. Yet, as Panofsky notes, there are important differences between the triumph depicted by Titian and that described by Savonarola. Titian omits a large portion of the cast envisioned by Savonarola, for example, the numerous enemies who threaten the procession from all sides. He also leaves out many of the props that Savonarola had included such as "the fallen idols," and "the burned works of the heretics." One of other major differences is the contrast between the linear marshalling of the holy company in Titian's print and the grouping imagined by Savonarola which Panofsky rightly calls "concentric." For Panofsky and others, Titian's imposition of a strong frieze composition on Savonarola's imagery derives from the influence of Mantegna's *Triumph of Caesar*.[5]

5. On these relationships, see Panofsky, *Problems in Titian*, 59f. The link to Savonarola is stressed by Sinding-Larsen, "Titian's Triumph of Faith," who reprints the relevant passage of the text with an English translation (318–20 and 350f.). He couches the problem of explaining Titian's use of the procession and the frieze composition particularly clearly (346f.).

There is another text that must have played an important role in shaping the imagery of Titian's *Triumph of Faith*. Although Panofsky briefly introduced Dante's chariot from *Purgatorio* XXIX in his discussion of the print, he did not consider the larger context of which it is a part. There are in fact fundamental similarities in the make-up and structure of Dante's and Titian's processions. Both recapitulate the story of salvation through a great file of holy figures. There are two principal differences. First, Titian has replaced Dante's personifications of the individual books of the Bible by their protagonists. Thus, instead of a stately pageant there is now an animated crowd that consists of concrete individuals. The second is the addition of other participants. They include sibyls in the Old Testament section and saints in the New Testament one. The scope of the procession has been enlarged, but its core remains Biblical. Titian has also preserved one of the essential feature's of Dante's pageant, the sense of an inexorably unfolding sacred history. Indeed, the procession in the print is more explicitly triumphal than the one in the poem, because Christ himself now rides on the vehicle. And now the actions of the symbols again make manifest the role of the Evangelists in his progress. Finally, Titian, like Dante, presents two time spans simultaneously. The procession, which contains within itself the successive phases of the story, moves irresistably forward as a single body, traversing the ages towards its goal. The frieze composition employed by Titian may well owe as much to Dante as to Mantegna. Indeed, the viewer experiences Titian's aligned figures very much as Dante saw the procession on the opposite bank of Lethe in *Purgatorio* XXIX.

Dante may have been a more important source than Savonarola for Titian's print. This is suggested by the sequence of components in each of the processions. In Savonarola's triumph, the vehicle bearing Christ is preceded by two groups: the first consists of the patriarchs and prophets of the Old Testament at the head of the procession and the second contains the Apostles and preachers. The position of the vehicle in Titian's print is different. There it is placed between these two groups rather than behind them and thus, as Panofsky notes, it "clearly marks the dividing line between the eras before and after Grace."[6] This is also where Dante had placed it and this is where it logically belongs. The origin of this conception is, as has been shown, Jerome's letter to Paulinus. There the *Quadriga Domini* first took its place at the beginning of the New Testament in the succession of Biblical revelation.

6. Panofsky, *Problems in Titian*, 59.

Although the debt of Titian's image to Dante's text is considerable, it is confined to the procession. The centerpiece of the print, the vehicle bearing Christ, follows the mainstream tradition, not the idiosyncratic griffin-drawn car of *Purgatorio* XXIX. Here the central issue is again the coordinated efforts of the four Evangelists in spreading the word of God.

It is possible that Titian received help from learned advisors in devising this complex image. The print is said to derive from a painting that he made for a house in which he was living in Padua. This story seems quite implausible, and it has been suggested instead that the print copies the painted decoration of a chapel. If it is indeed based upon some earlier undertaking, the scope and seriousness of the imagery indicate that the setting for which this composition was intended must have been a fairly grand and hallowed one.[7]

Titian's *Triumph of Faith* is, artistically and conceptually, the most ambitious Renaissance work that incorporates the imagery of the *Quadriga Domini*. Thus, the most remarkable embodiment of this idea in the visual arts of the Renaissance, as in those of the Middle Ages, is a Venetian work. What construction should be placed upon these facts is unclear. This conjunction may simply be a matter of chance or it may mean that the theme possessed a special resonance for Venetians. It is tempting to posit a connection between the two despite the differences in their imagery. After all, the memory of the San Marco composition may have lingered in the city long after it had been partially dismantled almost a century earlier. Any direct link, however, appears to be unlikely.

In the final analysis, however, it is the larger context, rather than the local one that is most important here. Seen in a broader perspective, Titian's print takes on a new stature. It is the culmination of a long development that began in Jerome's letter to Paulinus and was carried forward in Dante's *Commedia*. And it is Titian's print that brings this image of the triumphal progress of scriptural revelation and sacred history most richly to life.

7. For the derivation of the print from a painting in his Paduan residence, see D. Rosand and M. Muraro, *Titian and the Venetian Woodcut*, exh. cat. (Washington, D.C., 1976), 37, who call the story "probably apocryphal." For a learned adviser and for chapel decoration as a source, see Sinding-Larsen, "Titian's Triumph of Faith," 321f. and 346f.

Bibliography

PRIMARY SOURCES

Alain de Lille. *Liber in distinctionibus dictionum theologicalium.* In *PL* 210: 685–1012.

Alcuin. *Carmina.* In *Poetarum latinorum medii aevi.* Vol. 1 (=*Poetae latini aevi carolini,* vol.1), ed. E. Dümmler, 160–351. Monumenta Germaniae historica. Berlin, 1881.

Dante Alighieri. *Il Convivio.* Ed. M. Simonelli. Testi e saggi di letterature moderne, Testi 2. Bologna, 1966.

———. *The Divine Comedy.* 3 vols. in 6. Trans. with a commentary by S. Singleton. Princeton, 1970–75.

Ambrose, St. *Expositio psalmi CXVIII.* Ed. M. Petschenig. Corpus scriptorum ecclesiasticorum latinorum 62. Vienna and Leipzig, 1913.

Augustine, St. *De consensu evangelistarum.* Ed F. Weihrich. Corpus scriptorum ecclesiasticorum latinorum 43. Vienna and Leipzig, 1904.

Bede. *In Cantica Canticorum.* In *Bedae Venerabilis Opera.* Vol. 2, *Opera exegetica,* ed. D. Hurst and J. E. Hudson, 165–375. Corpus Christianorum, series latina 119B. Turnhout, 1983.

Bernard of Clairvaux, St. *Sancti Bernardi Opera.* Vols. 1–2, *Sermones super Cantica Canticorum,* ed. J. Leclercq, C. H. Talbot, and H. M. Rochais. Rome, 1957–58.

Biblia Sacra iuxta Vulgatam versionem. 2nd ed., ed. R. Weber. Stuttgart, 1975.

Boccaccio, Giovanni. *Esposizioni sopra la Comedia di Dante,* ed. G. Padoan. *Tutte le opere di Giovanni Boccaccio,* vol. 6, ed. V. Branca. Verona, 1965.

Brito, Guillelmus. *Summa Britonis sive Guillelmi Britonis expositiones vocabulorum biblie.* Ed. L. W. and B. A. Daly. 2 vols. Padua, 1975.

Canal, Martin da. *Les estoires de Venise: Cronaca veneziana in lingua francese dalle origini al 1275.* Ed. A. Limentani. Civiltà veneziana: Fonti e testi 12, ser. 3,3. Florence, 1972.

Chinazzo, Daniele di. *Cronica de la guerra da Veniciani a Zenovesi.* Ed. V. Lazzarini. Monumenti storici pubblicati dalla Deputazione di Storia Patria per le Venezie, n.s. 11. Venice, 1958.

Clari, Robert de. *La conquête de Constantinople.* Ed. P. Lauer. Paris, 1924.

Codex apocryphus Novi Testamenti. Ed. J. A. Fabricius. 2nd ed. 3 vols. in 2. Hamburg, 1719.

Dandolo, Andrea. *Chronica per extensum descripta.* Ed. E. Pastorello. 2nd ed. Rerum italicarum scriptores, 12, 1. Bologna, 1938.

Documenti sulle relazioni delle città toscane coll'oriente cristiano e coi Turchi. Ed. G. Müller. Florence, 1879.

Durandus, Guillelmus. *Rationale divinorum officiorum.* Lyons, 1612.

Erizzo, Sebastiano. *Discorso di M. Sebastiano Erizzo sopra le medaglie de gli antichi.* 4th ed. Venice, n.d.

Ermenrich von Ellwagen. "Epistola ad Grimaldum abbatem." In *Epistolae.* Vol. 5 (=*Epistolae Karolini aevi,* vol. 3), ed. E. Dümmler, 534–79. Monumenta Germaniae historica. Berlin, 1899.

Eusebius. *Eusebius Werke*, Vol. 1, ed. I. A. Heikel. Die Griechischen Christlichen-Schriftsteller der ersten drei Jahrhunderte 7. Leipzig, 1902.

Gatari, Andrea. *Chronicon Patavinum*. Ed. L. A. Muratori. *Rerum italicarum scriptores* 17. Milan, 1730.

Gatari, Galeazzo and Bartolomeo. *Cronaca Carrarese confrontata con la redazione di Andrea Gatari*. Ed. A. Medin and G. Tolomei. 2nd ed. Rerum italicarum scriptores, 17, 1, 1. Città di Castello and Bologna, 1909–31.

Glossa ordinaria. In *PL* 114: 9–752.

Gregory. *Magister Gregorius Narracio de mirabilibus urbis Rome*. Ed. R. B. C. Huygens. Textus Minores 42. Leiden, 1970.

———. *Master Gregorius The Marvels of Rome*. Trans. with a commentary by J. Osborne. Toronto, 1987.

Haimo of Auxerre. *Expositio in Cantica Canticorum*. In *PL* 70: 1055–1106.

Honorius Augustodunensis. *Elucidarium*. In *PL* 172: 1109–76.

———. *Expositio in Cantica Canticorum*. In *PL* 172: 347–496.

———. *Sigillum Beatae Mariae*. In *PL* 172: 495–518.

———. *Speculum Ecclesiae*. In *PL* 172: 807–1108.

Innocent III. *Sermones*. In *PL* 172: 309–688.

Isidore of Seville. *Etymologiarum sive originum libri xx*. Ed. W. M. Lindsay. Oxford, 1911.

Jerome, St. *Sancti Eusebii Hieronymi Epistulae*. Vol. 1, ed. I. Hilberg. Corpus scriptorum ecclesiasticorum latinorum 54. Vienna and Leipzig, 1910.

———. *Letters and Selected Works*. Trans. W. H. Fremantle with G. Lewis and W. G. Martley. Ed. P. Schaff and H. Wace. A Select Library of Nicene and Post-Nicene Fathers of the Christian Church. 2nd ser., 6. New York, 1893.

John of Salisbury. *The Historia Pontificalis of John of Salisbury*. Ed. and trans. M. Chibnall. Rev. ed. Oxford, 1986.

Maragone, Bernardo. *Annales Pisani*. Ed. M. Lupo Gentile. 2nd ed. Rerum italicarum scriptores, 6, 2. Bologna, 1930–36.

"Mirabilia urbis Romae." In *Codice topografico della città di Roma*. Vol. 3, ed. R. Valentini and G. Zucchetti, 17–65. Fonti per la storia d'Italia 90. Rome, 1946.

L'ottimo commento della Divina Commedia. 3 vols. Pisa, 1827–29.

Peter Damian, St. *Sancti Petri Damiani Sermones*. Ed. G. Lucchesi. Corpus Christianorum, continuatio medievalis 57. Turnhout, 1983.

Petrarca, Francesco. *Prose*. Ed. and trans. G. Martellotti et al. La letteratura italiana: Storia e testi 7. Milan, 1955.

Pliny. *Natural History*. 10 vols. Ed. and trans. H. Rackham, W. H. S. Jones, and D. E. Eichholz. Loeb Classical Library. London and Cambridge, Mass. 1938–62.

Rabanus Maurus. *De universo*. In *PL* 111: 9–614.

Ripa, Cesare. *Iconologia*. Padua, 1611. Repr. New York, 1976.

The Russian Primary Chronicle: Laurentian Text. Ed. and trans. S. H. Cross and O. P. Sherbowitz-Wetzor. Cambridge, Mass., 1953.

Sansovino, Francesco. *Delle cose notabili che sono in Venetia, libri II*. Venice, 1561.

———. *Venetia, città nobilissima, et singolare, descritta in XIIII libri*. Ed. G. Martinioni. Venice, 1663.

Sicard of Cremona. *Mitrale*. In *PL* 213: 13–434.

Song of Songs. Ed. and trans. M. H. Pope. Anchor Bible 7c. New York, 1977.

Vasari, Giorgio. *Le vite de' più eccellenti pittori scultori e architettori*. 6 vols. Ed. R. Bettarini and P. Barocchi. Florence, 1966–87.

Vico, Enea. *Discorsi di M. Enea Vico Parmigiano sopra le medaglie de gli antichi*. Venice, 1555.

Villani, Giovanni. *Chroniche di Giovanni, Matteo e Filippo Villani*. 2 vols. Trieste, 1857–58.

SECONDARY SOURCES

Ainalov, D. *Geschichte der russischen Monumentalkunst der vormoskovitischen Zeit.* Berlin and
 Leipzig, 1932–33.
Alexander, J. J. G. *Insular Manuscripts, 6th to 9th Century.* A Survey of Manuscripts Illumi-
 nated in the British Isles 1. London, 1978.
Alizeri, F. *Guida illustrativa del cittadino e del forastiero per la città di Genova e sue adiacenze.*
 Genoa, 1875.
Arias, P. E., E. Cristiani, and E. Gabba. *Camposanto monumentale di Pisa: Le antichità.* Vol. 1.
 Pisa, 1977.
Armour, P. *Dante's Griffin and the History of the World: A Study of the Earthly Paradise
 (Purgatorio, Cantos XXIX–XXXIII).* Oxford, 1989.
Arslan, E. *Venezia gotica: l'architettura civile gotica veneziana.* Venice, 1970.
Aurenhammer, A. "Aminadab." In *Lexikon der christlichen Ikonographie*, vol. 1: 103–5.
 Vienna, 1959.
Badstübner, E. "Justinianssäule und Magdeburger Reiter." In *Skulptur des Mittelalters:
 Funktion und Gestalt*, ed. F. Möbius and E. Schubert, 184–210. Weimar, 1987.
*La Basilica di San Marco in Venezia illustrata nei riguardi dell'arte e della storia da scrittori
 veneziani: Documenti per la storia dell'augusta ducale Basilica di San Marco in Venezia. . . .*
 Venice, 1881.
Bassett, S. G. "The Antiquities in the Hippodrome of Constantinople." *Dumbarton Oaks
 Papers* 45 (1991): 87–96.
Beckwith, J. *The Art of Constantinople: An Introduction to Byzantine Art, 330–1453.* 2nd ed.
 London, 1968.
Belting, H. "Zwischen Gotik und Byzanz. Gedanken zur Geschichte der sächsischen
 Buchmalerei im 13. Jahrhundert." *Zeitschrift für Kunstgeschichte* 41 (1978): 217–57.
Bergemann, J. "Die Pferde von San Marco. Zeitstellung und Funktion." *Mitteilungen des
 Deutschen Archaeologischen Instituts, Roemische Abteilung* 95 (1988): 115–28.
———. *Römische Reiterstatuen: Ehrendenkmäler im öffentlichen Bereich.* Beiträge zur
 Erschliessung hellenistischer und kaiserzeitlicher Skulptur und Architektur 11. Mainz
 am Rhein, 1990.
Berger, A. *Untersuchungen zu den Patria Konstantinupoleos.* Poikila Byzantina 8. Bonn, 1988.
Berger, S. "Les préfaces jointes aux livres de la Bible dans les manuscrits de la Vulgate."
 Mémoires présentés par divers savants à l'Académie des Inscriptions et Belles-lettres 11,2 (1904):
 1–78.
Beurlier, E. "Char." In *Dictionnaire de la Bible*, ed. F. Vigoroux, vol. 2: 565–77. Paris, 1899.
Bloch P., with U. Nilgen and E. Förster. "Evangelisten." In *Reallexikon zur deutschen
 Kunstgeschichte*, vol. 6: cols. 448–517. Munich, 1973.
Bober, P. P., and R. Rubinstein. *Renaissance Artists and Antique Sculpture: A Handbook of
 Sources.* London, 1986.
Bongiorno, L. M. "The Theme of the Old and the New Law in the Arena Chapel." *Art
 Bulletin* 50 (1968): 11–20.
Boni, G. "I marmi." In *La Basilica di San Marco in Venezia illustrata nella storia e nell'arte da
 scrittori veneziani*, ed. C. Boito, 389–402. Venice, 1888.
Borrelli Vlad, L. "Interrogativi sui cavalli di S. Marco." *Storia dell'arte* 38/40 (1980): 48–53.
———, and A. Guidi Toniato. "Fonti e documentazioni sui cavalli di S. Marco." In *I cavalli
 di S. Marco: Catalogo della mostra. Convento di Santa Apollonia Venezia Giugno/Agosto 1977*,
 137–48. Venice, 1977.
Borsook, E. *The Mural Painters of Tuscany from Cimabue to Andrea del Sarto.* 2nd ed. Oxford,
 1980.

Bosco, U. *Il Canto XXIX del 'Purgatorio.'* Rome, 1951.

Bovini, G. "Le vicende del 'Regisole' statua equestre ravennate." *Felix Ravenna* 3rd ser., 36 (1963): 138–54 (="Il 'Regisole': Un monumento equestre ravennate trasportato a Pavia nell'Alto Medio Evo." *Corsi di cultura sull'arte ravennate e bizantina* 10 [1963]: 51–66).

Boyer, M. N. "The Humble Profile of the Regal Chariot in Medieval Miniatures." *Gesta* 29 (1990): 25–30.

Bozzoni, C. *Saggi di architettura medievale: La Trinità di Venosa. Il Duomo di Atri.* Rome, 1979.

Brand, C. M. *Byzantium Confronts the West, 1189–1204.* Cambridge, Mass., 1968.

Brandis, T., and O. Pächt. *Historiae Romanorum: Codex 151 in scrin.der Staats- und Universitätsbibliothek Hamburg.* 2 vols. Frankfurt am Main, 1974.

Branner, R. *Manuscript Painting in Paris during the Reign of Saint Louis.* Berkeley, 1977.

Der Braunschweiger Burglöwe: Bericht über ein wissenschaftliches Symposion in Braunschweig vom 12.10. bis 15.10.1983. Göttingen, 1985.

Breckenridge, J. D. "Again the 'Carmagnola.'" *Gesta* 20 (1981): 1–7.

Brieger, P., M. Meiss, and C. S. Singleton. *Illuminated Manuscripts of the Divine Comedy.* 2 vols. Princeton, 1969.

Brown, P. F. *Venetian Narrative Painting in the Age of Carpaccio.* New Haven, 1988.

Buchthal, H. *Historia Troiana: Studies in the History of Medieval Secular Illustration.* Studies of the Warburg Institute 32. London, 1971.

———. *The "Musterbuch" of Wolfenbüttel and Its Position in the Art of the Thirteenth Century.* Byzantina Vindobonensia 12. Vienna, 1979.

Buddensieg, T. "Gregory the Great, the Destroyer of Pagan Idols: The History of a Medieval Legend concerning the Decline of Ancient Art and Literature." *Journal of the Warburg and Courtauld Institutes* 28 (1965): 44–65.

Bury, M. "The 'Triumph of Christ' after Titian." *Burlington Magazine* 131 (1989): 188–97.

Cameron, A., and J. Herrin. *Constantinople in the Early Eighth Century: the Parastaseis syntomoi chronikai.* Leiden, 1984.

Camille, M. *The Gothic Idol: Ideology and Image-making in Medieval Art.* Cambridge, 1989.

Carandente, G. *I trionfi nel primo Rinascimento.* N. p., 1963.

Castagnoli, F. "Faro." In *Enciclopedia dell'arte antica classica e orientale,* vol. 3: 596f. Rome, 1960.

Cattaneo, R. "Storia architettonica della Basilica." In *La Basilica di San Marco in Venezia illustrata nella storia e nell'arte da scrittori veneziani,* ed. C. Boito, 99–197. Venice, 1888.

I cavalli di S. Marco: Catalogo della mostra. Convento di Santa Apollonia Venezia Giugno/Agosto 1977. Venice, 1977.

Cellini, P. "La 'facciata semplice' del Duomo di Siena." *Proporzioni* 2 (1948): 55–61.

Ceschi, C. *Chiese di Genova.* Genoa, 1966.

Cessi, R. *Storia della Repubblica di Venezia.* Rev. ed. Milan and Messina, 1968. Reprint. Florence, 1981.

Charbonneau-Lessay, L. *La mystérieuse emblématique de Jésus Christ: Le Bestiaire du Christ.* Bruges, 1940.

Ciotti, A. "Processione mistica." In *Enciclopedia Dantesca,* 2nd ed., vol. 4: 685–89. Rome, 1984.

Cleve, T. C. van. *The Emperor Frederick II of Hohenstaufen: Immutator Mundi.* Oxford, 1972.

Cochetti Pratesi, L. "Contributi alla scultura veneziana del Duecento: II. Le altre realizzazioni della corrente antelamica." *Commentari* 11 (1960): 202–19.

———. "Contributi alla scultura veneziana del Duecento: III. La corrente bizantineggiante." *Commentari* 12 (1961): 12–30.

Condamin, A. "Les caractères de la traduction de la Bible par saint Jérôme." *Recherches de science religieuse* 2 (1911): 425–40.

Corboz, A. *Canaletto: Una Venezia immaginaria.* 2 vols. Milan, 1985.

Cornelius a Lapide. *Commentarius in Canticum Canticorum.* Antwerp, 1725.

Crosby, C. M., et al. *The Royal Abbey of Saint-Denis in the Time of Abbot Suger (1122–1151).* Exh. cat. New York, 1981.

Curschmann, M. "Imagined Exegesis: Text and Picture in the Exegetical Works of Rupert of Deutz, Honorius Augustodunensis, and Gerhoch of Reichersberg." *Traditio* 44 (1988): 145–69.

Dalla Costa, M. *La Basilica di San Marco e i restauri dell'Ottocento: Le idee di E. Violet-le-Duc, J. Ruskin, e le "Osservazioni" di A. P. Zorzi.* Venice, 1983.

Davidsohn, R. *Geschichte von Florenz.* 4 vols. Berlin, 1896–1922.

Davis, C. T. *Dante's Italy and Other Essays.* Philadelphia, 1984.

Deér, J. *The Dynastic Porphyry Tombs of the Norman Period in Sicily.* Cambridge, Mass., 1959.

Deichmann, F. W. "I pilastri acritani." *Rendiconti: Atti della Pontificia Accademia Romana di Archeologia* 3rd ser., 50 (1977–78): 75–89.

———, ed., with J. Kramer and U. Peschlow. *Corpus der Kapitelle von San Marco zu Venedig.* Forschungen zur Kunstgeschichte und christlichen Archäologie 12. Wiesbaden 1981.

Delbrueck, R. *Antike Porphyrwerke.* Berlin and Leipzig, 1932.

———. *Spätantike Kaiserporträts.* Berlin and Leipzig, 1933.

Dellwing, H. *Die Kirchenbaukunst des späten Mittelalters in Venetien.* Worms, 1990.

Demus, O. "Bisanzio e la scultura del Duecento a Venezia." In *Venezia e l'oriente fra tardo medioevo e rinascimento,* ed. A. Pertusi, 141–55. Florence, 1966.

———. *The Church of San Marco in Venice: History. Architecture. Sculpture.* Dumbarton Oaks Studies 6. Washington, D.C., 1960.

———. *The Mosaics of San Marco in Venice.* 4 vols. Chicago, 1984.

———. *Die Mosaiken von San Marco in Venedig, 1100–1300.* Baden bei Wien, 1935.

———. "Die Reliefikonen der Westfassade von San Marco: Bemerkungen zur venezianischen Plastik und Ikonographie des 13. Jahrhunderts." *Jahrbuch der Österreichischen Byzantinischen Gesellschaft* 3 (1954): 87–107.

———. "A Renascence of Early Christian Art in Thirteenth-Century Venice." In *Late Classical and Mediaeval Studies in Honor of Albert Mathias Friend, Jr.,* ed. K. Weitzmann, 348–61. Princeton, 1955.

———. *Romanesque Mural Painting.* Trans. M. Whittall. New York, 1970.

———. "Die skulpturale Fassadenschmuck des 13. Jahrhunderts." In Wolters, *Skulpturen von San Marco,* 1–15.

———. "Ein Wandgemälde in San Marco, Venedig." *Harvard Ukrainian Studies* 7 (1983): 125–44.

Diemer, P. Review of Wolters, *Skulpturen von San Marco. Kunstchronik* 35 (1982): 105–10.

Dodds, J. D., ed. *Al-Andalus: The Art of Islamic Spain.* Exh. cat. New York, 1992.

Dölger, F. J. "Das Sonnengleichnis in einer Weinachtspredigt des Bischofs Zeno von Verona." *Antike und Christentum* 6 (1940): 1–56.

Donati, F., and M. Cecilia Parra. "Pisa e il reimpiego 'laico': La nobilità di sangue e d'ingegno, e la potenza economica." In *Colloquio sul reimpiego dei sarcofagi romani nel Medioevo. Pisa 5.–12. September 1982,* ed. B. Andreae and S. Settis, 103–19. Marburger Winckelmann-Programm 1983. Marburg/Lahn, 1984.

D'Onofrio, C. *Castel S. Angelo e Borgo tra Roma e Papato.* Rome, 1978.

Dorigo, W. "The Medieval Mosaics of San Marco in the History of the Basilica." In *Patriarchal Basilica in Venice: San Marco.* Vol. 1, *The Mosaics. The History. The Lighting.* Contributions by O. Demus et al., 31–65. Milan, 1990.

————. "Sul problema di copie veneziane da originali bizantini." In *Venezia e l'archeologia: Un importante capitolo nella storia del gusto dell'antico nella cultura artistica veneziana: Congresso internazionale Venezia 25–29 Maggio 1988*, 151–56. Rivista di Archeologia Supplementi 7. Rome, 1990.

Dronke, P. *Dante and Medieval Latin Traditions*. Cambridge, 1986.

————. *Latin and Vernacular Poets of the Middle Ages*. London, 1991.

————. "The Procession in Dante's *Purgatorio*." *Deutsches Dante-Jahrbuch* 53/54 (1978–79): 18–45.

Dufour Bozzo, C. *Sarcofagi romani a Genova*. Genoa, 1967.

Ehlers, W. "Triumphus." In *Paulys Realencyclopädie der classischen Altertumswissenschaft*. Reihe 2, vol. 7a: 493–511. Stuttgart, 1939.

Eisler, E. *Die illuminierten Handschriften in Kärnten*. Beschreibendes Verzeichnis der illuminierten Handschriften in Österreich 3. Leipzig, 1907.

Erich, O. A. "Aminadab." In *Reallexikon zur deutschen Kunstgeschichte*, vol. 1: 638–41. Stuttgart, 1937.

Esch, A. "Spolien: Zur Wiederverwendung antiker Baustücke und Skulpturen im mittelalterlichen Italien." *Archiv für Kulturgeschichte* 51 (1969): 1–64.

Esch, J. *La chiesa di San Pietro di Spoleto: La facciata e le sue sculture*. Florence, 1981.

Esmeijer, A. C. *Divina Quaternitas: A Preliminary Study in the Method and Application of Visual Exegesis*. Amsterdam, 1978.

d'Essling, V., and E. Müntz. *Pétrarque: ses études d'art, son influence sur les artistes*. . . . Paris, 1902.

Euler, W. *Die Architekturdarstellung in der Arena-Kapelle: Ihre Bedeutung für das Bild Giottos*. Bern, 1967.

Falkenstein, L. *Der 'Lateran' der Karolingischen Pfalz zu Aachen*. Kölner historische Abhandlungen 13. Cologne and Graz, 1966.

Fasoli, G. "Nascita di un mito." In *Studi storici in onore di Giacchino Volpe*, vol. 1: 447–79. Florence, 1958.

————. *Scritti di storia medievale*. Bologna, 1974.

Favaretto, I. *Arte antica e cultura antiquaria nelle collezioni venete al tempo della Serenissima*. Rome, 1990.

Fehl, P. "The Placement of the Equestrian Statue of Marcus Aurelius in the Middle Ages." *Journal of the Warburg and Courtauld Institutes* 37 (1974): 362–67.

Fischer, B., ed. *Novae concordantiae bibliorum sacrorum iuxta Vulgatam versionem critice editam*. 5 vols. Stuttgart, 1977.

Flint, V. I. J. "The Career of Honorius Augustodunensis: Some Fresh Evidence." *Revue Bénédictine* 82 (1972): 62–86.

————. "The Chronology of the Work of Honorius Augustodunensis." *Revue Bénédictine* 82 (1972): 215–42.

————. "The Commentaries of Honorius Augustodunensis on the Song of Songs." *Revue Bénédictine* 84 (1974): 196–211.

————. "Heinricus of Augsburg and Honorius Augustodunensis: Are They the Same Person?" *Revue Bénédictine* 92 (1982): 148–58.

————. *Ideas in the Medieval West: Texts and Their Contexts*. London, 1988.

Forlati, F. *La Basilica di San Marco attraverso i suoi restauri*. Trieste, 1975.

————. "The Work of Restoration in San Marco." In O. Demus, *The Church of San Marco in Venice: History. Architecture. Sculpture*, 193–201. Washington, D.C., 1960.

Fossati, G. and G. *Rilievi storico-artistici sulla architettura bizantina dal IV al XV e fino al XIX secolo*. Milan, 1890.

Foster, K., and P. Boyde, eds. *Cambridge Readings in Dante's Comedy*. Cambridge, 1981.

Freccero, J., ed. *Dante: A Collection of Critical Essays*. Englewood Cliffs, 1965.

Friedman, J. I. "La processione mistica di Dante: Allegoria e iconografia nel canto XXIX del *Purgatorio*." In *Dante e le forme dell'allegoresi*, ed. M. Picone, 125–48. Ravenna, 1987.

Frugoni, C. "L'antichità: dai *Mirabilia* alla propaganda politica." In *Memoria dell'antico nell'arte italiana*. Vol. 1, *L'uso dei classici*, ed. S. Settis, 5–72. Biblioteca di storia dell'arte, nuova serie 1. Turin, 1984.

Galliazzo, V. *I cavalli di San Marco*. Treviso, 1981.

Ganz, P., et al. *Wolfenbütteler Cimelien*. Exh. cat. Wolfenbüttel, 1989.

Gardner, J. "An Introduction to the Iconography of the Medieval Italian City Gate." *Dumbarton Oaks Papers* 41 (1987): 199–214.

Gavazzoli, M. L. "L'allegoria del carro nelle opere letterarie e figurative del XII secolo." *Aevum* 46 (1972): 116–22.

Gioseffi, D. *Giotto architetto*. Milan, 1963.

Goldner, G. "The Decoration of the Main Façade Window of San Marco in Venice." *Mitteilungen des Kunsthistorischen Institutes in Florenz* 21 (1977): 13–34.

Gosebruch, M. "Die Anfänge der Frühgotik in Niedersachsen." *Niederdeutsche Beiträge zur Kunstgeschichte* 14 (1975): 9–58.

———. "Die Zeichnungen des Wolfenbütteler 'Musterbuches': Ihre westlichen Beziehungen-ihre byzantinische Vorlage." *Niederdeutsche Beiträge zur Kunstgeschichte* 20 (1981): 25–59.

Gramaccini, N. "Zur Ikonologie der Bronze im Mittelalter." *Städel-Jahrbuch* n.f., 11 (1987): 147–70.

———. "Die Umwertung der Antike—Zur Rezeption des Marc Aurel in Mittelalter und Renaissance." In *Natur und Antike in der Renaissance*, ed. H. Beck and P. C. Bol, 51–83. Exh. cat. Frankfurt, 1985.

Greenhalgh, M. "The Discovery of Roman Sculpture in the Middle Ages: Venice and Northern Italy." In *Venezia e l'archeologia: Un importante capitolo nella storia del gusto dell'antico nella cultura artistica veneziana: Congresso internazionale Venezia 25–29 Maggio 1988*, 157–64. Rivista di Archeologia Supplementi 7. Rome, 1990.

———. "*Ipsa ruina docet*: l'uso dell'antico nel Medioevo." In *Memoria dell'antico nell'arte italiana*. Vol. 1, *L'uso dei classici*, ed. S. Settis, 115–67. Biblioteca di storia dell'arte, nuova serie 1. Turin, 1984.

———. *The Survival of Roman Antiquities in the Middle Ages*. London, 1989.

Greenhill, E. S. *Die geistigen Voraussetzungen der Bilderreihe des Speculum Virginum: Versuch einer Deutung*. Beiträge zur Geschichte der Philosophie und Theologie des Mittelalters 39,2. Münster, 1962.

Grégoire, R. "Girolamo." In *Enciclopedia Dantesca*, 2nd ed., vol. 3: 209f. Rome, 1984.

Grodecki, L. "Les vitraux allégoriques de Saint-Denis." *Art de France* 1 (1961): 19–46.

Guilland, R. "Études byzantines: La disparition des courses." In *Mélanges offerts à Octave et Melpo Merlier*, vol. 1: 31–47. Athens, 1956.

———. "Études sur l'Hippodrome de Byzance: A propos du chapitre 69 du Livre I du Livre des Cérémonies. Les courses à Byzance." *Byzantinoslavica* 23 (1962): 203–30.

———. "Études sur l'Hippodrome de Byzance III: Rôle de l'empereur et des divers fonctionnaires avant et pendant les courses.—Les spectateurs de l'Hippodrome." *Byzantinoslavica* 26 (1965): 1–39.

———. *Études de topographie de Constantinople byzantine*. 2 vols. Berliner byzantinische Arbeiten 37. Berlin, 1969.

Guldan, E. *Eva und Maria: Eine Antithese als Bildmotiv*. Graz-Cologne, 1966.

Haftmann, W. *Das italienische Säulenmonument*. Beiträge zur Kulturgeschichte des Mittelalters und der Renaissance 55. Leipzig and Berlin, 1939.

Hahnloser, H. R., and F. Rücker. *Das Musterbuch von Wolfenbüttel.* Vienna, 1929,

Hamilton, G. H. *The Art and Architecture of Russia.* 3rd ed. Harmondsworth, 1983.

Hardie, C. "The Symbol of the Gryphon in *Purgatorio* XXIX. 108 and Following Cantos." In *Centenary Essays on Dante,* 103–31. Oxford, 1965.

Harrison, R. M. *Excavations at Saraçhane in Istanbul.* Vol. 1. Princeton, 1986.

———. *A Temple for Byzantium: The Discovery and Excavation of Anicia Juliana's Palace-Church in Istanbul.* Austin, 1989.

Hatch, E., and H. A. Redpath. *A Concordance to the Septuagint.* 2 vols. Oxford, 1897.

Haussherr, R. "Der typologische Zyklus der Chorfenster der Oberkirche von S. Francesco zu Assisi." In *Kunst als Bedeutungsträger: Gedenkschrift für Günter Bandmann,* ed. W. Busch, R. Haussherr, and E. Trier, 95–128. Berlin, 1978.

———. ed. *Bible moralisée: Faksimile-Ausgabe im Originalformat des Codex Vindobonensis 2554 der Österreichischen Nationalbibliothek.* Codices selecti 40 and 40*. Graz, 1973.

———. ed. *Die Zeit der Staufer.* 5 vols. Stuttgart, 1977.

Hawkins, P. S. "Scripts for the Pageant: Dante and the Bible." *Stanford Literature Review* 5 (1988): 75–92.

Heckscher, W. S. "Dornauszieher." In *Reallexikon zur deutschen Kunstgeschichte,* vol. 4: 289–99. Stuttgart, 1958.

Herklotz, I. "Der Campus Lateranensis im Mittelalter." *Römisches Jahrbuch für Kunstgeschichte* 22 (1985): 1–43.

———. *"Sepulcra" e "Monumenta" del Medioevo: Studi sull'arte sepolcrale in Italia.* Rome, 1985.

Herzner, V. "Die Baugeschichte von San Marco und der Aufstieg Venedigs zur Grossmacht." *Wiener Jahrbuch für Kunstgeschichte* 38 (1985): 1–58.

Herzog, H.-M. *Untersuchungen zur Plastik der venezianischen "Protorenaissance".* Munich, 1986.

Heydenreich, H. "Marc Aurel und Regisole." In *Festschrift für E. Meyer,* 146–59. Hamburg, 1959.

Hill, P. V. *The Monuments of Ancient Rome as Coin Types.* London, 1989.

Hoffmann, H. "Die Aachener Theoderichstatue." In *Das erste Jahrtausend: Kultur und Kunst im werdenden Abendland an Rhein und Ruhr,* ed. V. H. Elbern, 1:318–35. Düsseldorf, 1962.

Hoffmann, K. *The Year 1200.* Exh. cat. 2 vols. New York, 1970.

Hollander, R. "Dante 'Theologus-Poeta.' " *Dante Studies* 94 (1976): 91–136.

———. *Studies in Dante.* Ravenna, 1980.

Hope, C. "Reply to Letter to the Editor." *The New York Review of Books* 38, no. 18 (11/22/1990): 51f.

Hülsen, C. *Das Skizzenbuch des Giovannantonio Dosio im Staatlichen Kupferstichkabinett zu Berlin.* Berlin, 1933.

Hunger, H. *Reich der neuen Mitte: Der christliche Geist der byzantinischen Kultur.* Graz, 1965.

Jenkins, M. "New Evidence for the History and Provenance of the So-called Pisa Griffin." *Islamic Archaeological Studies* 1 (1978): 79–81.

Jestaz, B. *La chapelle Zen à Saint-Marc de Venise: D'Antonio à Tullio Lombardo.* Forschungen zur Kunstgeschichte und christlichen Archäologie 15. Stuttgart, 1986.

Jope, E. M. "Vehicles and Harnesses." In *A History of Technology.* Vol. 2, *The Mediterranean Civilizations and the Middle Ages, c. 700 B.C. to c. A.D. 1500,* ed. C. Singer et al., 537–62. Oxford, 1956.

Jullian, R. *L'éveil de la sculpture italienne.* Vol. 1, *La sculpture romane dans l'Italie du nord.* Paris, 1945.

Kähler, H. "Triumphbogen (Ehrenbogen)." In *Paulys Realencyclopädie der classischen Alter-tumswissenschaft.* Reihe 2, vol. 7a: 373–493. Stuttgart, 1939.

Kantorowicz, E. *Kaiser Friedrich der Zweite.* 2 vols. Berlin, 1931.

Kauffmann, C. M. *Romanesque Manuscripts, 1066–1190.* A Survey of Manuscripts Illuminated in the British Isles 3. London, 1975.

Keller, H. "Die Bauplastik des Sieneser Doms. Studien zu Giovanni Pisano und seiner künstlerischen Nachfolge." *Kunstgeschichtliches Jahrbuch der Bibliotheca Hertziana* 1 (1937): 139–221.

———. *Giovanni Pisano.* Vienna, 1942.

Kelly, J. N. D. *Jerome: His Life, Writings and Controversies.* London, 1975.

Kerscher, G. "*Quadriga temporum.* Studien zur Sol-Ikonographie in mittelalterlichen Handschriften und in der Architekturdekoration." *Mitteilungen des Kunsthistorischen Instituts in Florenz* 32 (1988): 1–76.

Kieslinger, F. "Le transenne della basilica di San Marco del secolo XIII." *Ateneo Veneto* 132 (1944–45): 57–61.

Kinney, D. "'Mirabilia urbis Romae.'" In *The Classics in the Middle Ages,* ed. A. S. Bernardo and S. Levin, 207–21. Binghamton, 1990.

Koch, H. "Bronzestatue in Barletta." In *Antike Denkmäler,* vol. 3: 20–27. Deutsches Archäologisches Institut. Berlin, 1912–13.

Kraus, F. X. *Dante: Sein Leben und Sein Werk: Sein Verhältnis zur Kunst und zum Politik.* Berlin, 1897.

Krautheimer, R. *Ausgewählte Aufsätze zur europäischen Kunstgeschichte.* Cologne, 1988.

———. "Introduction to an 'Iconography of Medieval Architecture.'" *Journal of the Warburg and Courtauld Institutes* 5 (1942): 1–33.

———. *Rome: Profile of a City, 312–1308.* Princeton, 1980.

———. *Studies in Early Christian, Medieval, and Renaissance Art.* New York, 1969.

Krinsky, C. H. "Representations of the Temple of Jerusalem before 1500." *Journal of the Warburg and Courtauld Institutes* 33 (1970): 1–19.

Kroos, R. "Sächsische Buchmalerei, 1200–1250." *Zeitschrift für Kunstgeschichte* 41 (1978): 283–316.

Kruft, H.-W. "Giotto e l'antico." In *Giotto e il suo tempo: Atti del congresso internazionale per la celebrazione del VII centenario della nascita di Giotto: 24 settembre–1 ottobre 1967,* 169–76. Rome, 1971.

de Laborde, A. *La Bible moralisée illustrée conservée à Oxford, Paris et Londres.* 5 vols. Paris, 1911–27.

de Lachenal, L. "Il monumento nel Medioevo fino al suo trasferimento in Campidoglio." In *Marco Aurelio: Storia di un monumento e del suo restauro,* ed. A. Melucco Vaccaro and A. Mura Sommella, 129–55. Milan, 1989.

Lane, F. C. *Venice: A Maritime Republic.* Baltimore, 1973.

Lanfranco e Wiligelmo: Il Duomo di Modena. Modena, 1984.

Latham, R. E. *Revised Latin Word-List from British and Irish Sources.* London, 1965.

Lavin, M. A. *The Place of Narrative: Mural Decoration in Italian Churches, 431–1600.* Chicago, 1990.

Lazzarini, V. "La presa di Chioggia (16 Agosto 1379)." *Archivio veneto* 5th ser., 48/49 (1951): 53–74.

Leclerq, J. *Saint Pierre Damien ermite et homme d'église.* Rome, 1960.

Leighton, A. C. *Transport and Communication in Early Medieval Europe, AD 500–1100.* New York, 1972.

Lethaby, W. R., and H. Swainson. *The Church of Sancta Sophia Constantinople: A Study of Byzantine Building.* London, 1894.

Levine, S. "The Location of Michelangelo's *David*: The Meeting of January 25, 1504." *Art Bulletin* 56 (1974): 31–49.

Lightbown, R. *Sandro Botticelli.* 2 vols. Berkeley and Los Angeles, 1978.

Lilie, R.-J. *Handel und Politik zwischen dem byzantinischen Reich und den italienischen Kommunen Venedig, Pisa und Genua in der Epoche der Kommenen und der Angeloi (1081–1204).* Amsterdam, 1984.

Limentani, A. "Martino da Canal, la basilica di San Marco e le arti figurative." In *Mélanges offerts à René Crozet,* vol. 2: 1177–90. Poitiers, 1966.

Lissowsky, G., with L. Rost. *Konkordanz zum hebräischen Alten Testament.* Stuttgart, 1958.

Littledale, R. F. *A Commentary on the Song of Songs from Ancient and Mediaeval Sources.* London, 1869.

Lopes Pegna, M. *Firenze dalle origini al Medioevo.* 2nd ed. Florence, 1974.

L'Orange, H. P. *Studies in the Iconography of Cosmic Kingship in the Ancient World.* Oslo, 1953.

———, with R. Unger. *Das spätantike Herrscherbild von Diokletian bis zu den Konstantinsöhnen, 284–361 n. Chr.* Deutsches Archäologisches Institut. Das römische Herrscherbild. 3 Abteilung. Band 4. Berlin, 1984.

Lubac, H. de. *Exégèse médiévale: les quatre sens de l'écriture.* 4 vols. Paris, 1959–64.

Magi, F. "Osservazioni sul grifo e il leone di Perugia." *Rendiconti: Atti della Pontificia Accademia Romana di Archeologia* 3rd ser., 44 (1971–72): 275–303.

Magnani, L. *La cronaca figurata di Giovanni Villani.* Codices e Vaticanis selecti 14. Vatican City, 1936.

Mähl, S. *Quadriga virtutum: Die Kardinaltugenden in der Geistesgeschichte der Karolingerzeit.* Beiheft zum Archiv für Kulturgeschichte 9. Cologne and Vienna, 1969.

Mango, C. "Antique Statuary and the Byzantine Beholder." *Dumbarton Oaks Papers* 17 (1963): 53–75.

———. *Byzantium and Its Image: History and Culture of the Byzantine Empire and Its Heritage.* London, 1984.

———. "Daily Life in Byzantium." In *XVI. Internationaler Byzantinistenkongress: Wien, 1981, Akten,* 1,1 (=*Jahrbuch der Österreichischen Byzantinistik* 31,1 [1981]), 337–53.

———. *Le développement urbain de Constantinople (IVe–VIIe siècles).* Paris, 1985.

Mariani, V. *Giotto e l'architettura.* Milan, 1967.

Martin, A., and C. Cahier. *Monographie de la cathédrale de Bourges.* Vol. 1. Paris, 1841–44.

Matter, E. A. *The Voice of My Beloved: The Song of Songs in Western Medieval Christianity.* Philadelphia, 1990.

Meer, F. van der. *Maiestas Domini.* Rome, 1938.

Mellini, G. L. *Giovanni Pisano.* Venice, [1970].

Meyer, H. "*Mos Romanorum.* Zum typologischen Grund der Triumphmetapher im 'Speculum Ecclesiae' des Honorius Augustodunensis." In *Verbum et signum: Beiträge zur mediävistischen Bedeutungsforschung F. Ohly überreicht,* ed. H. Fromm, W. Harms, and U. Ramberg, vol. 1: 45–58. Munich, 1975.

———, and R. Suntrup. *Lexikon der mittelalterlichen Zahlenbedeutungen.* Münstersche Mittelalter-Schriften 56. Munich, 1987.

Middeldorf Kosegarten, A. *Sienesische Bildhauer am Duomo Vecchio: Studien zur Skulptur in Siena, 1250–1330.* Munich, 1984.

Milde, W. *Mittelalterliche Handschriften der Herzog August Bibliothek.* Frankfurt am Main, 1972.

———. "Zum 'Wolfenbütteler Musterbuch.'" In R. Haussherr, ed. *Die Zeit der Staufer.* Vol. 5, 331–33. Stuttgart, 1977.

Molmenti, P. *La storia di Venezia nella vita privata.* 7th ed. 3 vols. Bergamo, 1927–29.

Molsdorf, W. *Christliche Symbolik der mittelalterlichen Kunst.* 2nd ed. Leipzig, 1926.

Monaci, E., ed. *Storie de Troja et de Roma altrimenti dette Liber historiarum Romanorum.* Miscellanea della Reale Società di Storia Patria 5. Rome, 1920.

Mueller, R. C. "The Procurators of San Marco in the Thirteenth and Fourteenth Centuries: A Study of the Office as a Financial and Trust Institution." *Studi Veneziani* 13 (1971): 105–220.

Müller-Wiener, W., with R. and W. Schiele. *Bildlexikon zur Topographie Istanbuls: Byzantion, Konstantinupolis, Istanbul bis zum Beginn des 17. Jahrhunderts.* Tübingen, 1977.

Muir, E. *Civic Ritual in Renaissance Venice.* Princeton. 1981.

———. "Images of Power: Art and Pageantry in Renaissance Venice." *American Historical Review* 84 (1979): 16–52.

Muraro, M. *La vita nelle pietre: Sculture marciane e civiltà veneziana del Duecento.* Venice, 1985.

———, and A. Grabar. *Treasures of Venice.* Geneva, 1963.

Murray, P. "Notes on Some Early Giotto Sources." *Journal of the Warburg and Courtauld Institutes* 16 (1953): 58–80.

Nagy, M. von. *Die Wandbilder der Scrovegni-Kapelle zu Padua: Giottos Verhältnis zu seinen Quellen.* Bern, 1962.

Naumann, R. "Der antike Rundbau beim Myrelaion und der Palast Romanos I. Lekapenos." *Istanbuler Mitteilungen* 16 (1966): 199–216.

———. "Neue Beobachtungen am Theodosiusbogen und Forum Tauri in Istanbul." *Istanbuler Mitteilungen* 26 (1976): 117–41.

Negri, D. *Chiese romaniche in Toscana.* Pistoia, 1978.

Nesselrath, A. "I libri di disegni di antichità. Tentativo di una tipologia." In *Memoria dell'antico nell'arte italiana.* Vol. 3, *Dalla tradizione all'archeologia*, ed. S. Settis, 87–147. Biblioteca di storia dell'arte, Nuova serie 3. Turin, 1986.

Nicol, D. M. *Byzantium and Venice: A Study in Diplomatic and Cultural Relations.* Cambridge, 1988.

Niero, A. "I cicli iconografici marciani." In B. Bertoli, A. Niero, and W. Dorigo, *I mosaici di San Marco: Iconografia dell'Antico e del Nuovo Testamento*, 9–36. Milan, 1986.

———. "I santi patroni." In S. Tramontin et al., *Culto dei santi a Venezia*, 75–98. Venice, 1965.

Nilgen, U. "Evangelisten." In *Lexikon der christlichen Ikonographie*, vol. 1: 696–713. Freiburg im Breisgau, 1968.

———. "Evangelistensymbole." In *Reallexikon zur deutschen Kunstgeschichte*, vol. 6: 517–72. Munich, 1973.

Ohly, F. *Hohelied-Studien: Grundzüge einer Geschichte der Hoheliedauslegung des Abendlandes bis um 1200.* Wiesbaden, 1958.

Opelt, I. "Hieronymus bei Dante." *Deutsches Dante-Jahrbuch* 51/52 (1976–77): 65–83.

Oxford Latin Dictionary. Ed. P. G. W. Glare. Oxford, 1982.

Paatz, W. and E. *Die Kirchen von Florenz.* 6 vols. Frankfurt am Main, 1940–55.

Panofsky, E. *Problems in Titian: Mostly Iconographic.* New York, 1969.

———. *Renaissance and Renascences in Western Art.* 2nd ed. Stockholm, 1960.

Patriarchal Basilica in Venice: San Marco. Vol. 1, *The Mosaics. The History. The Lighting,* contributions by O. Demus et al. Milan, 1990.

Patriarchal Basilica in Venice: San Marco. Vol. 2, *The Mosaics. The Inscriptions. The Pala d'Oro,* contributions by M. Andaloro et al. Milan, 1991.

Patrologiae cursus completus: Series latina, ed. J. P. Migne. 221 vols. Paris, 1844–64.

Perler, O. *Die Mosaiken der Juliergruft im Vatikan.* Freiburg, 1953.

Perocco, G. "I cavalli di S. Marco a Venezia." In *I cavalli di S. Marco: Catalogo della mostra. Convento di Santa Apollonia Venezia Giugno/Agosto 1977*, 59–92. Venice, 1977.

————. "San Marco: History of the Basilica." In *Patriarchal Basilica in Venice: San Marco.* Vol. 1, *The Mosaics. The History. The Lighting,* with contributions by O. Demus et al., 21–29. Milan, 1990.

————, and A. Salvadori, *Civiltà di Venezia.* 3 vols. Venice, 1973–76.

Perry, M. "Saint Mark's Trophies: Legend, Superstition and Archaeology in Renaissance Venice." *Journal of the Warburg and Courtauld Institutes* 40 (1977): 27–49.

Perry Caldwell, M. "The Public Display of Antique Sculpture in Venice, 1200–1600." Ph.D. diss. University of London, 1975.

Peschlow, U. "Dekorative Plastik aus Konstantinopel an San Marco in Venedig." In *Aphierōma stē mnēmē Stylianou Pelekanidē,* 406–17. Makedonika: Periodikon Suggramma Heteireias Makedonikon Spoudōn, Parartēma 5. Thessalonica, 1983.

————. "Eine wiedergewonnene byzantinische Ehrensäule in Istanbul." In *Studien zur spätantike und byzantinischen Kunst Friedrich Wilhelm Deichmann gewidmet,* ed. O. Feld and U. Peschlow, vol. 1: 21–33. Bonn, 1986.

Pfanner, M. *Der Titusbogen.* Mainz am Rhein, 1983.

Phillips, J. G. *Early Florentine Designers and Engravers.* Cambridge, Mass., 1955.

Pincus, D. *The Arco Foscari: The Building of a Triumphal Gateway in Fifteenth-Century Venice.* New York, 1976.

Pinelli, A. "Feste e trionfi: continuità e metamorfosi di una tema." In *Memoria dell'antico nell'arte italiana.* Vol. 2, *I generi e i temi ritrovati,* ed. S. Settis, 281–350. Biblioteca di storia dell'arte, nuova serie 2. Turin, 1985.

Polacco, R. "I bassorilievi marmorei duecenteschi raffiguranti il Cristo e gli Evangelisti sulla facciata settentrionale della Basilica di S. Marco." *Arte Veneta* 32 (1978): 10–17.

————. "I mosaici di San Marco." *Venezia Arti* 3 (1989): 193f.

————. "San Marco e le sue sculture nel Duecento." In *Interpretazioni veneziane: Studi di storia dell'arte in onore di Michelangelo Muraro,* ed. D. Rosand, 59–75. Venice, 1984.

————, with G. Rossi Scarpa and J. Scarpa. *San Marco: La Basilica d'oro.* Milan, 1991.

Prosdocimi, A. "Classicismo di Giotto: Un ricordo dei cavalli di S. Marco e una citazione dalla Colonna Traiana." *Bollettino del Museo Civico di Padova* 68 (1979): 9–14.

Queller, D. E. *The Fourth Crusade: The Conquest of Constantinople, 1201–1204.* Philadelphia, 1977.

Reau, L. *L'art russe des origines à Pierre le Grand.* Paris, 1921.

Reinle, A. "Der Reiter am Zürcher Grossmünster." *Zeitschrift für Schweizerische Archäologie und Kunstgeschichte* 26 (1969): 21–47.

Ricci, C. *L'architettura romanica in Italia.* Stuttgart, 1925.

Rocca, L. *Il Canto XXIX del Purgatorio.* Florence, 1904.

Ronchi, O. *Guida storico-artistica di Padova e dintorni.* Padua, 1922.

Rosand, D., and M. Muraro. *Titian and the Venetian Woodcut.* Exh. cat. Washington, D.C., 1976.

Rough, R. H. "Enrico Scrovegni, the *Cavalieri Gaudenti,* and the Arena Chapel in Padua." *Art Bulletin* 62 (1980): 24–35.

Rubinstein, R. "The Beginnings of Political Thought in Florence." *Journal of the Warburg and Courtauld Institutes* 5 (1942): 198–227.

Rushforth, G. McN. "*Magister Gregorius de Mirabilibus Urbis Romae*: A New Description of Rome in the Twelfth Century." *Journal of Roman Studies* 9 (1919): 14–58.

Saccardo, G. "I pilastri acritani." *Archivio veneto* 34 (1887): 285–309.

Salomon, R. *Opicinus de Canistris: Weltbild und Bekenntnisse eines Avignonesischen Klerikers des 14. Jahrhunderts.* Studies of the Warburg Institute 1a. London, 1936.

Salzenberg, W. *Alt-christliche Baudenkmale von Constantinopel von V. bis XII. Jahrhundert.* Berlin, 1854.

Sauer, J. *Symbolik des Kirchengebäudes und seiner Ausstattung in der Auffassung des Mittelalters.* 2nd ed. Freiburg im Breisgau, 1924.

Sauerländer, W. *Gothic Sculpture in France, 1140–1270.* Trans. J. Sondheimer. New York, 1973.

Scarfi, B. M. "La statua del leone della Piazzetta." In *Il leone di Venezia: Studi e richerche sulla statua di bronzo della Piazzetta,* ed. B. M. Scarfi, 32–123. Venice, 1990.

Schild, M. E. *Abendländische Bibelvorreden bis zur Lutherbibel.* Quellen und Forschungen zur Reformationsgeschichte 39. Heidelberg, 1970.

Schiller, G. *Ikonographie der christlichen Kunst.* 5 vols. Gütersloh, 1966–91.

Schlegel, U. "Zum Bildprogramm der Arena-Kapelle." *Zeitschrift für Kunstgeschichte* 20 (1957): 125–46.

Schmidt, G. *Die Malerschule von St. Florian.* Graz, 1962.

Schnapp, J. T. *The Transfiguration of History at the Center of Dante's Paradise.* Princeton, 1986.

Schramm, P. E. "Die römische Literatur zur Topographie und Geschichte des alten Rom im XI. und XII. Jahrhundert." In his *Kaiser, Könige und Päpste: Gesammelte Aufsätze zur Geschichte des Mittelalters,* vol. 4, 1: 22–42. Stuttgart, 1970.

———, and F. Mütherich. *Demkmale der deutschen Könige und Kaiser.* 2nd ed. Munich, 1981.

Schulz, A. Markham. "Revising the History of Venetian Renaissance Sculpture: Niccolò and Pietro Lamberti." *Saggi e memorie di storia dell'arte* 15 (1986): 7–61.

Seidel, M. "Die Rankensäulen der Sieneser Domfassade." *Jahrbuch der Berliner Museen* 11 (1969): 81–160.

———. "Studien zur Antikenrezeption Nicola Pisanos." *Mitteilungen des Kunsthistorischen Institutes in Florenz* 19 (1975): 307–92.

Settis, S. "Continuità, distanza, conoscenza. Tre usi dell'antico." In *Memoria dell'antico nell'arte italiana.* Vol. 3, *Dalla tradizione all'archeologia,* ed. S. Settis, 375–486. Biblioteca di storia dell'arte, nuova serie 3. Turin, 1986.

———. "Iconografia dell'arte italiana, 1100–1500: Una linea." In *Storia dell'arte italiana.* Vol. 1, 3, *L'esperienza dell'antico, dell'Europa, della religiosità,* 173–270. Turin, 1979.

———, ed. *Camposanto monumentale di Pisa: Le antichità.* Vol. 2. Modena, 1984.

Sinding-Larsen, S. "Titian's Triumph of Faith and the Medieval Tradition of the Glory of Christ." *Acta ad archaeologiam et artium historiam pertinentia* 6 (1975): 315–51.

Singleton, C. S. "The Pattern at the Center." In his *Dante Studies.* Vol. 1, *Commedia: Elements of Structure,* 45–60. Cambridge, Mass., 1954.

Smart, A. *The Assisi Problem and the Art of Giotto.* Oxford, 1971.

Spitzer, L. "Speech and Language in *Inferno* XIII." *Italica* 19 (1942): 81–104.

Stork, H. W. *Bible moralisée: Codex Vindobonensis 2554 der Österreichischen Nationalbibliothek: Transkription und Übersetzung.* St. Ingebert, 1988.

Striker, C. L. *The Myrelaion (Bodrum Camii) in Istanbul.* Princeton, 1981.

Stringa, G. *La chiesa di S. Marco.* Venice, 1610.

Stummer, F. "Griechisch-römische Bildung und christliche Theologie in der Vulgata des Hieronymus." *Zeitschrift für die Alttestamentliche Wissenschaft* 58 (1940–41): 251–69.

Swarzenski, G. *Die Salzburger Malerei von den ersten Anfängen bis zur Blütezeit des romanischen Stils.* 2 vols. Leipzig, 1913.

Tatlock, J. S. P. "The Last Cantos of the *Purgatorio*." *Modern Philology* 32 (1934): 113–23.

Telpaz, A. Markham. "Some Antique Motifs in Trecento Art." *Art Bulletin* 46 (1964): 372–76.

Thürlemann, F. "Die Bedeutung der Aachener Theoderich-Statue für Karl den Grossen (801) und bei Walahfrid Strabo (829): Materialien zu einer Semiotik visueller Objekte im frühen Mittelalter." *Archiv für Kulturgeschichte* 59 (1977): 25–65.

Tintori, L., and M. Meiss. *The Painting of the Life of Saint Francis at Assisi.* New York, 1962.

Tiziano. Exh. cat. Venice, 1990.

Todisco, L. "L'antico nel campanile normanno di Melfi." *Mélanges de l'École Française de Rome: Moyen âge-Temps modernes* 99 (1987): 123–158.

—————. "Il busto della cattedrale di Acerenza." *Xenia* 12 (1986): 41–64.

Toynbee, P. *A Dictionary of Proper Names and Notable Matters in the Works of Dante.* Rev. by C. S. Singleton. Oxford, 1968.

Traina, G. "Fruizione utilitaristica e fruizione culturale: i reimpieghi nelle Venezie." In *Colloquio sul reimpiego dei sarcofagi romani nel Medioevo. Pisa 5.–12. September 1982,* ed. B. Andreae and S. Settis, 63–70. Marburger Winckelmann-Programm 1983. Marburg/Lahn, 1984.

Trincanato, E. R. "Rappresentatività e funzionalità di Piazza San Marco." In G. Samonà et al., *Piazza San Marco: L'architettura. La storia. Le funzioni,* 79–91. Venice, 1970.

Tronci, P. *Il Duomo di Pisa descritto dal Can. Paolo Tronci.* Ed. P. Bacci. Pisa, 1922.

Unrau, J. *Ruskin and St. Mark's.* London, 1984.

Valcanover, F. "I cavalli di S. Marco nella pittura veneziana." In *I cavalli di S. Marco: Catalogo della mostra. Convento di Santa Apollonia Venezia Giugno/Agosto 1977,* 95–119. Venice, 1977.

Verzone, P. "I due gruppi in porfido di S. Marco in Venezia ed il Philadelphion di Costantinopoli." *Palladio* n.s., 8 (1958): 8–14.

Vickers, M. "Wandering Stones: Venice, Constantinople, and Athens." In *The Verbal and the Visual: Essays in Honor of William Sebastian Heckscher,* ed. K.-L. Selig and E. Sears, 225–42. New York, 1990.

Vigorelli, G., and F. Baccheschi. *L'opera completa di Giotto.* Milan, 1966.

Vin, J. P. A. van der. *Travellers to Greece and Constantinople: Ancient Monuments and Old Traditions in Medieval Travellers' Tales.* 2 vols. Leiden, 1980.

Vio, E. "Le levate fotogrammetriche della Basilica di S. Marco." *Venezia Arti* 2 (1988): 157–62.

Volbach, W. F., et al. *La Pala d'oro.* Vol. 1 of *Il Tesoro di San Marco,* ed. H. R. Hahnloser. Florence, 1965.

Ward Perkins, J. B. "The Bronze Lion of St. Mark at Venice." *Antiquity* 21 (1947): 23–41.

Weitzmann, K., and H. L. Kessler. *The Cotton Genesis: British Library Codex Cotton B VI.* Princeton, 1986.

White, J. *Art and Architecture in Italy, 1250–1400.* 2nd ed. Harmondsworth, 1987.

—————. *Duccio: Tuscan Art and the Medieval Workshop.* London, 1979.

—————. "Giotto's Use of Architecture in 'The Expulsion of Joachim' and 'The Entry into Jerusalem' at Padua." *Burlington Magazine* 115 (1973): 439–47.

Wolters, W. *La scultura veneziana gotica (1300–1460).* 2 vols. Venice, 1976.

—————, ed., with O. Demus, G. Hempel, J. Julier, and L. Lazzarini. *Die Skulpturen von San Marco in Venedig: Die figürlichen Skulpturen der Aussenfassaden bis zum 14. Jahrhundert.* Deutsches Studienzentrum in Venedig Studien 3. Munich and Berlin, 1979.

Zanotto, F. *Il Palazzo Ducale di Venezia.* 5 vols. Venice, 1842–61.

Zatta, A. *L'augusta ducale Basilica dell'Evangelista San Marco.* Venice, 1761.

Zuliani, F. *I marmi di San Marco: Uno studio ed un catalogo della scultura ornamentale marciana fino all'XI secolo.* Alto medioevo 2. Venice, [1969].

Index

ILLUSTRATIONS

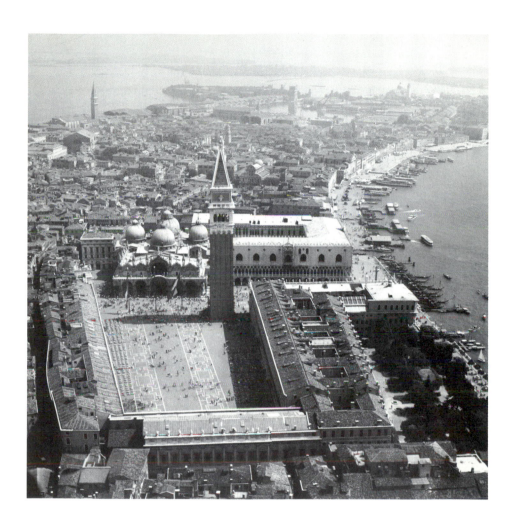

Fig. 1. San Marco, Piazza San Marco, and Piazzetta di San Marco. Aerial View

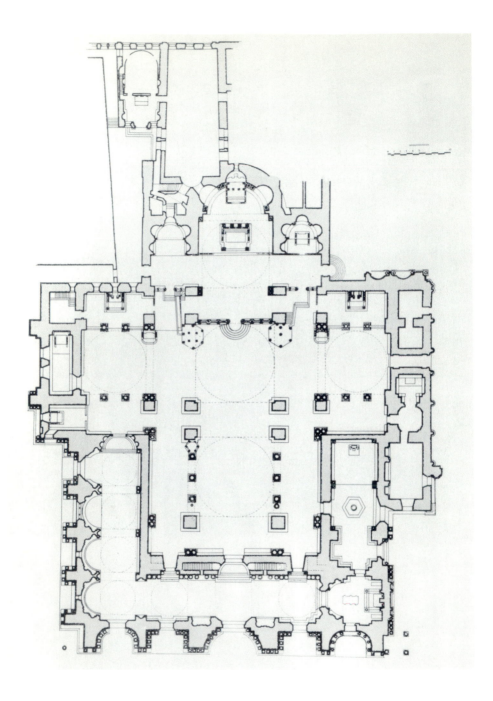

Fig. 2. Plan of San Marco

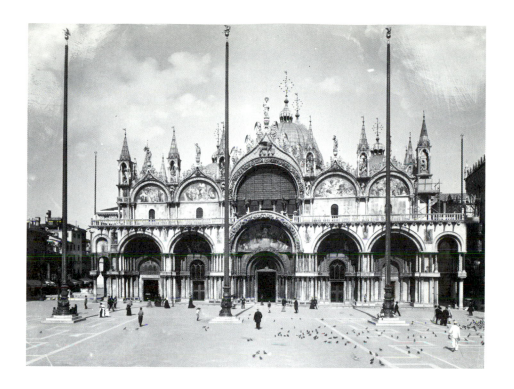

Fig. 3. West Façade, San Marco

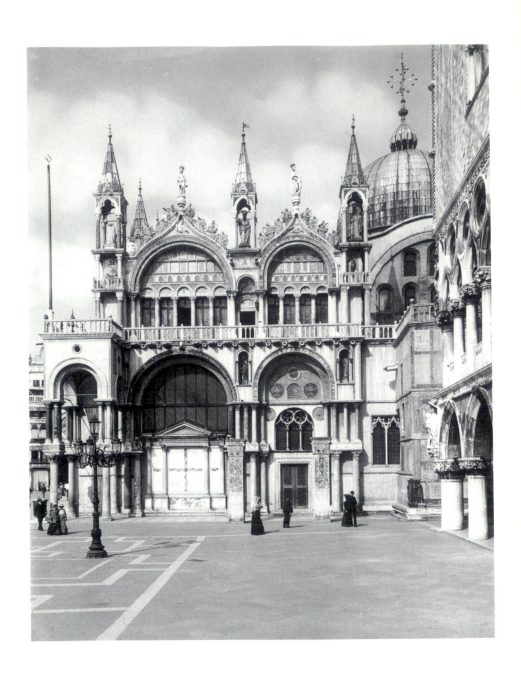

Fig. 4. South Façade, San Marco

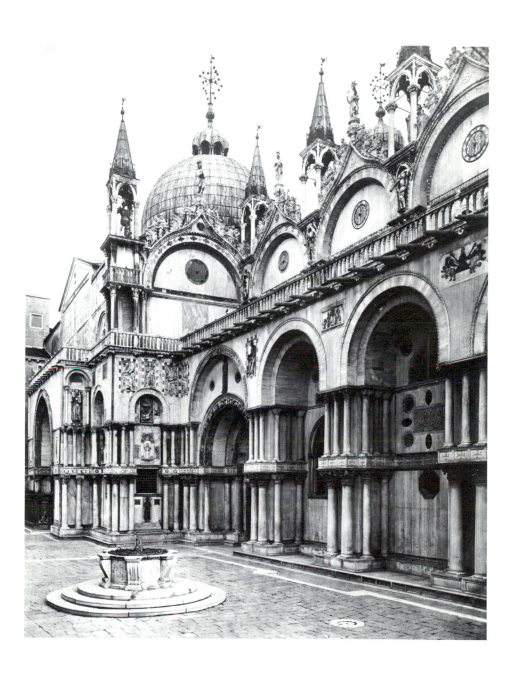

Fig. 5. North Façade, San Marco

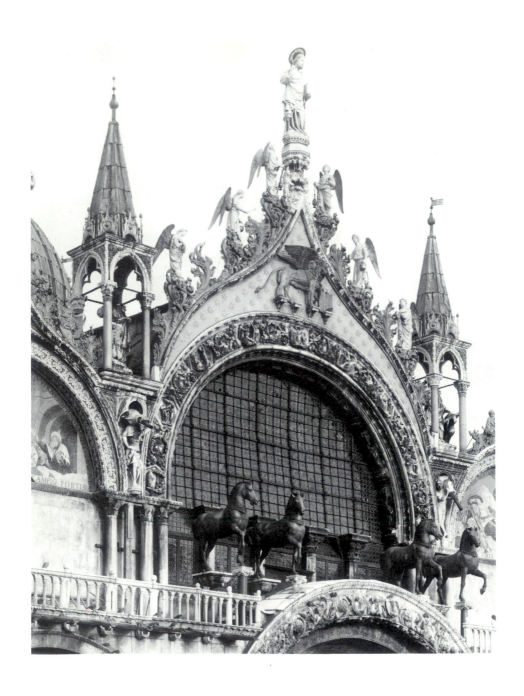

Fig. 6. Horses, San Marco

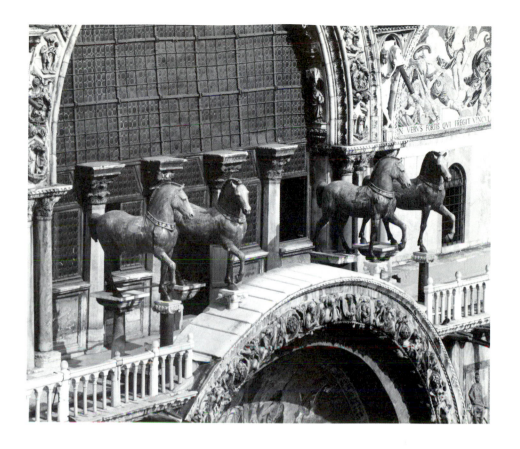

Fig. 7. Horses, San Marco

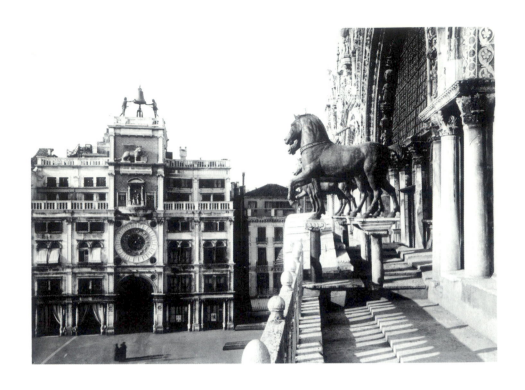

Fig. 8. Horses, San Marco

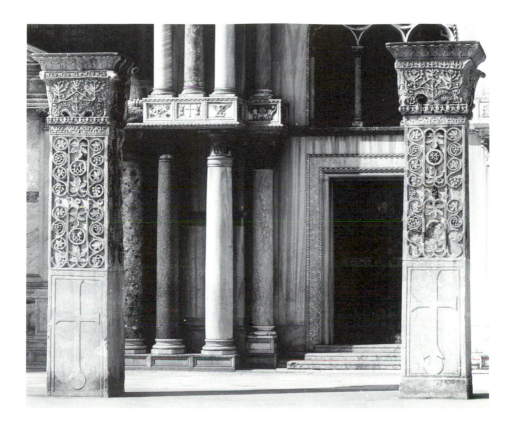

Fig. 9. Piers from St. Polyeuktos, San Marco

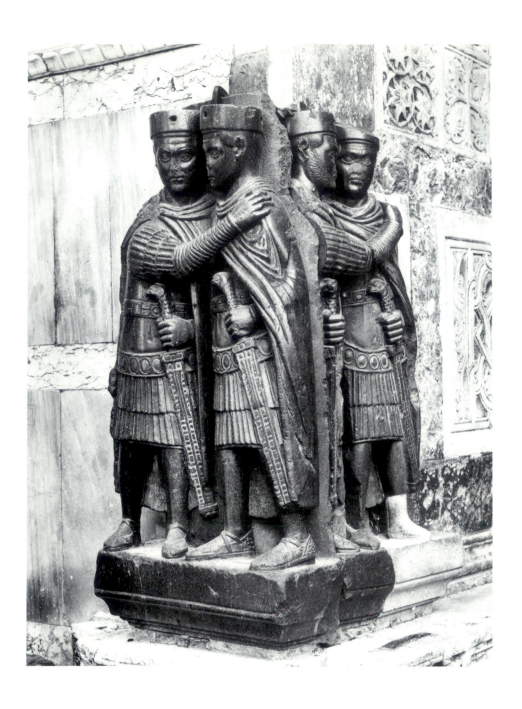

Fig. 10. Porphyry Emperors, San Marco

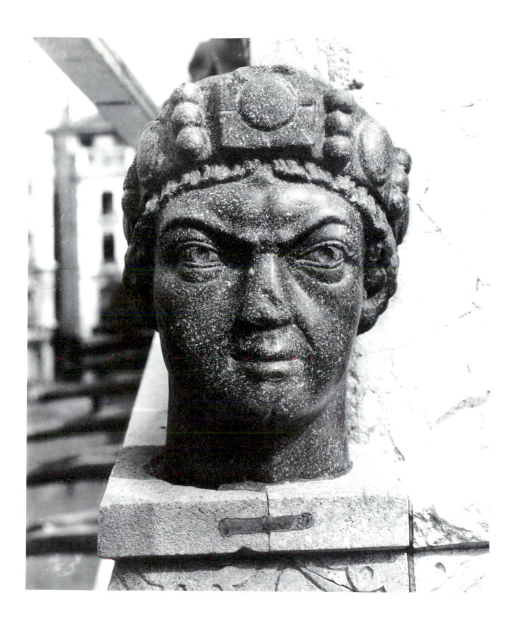

Fig. 11. Prophyry Head, San Marco

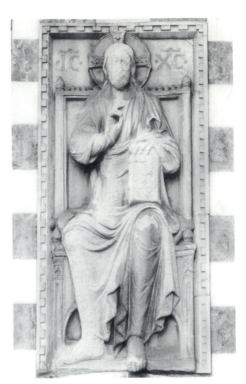

Fig. 12. Christ, San Marco

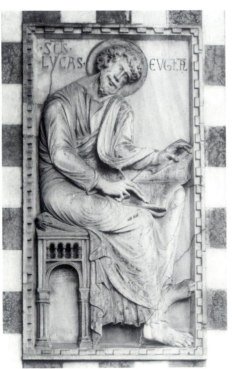

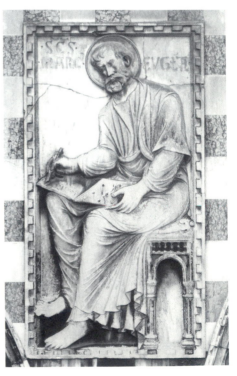

Figs. 13 & 14. St. Luke and St. Mark, San Marco

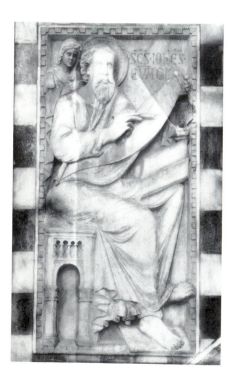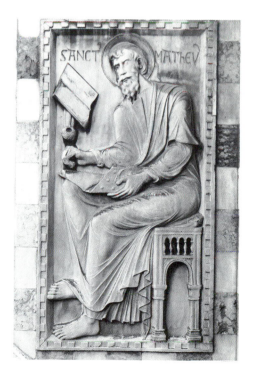

Figs. 15 & 16. St. John and St. Matthew, San Marco

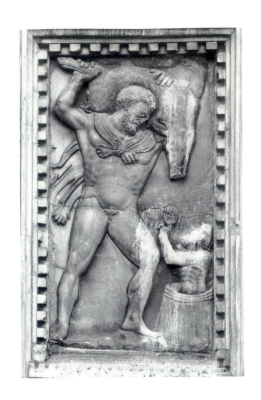

Fig. 17. Heracles and the Boar,
San Marco

Fig. 18. Virgin Mary, San Marco

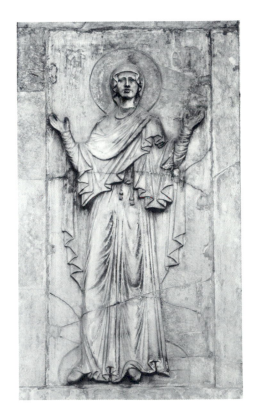

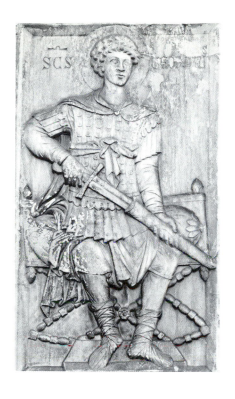

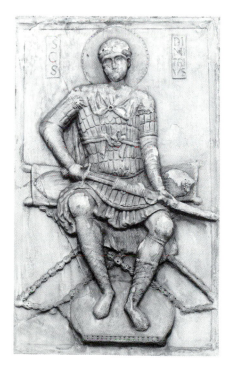

Fig. 19. St. George, San Marco

Fig. 20. St. Demetrius, San Marco

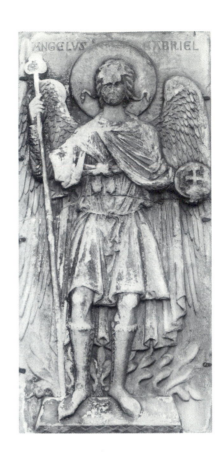

Fig. 21. Archangel Gabriel, San Marco

Fig. 22. Heracles with the Hind
and the Hydra, San Marco

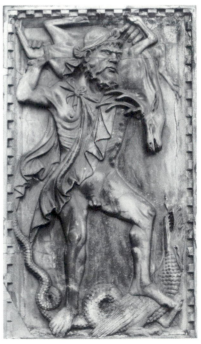

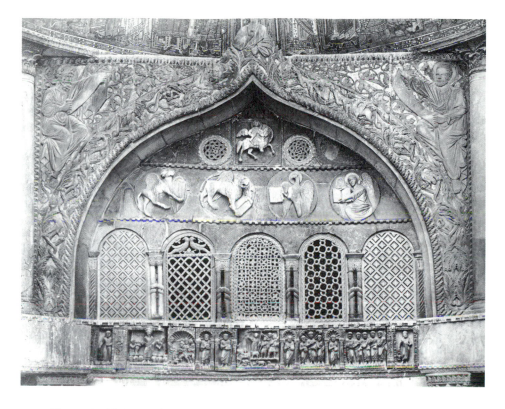

Fig. 23. Middle Zone of the Porta Sant'Alipio, San Marco

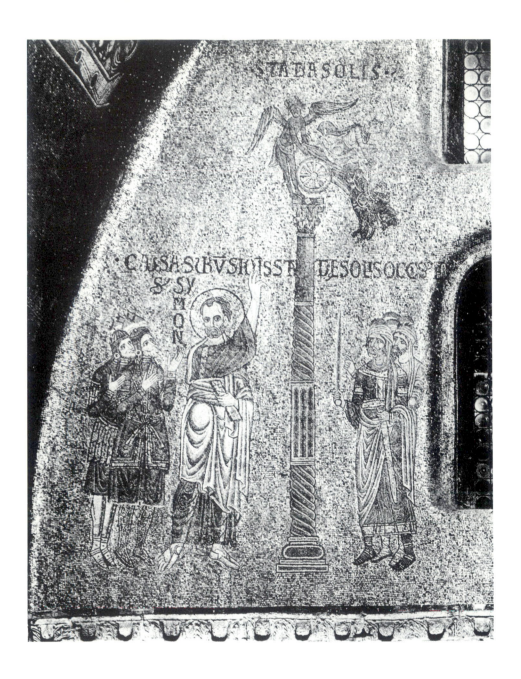

Fig. 24. Martyrdom of St. Simon, San Marco, South Wall of West Arm

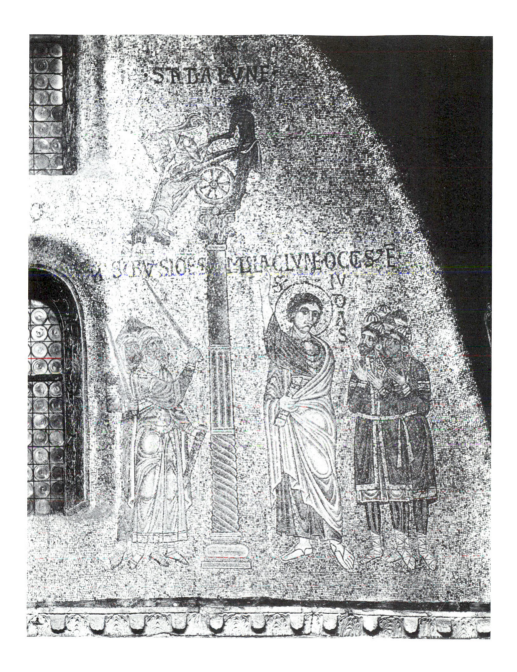

Fig. 25. Martyrdom of St. Jude, San Marco, South Wall of West Arm

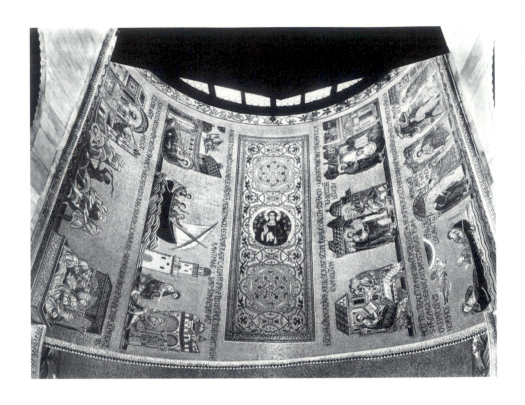

Fig. 26. Life of St. Mark, San Marco, Cappella Zen

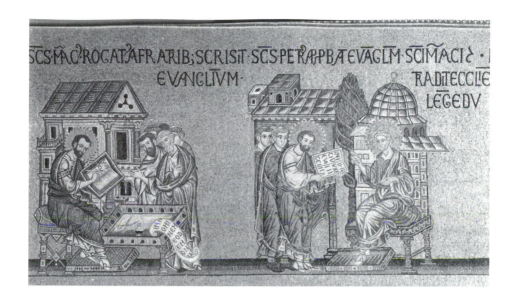

SCS MACR ROGAT A FRARIB; SCRISIT SCS PE RA PBA EVAGLM SCI MACI &
EVANGLIVM· RADIT ECCLIE
 LEGEDV

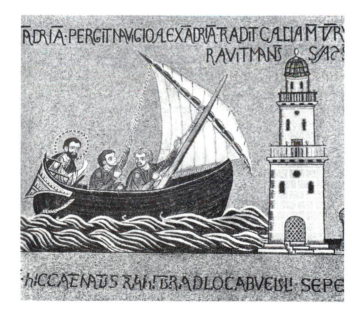

ADRIA·PERGIT NAVGIO ALEX ADRIA RADIT CALIAM TVR
 RAVIT MANS & SA?

HIC CAE NATIS RAII BRAD LOCABVELII SEPE

Figs. 27 & 28. St. Mark Writing His Gospel and Presenting It to St. Peter,
and Arriving at Alexandria, San Marco, Cappella Zen

Fig. 29. Body of St. Mark Being Carried into San Marco, San Marco,
Porta Sant'Alipio

Fig. 30. Gentile Bellini, *Procession in Piazza San Marco*, Venice, Gallerie dell'Accademia

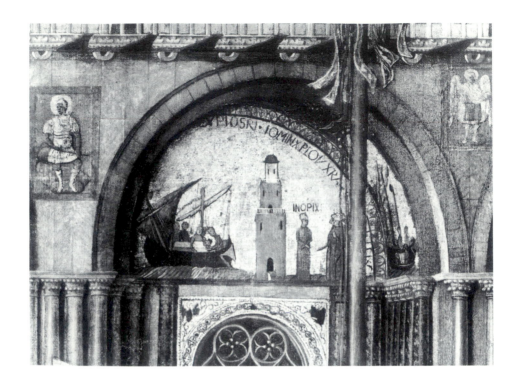

Fig. 31. Venetians Departing Alexandria with the Relics of St. Mark, detail from Gentile Bellini, *Procession in Piazza San Marco*

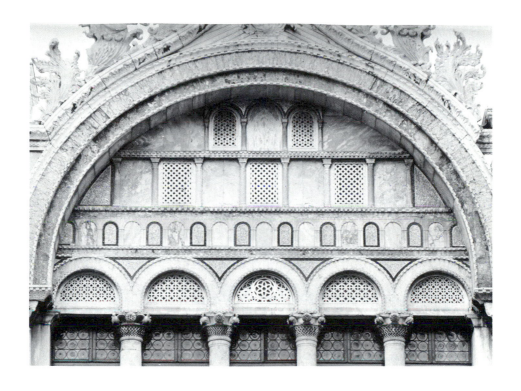

Fig. 32. Upper Lunette at the West End of the South Façade, San Marco

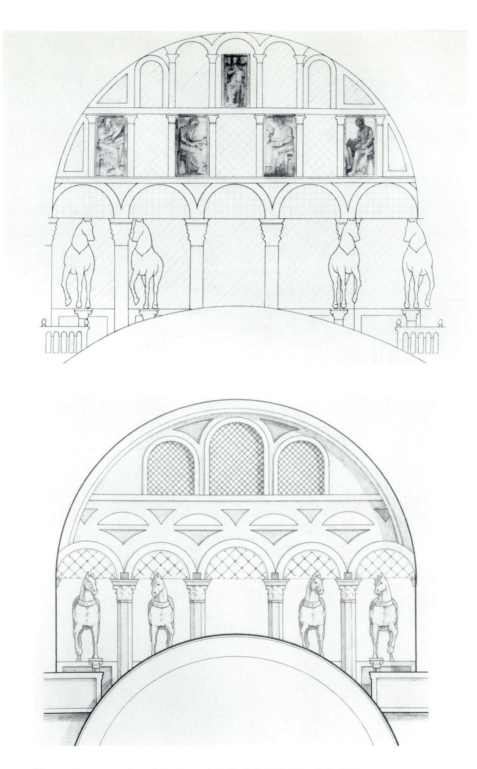

Fig. 33. Reconstruction of the Central Arch of the West Façade by Polacco

Fig. 34. Reconstruction of the Central Arch of the West Façade by Galliazzo

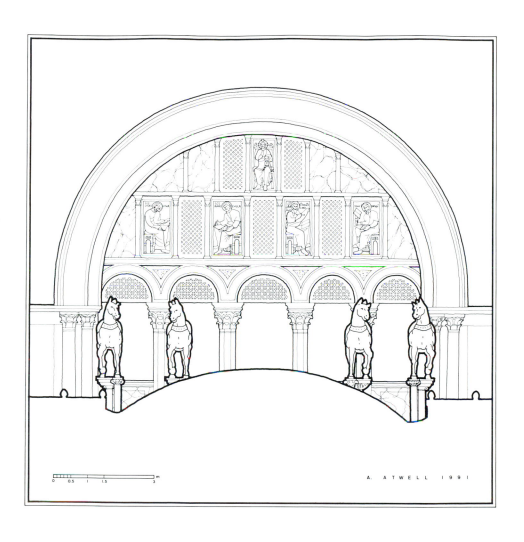

Fig. 35. Author's Reconstruction of the Central Arch of the West Façade

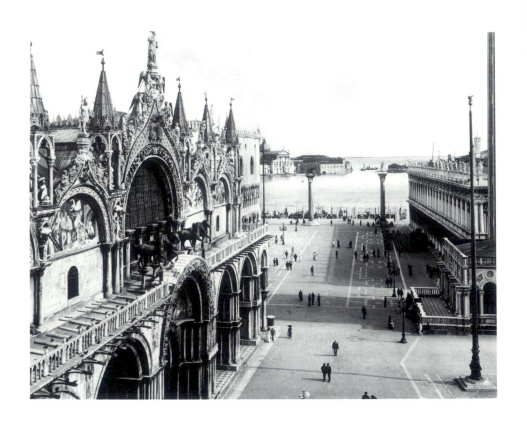

Fig. 36. Piazzetta di San Marco

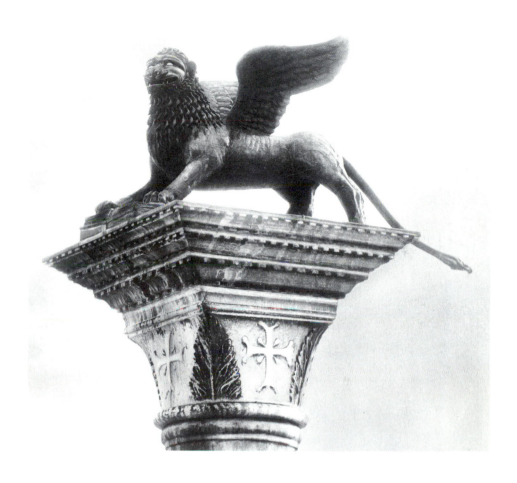

Fig. 37. Lion, Venice, Piazzetta di San Marco

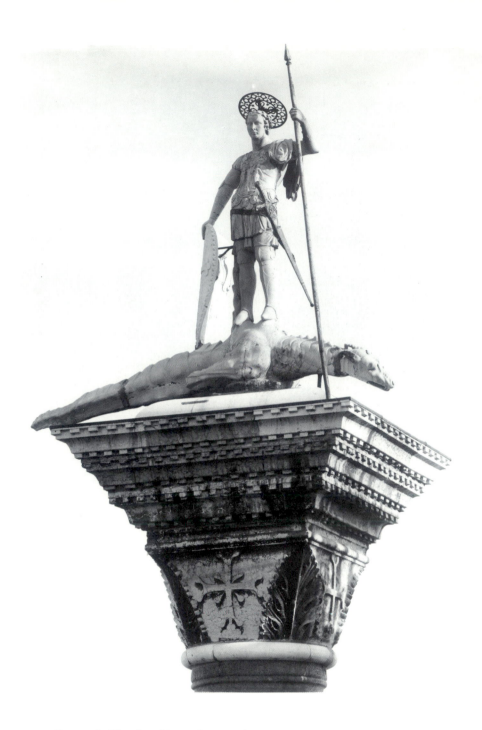

Fig. 38. St. Theodore, Venice, Piazzetta di San Marco

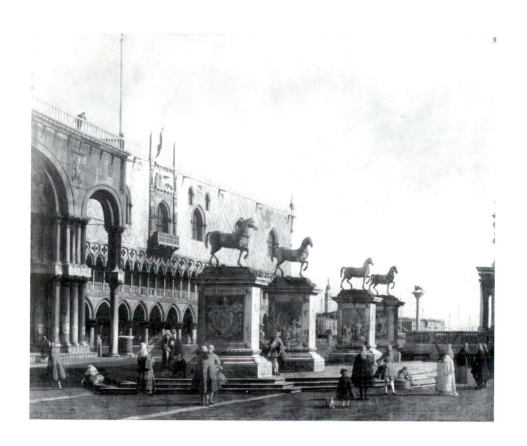

Fig. 39. Antonio Canaletto, *Capriccio with the Four Horses of San Marco*

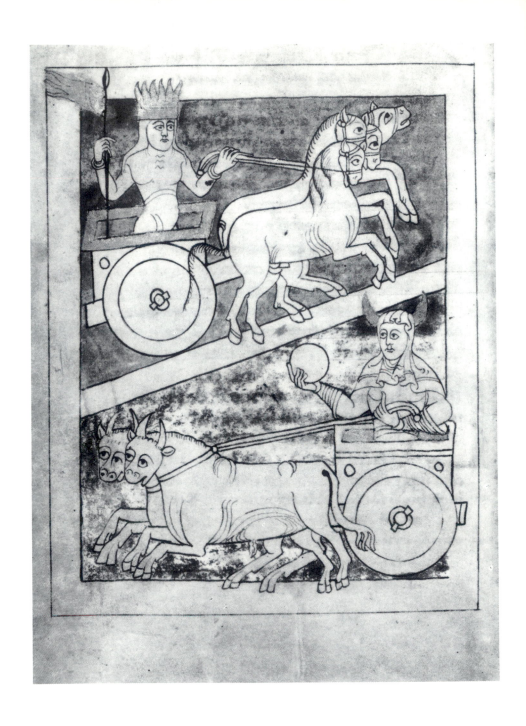

Fig. 40. Sun and Moon, Treatise on Astronomy, Oxford, Bodleian Library,
Ms. Bodley 614, fol. 17v

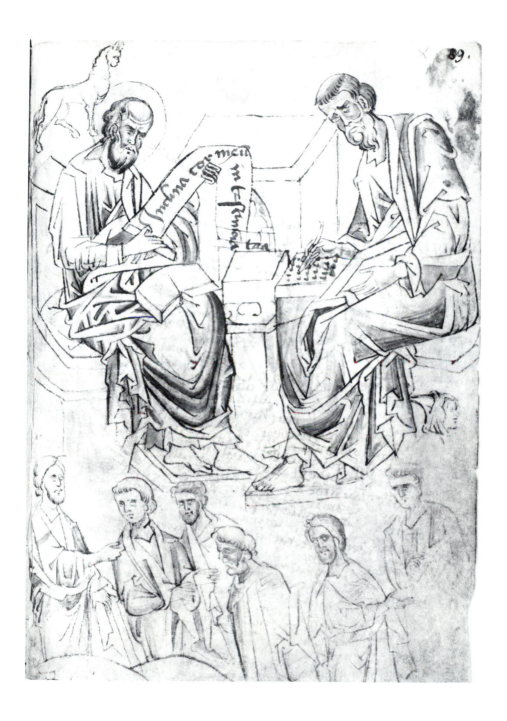

Fig. 41. Sts. John and Matthew, Wolfenbüttel, Herzog August Bibliothek,
Cod. Guelf. 61.2 Augusteus 4°, fol. 89r

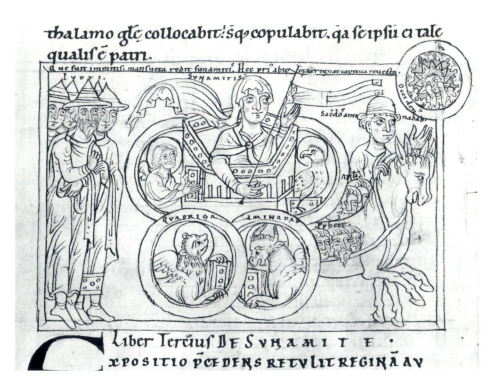

Fig. 42. Quadriga of Aminadab, Honorius Augustodunensis,
Commentary on the Song of Songs, Vienna, Österreichische Nationalbibliothek,
Cod. 942, fol. 79v

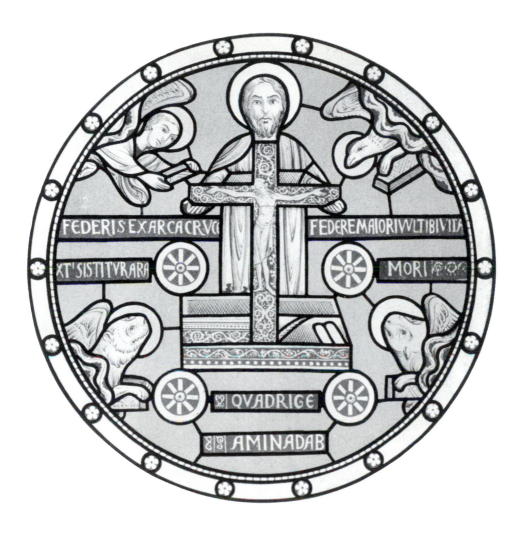

Fig. 43. Quadriga of Aminadab, Saint-Denis

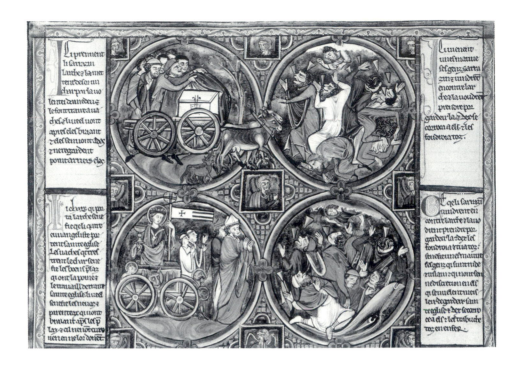

Fig. 44. Return of the Ark from the Philistines and the Car of the Gospels,
Bible moralisée, Vienna, Österreichische Nationalbibliothek, Cod. 2554, fol. 36v

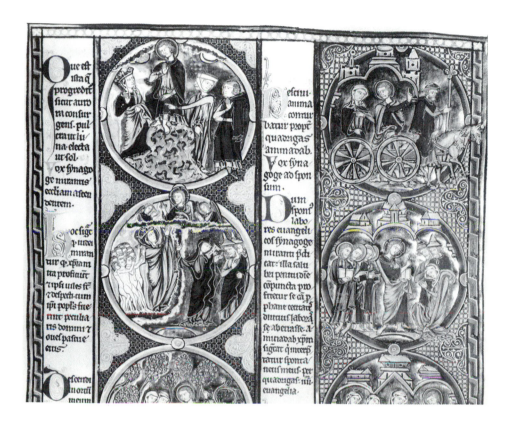

Fig. 45. Quadriga of Aminadab and Christ Preaching to the Jews,
Bible moralisée, Toledo, Catedral, II, fol. 86

Fig. 46. Opicinus de Canistris, Duomo of Pavia with the *Regisole*, Rome, Biblioteca Apostolica Vaticana, Cod. Pal. Lat. 1993, fol. 2

Onte alla nostra aitta seggui molto male fi merli gentil huomini tucto fossero

Fig. 47. Marten van Heemskerck, North Side of the Lateran with the Statue of Marcus Aurelius, Berlin, Kupferstichkabinett, Staatliche Museen Preussischer Kulturbesitz, 79 D 2, fol. 71v

Fig. 48. Murder of Buondelmonte de' Buondelmonti near the Statue of Mars, Giovanni Villani, *Cronaca*, Rome, Biblioteca Apostolica Vaticana, Cod. Chigi L. VIII, 296, fol. 70r

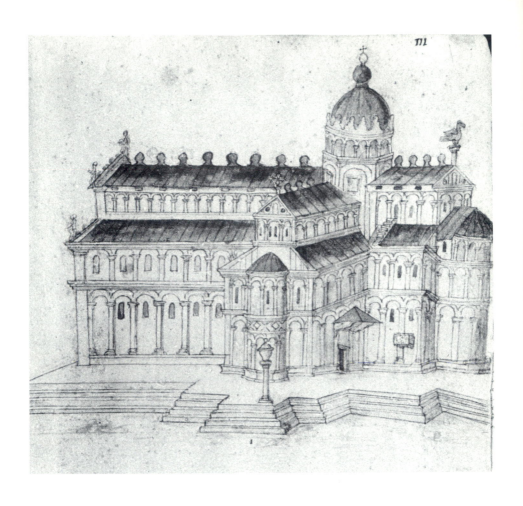

Fig. 49. Pisa, Duomo (after P. Tronci, *Descrizione del Duomo di Pisa*)

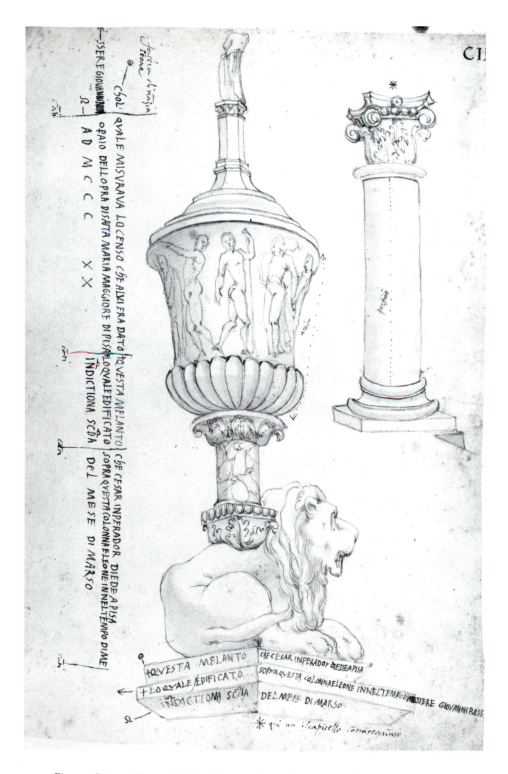

Fig. 50. Giovanni Antonio Dosio, Krater with Bacchic Scenes, Berlin, Kupferstichkabinett, Staatliche Museen Preussischer Kulturbesitz, 79 D 1, fol. 17r

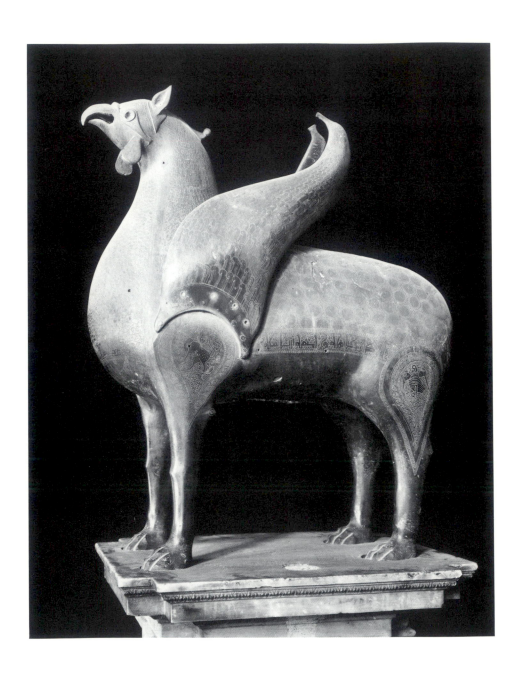

Fig. 51. Griffin, Pisa, Duomo

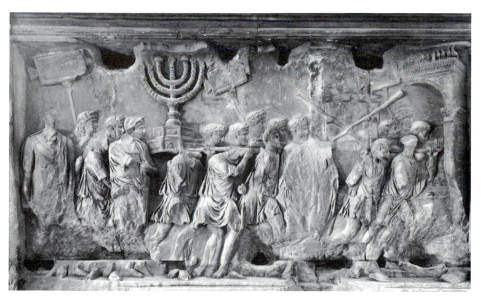

Figs. 52 & 53. Triumph of Titus and Victory Procession, Rome, Arch of Titus

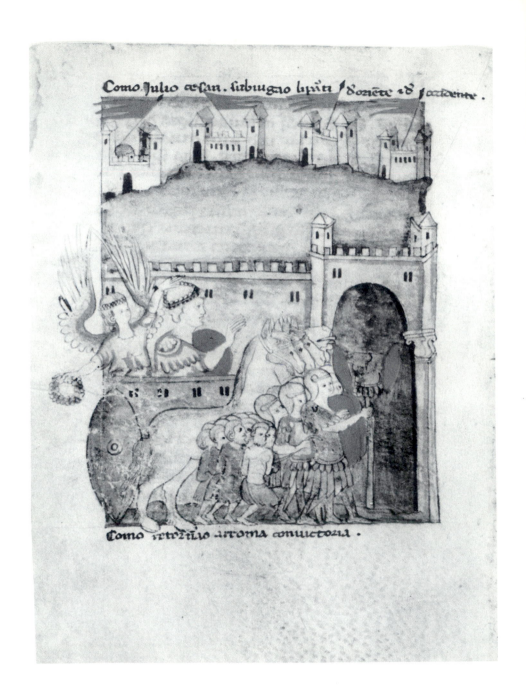

Fig. 54. Triumph of Julius Caesar, *Liber ystoriarum romanorum*, Hamburg, Staats- und Universitätsbibliothek, Cod. 151, fol. 90v

Fig. 55. Colossus, Barletta

Fig. 56. North Transept
Portal, Venosa, Chiesa
Nuova della Santissima
Trinità

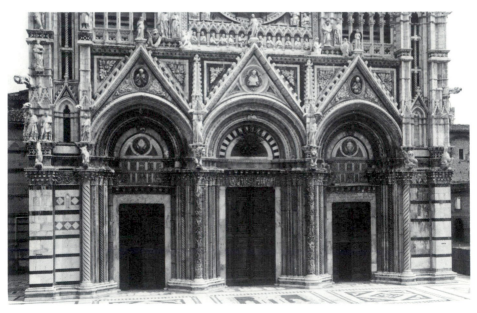

Fig. 57. West Façade, Siena, Duomo

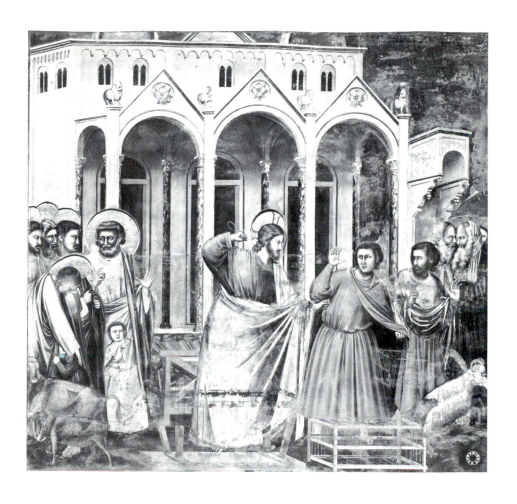

Fig. 58. Giotto, Expulsion of the Merchants from the Temple, Padua, Arena Chapel

Fig. 59. Titian, Triumph of Faith, Sheet I, New York, Metropolitan Museum

Fig. 60. Titian, Triumph of Faith, Sheet II, New York, Metropolitan Museum

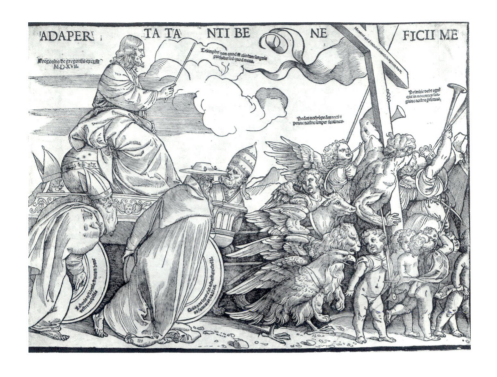

Fig. 61. Titian, Triumph of Faith, Sheet III, New York, Metropolitan Museum

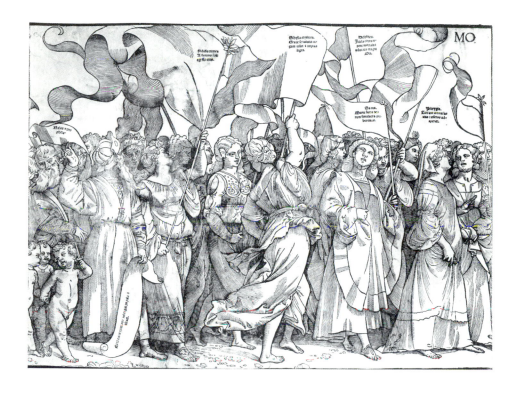

Fig. 62. Titian, Triumph of Faith, Sheet IV, New York, Metropolitan Museum

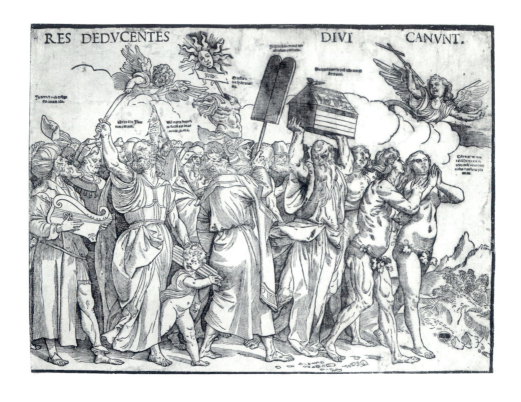

Fig. 63. Titian, Triumph of Faith, Sheet V, New York, Metropolitan Museum

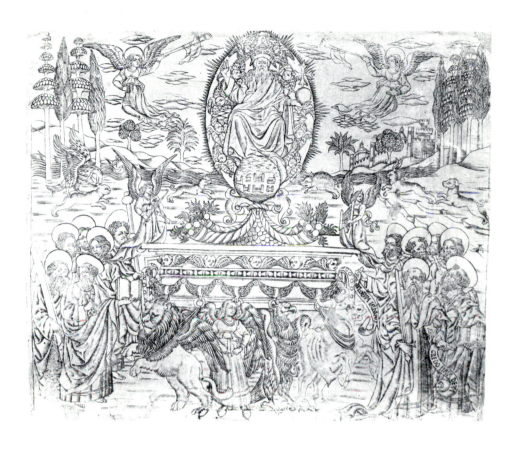

Fig. 64. Petrarch's Triumph of Divinity, Vienna, Albertina